Classical Art
From Greece to Rome

D1490369

Oxford History of Art

Mary Beard and John Henderson teach Classics at the
University of Cambridge. Together they wrote *Classics.
A Very Short Introduction* (Oxford).

Mary Beard is a Fellow of Newnham College and Curator
of the Museum of Classical Archaeology, Cambridge. Her
books include *The Invention of Jane Harrison* (Harvard) and
(with John North and Simon Price) *Religions of Rome, I–II*
(Cambridge).

John Henderson is a Fellow of King's College. His books
include *Fighting for Rome* (Cambridge) and *Writing Down
Rome* (Oxford).

Oxford History of Art

Titles in the Oxford History of Art series are up-to-date, fully illustrated introductions to a wide variety of subjects written by leading experts in their field. They will appear regularly, building into an interlocking and comprehensive series. In the list below, published titles appear in bold.

WESTERN ART

Archaic and Classical Greek Art
Robin Osborne

Classical Art From Greece to Rome
Mary Beard & John Henderson

Imperial Rome and Christian Triumph
Jas Elsner

Early Medieval Art
Lawrence Nees

Medieval Art
Veronica Sekules

Art in Renaissance Italy
Evelyn Welch

Northern European Art
Susie Nash

Early Modern Art
Nigel Llewellyn

Art in Europe 1700–1830
Matthew Craske

Modern Art 1851–1929
Richard Brettell

After Modern Art 1945–2000
David Hopkins

Contemporary Art

WESTERN ARCHITECTURE

Greek Architecture
David Small

Roman Architecture
Janet Delaine

Early Medieval Architecture
Roger Stalley

Medieval Architecture
Nicola Coldstream

Renaissance Architecture
Christy Anderson

Baroque and Rococo Architecture
Hilary Ballon

European Architecture 1750–1890
Barry Bergdoll

Modern Architecture
Alan Colquhoun

Contemporary Architecture
Anthony Vidler

Architecture in the United States
Dell Upton

WORLD ART

Aegean Art and Architecture
Donald Preziosi & Louise Hitchcock

Early Art and Architecture of Africa
Peter Garlake

African Art
John Picton

Contemporary African Art
Olu Oguibe

African-American Art
Sharon F. Patton

Nineteenth-Century American Art
Barbara Groseclose

Twentieth-Century American Art
Erika Doss

Australian Art
Andrew Sayers

Byzantine Art
Robin Cormack

Art in China
Craig Clunas

East European Art
Jeremy Howard

Ancient Egyptian Art
Marianne Eaton-Krauss

Indian Art
Partha Mitter

Islamic Art
Irene Bierman

Japanese Art
Karen Brock

Melanesian Art
Michael O'Hanlon

Mesoamerican Art
Cecelia Klein

Native North American Art
Janet Berlo & Ruth Phillips

Polynesian and Micronesian Art
Adrienne Kaeppler

South-East Asian Art
John Guy

Latin American Art

WESTERN DESIGN

Twentieth-Century Design
Jonathan Woodham

American Design
Jeffrey Meikle

Nineteenth-Century Design
Gillian Naylor

Fashion
Christopher Breward

PHOTOGRAPHY

The Photograph
Graham Clarke

American Photography
Miles Orvell

Contemporary Photography

WESTERN SCULPTURE

Sculpture 1900–1945
Penelope Curtis

Sculpture Since 1945
Andrew Causey

THEMES AND GENRES

Landscape and Western Art
Malcolm Andrews

Portraiture
Shearer West

Eroticism and Art
Alyce Mahon

Beauty and Art
Elizabeth Prettejohn

Women in Art

REFERENCE BOOKS

The Art of Art History: A Critical Anthology
Donald Preziosi (ed.)

Classical Art

From Greece to Rome

Mary Beard and John Henderson

OXFORD

UNIVERSITY PRESS

OXFORD

UNIVERSITY PRESS

Great Clarendon Street, Oxford OX2 6DP

Oxford New York

Auckland Bankok Buenos Aires Cape Town Chennai
Dar es Salaam Delhi HongKong Istanbul Karachi Kolkata
Kuala Lumpur Madrid Melboure Mexico City Mumbai Nairobi
São Paulo Shanghai Taipei Tokyo Toronto

Oxford is a registered trade mark of Oxford University Press
in the UK and in certain other countries

ISBN 978-0-19-284237-4

10 9

British Library Cataloguing in Publication Data
Data available

Library of Congress Cataloguing in Publication Data
Data available

Picture research by Elisabeth Agate
Typeset by Paul Manning
Design by Oxford Designers and Illustrators
Printed in China on acid-free paper by C&C Offset Printing Co. Ltd

*The web sites referred to in the list on pages 280–1 of this book are in the public domain and
the addresses are provided by Oxford University Press in good faith and for information
only. Oxford University Press disclaims any responsibility for their content.*

Contents

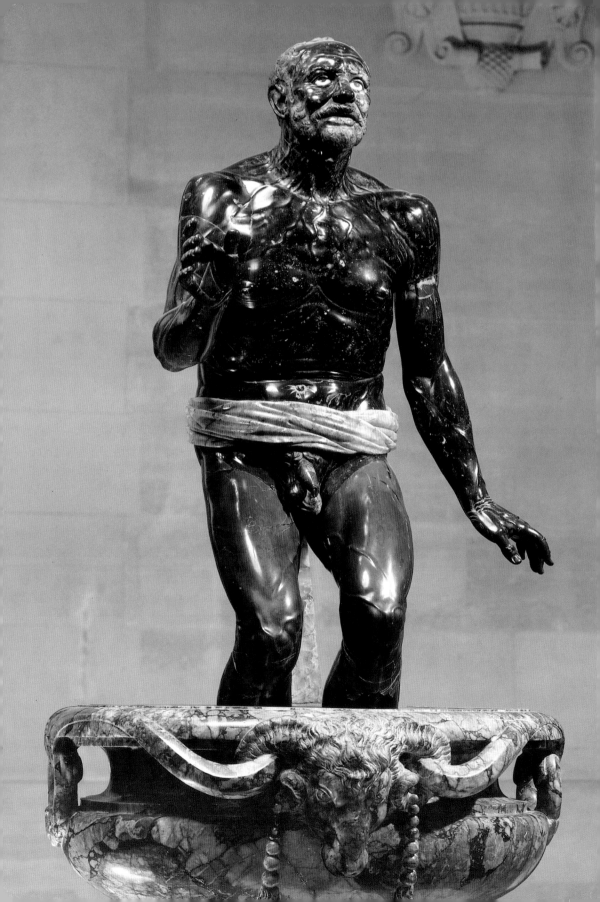

Introduction

By 65 CE the Roman court had had enough of its increasingly psychotic post-adolescent emperor Nero. The conspiracy to do away with him was hopelessly bungled, and in the reprisals Nero roped in a number of high-profile suspects. Among these was his former tutor Seneca, now in retirement and busy turning himself into a full-blown philosopher, the Roman Socrates. When he received the customary 'invitation' to take his own life, Seneca grabbed the chance for glamorous martyrdom. Opening his veins (arms, wrists, and legs), he stepped into a warm bath to hasten the flow of blood—and died (as he himself made sure to proclaim) in the cause of Liberty.[1]

Fifteen hundred years later, an ancient marble statue surfaced in Rome, capturing the very moment of Seneca's suicide: the philosopher straining to surmount agonizing pain, his face scored with lines of wear and renunciation, veins graphically playing across the emaciated body, pulsating through the shrunken skin; and an eery glow all around, from the gleaming black stone [1]. This sensational pagan image of Stoic fortitude struck an immediate chord with Rubens, who made it an icon of 'passion', as the centrepiece of his *Death of Seneca* [2], and it prompted extravagant eulogies from all and sundry: 'If our sculptors knew how to make a comparably expressive CHRIST it could be depended on to bring tears to all Christian eyes', heaved one stricken admirer in 1700.[2] Another admirer, Napoleon Bonaparte, bought up Seneca in 1807 for his grand new museum, the Louvre, where the visitor can still see him standing in his bath. Facing up to death, and challenging us to do the same.

But take this story more slowly and you will find it much richer than it looks. For a start, when it was discovered, the statue was evidently missing its eyes and parts of the face, both legs from the crotch to below the knees (only a small wedge of calf seems to be ancient), and probably both arms below the armpits; and it was certainly not standing in a basin. All these are Renaissance restorations, designed to give us a whole work of classical art and to recreate a famous figure from antiquity in his moment of glory. The statue also acquired a garish modern 'belt', whose ends bunch together behind him to form a supporting stone pillar that props the alarmingly hunched figure

1
Statue commonly known as the *Dying Seneca* or the *Louvre Fisherman*.

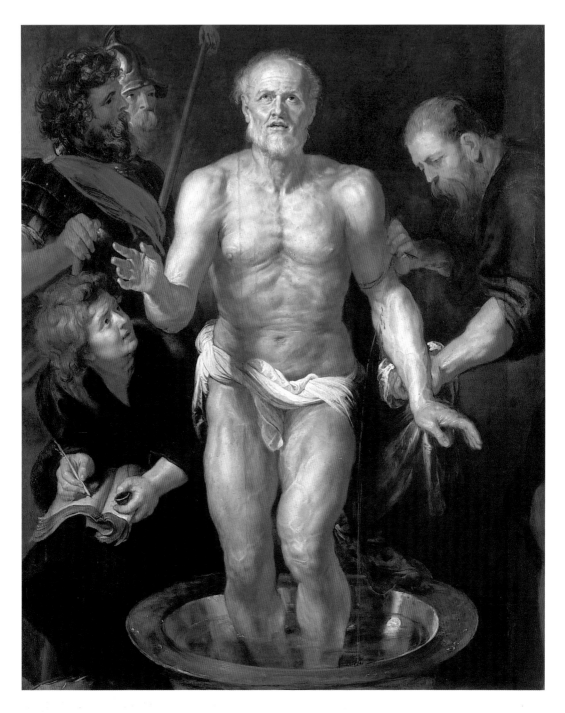

2 Peter Paul Rubens
The Death of Seneca, c.1608.

upright. Almost at once, the identification, and the restoration, were doubted. In the 1760s, J. J. Winckelmann (the 'father' of art history, who will be a key player in this book, pp. 68–72) was scornful, sure that this was no Seneca, but rather a comic slave from the Roman stage. Today's art historians see the statue as an 'Old Fisherman' (very

likely depicted wading in water, hence nothing below the top of the calves). And they count it a Roman copy of a lost Greek original; in fact over a dozen more or less well-preserved versions of the type have turned up in different places across the Graeco-Roman world—wearing similar 'belts', or loin-cloths, but none of them with knees bent and torso jack-knifing back at such an angle.

These disputes have taken their toll on the Louvre's *Seneca*. Around 1900, in a fit of half-hearted purism, the museum removed the gorgeous Renaissance basin and perched the statue on a concrete block; only to put the basin back in the late 1990s, as if to recognize the significance of the astonishingly drastic restoration itself. Changing aesthetics have made their impact too. If his discovery was greeted with eulogies, the tide had already begun to turn when Napoleon took *Seneca* to Paris, and the emaciated body and haggard face were found disgusting rather than uplifting. It is certainly no longer highly prized among the masterpieces of classical sculpture.

This story heralds many of the themes of this book: identification and restoration, controversy and copying, international scholarship and imperial spectacle. Our period starts with the meteoric career of Alexander the Great of Macedon. Putting paid once and for all to the independence of the free city-states of classical Greece (Athens, Sparta, Corinth, and the rest), his armies blazed their way to the borders of India—before their charismatic leader perished in 323 BCE on the return leg of the journey. It ends in 138 CE with the death of the Roman emperor Hadrian, who had ruled territory that stretched from Britain and Spain to the Sahara and Syria (Maps and Plans 1). The four hundred and fifty years in between were first marked by the rivalry of the kingdoms founded when Alexander's generals carved up his conquests; and then dominated by the irresistible rise of Rome from a middle-ranking tribal stronghold to the greatest imperial superpower the world had ever known. In the process, Rome itself was transformed from a quasi-democratic republic to an arbitrary despotism under the Caesars (even if their regime did masquerade as a benign adaptation of the Republic). Much of the art we shall be exploring in this book was produced for autocrats, whether Greek kings or Roman emperors. Inevitably, their dominance has pushed other traditions—whether Etruscan, native Italic, or Near Eastern art—to the periphery.

Our period has made itself the crucial episode in the story of ancient art: it saw the first attempts to produce a critical analysis of painting and sculpture, and the invention of the 'artist' as a figure of fame. Particular Graeco-Roman objects produced during this half-millennium have not only enjoyed lasting prestige (think first of the Venus de Milo [**84**], pp. 120–3, or Laocoon [**49**], pp. 65–8), but for

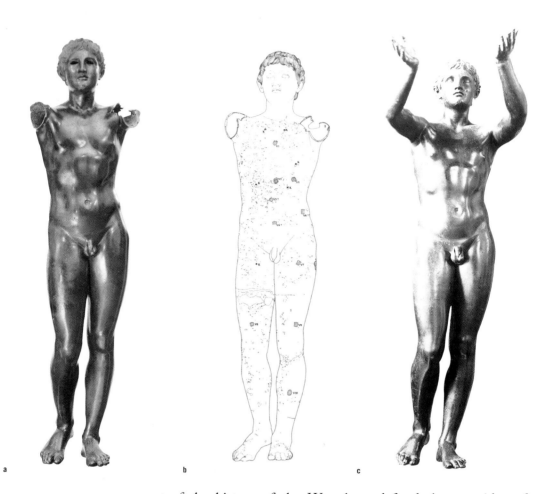

a b c

most of the history of the West have defined the very idea of classical art. Before the early nineteenth century almost nothing was known of the Parthenon marbles or any of the other treasures of fifth-century Greece (which specialists tend to label, in a narrower sense, 'Classical'). What came out of the ground in Renaissance Rome and later in the excavations at Pompeii and Herculaneum (in south Italy)—the art treasures which became the inspiration for the Renaissance itself and provided models for generations of European painters and sculptors—almost all belonged to the period between Alexander and Hadrian. And it was in the attempt to understand this material that the modern discipline of art history was born.

We shall treat classical art by topic, theme, and genre, with chapters on painting, sculpture, desire, power and scale, and portraiture. To organize the book chronologically, along a linear thread of artistic development, would have been impossible (see Timeline). On the one hand, the kaleidoscopic complexities of the political history of the Greek world after Alexander (conventionally known as the

Hellenistic period) cannot be resolved into an intelligible narrative against which we could plot a succession of artistic styles or regional idioms. On the other hand, as we shall see, the diverse visual culture of the Roman empire and the dominant ethos of creative imitation (as works of art were copied and multiplied, adapted and parodied, across the centuries) inevitably preclude any single model of change. The world incorporated by Rome was a seething global multi-culture: 'Hellenism' was everywhere, not least in Rome itself; 'Romanization' proceeded apace, not least in Greece and the whole sweep of the east Mediterranean. As we shall see, there is only one general formula that holds: in classical art Greece is always mediated through Rome.

We shall be concerned not to sever the objects we study from their origins in classical antiquity, but just as fundamental to our approach is the determination to keep in clear view their history since antiquity. We shall give full attention to the collection and restoration of art works, and to their roles in inspiring artists to fashion faithful copies and fresh creations; to changes of ownership and movement between museums, and to their fluctuating fortunes in the wrangling of critical disputes and the game of fame [**3, 4**].

These works have influenced the history of western culture massively. Ever since their rediscovery, they have provided artists with direct inspiration: *Seneca* handed Rubens his vision of fortitude; Raphael decorated papal palaces patterned on the extravagant 'Golden House' of the Emperor Nero himself [**46**]. And on a yet grander scale, great collectors put together displays of classical art

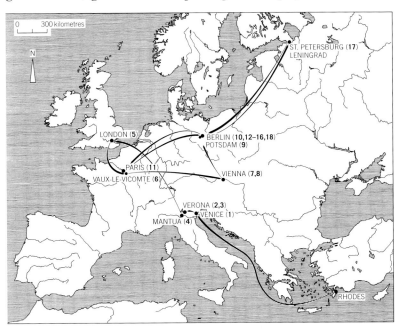

5 G. P. Panini

Roma Antica, from *Gallery of Views of Ancient Rome*, *c*.1755.

This imaginary ensemble of canonical works of classical art does more than show off treasures – among them, many we shall highlight in this book: (a) *Arch of Titus* (**131–2**), (b) *Pantheon* (**123**), (c) *Farnese Hercules* (**144–6**), (d) *Dying Gaul* (**110**), (e) *Apollo Belvedere* (**77–8**), (f) *Aldobrandini Wedding* (**44**), (g) Column of Marcus Aurelius (p. 181), (h) *Laocoon* (**49**).

Panini also catalogues the different ways that modern art lovers interact with ancient paintings, sculpture, and architecture: absorption, discussion, reproduction of the masterpieces, and modern representations of them (including, of course, Panini's own panorama). At the heart of the painting, the artist who finishes a copy of the 'Aldobrandini Wedding' (= **44**) conveys the classic insight of all classicism: to copy is to *re*create the original; but it is also to *create* an original.

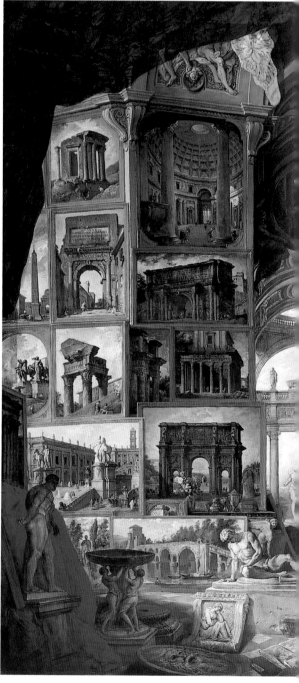

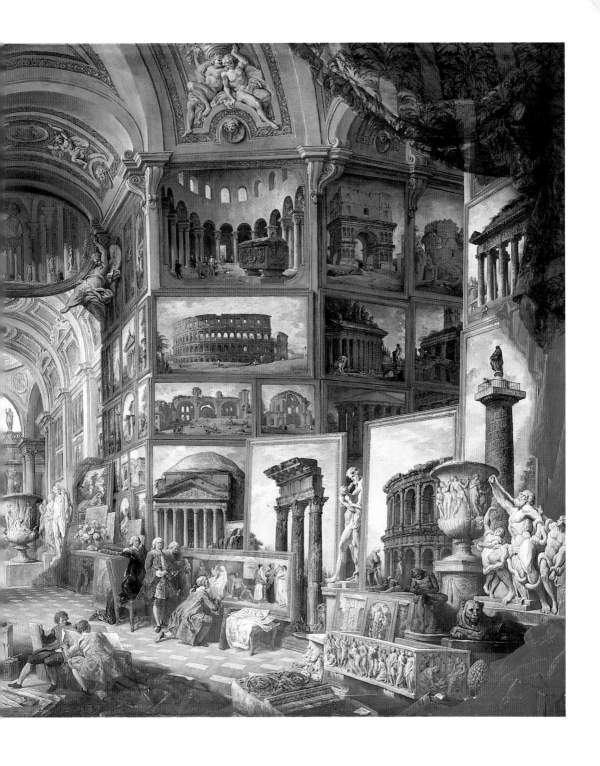

which defined and redefined civilization itself in terms of these very objects [**5**]. It was as the agent of Cardinal Albani, the star collector in Renaissance Rome, that Winckelmann came to theorize the canon of classical art; and Napoleon's investments and seizures of masterpieces made his museum (the Louvre) not only the greatest gathering of art since classical Rome but a model of civilization at its zenith. Each will therefore be a major focus for this book ([**63**], [**76**], [**110**], [**111**], pp. 68–72, 107–9; and [**77 (b)**], [**92–3**], [**129**], [**150**].

But, still more vitally, the works we shall be featuring *cannot* be seen outside their history since their modern rediscovery. At the most basic level, *Seneca* was essentially created by Renaissance restoration; and (as we shall see, pp. 214–5) the eighteenth century manufactured its own favourite portrait of the first Roman emperor, Augustus. More generally, the history of museology and strategies for display, of

6 L. Alma-Tadema

The Picture Gallery, 1874.
This picture imaginatively recreates an ancient Roman gallery, displaying on its walls lost masterpieces of Greek painting – known only through copies from Pompeii or references in Roman authors. The artist is partly making a telling point about the imperfect preservation and the severe limitations of our knowledge of these artworks (for the portrait of Medea at the centre, and the half-glimpsed image at the far left, in fact a famous image of a victory of Alexander the Great, see **22**, **12**). But he is also dramatizing for us the dilemma we face in imagining the circumstances in which ancient painting was produced, circulated, and viewed. As such it constitutes an allegory of classical viewing, no less.

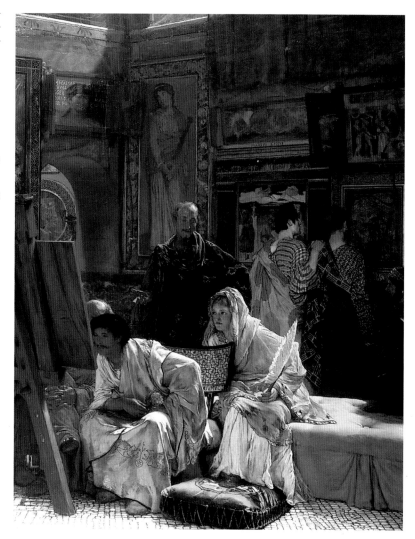

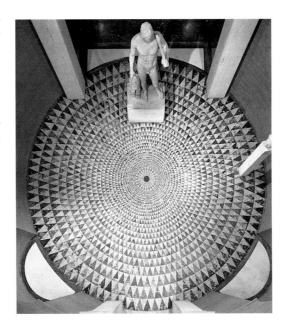

J. Paul Getty Museum in Malibu, California, 'Temple of Herakles' (1974), with replica of mosaic from the Villa of the Papyri, Herculaneum, and statue of Hercules (the *Lansdowne Hercules* – **66**).
The billionnaire collector's dream come true. This mosaic is a replica of the first find (1751) at the Villa of the Papyri, Herculaneum (on which Getty's Museum was modelled). Made from Italian marbles in coloured triangles, it was shipped to Malibu as flooring for the 'Temple of Herakles' built to house Getty's favourite statue.

aesthetics and art theory, of archaeological discovery and academic scholarship, have helped to determine how we see and understand the art of the ancient world [**6**]. It is for these reasons that the drive behind our display of the splendour of classical art must be a stereoscopic vision of art in ancient *and* modern cultural history (see Timeline).

These processes of recovery, restoration, recreation, and reinterpretation are, necessarily, far from over. As we shall find in the chapters that follow, major works of art continue to be uncovered (pp. 189–92, 197–9) and indeed to be 'manufactured' under the technological regime of modern restoration (one of the most notable sculptural groups to be discovered in the twentieth century was 'reassembled' from hundreds of tiny fragments [**52**], pp. 74–82). We have never stopped trying to see how Greek and Roman art was seen, how it looked and was meant to look, what it meant and can mean. Museums and collectors too continue to reshape our vision of the classical world. Appropriately enough, the collection of J. Paul Getty in California (the largest and most costly collection of classical and other works of art to be assembled in the twentieth century) tells this story loudest of all. Modelling his first museum beside the Pacific Ocean on the plan of one of the largest and richest villas of the Roman town of Herculaneum, itself a treasure trove of ancient sculpture, Getty offered a parable of engagement with the art of the classical past—telling how we must all keep making our own copies in order to recreate theirs [**7**] (cf. **65**, pp. 93–6; **72**, pp. 104–5).

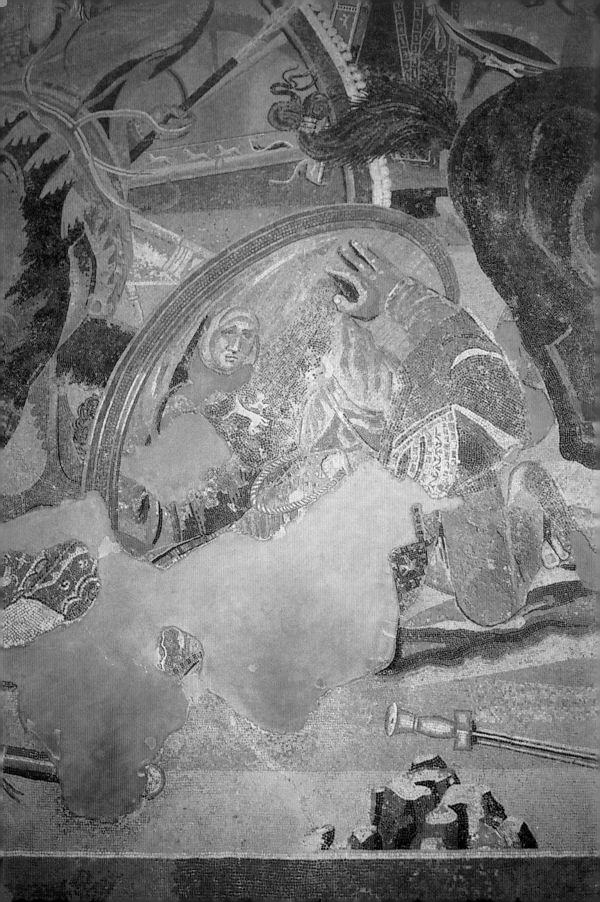

Painting Antiquity: Rediscovering Art

1

Archaeology's greatest moment ever was the discovery of the ancient towns of Pompeii and Herculaneum, buried beneath the volcanic debris of Vesuvius in 79 CE (Maps and Plans 2). The finds were sensational and immediately caught the imagination of mid-eighteenth-century Europe: a terrific investment for the kings of Naples, who were paying for the excavations and praying for the kind of plunder that would put their kingdom on the map. It did. Tourists flocked to see the treasure; publications spread images of the paintings and statues all over the continent, from St Petersburg to London. But what caught the imagination more than any individual object was the sense that here whole cities lay buried; that here for the first time you could experience how it might *feel* to look around the ancient world. The drama of the imagination was enhanced as much by the fabric of everyday life (the candlesticks, the carpenter's tool kit, the graffiti on the walls, the kennels for the slaves) as it was by prestige works of 'Art' in the grandiose villas of the rich. Not to mention the melodrama of the death of a city. What touched everyone most directly—as it still does—was the thought of a whole population dislodged at a stroke. Skeletons [**9**] and corpses [**10, 149**]; a city of ghosts.

The initial excavations were very much part of royal display. In 1739 Charles III, the Bourbon king of Naples, built on site a summer palace, as soon as he heard a Roman theatre had been discovered (later identified as the theatre of Herculaneum). King and queen together could be seen surveying the dig, and watching as new treasures were carefully added to their growing collection. By the end of the century, the dynasty had become major players in amassing antiquities (Charles himself was king of Spain 1759–88): they had also inherited the most famous Renaissance collection of ancient sculpture, assembled by the Farnese family in Rome (pp. 163, 199–200). All this, and the sheer quantity of material coming out of the ground at Pompeii and Herculaneum, soon demanded the provision of a palatial museum in Naples itself, eighteenth-century Europe's third largest city (after London and Paris).

Even so, no one at that time could have imagined that excavators would still be at work on the 'cities of Vesuvius', and pioneering fresh

8 Detail of the *Alexander Mosaic* (**12**)

techniques, into the third millennium; in fact 20 per cent of Pompeii and 75 per cent of Herculaneum remain buried (Maps and Plans 3). Nor could anyone in the eighteenth century have guessed that the haul (most of it still displayed together in what is now the National Archaeological Museum of Naples) would be drawing in hordes of visitors from all over the world. It would have been simply impossible for anyone then to conceive the role these discoveries have played ever since. *They* supposed that they were exploring a small part of the Roman empire, savouring the luxury, the decadence, the life, and the colour of two Roman towns. They were. But, far beyond that, their

10 Allan McCollum

The Dog from Pompeii, concrete cast installation, Galeria Weber, Madrid, 1991.

Living death. The agonies of Vesuvius' victims have been captured since the 1860s by G. Fiorelli's technique of pouring plaster into the cavity left when the bodies decomposed beneath the volcanic ash; cf. pp. 205–6. Here McCollum exposes our own voyeurism by replicating to absurdity the cast of a Pompeian dog, tearing at its tether.

11

The House of the Faun, Pompeii (see Maps and Plans 3 (g)); view inside from the front door.

The cities of Vesuvius capture a sense of the domestic and social ambience of the classical world, better than any other sites. Here the visitor steps straight into the main *atrium* (**14**) of an opulent Pompeian house, designed and built in the second century BCE.

enterprise became the basis of our understanding of Greek, as well as Roman, art after Alexander. Indeed, in terms of ancient *painting*, it has given us virtually the only repertoire of images that we can still look at today.

This is why our account starts, and works out, from two provincial towns in middle Italy, rather than the great metropolitan centres of the Hellenistic kings, or their successors in Rome. At the same time, Pompeii in particular is a prime example of the cultural complexity of our period, which we outlined in our introduction. The town entombed in 79 was Roman, but it had not lost all traces of its earlier history as an Italic community, closely linked to the neighbouring cities of Naples and Cumae (themselves Greek foundations) and part of the deeply Hellenized world of southern Italy in the third and second centuries BCE [**11**].

Alexander the Great rides in: a mosaic at Pompeii

Our first case study is one of the most extraordinary works of art to have survived from the ancient world: a vast mosaic floor, measuring 3.13 by 5.82 m [**12**]. Unearthed in 1831, it was not one of the very earliest discoveries from Pompeii; but it came from what is still the largest house, and one of the grandest, to have been excavated in the city, the so-called 'House of the Faun' (Maps and Plans 3 (g)).

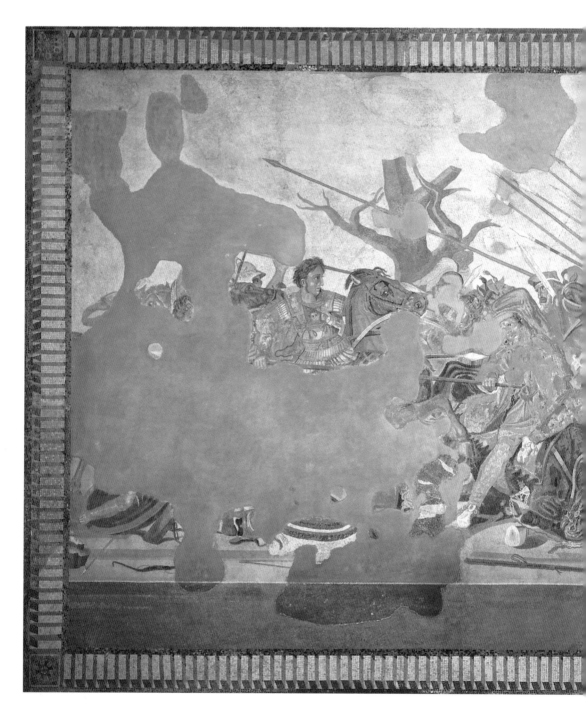

12

The *Alexander Mosaic*, from the House of the Faun, Pompeii.

The modern title derives from the figure on the left, always identified as Alexander the Great, who charges in with world dominion and massacre in his eye. But the focus is on the emotional trauma of his opponent, caught just at the moment when he wheels in flight; the silhouette of the bare tree, which mirrors his posture, serves to emphasize his utter devastation.

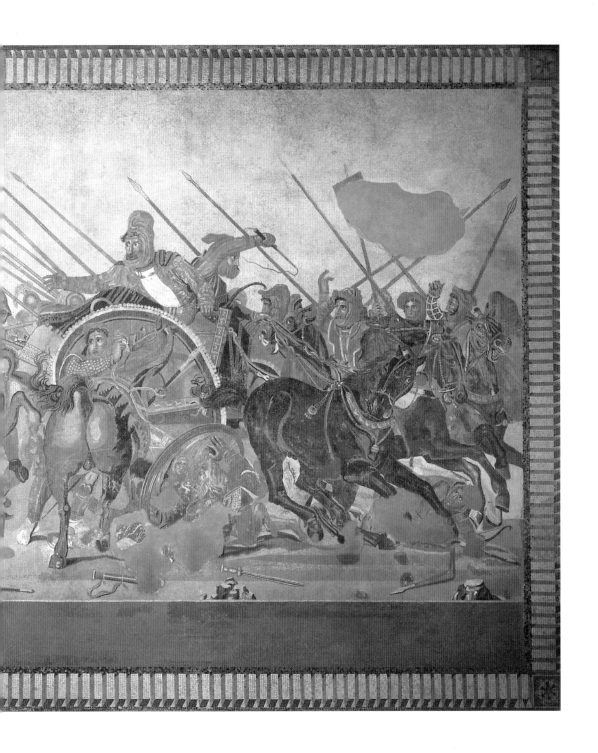

7th century BCE: earliest known traces of settlement

c.5th century: town settled by Italic people, speaking Oscan

4th/3rd centuries: earliest surviving houses

Early 3rd century: Roman power extends through south Italy; Pompeii becomes ally of Rome (though Oscan remains principal language)

By late 2nd century: layout of largest surviving mansion, the House of the Faun, substantially complete

91–89: Pompeii sides with confederacy of Roman allies, demanding Roman citizenship; Rome quashes the uprising, but concedes citizenship

c.80: forcible settlement of Roman veteran soldiers in Pompeii; town formally renamed '*Colonia Cornelia Veneria Pompeianorum*' ('Cornelius Sulla's veteran settlement of Pompeii, under the protection of Venus'); Latin becomes the official language

62 CE: earthquake severely damages the city

79, 24 August: eruption of Vesuvius

79–1748: millennium-and-a-half of looting

1748: first systematic excavations at the hill known as 'Città' (later found to be Pompeii)

1762: Winckelmann visits the site

1763, 20 August: inscription excavated proving that the buried town was Pompeii (previously thought to be Stabiae)

1830–2: House of the Faun excavated

1860–75: Giuseppe Fiorelli in charge of excavations; devises technique of casting corpses

1882: August Mau publishes his stylistic typology of Pompeian wall painting

1894–5: House of the Vettii excavated

1895: Boscoreale silver treasure discovered

1909–10: Villa of the Mysteries discovered (excavated 1929/30)

1924–61: Amadeo Maiuri in charge of excavations

1940: Mussolini entertains German minister of education in the Dining Room of the House of the Menander

1943: August and September: Allied planes drop 162 bombs on Pompeii, inflicting severe damage on (amongst others) the House of the Faun and the site museum

1980: The cities of Vesuvius badly damaged by a series of earthquakes.

This dazzling composition achieves its effects with countless tiny cubes of stone (*tesserae*) in just four or five main colours; estimates projecting a density of between 15 and 30 cubes per cm² give anything between two and a half million and five and a half million in total. The mosaic shows a confused whirl of battle, its central drama half-curtained from our view through a cluttered foreground of casualties, lost weapons, and the unforgettable hindquarters of a horse. At the same time, a massively energetic team of four black horses thunders out of the picture to lower right; they carry off the figure who dominates the scene—pushed away from centre-stage by the direct thrust of the charging horseman coming from the left. Raised in his chariot high above the throng careering all around, his chest the brightest area of radiance in sight, this focal figure opens his body along the picture-surface to show the viewer how to enter the image; for his gaze relays us along the length of his outstretched

arm and through his splayed palm to the extended tips of his fingers, at this instant before blind flight. This scene is literally a turning-point: we catch the moment when the passenger just hangs on to his last view of the carnage before his charioteer (who already points where his master will face as they quit the fray) whips the team away. Tension and torsion combine to make the melée a spectacular feat of composition, rewarding the viewer with the shock of a mighty display of chaotic force; yet, at the same time, with a firmly structured interaction between decisive aggression and organized response.

This feat of design also repays attention to its wealth of detail. That unforgettable horse, showing us its rear, is a visual puzzle that operates as the pivot for the whole scene: the pull of this spare mount's head against its squire's grip, together with both their gazes, acts out the scene on the chariot behind them—as the staring commander strains to eke out the last moment before the chariot swivels off in flight and he must abandon his brave comrades. The mosaic is also famous for the cameo in the foreground next to the horse: a fallen warrior shields himself in vain from being crushed beneath the huge wheel of his commander's chariot. In his attempt to block out the sight of impending doom, he inadvertently presents us with a reflected image of his own face—the instant before annihilation [8].

This *tour de force* is known as the *Alexander Mosaic*. The dashing rider who leads the charge from the left, showing off his gleaming breastplate as he skewers a brave opponent with his lance, is always identified as Alexander the Great—routing Darius, the king of Persia (in the 330s BCE). Costume, equipment, and weapons all brand the commander in his chariot a Persian, while his adversaries have distinctively Macedonian gear. We are looking upon the critical moment of disaster and triumph, victory and defeat: whether or not the mosaic evokes a precise historical occasion (art historians forever try to read this work of art as if it were a transcription of some specific battle), it represents the turning-point that would assure world conquest, the founding moment of empire. It is also a turning-point in the history of art. As we have seen, the rise of Alexander inaugurates the Hellenistic era.

The discovery of this epic image, taking pride of place in a town house in Pompeii, also serves to remind us that Alexander the Great was a crucial figure in Roman culture too. As we shall see in Chapter 5 (pp. 211–2, 226–7), he was the forerunner of world conquerors, such as Pompey 'the Great' and Julius Caesar; the yardstick of military glory; and eventually the model for successive Roman emperors. More than that, his conquests shaped the world stage not only for the kings and princelings that disputed his territories after his death, but

The largest surviving house in Pompeii, it covers an area that would comfortably have contained anywhere up to a dozen respectable houses (at more than 3,000 m² overall, rivalling, for example, the royal palace of Pergamum; see Maps and Plans 17).

later for the Romans too. Our mosaic picks out the most fitting theme for grandiose display: for the people of Pompeii lived in an emphatically post-Alexander world. If it is the figure of King Darius, impeccably noble in defeat, that holds the centre-stage that is because, as we shall see in Chapter 4, civilized art must continually parade its triumphalism as pathos.

'The House of the Faun': a Pompeian mansion

The *Alexander Mosaic* (long since removed to the National Museum in Naples) formed the floor of a made-to-measure room leading off a colonnaded garden (*peristyle*) in the largest house of Pompeii [13]. We cannot be certain how far the mosaic was regarded as a 'work of art', for guests to admire; or how far it served as just a backdrop to life in the house. But the layout of the room (however it was used) suggests that it was in some sense 'special'. From the front, a pair of columns replaced the wall, allowing a direct view inside. Behind, the rear wall of the room was cut by a large window, which allowed a view from the second peristyle garden beyond. On the threshold a mosaic strip lined up exotic creatures from the Nile, making an urbane allusion to Alexander's most famous foundation, Alexandria (the city that grew from fishing village to be the new capital of Egypt, and the largest conurbation in the world before Rome). It is hard not to suppose that this was a room designed specially to show off the grand mosaic.

The house as a whole was built on the principle of display. Rich houses at Pompeii (as anywhere in the Roman world) were organized on the assumption that prestige and power go hand in hand with a parade of tasteful opulence; that a properly appointed 'private' house was essential in determining 'public' status. The outside of most of these houses gave nothing away; blank walls topped with endless rows of tiles. Inside, elaborate gardens, cleverly designed vistas from one individualized suite to the next, collections of sculpture and paintings, antiques or the latest fashion, adorned these would-be palaces. Here the hard business of life was theatre; the owners of the house played the lead [14].

The House of the Faun offers a very special version of this drama. Uniquely, it occupies an entire city block (*insula*). In its final form it boasted the two peristyle gardens, a pair of interior courtyards (*atria*), and a host of rooms for receiving, entertaining, and impressing guests. Its modern name is taken from a bronze statue found on the premises [15]. This shows a dancing satyr, or 'faun', a mythical creature part human and part goat (budding horns, tail, and pointed ears). Once stationed in a focal position where he could command attention from all sides, the precious statuette's combination of balletic poise with raw energy signalled the artistry of the architectural interplay

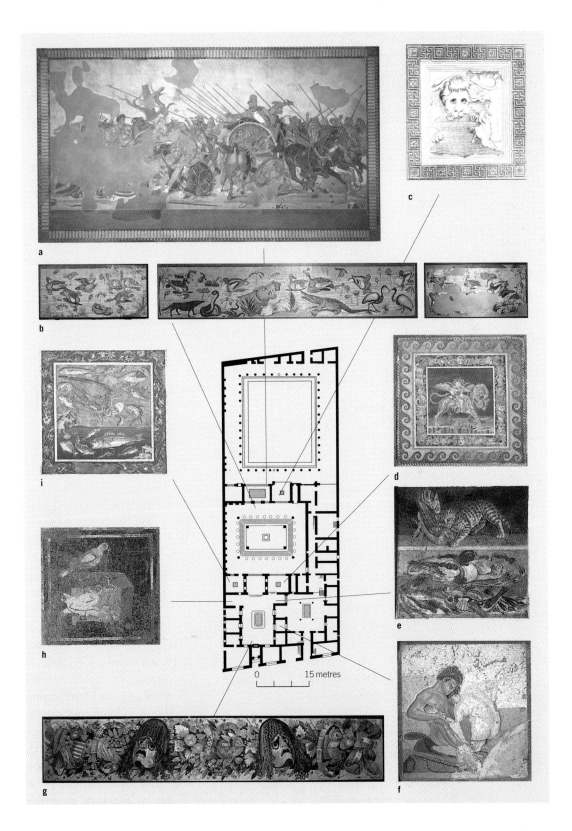

a

b

c

d

e

f

g

h

i

0 15 metres

14 J. H. Strack

Idealized reconstruction of the *atrium* of the House of the Faun, 1855.

Different reconstructions offer very different impressions of life in Pompeii. Little has survived of roofs, upper storeys, or anything made of wood (though there are some exceptions at Herculaneum), inevitably leaving a great deal to the imagination. But on any score, we are bound to be struck by the essential melodrama of the show houses.

between luxuriant greenery and powerful masonry, and an ambience of civilized vivacity.

The house must once have contained much the same range of choice furnishings as the other rich residences in the city: Pompeian houses were more sparsely furnished than ours, but at the top end of the market you would certainly have found elegant tables, chairs and couches, as well as bronze candelabra, and precious glassware and silver (cf. **180**; **140, 141, 153**). What makes the House of the Faun stand out (apart from its size) is the extraordinary array of mosaic floors. Not just the *Alexander Mosaic* with its Nilotic cordon, but six lavish— and very different—scenes. These range from a glaring lion to a strongly erotic display of nudity, as another energetic young satyr, or faun, gets to grips with his attentive partner; and large mosaic lettering at the front entrance picks out the word H A V E ('Welcome'), to be matched inside by a teeming strip of fruit and flowers, alternated with theatrical masks, to mark the inner threshold to the main *atrium* (inner courtyard: [**13**]; cf. Maps and Plans 3 (g)). These are striking images and must always have played an important part in the pattern of life, as it was lived in the mansion. But their significance must have changed over time; and it is important not to lose sight of the long history of the House and its contents.

What we see today is, of course, the House of the Faun as it was

in 79 CE, at the moment of the eruption. But the fabric of the house and its decor were the product of a complex series of decisions, developments, and renovations stretching back across three centuries or more. Only seventeen years before the eruption, Pompeii had been shaken by a severe earthquake—which accounts for much of the damage to the *Alexander Mosaic*, and some tell-tale signs of ancient repairs. But that was only the last episode in the long story that began many years before the town became an ally of Rome, and continued through the period when Pompeii was progressively 'Romanized' (granted full Roman citizenship, but also forcibly resettled with a large number of Roman veteran soldiers). It may well be, though we do not know for sure, that all the main mosaics were installed together as early as the second century BCE, when the house first developed to its full extent. In that case, when they were buried, they had long ceased to be high fashion; instead they will have become period pieces and valued as such. Yet the passing of time will have brought them new resonances and new relevance. In particular, the people of the second century BCE could never have imagined the stream of Roman generals who would shortly stake their claim to greatness in a competition to be the ultimate Alexander. No image of Alexander the Great could ever look the same against the background of Rome's own world conquest.

How did the *Alexander Mosaic* get there?

So far we have considered the *Alexander Mosaic* in its Pompeian context, in terms of the history of Pompeii and the life of the Pompeian house. But this extraordinary object has been taken up and explained in ways that lead us far beyond the confines of a modest town in central Italy. When we ask how these myriad *tesserae* came to be set into their flooring, various answers compete for our attention, each with different implications for the history of artistic production in the Hellenistic and Roman world. So far no analysis of the mosaic (archaeological, stylistic, or scientific) has won any agreement about its date or origin.

One possibility is that the 'Alexander' was bodily transported as plunder from Rome's wars of conquest in the Greek East—a Hellenistic Greek mosaic relaid in Pompeii; that is, it might itself be a product of the very expansion of the Roman empire on which (as we have seen) it encourages us to reflect. Alternatively, it might be a product of Roman expansion in a rather more elaborate sense. For many of the scenes featured in Pompeian mosaics are regarded by modern scholars as the work of craftsmen in Italy generating their own variations on famous designs borrowed from the repertoire of Greek painting. In fact Pompeian mosaics, as a genre, have often been prized precisely because they preserve for us (albeit at one

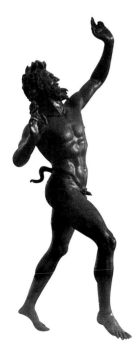

15

Dancing Faun, from the House of the Faun, Pompeii. The Faun was discovered in the main *atrium*, and it is usually presumed that it stood in, or near, the central pool (*impluvium*). The original is now safe in the Naples museum, still capturing wild, abandoned sexuality in a flourish of urbane display. A replica has been set in the *impluvium*, welcoming visitors to 'his' house – the most successful icon in the whole town (**11**, **14**).

remove, in a quite different medium) traces of otherwise lost master-pieces. This may seem surprising; but we shall shortly see just how little painting survives from the Greek world.

The *Alexander Mosaic* itself has been thought of as an extremely faithful copy of a painting produced in (or very shortly after) the life-time of Alexander, celebrating one or another of his finest massacres. Various lines of argument lead us towards different identifications of the original, and different ideas about where the original might have been. It could, for example, have made a splendid display piece at the Macedonian court itself, perhaps the very painting, by a certain Philoxenos of Eretria of a *Battle of Alexander against Darius* men-tioned by Pliny the Elder (p. 26) in his inventory of Greek master-pieces.[1] The (suspect) claims of one 'Helen of Alexandria' have also been canvassed; she is reported to have painted the *Battle of Issos*, which was later displayed in a temple erected in the middle of Rome by the emperor Vespasian.[2] On this theory, its first home could have been Helen's city of Alexandria, capital of Egypt—founded by, and named for, Alexander precisely to celebrate the very world conquest so dramatically portrayed in her painting.

So is this Greek booty transported wholesale to Italy, or a careful replica, made in Pompeii, of a Hellenistic masterpiece? The issue of appropriation and imitation that underlies this question will be a cen-tral theme throughout the rest of this book. One standard line of argument traces a pattern of development that begins with wholesale plunder of Greek art by the Romans and leads in time to ever more sophisticated forms of Roman copying of Greek masterpieces; where at first the Romans simply stole the superior culture, they later learned to emulate, rival, and eventually displace their Greek antecedents. On this model, the *Alexander Mosaic* must lie either at the beginning of the process (as plunder) or further down the line (proud to be a Roman imitation).

The argument is perfectly plausible. But the brute fact that we cannot agree about the date or provenance of even such an important piece as the *Alexander Mosaic* must undermine the simple chronolog-ical and cultural development that the model proposes. Instead, our period will show, time and again, that right from its beginning Hellenistic Greek artists and patrons, as well as their equivalents in Rome and Italy, always worked with a range of options at their dis-posal. At one extreme, seizure remained a possibility throughout: art travelled from one city to another, gravitating towards the major cen-tres of power (pp. 89–91). And copy and imitation covered a wide spectrum of relations between original and reproduction: faithful replication was one thing; as we shall see later in this chapter, inno-vative 'variations on a theme', modulations, even parodies and sub-versions, were other options in the range.

From what we have said about the *Alexander Mosaic*, you will see how no linear account of the processes of cultural borrowing can adequately respond to the range of issues raised by an individual object. How different is plunder from other forms of importation? Did the origins of a mosaic matter less as time went on? In what sense could mosaic 'faithfully' replicate painting? What should count as a 'faithful' reproduction? What criteria make art 'Greek' rather than 'Roman'? In the House of the Faun as a whole, the distinctive set of mosaics (every item with its own story) prompts these questions and more. Each one offered visitors in antiquity the chance to enjoy, appreciate, and explore the subtleties of imitation and representation: famous designs might bring the pleasure of recognition; piquant juxtapositions in different idioms would startle, puzzle, or amuse; between them the images would texture the ambience of individual rooms within the House.

The painted walls of Pompeii and Herculaneum

Masses of images survive from Pompeii and Herculaneum. In particular the fresco-paintings that decorate the walls of many (and not just the richest) houses provide us with a vast store of wonderfully preserved works of art: from intricate still-life to dramatic scenes from mythology. Some of these remain where they were painted, as part of the complete decoration of the surface of the wall. Many others, and until recent times almost all of the most highly prized, have been removed to the museum in Naples. The figured scenes that took pride of place have been hacked from their walls: the visitor to Pompeii must deal with the uncomfortable experience of a whole decorative scheme surviving intact but for a rough cavity where the featured centrepiece once was. Visitors to the museum, on the other hand, enjoy masterpieces safely preserved from vandalism and the elements—but removed from their context and presented, not as murals, but as if they were easel paintings made to hang on a wall. In fact, the Romans themselves occasionally did much the same, cutting out a piece of wall painting to insert it in a frame.[3] But the museum experience is still misleading, as it transforms excerpts of an overall interior design into deceptively familiar specimens of 'gallery art'.

Many of the scenes that formed the centrepieces of these walls have been understood (just as the *Alexander Mosaic*) as copies of paintings of the Hellenistic world. In fact, the search for lost Greek 'originals' has long dominated the study of these images. There was, as we shall see, a major tradition of easel painting all over the Greek and Roman world, with its own genealogies of famous artists and competing studios, and a brisk international trade in fashionable masterpieces. Plenty of Greek masterpieces came to Rome, by plunder or purchase, ending up in temples and art galleries open to the

public, as well as in the private collections of the elite. But nothing of this has survived (cf. **16**). In fact, precious little mainstream Greek painting of any sort has survived in good condition elsewhere in the ancient world. Exciting discoveries made at the cemetery of Alexander the Great's family at Vergina do give us a glimpse of painting in the culture of Macedon at the very beginning of Hellenistic art [**17**]. However, the images so far unearthed are few, fragmentary, and all too poorly preserved; they cannot generate (or support) a history of painting, still less provide visual pleasure. At most we can spot an occasional tantalizing link between them and the repertoire of images from Pompeian painting and mosaic.

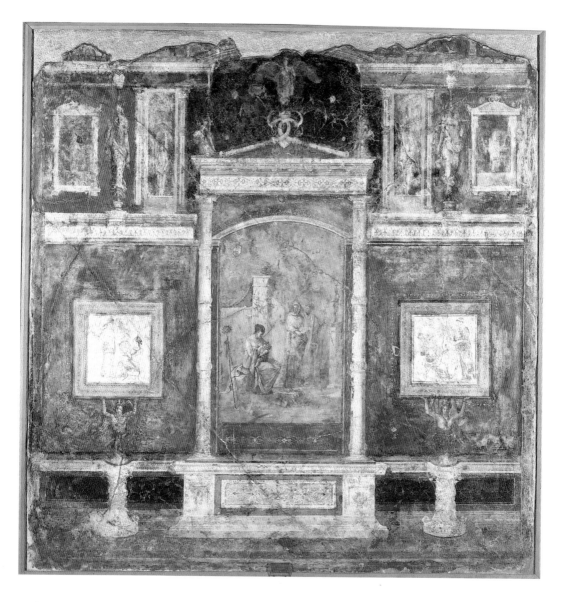

16

North-east wall from *cubiculum B*, Villa della Farnesina, Rome.

This vast Roman house beneath the gardens of the early sixteenth-century Villa Farnesina was found during construction of the Tiber embankments in 1879 (see Maps and Plans 9). Its show rooms, decorated with our most breathtaking murals from Rome, were rescued and are now reconstructed in the National Museum. The Roman custom of hanging easel paintings on their walls is here the basis of a *jeu d'esprit*: the twin side panels frame what look like a pair of free-hanging paintings in classical Greek style, while *trompe l'oeil* sirens, apparently propped on marble pedestals, take the 'weight' of the paintings.

17

Persephone Snatched by Pluto to his Underworld Kingdom, wall painting from Tomb 1, Vergina (north Greece).

A flash of fleshy bodies, flying hair, and charging steeds – though hard to make out, even at full scale.

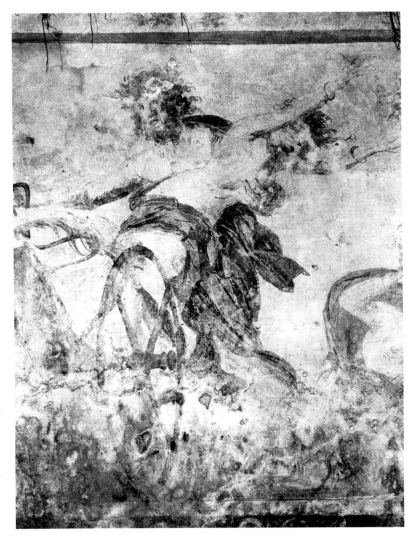

Reading up on classical art

The traditional link between Pompeii and the lost world of Hellenistic painting has been through texts. Scholars have scoured Greek and Roman writing of whatever kind for any hints at all of what has been lost: names of artists, casual references to famous paintings, suggestions of styles and trends, viewers' reactions and judgements. One author in particular has been pressed into service. By a bizarre coincidence, the volcanic eruption that both destroyed Pompeii and preserved its paintings, also ended the life of an eccentric Roman polymath, who was in charge of the Roman fleet stationed nearby—and whose writing has been used as the principal 'source' for our knowledge of classical painting and sculpture, from Greece to Rome: Pliny 'the Elder'.

Gaius Plinius Secundus (born 23/4 CE) was an active soldier, advocate, and historian. Modern art historians draw heavily on his only surviving work, the *Natural History*, in 37 books—a compilation (as he himself claimed) of '20,000 noteworthy facts' into a single universal encyclopaedia. As its title suggests, this is emphatically *not* a work of art history, but a global synthesis of data about the natural world. Pliny's discussions of sculpture and painting are part of his exploration of the use of natural materials (bronze and marble); he tackles the history of painting as (so he describes it) a rather regrettable digression from his treatment of the properties of various kinds of natural pigment. On the other hand, his concerns do overlap with the central topics of art history up to the present day: innovation, naturalism, value, collecting, decadence. So, for example, whatever his misgivings, he outlines a chronology of painting, and gives a brief account of the achievements of major artists, together with the subjects of their most celebrated work (he counts up to 405), repeatedly emphasizing those that were to be found in Rome.

To read between the lines of a hammed-up account given by his nephew (Pliny 'the Younger'), this cranky workaholic was suffocated by the fumes of Vesuvius, after he had set out in a boat to gather data about the eruption, underestimating its danger. He succumbed to his asthma, and was left for dead on the beach at Stabiae, while others about him escaped.[4]

Tracking down the original: Achilles among the girls

In the urgency of the quest for information about Greek painting, every avenue has been explored to match the details supplied by Pliny with the surviving paintings on the walls of Pompeii and Herculaneum. Let us take one simple case. Pliny mentions among the works of a certain Athenion of Maronea (in north Greece) an easel painting on the subject of 'Achilles concealed in girl's clothes as Ulysses finds him out' (or 'catches him').[5] This refers to a story from the preliminaries of the Trojan War. The Greek hero Achilles was hidden by his mother among the daughters of King Lycomedes on the backwater of Skyros, disguised as a girl, because she knew that her son would die if he went to Troy. The other Greeks, knowing that only Achilles could sack Troy, sent their most cunning representative, Odysseus (Ulysses), to root him out. He arrives at Skyros with his comrade Diomedes, bearing a range of gifts for the king's daughters— including a suit of armour. As the girls are choosing, a blast from a war trumpet sounds, and the startled young Achilles blows his cover by instinctively grabbing the arms.

Two paintings from Pompeian walls (both now in the Naples Museum) have generally been taken to copy Athenion's 'original' [18, 19]; a mosaic too offers a (simplified) version of what must count as the same scene [20]. Certainly a first glance compels us to take these Pompeian images together, to compare and contrast, to explore for similarity and difference. It leaps to the eye that they fit the same mythological scene and that the disposition of figures is closely

18

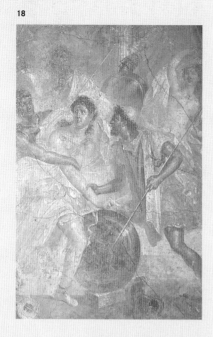

19

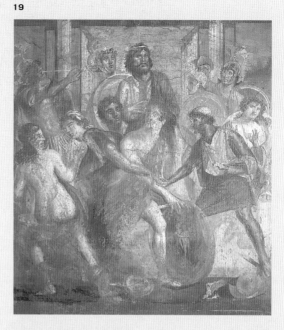

20b

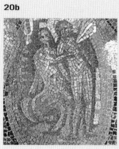

20a

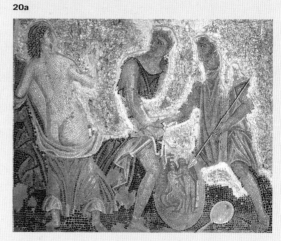

18

Achilles Discovered on Skyros, from the *tablinum* of the House of the Dioscuri, Pompeii (see Maps and Plans 3 (f)).

The painting has lost its left-hand side; hence the absence of the trumpeter in the rear and two girls in front of him (as in **19**).

19

Achilles Discovered on Skyros, from the peristyle of the House of Achilles in Pompeii (see Maps and Plans 3 (o)).

20 a, b

(a) *Achilles Discovered*, mosaic in the House of Apollo, Pompeii (see Maps and Plans 3 (e)).

The mosaic is set at eye-level on the outside wall of a summer nook, adjacent to a fountain, in one corner of the garden of a compact 'designer house'. The interior of the

room featured a series of pictures starring Apollo: hence the house's modern name.

(b) Detail of **20 (a)**: Chiron teaches Achilles.

related: Achilles, in the centre, grabs the shield, while the 'other' girls scatter in fright; Odysseus, on the right, penetrates the disguise with a stare, as Diomedes (in the two paintings) reclaims Achilles for masculinity; the picture makes us look intently at Achilles for the clinching sign of his identity. At the same time no viewer could fail to spot several salient points of difference. The most significant lies in the treatment of the central area, where the physical struggle for Achilles' body is played out. In one [18] Odysseus and Diomedes grip the arm of their victim with an intensity that signals rape; the erotic charge of the image is emphasized by the bracketing of Achilles between the frontally exposed nakedness of the girl on the right and her rhyming sister, whose naked rear view must once have completed the line-up to the left (as in **19** and **20**). The energy of this composition in part derives from a play between gender and sexuality in which, for an instant, we catch heroes treating one of their kind as if he were exactly what he is pretending to be: a woman. It turns on a visual disturbance in our reading of the rules of gender, the rules that polarize male and female. The other painting [**19**] plays down the aggression in an altogether gentler rendering (which has often been regarded as decidedly inferior); on the right, the muted pose of the daughter, who is so prominently exposed in the other picture, colours the scene very differently. Her concealment behind the figure of Odysseus here adds one more twist to the already complex theme of disguise, veiling, and recognition. Playing down the overtness of the sexuality means playing up the acumen of Odysseus the detective. The pleasure is now more of a tease, and literally less up front.

Another difference in the central scene of the paintings may be crucial to our response: in **18** Odysseus carries a long spear, while in **19** he fingers his sword. The spear directs our attention to the centre of the shield, and to an emblem which is now, in this version, too indistinct to make out. At this point we can turn to the mosaic [**20**], which still adorns an elaborate garden installation in a particularly *bijou* house in Pompeii (Maps and Plans 3 (e)). It shows the bare bones of the composition: just Achilles, Odysseus, and one daughter. But this time Odysseus' spear points towards a very clear device on the shield. Our attention is being drawn to another famous mythological moment in the saga of Achilles (a popular subject in Pompeian painting and, according to Pliny, one immortalized in a sculpture on public display at Rome).[6] In it, we see the child Achilles' first lesson on his way to heroic destiny, as the centaur Chiron teaches him the finer points of lyre-playing—the discipline and harmony of music as the perfect training for his epic future of irresistible massacre, and a young man's death. The spear then indicates a different emphasis in our reading of the images. We must recognize in the scene on Skyros

Achilles' second lesson in duty: he must resume the path set by Chiron, and meet glorious death at Troy.

Inspection of these works of art takes us directly into the mainstream of Greek culture: the classic myths of the Trojan war and its cast of heroes. We are reminded of the story which said the epic warrior Odysseus, the original anti-hero, had tried to play the draft-dodger, too, when the call to arms came to him—just like, but nothing like, Achilles; and we are invited to reflect on the symbolic values of shield and lyre in epic, myth, and the classical tradition. But do the pictures lead us back to an individual Greek masterpiece by a particular Greek painter? It is clear enough that our three versions of Achilles on Skyros are closely related; and that relationship may be explained by their common derivation from an earlier painting. That does not necessarily mean, however, that their source was the painting by Athenion mentioned by Pliny. After all, Pliny's description is so meagre that it would fit virtually any representation of the scene (and the story appears in several other paintings in Pompeii, in quite different, and evidently unrelated, compositions). How could we know which derives from Athenion? Even if we *could* tie our three images to Athenion, which elements in them would we ascribe to him and which to the Pompeian artists? How would we decide which was the most 'faithful' copy? Do we assume that the 'best' version is closest to the original? How are we to account for the differences we have noticed between our versions?

These problems confront anyone who tries to tie any Pompeian painting to any specific Greek masterpiece mentioned in ancient literature. Pliny provides a wealth of data on the tradition of painting that must lie behind what we see at Pompeii; but it has proved extremely difficult to use his work to identify or attribute individual pieces. There are, however, other ways of using ancient texts, Pliny included, to help us understand the artistry, cultural context, and power of these paintings.

Reading Medea's mind

One famous artist named by Pliny is Timomachus of Byzantium: 'a contemporary of Julius Caesar, he painted an Ajax and a Medea, hugely expensive purchases, hung by Caesar in the Temple of *Venus Genetrix* [at Rome]'.[7] Two paintings now in the Naples Museum have been identified as copies of Timomachus' Medea: one [21], from the same house in Pompeii as the incomplete painting of Achilles on Skyros [18], showing Medea on the right, with the children (whom she is about to kill, as revenge for her abandonment by her husband Jason) and their old minder on the left; the other, originally in Herculaneum (but with no record of its location), highlighting Medea on her own, cropped from a larger painting [22]. Comparing

Medea, from the peristyle of
the House of the Dioscuri,
Pompeii (see Maps and Plans
3 (f)).

The composition draws on the
viewers' familiarity with the
story of Medea's revenge on
her husband Jason, and its
structure, using strong
diagonals and
horizontal/vertical
segmentation, saturates the
visual field with the imminent
prospect of butchery. The
crosswise placement of the
children's 'island' of safety,
linking the foreground plane to
the background, sets up a
stark antithesis between the
physical pull of the loving
minder (on the left) and
repulsion of the mother in
denial (on the right). Blind to
their peril, the children take
their chances in a deadly
game, caught between their
two carers: the one,
overseeing his charges,
propped on his pastoral staff;
the other turned away, furtively
and scandalously fingering the
hilt and scabbard. Note how
the door-frame highlights the
minder, guarding the home;
while the window-frame
divides Medea's head from
her body, as she takes stock
before taking aim.

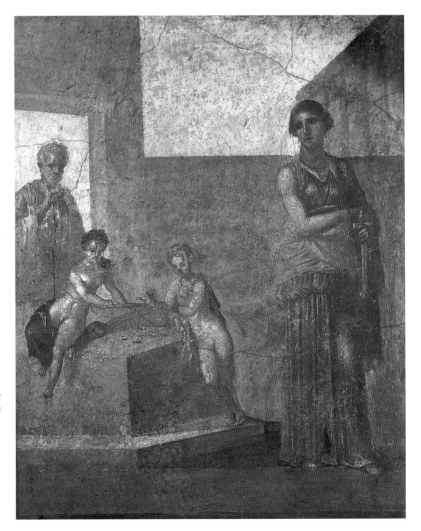

these two interpretations, we can spot the same kinds of play of
similarities and differences that we found with Achilles on Skyros.
In particular, the way that the imposing figure of the mother
handles her sword changes the dynamics of the drama. One bran-
dishes the sword purposefully, as if she knows how to use one (at the
same time concealing it from the others); the other does its best to
dissociate the woman's handclasp from the weapon she scarcely
knows how to hold.

Pliny gives no description of Timomachus' Medea. But a whole
cluster of nine Greek epigrams, written over several centuries by dif-
ferent (often anonymous) authors, dissect this painting; smart and
sharp as can be. We have chosen one of these, by Antiphilus of
Byzantium, who was probably writing around the middle of the first
century CE (and so was roughly contemporary with our pair of
Medeas):

Murderous Medea. When the hand of Timomachus was painting her,
 as she was dragged in opposite directions by spite and by children,
he took on himself infinite pains to inscribe her schizophrenia,
 one side leaning to anger, the other to pity.
He got both in full measure—look at the figure: in threats
 tears re-surface, and temper in pity.
'Deferral will do just fine', as the sage put it. The blood of children
 was right for Medea, but not for the hand of Timomachus.
 Antiphilus of Byzantium[8]

What Antiphilus attempts to bring out is the energy and effort
which Timomachus packed into showing the dilemma of Medea,
giving full value to both sides of the dichotomy, her anger and her
pity. For him the achievement of the artist is to represent two peo-
ple—the murderess and the mother—in one body. At the same time,
Antiphilus nails the problem Timomachus set himself as the repre-
sentation of bloodlust without blood.

Of course, we cannot know the relationship between our paint-
ings, the Medea of Timomachus cited by Pliny, and the painting
Antiphilus claims to be describing. Irrespective of that, the epigram
conveys the excitement generated by ancient mythological painting.
It also shows how sophisticated and animated the interpretation of
visual images might be in antiquity. We can be sure that ancient view-
ers were in a position to explore the works of art which surrounded
them with just as much passion and subtlety as any modern art his-
torian can muster.

Fitting topics for walls: sea-side and sex-show

The range of paintings discovered at Pompeii and Herculaneum
extends far beyond the kinds of mythological subjects we have been
exploring up to this point. From the very beginning excavators
brought to light more than they bargained for. Some of the material
has fitted relatively easily into already familiar categories of 'high art',
particularly when turned into paintings to hang on the walls of the
Naples Museum: delicate 'still-lifes', for example [**23**]; engaging 'por-
traits' that seem to communicate living presence, men and women in
all their individuality [**24**]; or impressionistic 'landscapes' that trans-
port the viewer to idyllic worlds with their fantastic porticoes, haunt-
ing shrines [**25**], and sea-side palaces [**26**].

But other discoveries have proved harder to handle. Acres of naked
body were on display in Pompeii. Some of these paintings translate
easily enough into the modern idea of the 'nude' [**27**]; but others
instantly read as 'pornography', on anyone's definition today. Many a
scene of coupling decorated walls in rooms dotted about in bars,

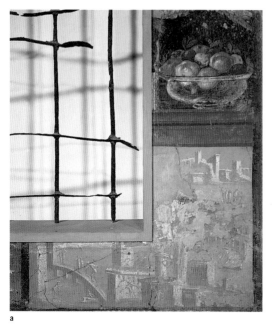

a

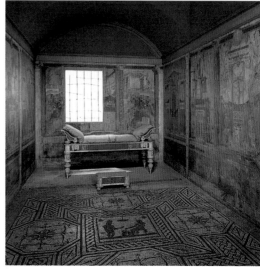

b

23 a, b

Cubiculum M of the Villa of P. Fannius Synistor at Boscoreale, near Pompeii (see Maps and Plans 7).

The detail (**a**) shows the lower right-hand corner of the window-surround. The bowl of fruit, much as a modern still-life, evokes material comfort and plenty, while at the same time celebrating its own virtuoso display of painterly talent, squandered on the everyday objects of domestic life. But the juxtaposition with the seaside town below, with further architectural vistas in the section above the bowl, adds another dimension: he combination of images artfully juxtaposes ornament and vista to exploit the interplay of interior and exterior at the edge of the main window. The entire room (**b**) has been reconstructed in the Metropolitan Museum of Art, New York.

24

Portrait of a Girl, wall painting from a house in Pompeii (region VI, 17; see Maps and Plans 3 (j)).

Ms X, formerly known as Sappho. Nineteenth-century art historians could not resist identifying this image with the Greek poetess of Lesbian passion. The twentieth century preferred to find a real-life portrait of a Pompeian girl. This could be either dutiful homework or erotic lyric, for this image originally paired with a matching young man holding a scroll, around a centrepiece with Perseus rescuing Andromeda.

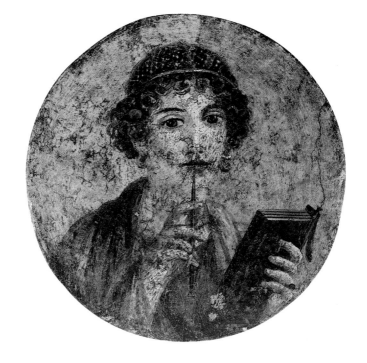

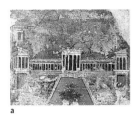

a

b

brothels, baths, and all sorts of houses, from the relatively modest to the very grandest, without clear-cut distinctions either of subject matter or of quality. Ever since the eighteenth century, more or less desperate attempts have been made to tidy them all off into suitable categories—as if any place they decorated must have been 'low-class', slave quarters, bedrooms to suit bachelors or even spice marital sex, or dedicated brothels (the tally of these rose to 35; that is, roughly one for every 71 men in the town). In fact, what is most important about these images is their ubiquitous distribution: some, to be sure, were part of the town's sex-industry; but others adorned the public, no less than the secluded, areas of stylish and would-be stylish houses [28, 29]. Likewise, the images of phallic display: there were erections in full view wherever you looked in Pompeii—carved in stone, cast in bronze, painted on walls. One of the most notoriously well-loved paintings from Pompeii [30] shows off economic power by dramatizing an equivalence between money, produce, and phallic potency: the god of erections' own erection was splashed across the very entrance of the House of the Vettii (across the street from the back of the House of the Faun; Maps and Plans 3 (g)), and he was meant to thrust it right in the face of every visitor. We treat this as funny, naughty, or embarrassing—a favourite among *risqué* postcards. But we can only guess at Roman attitudes: impressed, amused, outraged, unmoved … mixed? The cross-cultural question always remains: how far did ancient categories of the pornographic correspond with our own?

These images can seem to speak directly and openly to erotic stimulation, regardless of their artistic status. Accordingly, when they

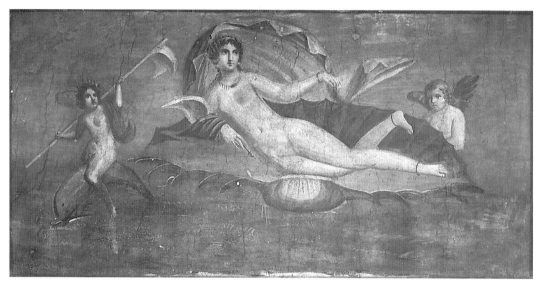

27 (above)
Venus, wall painting in the peristyle of the House of the Marine Venus, Pompeii (see Maps and Plans 3 (b)).

Venus is here shown afloat on a shell, an allusion to the myth of her birth from the sea. She was a versatile goddess, not only of sex and desire but of horticulture, and patron deity of the colony of Pompeii.

28 (below)
Nymph and Satyr, mosaic from the House of the Faun (= **13 (f)**).

This 'faun' was laid in a side-chamber off the main *atrium* of the house. We have no real clue whether the smallish mosaic signalled the room as a private place for loosening inhibitions, or added one more variety of tasteful decoration to the repertoire of the mansion. Perhaps the trick was to cover both options.

29 (below)
Wall painting from peristyle in the House of L. Caecilius Iucundus, Pompeii (see Maps and Plans 3 (d)).

A bedroom scene on the wall of a courtyard garden. But is it raunchy or sentimental? Some critics find that the presence of a third party heightens the sensuality for the viewer; others see the servant as a guarantee that the couple's every need is taken care of. Either way, we have to reckon with the impossibility of placing this scene on the social spectrum from hired-in sex to the celebration of love (perhaps even conjugal relations?).

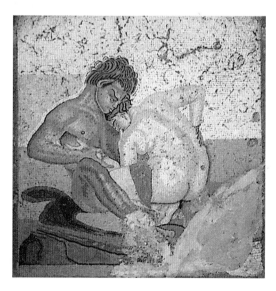

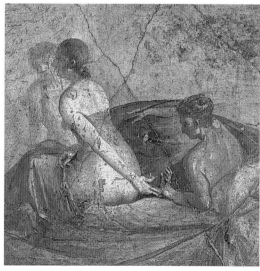

The god Priapus protected
homes and gardens by
guaranteeing to assault
intruders of all shapes and
sizes. Here is his welcome –
weighing his giant penis
against a money bag, swag
versus swagger. Romans
might have enjoyed the verbal
pun (on *penis* and *pendere*,
'to weigh') visualized in
Priapus' balancing act, as well
as appreciating the irony that
an erection would complicate
any weighing operation.

were discovered, many were removed to Naples—not to hang in the
public galleries of the museum, but locked away in a 'secret cabinet',
a collection forbidden to all but specially privileged visitors. Even
when they were copied, and reproduced in sumptuously bound vol-
umes, these images were for centuries restricted to an equally privi-
leged clientele, as sex took scholarship for its fig-leaf. All this secrecy
lumped together a vast spectrum of Pompeian nakedness and
branded the lot as 'pornography'. It is now all too easy to reject (or
accept) that label wholesale; either way, it cuts across our under-
standing of the rules of sexual representation in antiquity, as we shall
see in Chapter 3 (p. III and *passim*).

How do Pompeian paintings rate as 'works of art'?

The sheer number and variety of painted images discovered in Pompeii and Herculaneum raised all kinds of questions about quality, dating, and interpretation. Strategies of assimilation, the process of translating these mural paintings into more familiar kinds of fine art, could only take you so far. Not everything uncovered could possibly count as a masterpiece: some paintings everyone could agree were cheap, hurriedly done, or second-rate hack work. But which works were to be admired, and on what criteria?

Right from the beginning opinions differed. On the one hand, the figured scenes, still-lifes, and landscapes, as well as the whole 'interior design' of Pompeian rooms, were enthusiastically reproduced in a fashion that swept Europe in the eighteenth and nineteenth centuries [31]. Victorian painters, too, such as Alma-Tadema [6], drew directly on what they saw in Pompeii in elaborating their vision of Roman style and splendour. On the other hand, some visitors found

31

The 'Pompeian Room' at Ickworth, Suffolk, completed 1879.

The figured panels were based on ancient paintings found in Rome in 1777, and for a time the property of the first owner of Ickworth. He died in Italy in 1803, having lost most of his treasures in the French occupation of Rome.

much of it a terrible disappointment: Stendhal, for example, felt that the paintings 'reveal a complete absence of *chiaroscuro*, a very limited range of colour ...The general impression is of a series of bad works by Domenichino, albeit further still removed from greatness by the presence of numerous faults of draughtsmanship.'[9] Of course, it was easy to write off the entire haul of art at Pompeii as the sort of mediocre ensemble to be expected of a 'provincial' backwater; and, by the same token, to decide that the main value of this unique repertoire of ancient painting was the glimpse it offered of the art of the Hellenistic world. The best of Pompeii could attest the best of Greek art; even its less convincing works could give us a notion of their lost ancestors, the masterpieces they mute and botch.

Debates on quality led inescapably to art historical enquiry, and with it to questions of chronology, classification, and meaning: if the images could be dated, would that help in discriminating between excellent and poor, or in separating out what was 'Pompeian' from what belonged to 'Hellenistic' art? These issues turned the focus back onto the whole walls from which the centrepieces had been ripped, and onto the overall interior design of Pompeian rooms and houses. Already in the 1780s, on his immortalized *Italian Journey*, Goethe and his companions found that 'the mummified city left us with a curious, rather disagreeable impression'; but at the museum housing the finds, they were:

vividly transported back into the past, when all these objects were part and parcel of their owners' daily life. They quite changed my picture of Pompeii. In my mind's eye its homes now looked both more cramped and more spacious—more cramped because I now saw them crowded with objects, and more spacious because these objects were not made merely for use but were decorated with such art and grace that they enlarged and refreshed the mind in a way that the physical space of even the largest room cannot do.[10]

'Interior design'?

This emphasis on 'domestic space' was to become (and still remains) crucial in the understanding of Pompeian painting. In recent times, as we shall shortly see, the design of individual rooms, of particular suites and sequences of rooms, and of whole houses, as well as the links between images, or between the images and their decorative surrounds, have inspired some of the most suggestive ways of thinking about the significance of the painting that survives. But even before this surge of interest got off the ground, the design of the walls as a whole, rather than their individual scenes, had provided what is still (more than a hundred years later) the basic framework for classifying and dating the material.

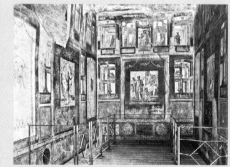

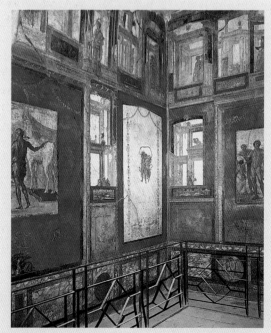

32 a,b

Triclinium (dining-room) in the House of the Vettii, Pompeii (see Maps and Plans 3 (h)).

The House of the Vettii was decorated throughout shortly after the earthquake of 62 CE. Carefully conserved on site, it gives us our best chance of dropping in on the habitat of up-town Pompeii at the moment of disaster. It has been generally rather deplored as Pompeian flash, and plugged into a story of *nouveaux riches* owners. It is a moot point whether the central panels are 'interestingly complicated' by the plethora of rival visual stunts, or swamped by them. Social prejudice apart, however, gauging the original aesthetic impact of any interior design is never a simple matter – particularly when we take into account how little we know of lighting conditions or patterns of room use. (See also **30**.)

'Wall painting' means exactly that. Walls in Pompeian houses were painted from floor to ceiling with bold washes of colour (in black, white, blue, and yellow, not just the characteristic 'Pompeian red'), showing off a whole range of delicate decorations or daring artistic 'effects': *trompe l'oeil* columns, luxuriant swags of fruit and flowers, vistas of fantastic architecture, birds perched precariously on painted curtains, 'windows' (miraculously) opening onto an outside world beyond [**32**]. Elements like these formed the frame and the background for the panels we have been discussing. In antiquity they must inevitably have vied for the viewer's attention; in modern times they have been more wholeheartedly admired than the mythological paintings, and (as we just saw) have been copied avidly into our own decorative repertoire [**31**].

Pompeian painters produced a very wide range of decorative schemes—from elegantly restrained two-colour designs to multi-coloured virtuoso displays of illusionism. It was from these differences that art historians first devised a comprehensive system for classifying (and ultimately, they believed, dating) the images that survived. Still fundamental today is the system mapped out in the 1880s by the Pompeian expert, August Mau.

This stylistic division articulates four very different approaches to the manipulation of interior space that construe the place of figural or panel paintings no less differently. The first style offers no such place at all (unless you were to imagine—and even this is difficult—an easel

painting hanging on it); the fourth style may pack every inch of wall surface with exuberant representations, where panels get lost in the melée; in the third style, precise symmetry of decorative scheme directs attention to relatively restrained centrepieces. The system as refined since Mau does offer a broad framework for mapping the history of decor at Pompeii and its main periods; it is certainly the case that Mau's 'Fourth Style' helps us distinguish painting under way at the time of eruption and just before (above all in the House of the Vettii: pp. 35, 38). On the other hand, the system plays down other factors that affect choice of decorative style (the intended function of a room, for example, would influence its decoration).

But more crucially, it disguises the vital fact that all these styles were visible in the last days of Pompeii. The visual environment of Pompeii, like that of any city, embodied a host of decisions to be modern, conservative, idiosyncratic, fashionable, conformist, or avant-garde. As we have seen, at the time of the eruption the House

Mau's four styles of wall decoration at Pompeii

August Mau (1840–1909) produced what remains the scheme that underpins all stylistic analysis of Pompeian decor: he divided the wall painting into four 'Styles', each representing a phase in the chronology of Pompeian painting, from the second century BCE to the final eruption in 79 CE.

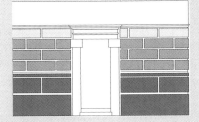

1. 'The First, or Incrustation, style': the wall is painted (and moulded in stucco) to imitate masonry blocks; no figured scenes. Second century BCE.

2. 'The Second, or Architectural, style': characteristically featuring illusionistic architectural vistas. c.100—15 BCE

3. 'The Third, or Ornate, style': the vistas here give way to a delicate decorative scheme, concentrating on formal ornament. c.15 BCE—c. 50 CE.

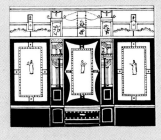

4. 'The Fourth, or Intricate, style': a more extravagant painterly style, parading the whole range of decorative idioms. From c. 50 CE.

of the Faun still displayed mosaics that had probably been installed centuries before. Successive owners must have chosen to keep them as they were. Elsewhere in the property, right up to the end, they chose to retain some wall decoration in what we call 'the First Style', while modernizing in other areas. This combination of old and new is what creates the specific atmosphere of every Pompeian house.

These issues of interior design and overall decorative scheme prompt other questions about how panel paintings are to be viewed in their original context. How do they relate to other images in the same room, or suite of rooms? Do they acquire significant meaning if they are read together? Can we find a programmatic design behind juxta-position and sequence? Look back at **29**. Consider its original position in a peristyle, right next to the entrance to a chamber (Maps and Plans 3 (d)), whose three inner walls (now hopelessly damaged) had their own suite of images: one showed the figure of a Muse playing a lyre (to left); opposite, Bacchus wielded his sacred wand; and between them, facing the doorway, was a group of Mars, a half-naked Venus and Cupid—Mars in the process of removing Venus's remaining clothes. In combination, these images clearly spoke to each other; but what story did they tell, of sex, divinity, art, intoxication?

Achilles caught again

It always impoverishes our reading of these paintings not to think of them in the context of their original environment, as we can see by turning back to another image we have already discussed: Achilles on Skyros. One of the paintings we considered [**18**] was paired with a second image of Achilles. In the showpiece room that dominates the House of the Dioscuri (Maps and Plans 3 (f)), the scene of Achilles' detection by Odysseus and Diomedes (the prelude to his return to fight at Troy) faced the next major episode in his heroic narrative: his quarrel with King Agamemnon that marks the start of Homer's *Iliad* [**33**]. What we see in this panel is Achilles drawing his sword in anger at the king's insult to his honour; while, from behind, the goddess Athena stops him in his tracks, before heroic impetuosity leads to dis-aster. These two paintings do more than show two stages in the same story. In visual terms, they play off against each other, around the focal gesture of the hero's lunge for his sword. And the visual pun is con-tinued with the shield and spear: while in the first painting those weapons are markers of Achilles' masculinity, in the second they are given to a female—albeit the virgin goddess Athena, whose gendering cuts across any clear division between male and female. As a pair, the images raise complex questions about the making of manhood, which is not only a matter of discovery and display. What is to count as hero-ism? Is the true hero the one who can leave his sword in its scabbard?

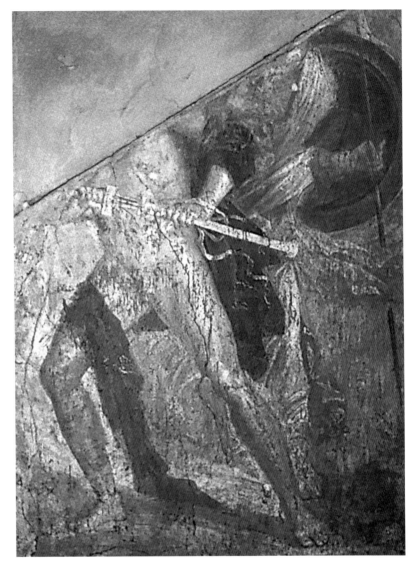

The wall painting has lost more than its upper portion. To judge from a mosaic version of the scene now in Naples (but originally from the House of Apollo, sharing a wall with the mosaic version of Achilles on Skyros (**20**)), Agamemnon would once have sat enthroned in front of Achilles.

Set Achilles on Skyros in other company and the meaning will shift, as different connections become salient. Put the version we saw at **19** alongside his room-mates, on the side walls to left and right [**34 (a-b)**]. The story of the making of Achilles now moves from its inception on Skyros to its tragic end, as the new armour (which we see his mother Thetis first obtaining from Vulcan, then presenting to her son) spells his death as well as his victory at Troy. Here we are drawn to join the characters in gazing upon the shield of destiny and to spot the rhyme between the scene on Skyros and the scene at Vulcan's forge: when Thetis is shown the new shield, a winged female figure points her to the shield, just the way that Odysseus points his spear at the shield on Skyros.

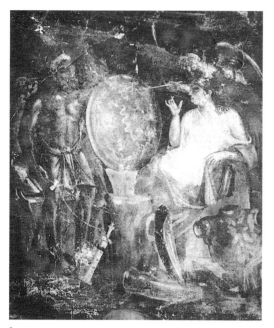

a

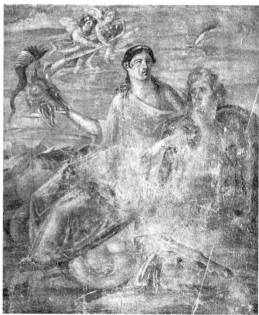

b

We find a clever twist on this theme at another house in the same district of Pompeii (now in the Naples Museum [**34 (c)**]): here when Thetis gazes upon the shield, what she sees is not its emblem, but herself—as if in a mirror; in looking into the shield that spells her son's destiny, she sees her own. It is a sophisticated, self-reflexive, manipulation of the gendered gaze; and a lesson in viewing for herself—and for us.

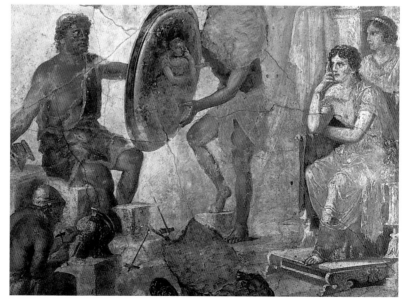

c

More wives like Medea

The connections between paintings need not be a matter of a single story-line. For example, in the 'House of Jason' at Pompeii (Maps and Plans 3 (p)), three paintings with quite separate subjects share the same room [35]: the wall opposite the door shows a version of Medea and her children [(a)], similar in its essentials to 21; on the left, Phaedra with her nurse and servant girl, struggling with her passion for her stepson, Hippolytus [(b)]; to the right, Helen contemplates leaving her husband Menelaus, and running away with the exotic stranger Paris [(c)].

Any juxtaposition of Medea, Phaedra, and Helen proposes a common theme of tragic love (indeed, the house 'of Jason' is sometimes called 'The House of Fatal Loves'). To all appearances, these are tranquil scenes from everyday life. Yet they add up to domestic tragedy in three varieties: infanticide, incest, and adultery. The mother (Medea) does not mind the children, but contemplates their murder; one wife (Phaedra) appears to be running her household, servant in attendance, but is actually making plans that will lead to her family's destruction; the other wife (Helen) is not entertaining a guest according to the rules of hospitality, but already (note Cupid in the doorway) entertaining the thought of deserting her husband and home. This last image neatly exploits the visual rhyme between the three

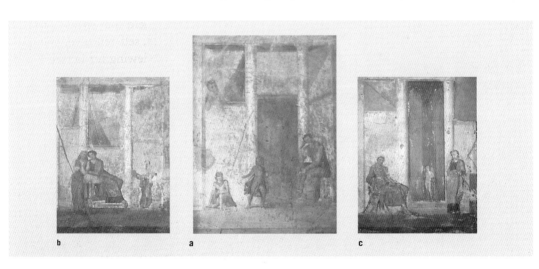

b a c

35 b, a, c

The three wall paintings from *cubiculum* e of the House of Jason (cf. Maps and Plans 3 (p)). Diagram, with: (**a**) Medea (west wall); (**b**) Phaedra (south wall); (**c**) Paris and Helen (north wall).

The visual links between these images are strongly emphasized, with each of their heroines placed against a matching background. The scenes represented could almost pass for an image of well-to-do Pompeian domesticity, with all the conventional formulae of a properly behaved wife, surrounded by children and attendants. But the next moves in each of these myths will spell disaster, and the paintings menace the very ideal they simulate.

a

b

c

d

Wall paintings in the *triclinium* (dining room) of the House of the Priest Amandus, Pompeii (see Maps and Plans 3 (a)): **(a)** *Polyphemus and Galatea* (south wall); **(b)** *Andromeda Rescued by Perseus* (west wall); **(c)** *Hercules in the Garden of the Hesperides* (north wall); **(d)** *Icarus plummets from the sky* (east wall).

This dining room has its narrow doorway in the south-east corner of the south wall. The scene of Hercules is opposite the entrance and stands out by foregrounding the figures, rather than emphasizing the landscape as do the three other paintings in the room, so prompting us to take this as the focal image. Paradoxically it is this painting that modern art historians either ignore or deplore for its sketchy two-dimensionality, even suggesting that it may well be a later make-over of the original decoration.

paintings. The figures of Medea and Phaedra sit in the characteristic pose of the Greek or Roman matron; in the other scene, Helen stands, while in her place Paris lounges in a gorgeous display of exotic, and effeminate, transgression calculated to explode the terms of family and marriage.

When myths share a room

It is easy enough to recognize a programmatic design in the room of 'fatal loves', no less clearly than in groups of paintings linked by one narrative thread. Much more commonly connections depend on various combinations of narrative, thematic, or visual features. Faced by a set of images in one room, or suite, viewers are always challenged to explore ways of reading them together—to devise links, to follow up contrasts, to see what makes (or not) a rewarding story. The four walls of the dining room in the modest House of the Priest Amandus (Maps and Plans 3(a)) present four standard mythological scenes [**36**]. Polyphemus (the one-eyed Cyclops) pines for the lovely sea-nymph, Galatea, riding on a giant dolphin; Perseus flies in to save Andromeda, chained to her rock, from the ferocious sea-monster about to devour her; Hercules comes on one of his Labours to get golden apples from the Hesperides and their guardian serpent; finally, Icarus plummets from the sky, after having flown too close to the sun, as the wax melts in his wings. It is not difficult to suggest a variety of connections, even in the absence of narrative continuity. In visual terms, the image of flight links Perseus to Icarus, as triumph to downfall; thematically, heroic achievement might connect Perseus with Hercules, pathetic failure might link Polyphemus and Icarus. But as a group, it must fall somewhere *between* a more or less random collection of images and a patently unified design, so that it will be up to viewers to make their own choice whether to explore juxtapositions or settle for appreciating the individual pieces separately.

Master class in mystery

In one particular Pompeian room, these issues of overall design bombard the viewer to saturation point. The extensive 'Villa of the Mysteries' (given its irresistible modern name from the stupendous painting we shall be discussing) was discovered just outside the city early in the twentieth century (Maps and Plans 4). Here, the most startling painting to survive from antiquity wraps around the four walls of a show room, which opens onto a shady portico and, beyond, a stunning view out to sea. There is no evidence for the room's function apart from the painting itself. Visitors are confronted by near life-size figures, against a rich red background, including a motley range of women, gods, and other creatures; these appear in busy groups, but look to belong together as part of a single composition.

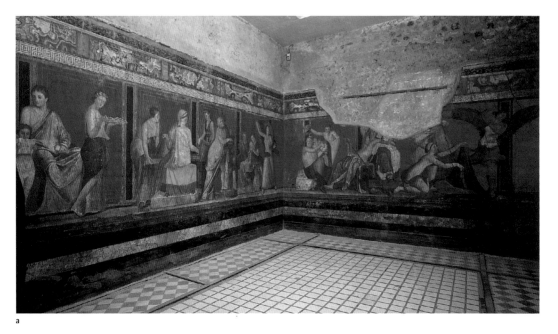

a

Key to diagrams (b)

1. A matron listens to a boy read as a second woman points to the words.

2. A woman with a loaded tray catches our eye.

3. A seated woman, her back to us, holds up the cover of a container held by a female attendant on her left, while on her right a second pours water from a jug.

4. Silenus the satyr plays the lyre.

5. Sitting behind a billy-goat, a male Pan plays pan-pipes while a female ('Panisca') suckles a goat.

6. A woman starts back in alarm, from the scene round the corner.

7. Another Silenus holds up a pot, which a young satyr examines intently; behind them, a second young satyr holds up a comic theatre-mask.

8. Dionysus sprawls across the lap of Ariadne. (The wall is damaged at this point.)

9. A kneeling woman balances a pole on her shoulder, while her hands play with the object (supposedly the mystic phallus), concealed by a cloth, that stands in a basket. Behind her, two women with a tray start back in alarm.

10. A winged female figure plies her whip, round the corner of the room.

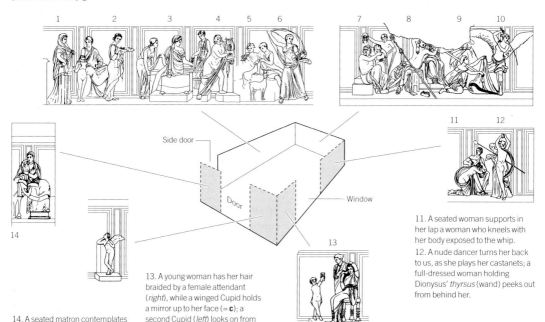

11. A seated woman supports in her lap a woman who kneels with her body exposed to the whip.

12. A nude dancer turns her back to us, as she plays her castanets; a full-dressed woman holding Dionysus' *thyrsus* (wand) peeks out from behind her.

13. A young woman has her hair braided by a female attendant (*right*), while a winged Cupid holds a mirror up to her face (= **c**); a second Cupid (*left*) looks on from round the corner.

14. A seated matron contemplates the scene before her.

What they are up to remains tantalizingly elusive. Attempts to interpret the painting have supposed the answer to lie somewhere in religion or ritual—initiation into the cult of Dionysus, perhaps, or the preparation of the bride for her wedding.

No photography can capture the charged atmosphere or the way in which the painting surrounds the viewer on every side; we must almost literally join the cast of the painting [**37**]. There is an overwhelming sense that what is afoot may only be understood with a very special eye. The activities and figures depicted insistently call for explanation (a woman starts back in fear—of what? a demon whips a victim—but why?). Yet the more you look at the picture the more the images throw back at you the limitations of your ability to see and describe. You cannot see what the naked boy is reading; you cannot hear the song of the satyr's lyre; you cannot see what the kneeling girl is revealing (and concealing) under the purple cloth. Throughout the frieze, it is precisely the endless complications of viewing that are emphasized: mirror, mask, and veiling. It takes to the limit the kind of sophisticated visual play that we have found wherever we have looked among the paintings of Pompeii.

37c

Moving up-market: the Cyclops at Boscotrecase and in Pompeii

For all the sophistication, the panache, and the sheer profusion of the paintings we have seen from Pompeii and Herculaneum, for all their links into the broad repertoire of Greek painting, it has proved hard entirely to banish doubt about how representative of ancient painting the material from these two small mid-Italian towns may be. Are we just looking at a pair of medium or mediocre provincial towns (albeit with a strong investment in their 'Hellenistic' past)? And how much does it matter that we are looking at an artificially circumscribed period in the history of art—cut off abruptly in 79 CE? One response to these concerns is to bring in evidence from the wider area, beyond the towns, that was also destroyed by the eruption of Vesuvius. For if it is true that Pompeii and Herculaneum themselves did not amount to much in the social and cultural hierarchy of Roman Italy, that is strikingly *not* true of their surrounding territory, where (as plenty of ancient writers make clear) the top notch of the Roman aristocracy, from the capital itself, had villas, country estates, and mini-palaces. It was here that some of the smartest (and, it may be, the brashest) members of the Roman elite, including the imperial family itself, came to luxuriate in self-advertising splendour (see Maps and Plans 2, 7, 8).

A few notable sites from this area deliver us wall paintings whose quality is beyond doubt, the best that money could buy. One of these was stumbled upon by pure accident in 1902, in the course of cutting a railroad (Maps and Plans 8). The owner of the land instantly saw his chance of turning whatever was found into hard cash, and moved in right away with a team of diggers. Over the next three years he ransacked what was soon recognized as an aristocratic country house for all the painting he could remove from the walls—and hope to sell. He soon had the Metropolitan Museum, New York, in his sights and carefully stored the precious slabs away, eager to clinch the deal. It would take until after World War I for a consignment to be shipped to America, at which point a share was retained by the Italian government for the museum in Naples. No proper excavation was conducted here at Boscotrecase, nor will be. For, ironically, the hoard of paintings was stashed away not a moment too soon: in 1906 a new eruption destroyed the site.

The paintings from the site are unforgettable: a room dressed in vivid red, with golden tracery, medallions, and monsters; next door, walls almost entirely in black, featuring exquisite miniature landscapes [**38**]. In our present discussion, Boscotrecase provides a specific point of comparison, with different versions of two pictures we have already considered [**39** = **36 (a, b)**]. From a room severely damaged in the eruption of 79, we have a pair of painted panels (now in New York), which show Polyphemus pining for Galatea [**39 (a)**], and Perseus sav-

38

Wall painting from the 'Black Room' of the villa at Boscotrecase (see Maps and Plans 8).

We must presume that such suites were designed for very special occasions, for shock value, for rewarding all lovers of exquisite, minute, minimalist, detail.

The Cyclops Polyphemus and the mythic hero Perseus appear twice over in their pictures, so that different phases of their narratives are tellingly juxtaposed. Polyphemus lost his heart to the sea-nymph Galatea on sight (*bottom left*); later he lost his sight to Odysseus, whose ship he blindly attempts to stone as it leaves the picture (*centre right*). Perseus rescued Andromeda from the sea-monster to be his bride (*centre*); but success turned to tragedy when her parents reneged on the deal to bestow on him her hand and with it the kingdom, as the handshake between Perseus and Andromeda's father hints (*centre right*).

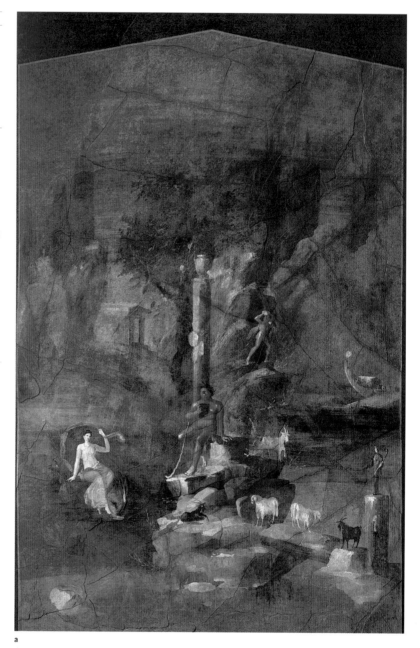

a

ing Andromeda from the sea-monster [**39 (b)**]. A first glance tells that these are essentially the same compositions as those we saw in the House of the Priest Amandus down at Pompeii. If ever an argument in terms of quality could be brought to bear, to distinguish the best works of art from the also-rans, this must be the occasion.

People have found much to admire in the versions from Boscotrecase: the trance-like weightlessness of these visions of an idyllic, fairy-tale world; the surreal role of the blue/green ground,

c

b

which does double duty for sea and sky; and the narrative sophistication. If we put the two paintings together, as they face each other on opposite walls of their room, the visual play of the matching colour and setting releases a host of connections between the two myths: the rewards of trickery and its punishment; the consequences of love; the different varieties of the monstrous.

In comparison, the versions in the House of the Priest Amandus are usually treated as (slightly) inferior copies—not, in this case, of

some Hellenistic 'original', but of the Boscotrecase masterpieces ('originals' in their own right) in their palatial villa just a few kilometres out of town. The colours are felt to be cruder throughout; the larger figures spoil the trance-like, fairy-tale setting of the 'originals'; the removal of the second figure of Polyphemus has, it is argued, collapsed the two phases of his story into one; and why has heartless Galatea turned her back on us to face the Cyclops? All this can seem plausible enough. But, as always, the value-judgements in such comparisons invite their own inversion. Attention to the differences alerts us to all the ways in which these paintings in Pompeii could mean to offer a creative re-reading and revisualization of the up-market efforts at Boscotrecase. For example, see how the changed posture of Andromeda, now turned towards Perseus, chimes with the increased prominence of the figures at the expense of the landscape (all too invasive in the 'original'). See also how the elimination of the second Polyphemus in the Pompeian version, the greater engagement between Polyphemus and Galatea and what we must now interpret as the arrival (not the departure) of Odysseus' ship, all alter the dynamics of the whole composition: these significant visual adjustments bring us into the story at an earlier phase, before disaster.

If we move beyond direct comparisons between the two versions of the scene to include context and room function, we shall find that this is bound to complicate our evaluation of the individual panels or groups of panels. How, for example, is it going to modify our judgement to recognize that in Pompeii the paintings adorned an interior dining room, while at Boscotrecase our pair came from a show room opening out onto a terrace, with postcard views of the Bay of Naples? And what difference does it make to know that at Pompeii they are two from an ensemble of four, while in the villa they were designed to stand alone as a pair or perhaps flanked a lost feature on the third wall?

But issues of preservation, conservation, and restoration are still more unsettling for any argument about the 'quality' of different paintings. The panels in the Pompeian House of the Priest Amandus have been kept on the site, to weather and fade with the years; that was the price paid for leaving them where they belonged. Those from Boscotrecase have been rescued and transformed into museum masterpieces, charged to stand for Rome in the New World, and for the best that Roman art could produce. The price of this is that they must look the part. Restoration is the name of the game. Our pair of panels have been 'restored' to mint condition, to be the same size, with the same evocative use of colour, and a perfect surface. What this means is that most of the sky in the Perseus panel is modern supplement, to bring it up to the appropriate height; and the Polyphemus panel, as **39 (c)** shows, has been determinedly restored into a single image out of what was actually a jigsaw of no fewer than

Odysseus Under Attack from the Laestrygonians, wall painting from a house on the Esquiline Hill, Rome.

The disruption of the conventional hierarchies of background and foreground in these '*Odyssey* Landscapes' is matched by their striking reorientation of the epic story itself. By devoting no fewer than four panels to Odysseus' brief episode with the Laestrygonians (just 50 lines in Homer and nowhere else represented in surviving ancient art), the paintings challenge our familiar perspectives of the *Odyssey* as a whole, encouraging us to explore the minor events of the epic background as centrally important in their own right.

132 fragments (all that remained when the plaster fell from the wall). The masterpiece we admire represents an enormous input of care and imagination, to (re-)create a wonderful painting from bits of plaster. Our evaluation of this painting rests squarely on a judgement on the quality of its *restoration*; and that is a dilemma we face in trying to see how 'good' any ancient painting is.

Pictures of Rome: the '*Odyssey* Landscapes'

If we want to consider painting over a longer period, we must move away from the sites destroyed by the eruption of Vesuvius altogether. Before these were rediscovered, the study of ancient painting had long centred on finds made within the city of Rome itself. Where else, after all, would you have looked for the finest masterpieces of the ancient world? Where else did the ancient texts point, with their lists of state monuments and works of art, and their sometimes elaborate presentations of palaces, temples, and the other wonders of the imperial capital? Important finds had already been made by the sixteenth century, and have continued to be made ever since, amidst all the difficulties of archaeological exploration within one of the world's great cities. Many of these discoveries link in easily with the material we have been looking at in Pompeii. Not only do we find much the

same repertoire of decorative styles in Rome as in Pompeii, but also a similar range of themes in the show-piece paintings.

The so-called '*Odyssey* Landscapes', a series of scenes which depict episodes from the wanderings of Odysseus, were found in Rome in the mid-nineteenth century (with one additional scene turning up in the 1950s) [40]. They take the form of an almost continuous frieze of narrative broken up into individual scenes by a series of painted pilasters. From the original 'rescue' excavations (when the Via Cavour was built in 1871–4), it can be reckoned that they were displayed maybe four or five metres from the floor, at the very top of the wall decoration in a corridor or gallery of what was probably a large private house (nothing of the rest of the house survived the 1940 building of the Rome Metro). Painted some time in the second half of the first century BCE, the surviving portions are dominated by four panels showing Odysseus' adventure in the land of the Laestrygonian cannibals, with other panels dealing more briskly with his later encounters with Circe, the Dead and the Sirens. The frieze may once have extended further, but how far we can't tell (perhaps onto the other walls?).

What catches the imagination is that the continuous landscape is given priority over the figures and their story. Even if some of its haunting effect depends on the quality of restoration (as the cleaning which removed some evocative, but nineteenth-century, greenish-blue proved), it is undeniably the impact of the 'background' that pulls the viewer into the picture—with an energy that even the restored panels from Boscotrecase cannot match. The reward is a surprise package: between the crags and caves we find ourselves in the grand epic of Homer's *Odyssey*.[11] It has also prompted the same range of questions as we have been considering throughout this chapter. Is it a Roman 'original'? Is it a copy of a Greek masterpiece? Is it tailor-made for its location on the wall? The arguments have proliferated. But one special feature of the painting has caught the attention: the names of many of the characters are written on the painting—in *Greek* lettering. For some, this clinches the argument that this is a Roman copy, and that a lost Greek 'original' must lie behind it. But this is to ignore all the complexities of the cultural interplay between Greece and Rome that we have been exploring. The writing tells that this Roman painting is about the *Odyssey*, the Greek *Odyssey*: as clear a token of the essential fusion of Graeco-Roman culture as you could wish.

Walls fit for a palace: the 'Garden Room' at Prima Porta

An even more celebrated installation from the neighbourhood of Rome provides a spectacular version of a subject also found in less majestic settings at Pompeii. Fifteen kilometres outside the city, in

the modern village of Prima Porta, nineteenth-century excavations uncovered a remarkable fragment of what must have been a lavish country house (Maps and Plans 15); it is traditionally identified as a property of Rome's first emperor, Augustus (who is reported to have had a villa in just this neighbourhood). Here, one room was found that was largely below ground level, used, most likely, for keeping cool in summer [41]. Realized on a much grander scale than any of the similar 'garden' designs from Pompeii, the Prima Porta room wraps round the viewer as comprehensively as the frieze in the Villa of the Mysteries. But here we are not asked to join a cast of characters; instead we are set in a space that arranges flora and fauna in an impossibly utopian mixture of bright flowers beside laden fruit trees, tidy shrubs before a receding woodland vista, planned garden display within a surround of Italian trees, as if in their natural habitat—visited only by sixty-nine beautiful birds, covering the entire range of local species. An exercise in blue and green. And a celebration of naturalistic technique: every petal and leaf, each individual feather, is precisely depicted, without recourse to obvious formulae or repetition. But this is not nature reproduced; instead, a world specially made for us—yet made to do without us. Beyond the balustrade, as no wild birds ever could, these pay not the slightest attention to anyone in the room, impossibly ignoring our proximity. Emblematized by the songbird in its golden cage, art here *creates* nature, beyond anything you could find in the real world [41 (b)].

41b

Wall painting from south wall of the 'Garden Room' in the imperial villa at Prima Porta, near Rome.

First excavated in the 1860s, the paintings were transferred to the National Museum in Rome in the 1950s for fear of the damp. The famous statue of Augustus (**160**) was unearthed from the same site.

42

Painting from a tomb on the Esquiline hill, Rome.

What this painting (which dates from some point between *c*.300 and 150 BCE) depicts has been endlessly debated. The two probably historical characters in the lower register are named 'M Fanio' and 'Q Fabio'; in addition, we may just make out scenes of battle and a fortified city.

Painting across the centuries

What does not emerge from the material at or around Rome is a *history* of painting that takes us very far beyond the time-span of the Vesuvian sites. To be sure, a few paintings do survive which are earlier than the earliest from Pompeii (but these, much like those from Vergina, are very fragmentary and frustrating indeed [**42**]); and there are many more dating from later than 79—found in private houses, tombs, and, especially, the imperial port of Rome at Ostia [**43**]. These continue (reinterpret or extend) the decorative repertoire we have traced at Pompeii, but no strikingly new idiom emerges either within our period or for many years after. To some extent this is precisely because Pompeii grabs the limelight, so that we are always drawn to see other painting very much 'in Pompeian terms'. That said, the eruption of Vesuvius does happen to coincide with the point at where the *narrative* of the development of Roman painting tails off.

The drama of discovery: the 'Aldobrandini Wedding'

But in another respect painting at Rome has a quite different chronology from painting at Pompeii. Sensational discoveries had begun at Rome centuries before systematic digging started at Pompeii; these images inscribed themselves in the history of modern western art at a significantly different moment. Take the painting

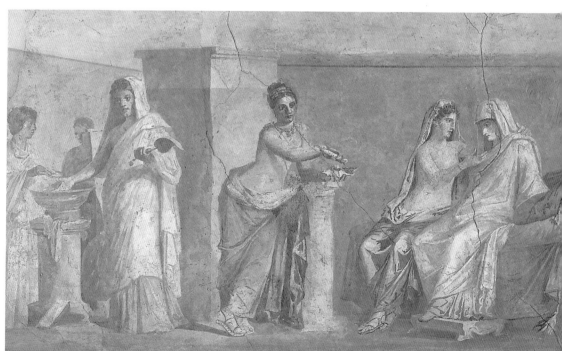

43

Wall painting in the House of Jupiter and Ganymede, Ostia.

How did wall painting look after 79 CE? The decorative scheme of this room from Ostia (the port of Rome) dates to the late second century CE, but it would not have looked completely out of place in first-century Pompeii.

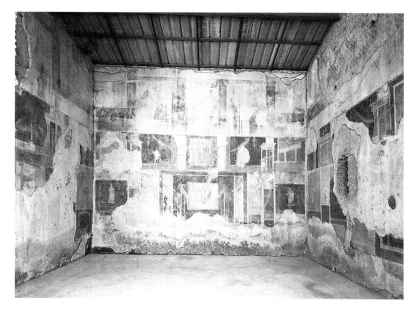

44

The 'Aldobrandini Wedding', wall painting from Rome.

Installed by its first owner, Cardinal Aldobrandini, in a purpose-built pavilion set in his garden, the 'Wedding' picture was sold on to the pope by the Aldobrandini family during the Napoleonic occupation of Rome (1814). It has been repeatedly and heavily restored. (Cf. **5**.)

shown in **44**, one of the first ancient figured scenes to resurface. When it was unearthed in Rome at the beginning of the seventeenth century, it instantly enjoyed enormous fame and prestige, and was repeatedly copied or adapted by artists from Van Dyck to Nicolas Poussin [**5**]. This was not archaeology in anything like our terms, but

part of the Renaissance quest to recover authentic Rome for admiration and emulation. All the same, every find posed problems of understanding. Interpretation fastened first on what the picture showed: a woman on a bed, with her head veiled; at her feet, a strapping young man sporting a garland; vaguely ritual or ceremonial activity in the wings. Almost from the moment of its discovery to the present day, the subject has been seen as a wedding. The painting retained its kudos when it was added to the collections in the Vatican, where it 'hangs' today. Certainly the piece has its qualities: elegant understatement, an air of apprehension, enigmatic reticence. But if we ask what makes it so famous, besides its *blue*ness, the answer lies in no small part in its history, as one of the first Roman masterpieces to be rediscovered, and with a distinctive title to keep it on the map.

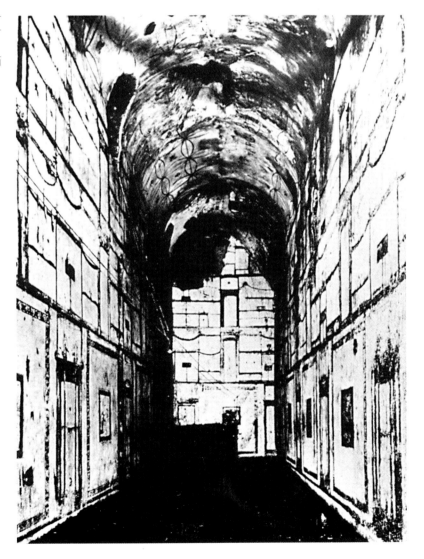

45

Corridor in the 'Golden House' of Nero, Rome, 64 CE.

These discarded underground 'tunnels', often cut through and blocked by the foundations of the emperor Trajan's Baths, built above, must somehow transport our imaginations into the experience of Nero's stupefying palace to end all palaces.

The tragedy of deterioriation: the 'Golden House' of Nero

The re-emergence of Roman painting had started still earlier, in the late fifteenth century, with the astonishing discovery of what was (at least by the end of the sixteenth century) recognized as the 'Golden House' of the notorious emperor Nero ([**45**], Maps and Plans 12). Among the foundations of the later Baths of the emperor Trajan lay a surreal suite of rooms, preserved almost intact, from this extravagant palace. If you tunnelled through the in-filled rubble, you emerged level with the ceiling vaults of a palace wing virtually intact, and complete with painted decoration. It was dark, cold, risky, and wet. But it quickly became a mecca for leading artists who went down to admire, absorb, copy, and (in many cases) to deface the walls by scratching their own names just like any of the 'Grand Tourists' in

46 Raphael and G. da Udine

The Vatican *Loggetta, c.*1519. The characteristic flourishes of Renaissance ornamentation were modelled on those of the Golden House, known as 'grotesques' (*grotteschi*) from the subterranean 'grottoes' in which the paintings were discovered. The range of subjects in these fantasies of structure and exuberance, of symmetry and caprice, runs across the whole spectrum of moods and tones; a dazzling, crazy descant, but certainly not what we would dub 'grotesque' as we now use the term.

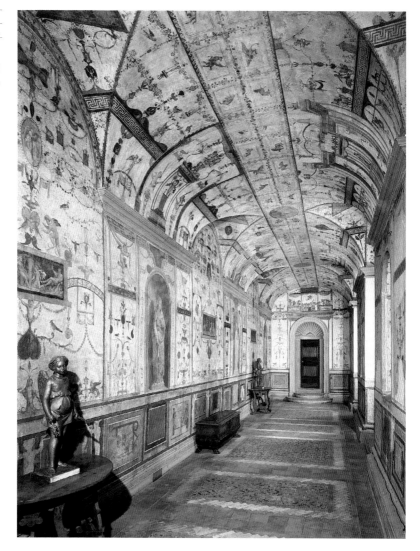

Rome (Casanova and de Sade among them, in the early 1770s—as cleaning revealed in 1999).

What they admired most of all was not the figured panels, but the tremendous impact of the overall design; and they set themselves to master the expressive possibilities of the mural decoration, and to adopt them for their own projects. It was here that Raphael, combining the two roles of Commissioner of Antiquities and renowned painter, found the visual language for those grand designs in the Vatican itself [46]. It was no wonder that a learned Renaissance pope would be keen to live in authentically Roman splendour. But one irony is that most of the finest show rooms of the Golden House had been stripped of decoration (most of it exotic coloured marble) when the palace was first abandoned; a good deal of what was left to dazzle Raphael and his friends was the decoration of back rooms and service corridors. From this point of view, you could say, the pope was housed not just in the palace of Rome's most deplored emperor, but in his servants' quarters.

There is a final irony. The decoration of the Golden House, like the Aldobrandini Wedding, has never lost its prime importance in the legacy of ancient Roman painting; it lives on in many a triumph of Renaissance art. But, unlike the Wedding and so many other treasures, the paintings in the Golden House were left just where they were

47

The Golden House today: 'The Room of Hector and Andromache'.

Parts of the Golden House were consolidated in the 1990s and reopened to the public. This room is one of the highlights of the tourist visit, featuring a painting of a famous scene from the *Iliad* (Trojan Hector's farewell to his wife Andromache). None the less it is hard to recapture the Neronian fantasia. (For a shamelessly imaginative restoration, see **49 (c)**.)

found [47]. Neither looted nor protected, they have gradually fallen victim to the damp and humidity of their own 'grottoes': awash with water in winter, steaming in the summer (sprinklers were still keeping the grass green overhead in summer 1999). Over half a millennium, art lovers have witnessed their progressive deterioration, until today they are scarcely legible and it is hard to imagine quite how they could ever have inspired the giants of Renaissance painting and their devotees.

Moving Statues: Art in the Age of Imitation

2

The city of Rome dominates the study of ancient sculpture. Some of the most significant finds of statuary ever made came from the same part of the city as yielded the frescoes of Nero's Golden House. Chief amongst them was a grand construction in marble, surviving almost intact and featuring three nude males being crushed in the muscular coils of two vast serpents [**49**]. From the moment of discovery in 1506, it was copied, imitated, and parodied; studied, fêted, and theorized. More has been written about this sculpture than about any other, ever. As we shall see, it must stand as the single most important stimulus behind the invention of the whole discipline of art history; it demands all the attention we can give it.

Icon of Rome: the Laocoon

The subject was at once recognized as an episode from the Trojan War: the death throes of the Trojan priest Laocoon, who was killed along with his son (or sons), by two monstrous sea-serpents, just as the Greeks were about to spill out from the Wooden Horse and sack Troy. This scene was known not from Homer's *Iliad*, but from the pages of Virgil's Roman epic, the *Aeneid*, where Aeneas, the Trojan hero who was to become Rome's founding father, painfully recounts the agony and anguish of Laocoon in the Armageddon of Troy. Only then, fate decreed, could Aeneas himself flee and establish in Italy the new order that would culminate in Eternal Rome. It was the possibility of connecting the sculpture with the central text of Latin literature, the most influential bearer of the entire myth of Rome, that put the Laocoon indelibly on the map. But even more than that, it came straight out of Pliny's roster of famous works of art in the Rome of his day. Discussing the problem of artistic collaboration, he speaks of:

Laocoon, the one in the residence of Prince Titus, a work to be preferred above all others, whether paintings or bronzes. He and the children and the wondrous coiling of the serpents were made from a single block of stone by the consummate artists, Hagesander and Polydorus and Athenodorus, all of them from Rhodes, in accordance with a joint agreement.[1]

48 Johann Zoffany

Charles Townley's Library at 7 Park Street, Westminster, c.1781–3.

Townley (far right) bones up with connoisseur chums. *Clytie* (= **59**) is on the table in front of the arch-conman of eighteenth-century antiquities, the self-ennobled 'Baron d'Hancarville'; but pride of place goes to Townley's notorious *Discus Thrower* (**60 (a)**), which Zoffany added to the picture a decade after its completion. For the *Satyr and Nymph* behind *Clytie*, see **94 (a)**.

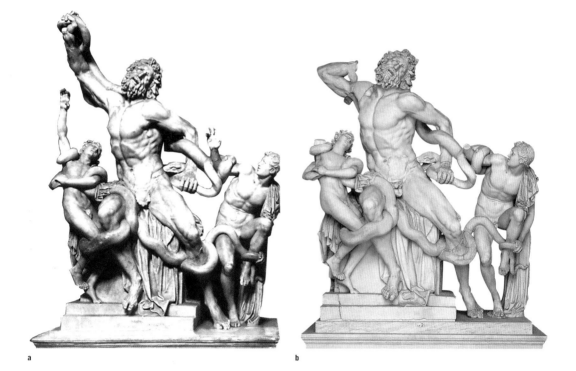

a b

49 a, b, c, d

Marble sculpture of Laocoon and his sons: (**a**) the traditional restoration; (**b**) the twentieth-century restoration

Laocoon's missing right arm was traditionally restored raised straight and high; but this was replaced in 1957 with what is believed to be the original, crooked arm, found by chance among marble scraps in a mason's yard near the statue's findspot (although there is no direct join and an extra piece had to be inserted to fix the new – i.e. old – arm to the shoulder). Note how the change also affects the restoration of one son's right arm, as well as disrupting the group's often remarked triangular profile.

It was too good to be true; and it inspired a powerful mythology of its own. All it took was some wishful juggling between Pliny's reference to 'the residence of Prince Titus' (Titus became emperor shortly after Pliny's death: 79–81 CE) and Nero's Golden House, and you could fancy that you were dealing with a work of art that once graced the Neronian palace itself; by the end of the seventeenth century the charismatic (but unfounded) story had grown up that the Laocoon had been discovered not just in the same general area, but precisely in the finest buried room (129) of the Golden House [**49 (c)**] (see Maps and Plans 12). How thrilling to have a sculpture, blessed with Pliny's admiration, and right in its place at the heart of Roman imperial culture—exactly where it belonged. No wonder it attracted the attention of leading Renaissance artists; and they in turn were sucked into the sculpture's mythology. One eye-witness account of the unearthing of the statue (though written more than half a century after the event) makes a point of spiriting Michelangelo onto the scene, to welcome the new discovery. And the legends that surrounded successive attempts to restore Laocoon's crucially missing right arm strengthened the association between contemporary genius and antique masterpiece. Although by the late sixteenth century most experts had settled on an outstretched pose, there was an early flurry of different attempts to supply a plausible replacement—including a roughly finished marble version, said to be Michelangelo's own attempt at restoration [**49 (d)**]. It was a glorious failure, and a witness that the Laocoon was too perfect for even the greatest modern artist to match.

d

c

Laocoon made an enormous—and continuing—impact. In about 1510, amidst huge publicity, a grand competition was held to see which of four celebrity artists could make the best copy. Raphael himself was the judge; and the winning entry was immortalized in bronze. Spin-off copies were produced by the hundred, and a parody credited to Titian quite literally *aped* it (showing the group as mon-

keys). Acquired by the pope, the Laocoon was triumphantly installed in the brand new Vatican sculpture gallery (the 'Belvedere Courtyard') within six months of its discovery. Almost three centuries later it starred in another triumph, when Napoleon carted off the greatest works of art in Rome to fill his new museum in Paris. There it took pride of place, until Napoleon's defeat obliged the Louvre to return the statue, for good, to the Vatican.

By Napoleon's day, the statue had gained an unassailable position in the artistic canon; a position that was sealed by its key role in the founding texts of modern art history. Laocoon was a virtually unique instance where a sculpture could be identified with certainty, as well as enjoying both ancient and modern acclaim; and it had captured the attention of, in particular, J. J. Winckelmann.

Winckelmann: the history of 'art history'

Today, Winckelmann is almost universally mythologized as the 'father' of art history: the first, most people would say, to embark on a systematic study not just of art, but of the *history* of art; the first indeed to coin the now inescapable phrase 'history of art', emblazoned in the title of his most famous book, *Geschichte der Kunst des Alterthums* ('History of Art of Antiquity'), which appeared in 1764. He is both revered and reviled, with equal intensity, for setting in place a chronological schema for plotting ancient art *as a development*; and for identifying the main stages or *periods* of that development. First comes the Older Style, followed by the High (or Sublime), the

Johann Joachim Winckelmann [50]

1717: Born in Stendal, east Germany.
1737–9, 1741: University in Halle and Jena, followed by a teaching position.
1747: Appointed as librarian and research assistant to Count von Bünau, a diplomat in Saxony.
1755: Publication of his first, explosively attention-seeking, book: *Gedanken über die Nachahmung der Griechischen Wercke in der Mahlerey und Bildhauer-Kunst* ('Reflections on the Imitation of Greek Works of Art in Painting and Sculpture'). This put current baroque style to scorn (Bernini and all), as a dereliction of proper respect for the principles of Greek art, a failure to imitate correctly.
1755, November: Moves to Rome; introduced to society by the painter and critic Anton Raffael Mengs.

1757: Hired as librarian in the papal Cancelleria.
1758: Appointed librarian and adviser to Cardinal Alessandro Albani.
1758 and thereafter: Visits to Naples, Herculaneum and Pompeii.
1764: Publication of *Geschichte der Kunst des Alterthums* ('History of Art of Antiquity').
 Appointed papal antiquary and director of antiquities in Rome.
1767 Publication of *Monumenti Antichi Inediti* ('Unpublished Antiquities').
1768, 8 June: Death in Trieste, murdered in a hotel room by a petty criminal, Francesco Arcangeli, with whom he had struck up a friendship.

Beautiful, and finally the Style of the Imitators—each one correlating
with an era in politics, the finest artistic activity acclaimed as the
product of periods of greatest 'Liberty'. Like every other account of
classical art, the series to which our book belongs ('Oxford History of
Art') still operates with Winckelmann's chronological stages, albeit
with different labels: Robin Osborne's *Archaic and Classical Greek Art*
scrupulously confines itself to the first three ('Older' broadly matches
'archaic'; 'High' and 'Beautiful' roughly correspond to 'early classical'
or fifth-century BCE, and 'late classical' or fourth-century); the book
you are looking at now covers the last of these periods (Hellenistic, or
'Graeco-Roman'). But it is not just a question of classical art history.
All art history, even now, traces back to (or, some would say, is stuck
with) Winckelmann's basic schema. In all accounts that treat the

development of artistic style in terms of rise, efflorescence, and decline we can recognize a debased version of his chronological stages.

Winckelmann's legendary status is one thing. But nothing would have surprised him more than to discover himself so lionized and demonized within the modern theory of art. A cobbler's son and culture vulture, he worked fanatically hard to become the right-hand man of the most notorious collector and dealer in eighteenth-century Rome, and then landed the plum position of papal antiquary. His impassioned, self-promoting, but always obsessively documented writing is inevitably much more provisional, much more open-ended, than the traditional myth of Winckelmann would have us believe. His great synthesis, for example, *Monumenti Antichi Inediti* ('Unpublished Antiquities') has a quite different thrust from the chronological theory of the *History*. Here Winckelmann starts 'systematically', by explaining that the Greeks first succeeded in bringing 'Beauty' to art (an important aspect of his theories, to which we shall return in Chapter 3, pp. 107–11), adding an account of the historical development of ancient art (reworking in brief the account given in the *History*) to guide us to the particular forms of beauty realized by the Greeks in their three periods of development, and to identify the fourth period with the political demise of Greece after Alexander the Great. But all this is a preliminary to the main business of the book: a vastly learned and daringly radical organization of the chief works to be found in the half-dozen prize collections of sculpture in Rome into a sensible arrangement, by subject matter. In other words, the classical treasures held by such as the pope, and (naturally) 'the most eminent Cardinal Albani', are presented as sufficient on their own to provide an analytic catalogue of the world's great sculpture. This is a work which prioritizes identification and iconography over chronology.

Winckelmann's ideas are bound to look different in the context of modern critical debate. At the time, they were not simply embryonic grand theory, but thoroughly caught up in the practical business of sorting out the mass of sculpture to be found in museums, on the market, or coming out of the ground in one sensational haul after another. The first requirement was to work out what these pieces were; to identify them by subject matter. So many artworks had been landed with more or less bizarre labels and traditional nicknames that cross-referencing, comparison, or indeed study of them was almost out of the question. The challenge to one and all was to produce an effective framework for classifying and explaining the monuments. Where Winckelmann made his breakthrough was in his insistence that the subject matter of sculpture from Rome was drawn substantially from Greek mythology. Let's take an example: many had interpreted **51** as the slave-barber who betrayed the conspiracy of

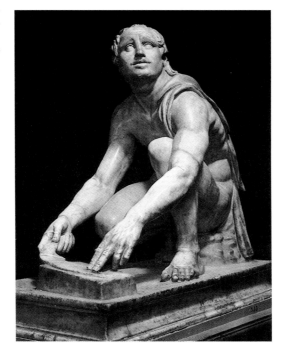

Catiline against Rome in 63 BCE (assuming that the crouching figure is overhearing the details of the plot, while busy sharpening his razor); Winckelmann, on the other hand, backed the line that it must show a precise moment and subject in Greek myth—the slave whetting his knife, before (according to the story) he skinned alive a satyr who had dared to insult the musical talents of the god Apollo.[2]

In making, or confirming, such identifications Winckelmann pressed to the limit a fundamental principle he had learned from reading Latin literature: that, in the high culture of the Romans, expert acquaintance with Greek works was the essential condition for all further artistic creativity; that Hellenism was the engine of Roman poetics. He was insisting—against, not least, the pugnacious Italian chauvinism of Piranesi—that the sculptors of ancient Rome shared with the writers a 'learnèd' aesthetic of imitation. These issues of 'imitation' will set the agenda for much of the rest of this book. If this sounds a bland or inert problem, try translating Winckelmann's key term *Nachahmung* as 'postmodernism' rather than the usual 'imitation'. This will make it easy to warm to the project, respect the perplexities, and appreciate the improvisations.

What Winckelmann wanted to find

Most of Winckelmann's identifications of the subjects of individual sculptures continue to be accepted, no less than his structuring of ancient art into successive periods. The same is not true, however, of his dating of individual works within that overall chronological

schema. Many people would say that he was trapped in a contradiction between his eighteenth-century enthusiasms and the values enshrined in his developmental chronology, which almost automatically (and perhaps even in spite of his own intentions) branded the final period of his scheme as 'decline'; and so he was consistently drawn to assign the works that he and his contemporaries most admired to the period that he deemed to be the zenith of classical Beauty (the fifth and fourth centuries BCE), even though many of them are now agreed to be Roman works in imitation of Greek 'originals'. It is certainly the case that he put some statues far too early in date; and conversely that he failed to recognize the precious few works he saw in Rome that were genuinely produced in classical Greece. There was as yet, we should remember, almost no direct knowledge of the original classical sculpture that survived in the Greek world itself.

But Winckelmann was not hidebound by his chronological schema. He was set on rhapsodizing over each statue in its own right and, well aware that the bulk of the material he was studying belonged to the Style of the Imitators, he found all manner of ways to associate the statues he admired with the High and Beautiful Styles, rather than pin early dates on them at all costs. For example, the statue which made the eighteenth century wax most lyrical of all was the *Apollo Belvedere* (as the very first resident of the pope's new sculpture court came to be known [77], pp. 110–13). Winckelmann himself rated this 'the most sublime of all ancient statues';[3] but he did not saddle it with a spurious early date. True, he made it a Greek 'original'; but he carefully avoided stating exactly when it was produced. Instead he found a place for it in his chronological scheme under the reign of Nero, when it was brought (so he guessed) from Greece to Italy as the choicest imperial plunder. This was a safe fallback position, since Nero was one of the most renowned collectors, or despoilers, of Greek statues—taking over 500 bronzes from the celebrated sanctuary of Delphi alone.[4]

Dating Laocoon: from Winckelmann to us

Winckelmann's enthusiastic admiration for the Laocoon provoked critical responses that have themselves become classics of art history. One tack taken by these discussions (by the critic G. E. Lessing and by Goethe, among others) is to explore the relationship between writing and art: starting from comparison of the statue and Virgil's poetry, Laocoon became the site for radical theorizing on the dynamics of textual and pictorial representation. But the most important topic for Winckelmann himself, and for us, was how to cope with the impossible clash in the image between our admiration for the heroic 'Beauty' of this man caught struggling against the unspeakable, and

our awareness that we are enjoying, but not sharing in, the agony of his last moments, and the helpless pain of his failure to save his children. Winckelmann so admired this piece and saw it as such a classic representative of his 'Beautiful' period that he allowed himself to take the bold step of proposing a fourth-century date, though readily admitting that his argument rested simply on a feel for style.

Winckelmann is not alone in his uncertainty about the exact date of the Laocoon. Although no one today dates it as early as the fourth century BCE, almost every other period between then and the first century CE (to be precise, the completion of Pliny's encyclopaedia in 77 CE) has been proposed. But this issue masks more fundamental questions: is Laocoon a Greek original, a Roman original, a Roman copy of a Greek statue, a Roman adaptation of an earlier Greek model? And what would we *mean* by any of those options? Does, for example, a sculpture made in Rome by Greek sculptors count as 'Greek' or as 'Roman'? And what of a sculpture made in the Greek world for a Roman patron?

All the known 'facts' about the Laocoon have been deployed in the attempt to answer these questions of cultural context and date. The sculptors from Rhodes, named by Pliny, have been linked with some artists of the same name known to have been working in the mid-first century BCE. The slab of Italian marble at the rear of the altar (Pliny was wrong in saying the statue was made out of one single block) has indicated that it was carved in Italy, no earlier than the late first century BCE, when marble was first systematically quarried in Italy (at Carrara). Stylistic similarity to the *Great Altar* of Pergamum (pp. 155–60; cf. **53, 107–8**) pushes the date of the sculpture (or its 'original') back toward the second or the third century BCE. The tie-in with Virgil, on the other hand, may dictate a date after the publication of the *Aeneid* (19 BCE), because earlier versions of the story give Laocoon one son, not two.

These claims cannot all be correct. They do not pull together, and every single one of them is wide open to challenge. The Rhodian names are common ones and cannot definitely be pinned to the first century. The Italian marble may or may not be a later repair in what is otherwise a sculpture made entirely out of Greek stone. Arguments from stylistic similarity always risk circularity (particularly in a world of imitation, where—as we shall see—the date of the *Great Altar* is itself insecure). For all we know, the sculptors may not have been relying on Virgil at all, but rather on a lost source for the story, which also gave Laocoon two sons. On the other hand, many critics see the older boy as unconvincingly attached to the group, and therefore envisage an 'original' with just one son, which must have been adapted by the Roman copyist to bring it into line with Virgil's epic.

The Laocoon is a classic instance of the general dilemma posed by

Graeco-Roman sculpture. It is simply false to suppose that there is a particular place to which this sculpture can be assigned in a linear development from one style to another. The defining characteristic of an aesthetic that values creative imitation and the expressive possibilities of copying is to defy any such plotting along a simple axis of time or place. But more than that, all the information that we have (in this case about the sculpture's creators, location and rediscovery) inevitably supports, and stimulates, rival narratives and interpretations. Inevitably, because in an age of imitation, every product is implicated in the split consciousness which lies at the heart of copying. Whether or not, or in what sense, a Laocoon is a 'copy' is not a preliminary question to be settled once for all, but a prompt to explore the many ways in which the work of art engages through time with its tradition and with its changing environment. Cumulatively, all the efforts to fix the truth of the object become the very stuff of its fame.

Buried treasure: the 'Cave of Tiberius' at Sperlonga

More evidence always fuels, rather than forecloses, questions about date, cultural context, and style. Suppose we were to learn that Pliny's three Rhodians sculpted our Laocoon in 40 BCE; we would still need to ask whether it copied or adapted an earlier Greek model. Even if we were to dig up 'the original', art historians would be bound to set it against the copy and then disagree about the significance of the differences and similarities (as we saw in the analogous case of painting in Chapter 1). For such is the logic of copying and reproduction. We have a perfect example of how this works, and of how new evidence itself becomes entwined in the questions it promises to answer, in the shape of a major discovery of sculpture in a cave near the village of Sperlonga, on the coast between Rome and Naples. Recovered in 1957, in the age of modern excavation and recording techniques, scientific conservation and scholarly publication, it has often been touted as the key to the problem of the Laocoon. In our argument, we shall see first why this cannot be so; and we shall go on to use the history of the discovery and interpretation of cave and contents as the occasion to reflect, at a general level, on how art history selects and processes its materials as it gets down to work.

This cave produced a hoard of more than 7,000 fragments of marble sculpture, a few hundred of which have now been reassembled and mounted in their own museum at the site. They originally formed a breathtaking installation, the surreal highlight of a sea-side dining room attached to a luxury villa on the shore. Here the natural cavern loomed overhead and the sea lapped outside, while an elaborate system of pools, stone cladding, rock carving, and paved flooring made the dream setting for a state-of-the-art Roman banquet. The sculpture was harmonized in an integrated design of four

groups (see Maps and Plans 14) [**52 (a)**]. On an 'island' in the centre of the main pool, the sea monster Scylla pounces on Odysseus' crew in traditional style—with the several mouths of the dogs which sprout from her genitals [**52 (b)**]. At the back of the grotto, Odysseus and his men drive a stake through the single eye of the giant Polyphemus before he can have them for supper—playfully (and menacingly) turning the dining room into the cavernous home of the worst host in the world [**52 (c)**]. On the right, Odysseus and Ajax steal the statuette of Athena known as the Palladium—the talisman that had kept the city of Troy safe [**52 (d)**]. The identification of the group on the left has been more disputed. Some people see it as the Greek warrior Menelaus rescuing the corpse of his comrade Patroclus from the field of battle outside Troy [**52 (e)**], relying on the group's likeness to other statues held to represent that pair—even at the cost of departing from the 'Odysseus theme' that seems to link the rest of the ensemble. Others have tried to preserve thematic unity by suggesting that it is Odysseus rescuing a fallen hero (Achilles might be a possibility, though there are no parallels to hand).

In fact, if a strong thematic frame is wanted, the cave setting itself provides a far better one. Ancient readers of epic (whose themes were, as we saw in Chapter 1, common currency) would have known that both the cloak and dagger theft of the Athena on one side and Menelaus' salvage operation on the other took place after dusk; as such they would be ideal for customized installation in a murky cave. Taken together, all four mythological groups set up dynamic relationships between epic text and physical setting. At the same time, they raise the vital questions of heroic, and human, values: how shall we rate the snatching of the fallen brother-in-arms from the hands of the foe as against the daring raid deep into the enemy's sacred citadel? What comments on the leadership of Odysseus are communicated by the horrendous suffering of his men in the grip of Scylla, and by their savage retaliation on the monster Polyphemus?

The relationship between the installation in the cave at Sperlonga and the Laocoon is founded on the inscription proudly displayed on the stern of Odysseus' ship in the cave's 'Scylla Group', recording the names of the artists: 'Made by Athenodorus son of Agesandros and Agesandros son of Paionios and Polydoros son of Polydoros, all from Rhodes', the very trio named by Pliny as the joint creators of Laocoon. Here was the perfect opportunity to date Laocoon, for Sperlonga had a place in Roman history that looked as secure as could be. The great historian Tacitus tells how in 26 CE the emperor Tiberius was dining in a natural grotto, at his villa called 'The Cave' (*Spelunca*), when 'the mouth of the cave suffered a sudden rockfall and several servants were crushed. Fear spread to everybody and the banqueters fled.'[5] But Sejanus, the emperor's strong-arm henchman,

52 a, b, c, d, e

(**a**) Reconstruction drawing of the principal groups of sculpture in the 'Cave of Tiberius' at Sperlonga.

From the mouth of the cave, across an artificial pool at the centre, we spy two small heroic scenes. To the left, a warrior supports a dead comrade (**e**); to the right, the pair of Diomedes and Odysseus steal away with the holy image of Pallas Athene (**d**). Behind, on an island in a circular pool, the monster Scylla preys on the crew of a ship (**b**). At the back of the cave, Odysseus and his men put out the Cyclops Polyphemus' single eye with a stake (**c**).

(**b**) The *Scylla* Group from Sperlonga, a modern reconstruction.

One attempt to recapture the original impact of the group; in fact, only the right hand survives of Scylla above the waist.

(**c**) The *Polyphemus* Group at Sperlonga, plaster reconstruction.

(**d**) Marble sculpture of the Palladium, from the *Theft of the Palladium* Group, Sperlonga.

(**e**) Marble fragments of the legs of Patroclus (or Achilles?), from the fourth main group at Sperlonga: Menelaus (or Odysseus) rescuing the corpse of a fallen comrade.

b

a

e

d

c

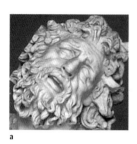

a

53 a, b

Two heads: (**a**) *Laocoon*; (**b**) the *Helmsman* from the *Scylla* Group at Sperlonga. Many art historians have emphasized the stylistic similarities between *Laocoon* and the sculptures from Sperlonga, comparing, for example, the detail of these two heads.

b

who was secretly aiming for the throne (and this is the point of Tacitus' story), spread himself over Tiberius to block the falling debris, and saved the day. The same incident (minus Sejanus, but with more fatalities—including guests) also makes a great moment in Suetonius' lurid biography of Tiberius.[6]

The grotto at Sperlonga could only be Tiberius' cave. It was in the very area where Tacitus locates Tiberius' villa; and there was a reassuring fit between the ancient name *Spelunca* and modern 'Sperlonga'. Besides, all this would suit our notions of Tiberius' character and taste perfectly: such a strange emperor, hiding himself away to indulge his depraved lusts in bizarre settings of extravagant luxury! The fantastic installation in the cave, the ingenious combination of rocky coast, sybaritic dining, and high art for the connoisseur, could only be a Tiberian design. If so, we would have a firm date for the sculpture in the cave, and therefore Laocoon: the early first century CE. Here also would be our perfect entrée into the workings of imperial patronage, through the activities of a single atelier or workshop; and a rare glimpse of the aesthetic preferences of the emperor's court. It would be a foothold for characterizing the stylistic idiom of the day. Between them Laocoon and Sperlonga add up to a substantial and coherent body of work, with the promise of direct access to the hands of individual artists [**53**].

All this makes an impressive and attractive edifice. But what it documents most starkly is our own continuing capacity (no less than the eighteenth century's) to mythologize great works of art. In fact, we do not know when the statues were set up in the cave, and nothing at all ties their creation or installation specifically to Tiberius (even assuming that this was the site of the emperor's eventful dinner party of 26 CE). Nor is there any way to decide where to place the sculpture in terms of relative fidelity to earlier Greek prototypes or distinctively Roman inspiration. Even the 'signatures' built into the 'Scylla Group' settle nothing, least of all the date. Strong claims have been made for identifying the three sculptors as members of a thriving and long-lasting 'school' of 'late Hellenistic Baroque' (any time between the third and first century BCE) based on the island of Rhodes. But just as strident are those who imagine Athenodoros and co. sailing off to work in Italy (at any point up to the first century CE), and produce genuine state-of-the-art copies of well-known artworks for the Roman market; and here at Sperlonga, so that story goes, they mounted a one-off extravaganza, maybe for the emperor himself, a virtuoso synthesis of inimitable Greek masterpieces. The fact that most people agree that (to judge from the style of the lettering) the signatures were carved between 50 BCE and 50 CE hardly affects the argument: those who want to suggest an earlier date can point to other sculptures where artists' names have been added later, for the

54

Bits of Scylla?
Fragments of marble sculpture recovered from the main pool in the cave of Sperlonga.

fame (spuriously or not); or to copies which incorporate the names of the original artists into the new version. As with the Laocoon, the sculptures at Sperlonga have been plausibly claimed for pretty well every phase within the period covered by this book.

Obsessive concentration on the problem of dating has been at the expense of the whole archaeological story of Sperlonga; and, above all, it has buried the crucial fact that these sculptures, now so theatrically reconstructed for display and idolized in books on classical sculpture, were found in thousands of badly battered, and mostly tiny, fragments. However princely a display they once made, the ultimate fate of the Sperlonga sculptures was systematic destruction. They were not merely abandoned to slide gracefully into disrepair; they were smashed into tiny pieces and dumped into the central pool (early Christians are the usual suspects) **[54]**. Undisturbed for centuries, the cache only came to light during the construction of the coast road. In the course of this work, the chief engineer took it into his head to explore the cave with especial care—partly from curiosity, partly no doubt because it had been laid with mines in the war, and a stash of live explosives still lurked there. With the help of his navvies, the marble fragments were sorted and, while the villagers glowed and got possessive over the discoveries in their cavern (it was at first thought that another Laocoon had been found), archaeologists began the jigsaw puzzle of reconstruction, much as we saw happening at Boscotrecase (pp. 52–3). A few substantial fragments did survive (the head we now recognize as Odysseus in the 'Polyphemus Group', for example) and some pieces, even if small, easily identified themselves (such as the statuette of Athena and the business end of the sharpened stake which blinds the giant). But, for the most part, all there was to go on was row upon row of chunks of stone, more or less recognizable as sculpture; as well as a Latin poem found inscribed on a plaque (also in pieces), which obviously celebrated the grotto's *coup de théâtre*, picking out the blinding of Polyphemus and the sadism of Scylla as the main subjects.[7]

'Find that date': a blinding compulsion

The feat of reconstruction is indeed impressive. But it hides a number of glaring facts: that a very large proportion of the fragments have so far found no place in it; that many of the figures (and indeed the articulation of whole groups) have been conjured up from precious little surviving marble; and that several of the core components have been shuffled from place to place within the whole ensemble, with drastically different results. When we presented 'Menelaus and Patroclus', we did not point out that the sole surviving pieces of marble in this group are the head of 'Menelaus' and part of his left arm, plus the trailing legs of 'Patroclus'. At least, that is the score at present. The

a

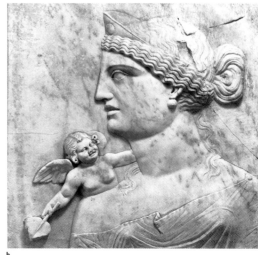

b

c

first reconstruction found a torso for 'Menelaus' in (what we now reckon as) the 'Odysseus' who directs the blinding of Polyphemus.

Moreover, the spectacular reconstructions have stolen all the limelight from the other sculpture found in and around the grotto, much of it (paradoxically) better preserved. And the idea of an epic theme park (fixated on the figure of Odysseus) has blotted out all thought of the other associations that the rest of the material might prompt. While everyone has been busy with Polyphemus and Scylla, they have determinedly neglected the much wider collection that stocked the cave—some of which we show in **55**: a charming marble maiden of the third or second century BCE [**55 (a)**]; a substantial relief panel of Venus and Cupid [**(b)**], and some doggedly Roman portraits of the second and third centuries CE [**(c)**]. This is not to forget a clutch of babies, one playing peek-a-boo with a comic theatrical mask, a gallery of assorted heads, a couple of genuinely high classical (fifth-century BCE) Greek vases and a scattering of early Christian bric-a-brac. The whole Aladdin's cave was crowned—but when?—with a massive statue of Ganymede in the clutches of his eagle, the shining white gleam of the boy's head offset by the most gorgeous purple-veined marble; he is on his way up to the lap of Jupiter, ready to serve the wine at every dinner party in heaven, that ultimate emperor's playground [**56**].

Before we even get into the cave, one ambitious *jeu d'esprit* gives notice that Odysseus is far from the only epic hero of Sperlonga. No visitor could have missed the rearing prow of a ship carved out of the living rock, topped with marble cladding and sparkling with brightly coloured glass mosaic, jutting out from the entrance to the main grotto. It is a striking variation on (as well as the perfect introduction to) the complex visual interplay between art and nature to be found

inside. But this boat declares itself to be nothing to do with Odysseus, sporting a text of its own, in mosaic—not this time the artists' signatures, but the bold emblazoning of its name: 'The Ship Argo'; it is for all the world as if Jason and the Argonauts were on board. But if this should raise expectations that the famous story of the *Argo*'s epic voyage in quest of the Golden Fleece will be amplified inside the cave, disappointment awaits.

Which came first, the installation of Polyphemus and Scylla inside the grotto, or the carving of the *Argo* in the rock outside? We do not know; nor (despite various assurances to the contrary) can we be certain of the relative chronology of most of the other pieces from the site. But this should not stop us exploring the possible implications of their juxtaposition. Some well-informed visitors to the villa, for example, might have figured that this stretch of coast was the only spot in Italy where the Argonaut and *Odyssey* sagas coincided. In fact,

56

Coloured marble statue of *Ganymede and the Eagle*, from the cave at Sperlonga. Originally sited above the cave, this statue was found in the sea at the cave's mouth in 1957. The gleaming white head is now exhibited separately in the museum in line with a recent theory that it is a later Roman replacement of the original head.

prominent in the view from the cave is the promontory (Circeii) where the legendary witch Circe was supposed to have lived, and where it was said that both Jason and Odysseus were entertained. Circe was the classic host(ess) for the epic hero to regale with his sailors' yarns—wars won, and monsters faced. These kinds of association may have occurred to any of those who had a hand in designing, and redesigning, the diorama of the cavern through the centuries; and they may have struck guests forcibly, or entirely passed them by, lost to the throng of images clamouring for attention.

However we handle its interpretation, Sperlonga must be a crucial lesson in methodology for all art historians at work on Winckelmann's Age of the Imitators. What is exposed here, for all to see, is the ruthlessness inherent in our drive to bind particular works of art to particular chronological and cultural moments. The emphasis on Tiberius, on the dominant theme of Odysseus in the reconstructed sculpture and on the connections (via the three Rhodians) with Laocoon, and so with the whole history of the development of Hellenistic art, combines (in what is little short of a collusive conspiracy) to exclude from view all the other objects in the cave, and most of its history. For all their many different inflexions, most accounts of Sperlonga offer what amounts to a powerful single story—which, as we have seen, sweeps aside all life in the cave after 26 CE (as if the roof fell in for good then); which turns a blind eye to all the sculpture which cannot be corralled into the story of Odysseus (recall how 'Menelaus' becomes a far-fetched 'Odysseus', despite the iconographic clues); and which fixates on placing the major groups of sculpture within a putative stylistic history of Hellenistic art (stretching back through the Laocoon to Rhodes and the eastern Mediterranean), at the expense of any response to the grotto as a whole. The usual insistence on 'the founding moment' puts these, or any, works of art into a spurious isolation and paralyses our sense of how they continue to play a part in the cultural history of their setting long afterwards.

As we have been concerned to stress, Sperlonga has had centuries of history. Every component played its part in the sculptural ensemble; as those components changed, so did the meaning and significance of the ensemble; no piece existed in a vacuum. The same is true for just about every statue that we discuss in the chapters ahead: almost every one of them had a role in the visual culture of later periods, from the Roman empire to the Renaissance and right up to today. As such they could find themselves on the pages of Jaś Elsner's volume in this series, *Imperial Rome and Christian Triumph*, or Matthew Craske's *Art in Europe 1700–1830*, as well as our own.

Sculpture culture: the market for Antiquity

Sculpture defines Greek and Roman art and will take the lion's share of attention in the rest of this book. The cities of antiquity were cities of sculpture. Full-length portraits of generals, statesmen, and local dignitaries lined the streets and squares of every town; temples were crowded with images that gave form to a whole host of deities; the houses of the Roman elite proudly displayed the busts of their ancestors; monuments crawled with figures carved on every side; cemeteries were crammed with effigies of the dead; gardens and galleries were decked with culture, kitted out with kitsch. Pliny reckons that in his day the city of Rhodes alone boasted 73,000 statues; with 'no fewer' at Athens and the sanctuary sites of Olympia and Delphi.[8] Sculpture is, of course, at home in our urban environment too. But its impact is nowhere near the same, its value and importance drastically diminished. The Greeks and Romans took sculpture for granted, as well as giving it a central place in the cultural and symbolic repertoire.

And so, since the Renaissance, sculpture has taken pride of place in the study, the collecting, and the display of the arts of antiquity: it is the most prestigious medium in the formation of (classical) art history. We have already mentioned that the triumph of Napoleon was crowned by the wholesale removal of ancient and modern masterpieces from Rome to Paris (p. 8). All the stars of classical sculpture went in their crates along with Laocoon, including many of those that will feature prominently in this book: the *Apollo Belvedere* [**77**], plus the Vatican's *Boy and Goose* [**98 (a)**] and *Genius of Augustus* [**159**]; the *Antinous Relief* [**76**]; the *Medici Venus* from Florence [**82**]; and, appropriately enough, the *Dying Gaul* [**110**].

For centuries, in palaces and state museums across the world, ancient marbles have played their part in dynastic pretensions, nationalist powerpolitics, and empire. But the reach of ancient sculpture has extended much further than that. Private wealth and personal taste have in our culture been invested in collecting and displaying classical bodies, torsos, and heads. From the haul of bargains picked up on the Grand Tour to the discriminating acquisitions of the grand connoisseur, the market supplied every need (and still does): 'originals', souped-up copies in every conceivable medium, from garish pottery to exquisite gemstones, cameo glass to plastic heroes. But no medium ever rivalled plaster casts, exact copies taken from the most famous sculptures and shipped in their thousands throughout the West. Right up to the 1950s these casts were the basis of just about all formal training in art, as the Academies insisted that artistic skill could only be acquired through the disciplined copying of the masterpieces of classical antiquity. For centuries European artists learned their trade by drawing and redrawing the sculptures that are the subject of this book [**57**]; some artists still do.

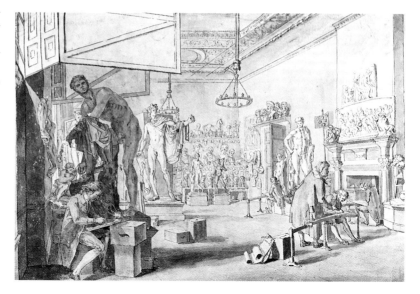

Sculpture of our period fills the museums of the world. In exploring painting in Chapter 1 we necessarily concentrated on a single site, and very largely the material housed within a single museum. With sculpture (although there is good reason to make the city of Rome our starting point) we shall explore sites much further afield—especially in Greece and the eastern Mediterranean. And we shall be choosing further examples from material that has travelled to museum collections as far apart as Moscow and Malibu. This is 'moving art', and always has been.

For all this huge volume of surviving material, it must be wrong to suppose that we have a representative sample of what there once was. Pliny and other ancient writers make perfectly clear that there was an enormous quantity of work in bronze, and that included many of the star items. But this stood little chance of surviving theft and all kinds of recycling (many a masterpiece probably ended up as cannonballs); the few bronzes that do survive have mostly been out of harm's way—often in wrecks on the seabed. Gold and silver statues and statuettes were also known, if much rarer; these were still more vulnerable, and precious few remain. What does survive in bulk is marble, which must on any reckoning have been the staple material for sculptors; but even with marble, we have to reckon with the probability that anything carved in exotic coloured stone has always been a more attractive candidate for reuse than pieces of plain white. Our standard image of Graeco-Roman sculpture as uniform shining white marble derives, in part at least, from the disproportionate loss of all the other materials and colours.

58

Marble statue of Mars *(Ares Ludovisi)* from Rome; *below*, detail of restored head of Cupid by G. L. Bernini (1622). This statue is traditionally interpreted as Mars, the Cupid at his feet alluding to his adultery with Venus, but some recent studies have suggested that it depicts Achilles, and was originally paired with a statue of his mother, Thetis.

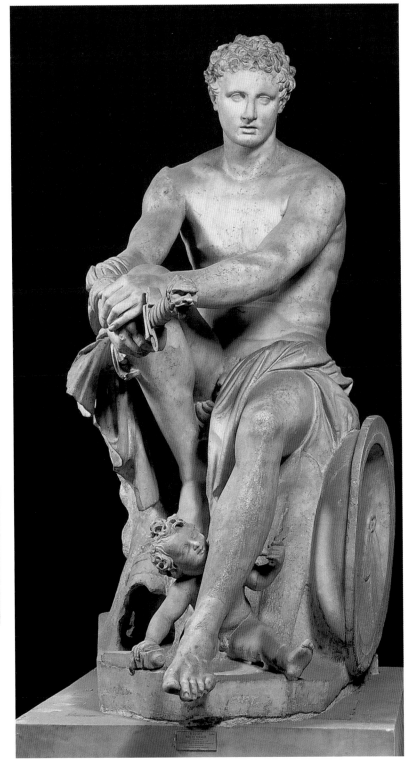

The makeover of 'classical' sculpture

That image is also the product of all kinds of later intervention. Most of the statues unearthed over the last five hundred years will have been determinedly cleaned and polished to look their 'best'. Most traces of paint surviving on them will have been obliterated in the process. (We can now only guess how regular the painting of statues was in antiquity.) And in its place, we have the gleaming surface that has become synonymous with classical style. But intervention could go much further than this. As we have seen, the greatest artists of the Renaissance were trusted to repair the often damaged sculptures that emerged from the ground; it is only more recently that fragments have come to be valued as such, and positively cultivated (p. 122). In a parade of sympathetic creativity, plenty of these works were quite literally 'reborn'—and it is in that new form that many of these Graeco-Roman statues are known (and loved) today. For us the Louvre *Hermaphrodite* will always sleep soundly on its seventeenth-century mattress, courtesy of the flair of Bernini [**92–3**]; and it was Bernini too who gave us the touching face of baby Eros, as he nestles at the feet of his next victim—the war-god Mars [**58**].

Sometimes the work of modern sculptors on ancient pieces is well documented and publicized; even if not, blatant joins can make it obvious, or subtle differences in the type of marble used may offer tell-tale clues. Sometimes the whole process of reworking and restoration itself makes a continuing story of controversy (as we saw

59

Female bust, commonly known as *Clytie* (cf. **48**).

Ancient or modern? The figure appears to emerge from a flower – hence the name 'Clytie', after the mythical nymph who fell in love with the sun-god and turned into the first sunflower.

with the different versions of Laocoon's 'missing' arm). But in other cases, there is no agreement about which parts of a statue are modern additions, or even whether the whole is ancient, modern, or a combination of the two. An exquisite example of just this problem is a female bust on display in the British Museum [59]. It has been confidently pronounced an entirely eighteenth-century creation; an early first-century CE portrait of the emperor Claudius' mother Antonia; and an ancient bust, but reworked in the eighteenth century (surely the skimpy décolleté effect must have been produced by cutting away heavier original clothing?). We can no more decide between these options than we can solve the problem of Laocoon; and for essentially the same reason. A culture of deliberate and painstaking imitation, in a tradition of marble working that had remained substantially unchanged since antiquity, celebrates continuity of style and craftsmanship. This culture may even set out as a principal objective to make it impossible to discriminate old from new.

The art collector goes mad: Chas. Townley

Clytie was originally part of the collection assembled in the late eighteenth century, mostly from Rome, by Charles Townley (who had swallowed the notion that she was the goddess 'Isis, placed upon the flower of the lotus'). Townley was about the biggest-spending British collector of the period, employing agents in Italy to pay out vast sums for the best and latest finds, to get them restored and shipped over to join the hundreds of others packed throughout his London home [48]. The history of some of the pieces in this collection (which is now in the British Museum) reveals another side to the culture of sculpture: namely an anxiety about authenticity and about the loss of money and face that went with being duped or caught out. Having the most famous artists of the day working on a few prize discoveries was one thing; but the more commercial the market in Roman antiquities became, the more there was at stake at the boundary between fidelity and forgery, original and supplement, good and bad restoration.

In 1792, Townley was sold for £400 a new discovery straight from the Villa of the Emperor Hadrian at Tivoli (pp. 102–5), via the workshop of a leading restorer. It was a Roman version of a bronze statue of a *Discobolus* ('Discus Thrower') by the fifth-century BCE sculptor Myron. It is now one of the most famous types of classical Greek art [60 (a)]; but then it had only recently been identified and attibuted to Myron—by matching up a listing in Pliny with some fresh finds.[9] Even before it arrived in London, Townley was worried about its head. He was assured that it had been found right next to the rest of the statue and had simply been put back in place. But something seemed wrong: the grain of the marble matches perfectly, but the head did not turn back to look at the discus, as it did in the version

60 a, b

Discus Throwers: (**a**) *The Townley Discobolus* (cf. **48**), traditionally seen as a Roman version of a bronze statue by Myron.

Townley was right to be worried about the restoration of the head. Something was wrong: no athlete ever had such a neck.

(**b**) The *Lancellotti Discobolus,* found in 1781 on the Esquiline Hill, Rome.

Admired by Hitler, partly as a symbol of Aryan athleticism, this statue was acquired for the Third Reich in 1938, but was returned from Munich to Rome in 1948. The *Discobolus* had already starred in the opening of Leni Riefensthal's film of the Berlin Olympics (*Fest der Völker,* 1937), where the statue dissolves into the living pose of the Olympic champion decathlete Erwin Huber.

that had been found shortly before [**60 (b)**]. When Townley pressed his inquiries, his dealer consulted the pope's expert, who assured him that Townley's version was the better, theorizing that although Myron's original might have been different, the Roman artist had improved on the Greek version with a new tilt of the head. When, soon after, the pope himself acquired a *Discus Thrower,* also from Tivoli, the same expert put his neck on the line, by choosing to restore it to match Townley's.

The story of Townley's *Discus Thrower* shows just how complex issues of authenticity must always be. Townley wanted a correct decision about his statue's head. But we can see in the answer that satisfied him how the technical expertise that appears to govern such decisions is itself always framed by the rhetoric of prestige and authority; not to mention mediated by self-interest and wish-fulfilment. The story also returns us to the problem of art in 'the Age of the Imitators'. For, though Myron's masterpiece itself was created in the fifth century BCE, we have no version of the statue which can be dated before Alexander the Great: our understanding of the work rests squarely on Roman sculpture. We can see it only as it was represented as part of the visual culture of the Roman world; only as reproduced by Graeco-Roman sculptors of our period.

Ancient Rome as collector

Townley's great collection was assembled in, and from, Rome. Not surprisingly, since (as we stressed at the start of this chapter) Rome was the greatest centre of sculpture the western world has ever seen. It still is. Not only has Rome operated as one of the largest sites of production, but as imperial, papal, and capital city it has sucked in sculpture from all over the Mediterranean, brought there as loot, tribute, commission, and purchase. (Almost as much probably flooded into Constantinople, the emperor Constantine's 'New Rome', founded by in 324 CE—but precious little survived successive fires and wars.)

Greek art as plunder

As soon as Rome expanded into the Greek world in the late third century BCE, conquest brought in spoils in the form of sculpture and other works of art, by the ship- and cartload. The victory parades of Roman generals featured captive Greeks and captured Greek art. The one we know best is the triumph of L. Aemilius Paullus, who decisively defeated the last ruler of Alexander's kingdom of Macedon in 168 BCE, and returned to Rome with one of the largest collections of booty ever, including the staggering haul seized from the palace near Vergina. One whole day, the story goes, was barely enough for trundling the statues, paintings, and colossal images past the crowd, loaded on 250 wagons.[10] Within a generation, another campaign saw the systematic dismantling of the entire city of Corinth, with everything valuable taken off to Rome, in a vast exercise of exemplary spoliation, until the imperial city was crammed full of marble. One unsmiling Greek visitor to Augustan Rome could claim that 'pretty well the most and the best of dedications in Rome came there from Corinth'.[11] Through more than a century, this pattern of plunder was repeated, almost annually, as the empire stretched through and beyond Alexander's; when the first emperor, Augustus, took over Egypt after defeating Antony and Cleopatra (31 BCE), the floodgates were opened for wholesale importation of ancient and modern artefacts, as well as exotic new varieties of stone for adorning the world capital.

Where did all this statuary end up, after its parade through the streets? One thing is for certain, not much would leave Rome— during antiquity, at least. A notorious exception, an Eros (or Cupid) by the fourth-century sculptor Praxiteles, proves the rule. The ancient travel writer Pausanias tells how this bronze was stolen from Thespiae in Greece by the wicked (and doomed) emperor Caligula, then returned by an obliging Claudius, but seized back by the wicked (but equally doomed) Nero, to be lost for good in the fire of 80 CE in Rome: a marble replacement (with nasty gilded wings) kept the

town's permanent loss fresh in Greek hearts and minds.[12] But Roman writers are generally silent on the question of *exactly* what happened to even the major works of art among the triumphal spoils. Occasionally we can confidently infer the story: when, for example, Pliny writes that Aemilius Paullus dedicated a statue of Athena by the fifth-century sculptor Pheidias in front of the temple of *Fortuna Huiusce Diei* ('Today's Good Luck'),[13] it seems certain that this was part of his Macedonian plunder (ironically, the Macedonians themselves had presumably looted it in their conquest of Greece). Likewise when Pliny tells us that a cedarwood Apollo was brought from the city of Seleuceia, in Syria, to the temple of 'Apollo Sosianus' in Rome (named for the general Gaius Sosius),[14] he does not say that Sosius seized it on campaign; but he may expect us not to need telling. While such detail is rare, the general picture is beyond doubt. Some pieces were set up in public or state buildings: baths, porticoes, and, most commonly of all, temples (whose construction itself was very often funded from spoils). Others were sold off at auction, to adorn the houses of the rich and powerful, or to fetch up in temples and other public spaces as dedications and benefactions. One way and another, plundered statues found their niches throughout the cosmopolis.

How many of the statues that we can still see in Rome first came there as spoils? We must presume that this was the story of several of the works we have. But, as it happens, we can never quite make the link for sure: there is not one single work of art which we can prove, without doubt, arrived as plunder from the Greek east. One of the most likely cases comes, again, from the temple of Apollo Sosianus, refurbished by Sosius—either in the 30s BCE to commemorate successes as a lieutenant of Mark Antony in Syria, or in the 20s after his pardon by Augustus for serving as Antony's admiral at the battle of Actium (or, perhaps, through both decades?). Excavations in the 1930s found the sculptures displayed in the temple pediment after its restoration by Sosius; they proved to be 'original' fifth-century BCE works of art, removed, somehow, from the pediment of some Greek temple [**61**]. The scale of these objects, plus the fact that they had been integral parts of a sacred building, suggests that they were forcibly removed to Rome, loot captured in war. On the other hand, we cannot be sure that they were not the proceeds of the flourishing trade in sculpture (maybe a Greek city disposing profitably of sculptures from a disused or revamped monument). This trade had pre-existed Roman domination of the Greek world, but quickly made a bee-line for the imperial city, and continued throughout antiquity, as a regular service industry to supply the ambience befitting a superpower and its elite.

Pedimental sculpture from the late first-century BCE Temple of Apollo Sosianus in Rome.

Fifth-century Greek art in first-century BCE Rome: Athena presides over a battle between Greeks and Amazons.

Vivid evidence for the wholesale movement of sculpture from the Greek world to Rome comes from a series of ancient shipwrecks, discovered on the Mediterranean seabed. The most exciting of these was salvaged in 1901 from 60 metres of water in the treacherous straits at the southern tip of the Peloponnese in mainland Greece. The ship (dating to the early first century BCE) was carrying a vast cargo of pottery, glass, amphoras, gold bars, lead ingots, and almost a hundred sculptures in bronze and marble. Some of these were 'old masters'; others were almost certainly contemporary pieces, some without parallel, others versions of statues we know. Even when the marble is horribly disfigured by its 2,000 years under the sea, we can still recognize subjects and types found elsewhere [62]. What lay behind the transport of this extraordinary collection, lost en route to Italy from Asia Minor? (Coins of the city of Pergamum found with the cargo point to its origin.) One suggestion is that the ship was carrying part of the reparations that the Romans had exacted from their province of Asia, after it had failed to fight off the colossal invasion of King Mithridates (this might explain the quantity and the sheer range of material, as houses and public buildings were stripped to meet the impossible Roman demands). But, again, we cannot be certain that this was not a vessel plying routine trade in Greek art for the Roman market. Nor, in the whole spectrum of Roman imperial exactions, can the boundaries between 'trade', 'reparation', and 'looting' be at all clear.

The Roman collector: Cicero

Certainly Roman collectors provided a ready market for sculptors, workshops, and dealers in the East. Letters sent by Cicero (arch-orator, political broker, self-publicist, and social climber) to his life-long confidant and agent, Atticus, give telling glimpses of the ins and outs of the business of collecting among the Roman elite from the first century BCE onwards. For much of his career, prudent Atticus was based in the tourist town and artistic mecca of Athens: a strategic location which kept him safe from the perils of life in revolutionary Rome, and at the same time made him the ideal middleman for helping out friends back in Italy—selecting tasteful pieces, arranging purchase, masterminding shipment.

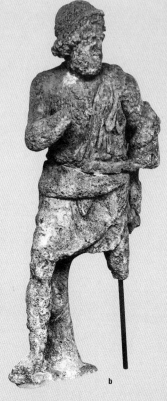

b

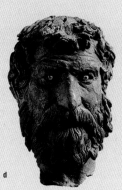

d

c

a

62 a, b, c, d

Sculpture from the first-
century BCE wreck off
Anticythera in southern
Greece: **(a)** *Weary Hercules*;
(b) *Odysseus*; **(c)** *Boy*;
(d) *Philosopher*.

Of these figures, **(a)** (*Weary
Hercules*) is a recognizable
version of a very well-known
type (**144**); **(b)** is reminiscent
of the *Odysseus* we saw at
Sperlonga (**52 (a)**); the
acclaimed (and enigmatic) **(c)**
is unparalleled; the Hellenistic
guru **(d)** is typically wild and
manic, ascetic and saintly (cf.
64 (b), **182**).

Rome, 13 Feb. 67 BCE.

…I have got hold of the 20,400 sesterces [Roman currency] for Lucius Cincius, for the statues in Megarian marble; those images of Hermes of yours, in Pentelic marble with heads in bronze, that you wrote to me about, are giving me quite a thrill already, this minute. So PLEASE …not just them but the statues and whatever else strikes you as right for that setting, for my passion, and for your sensibility, do send me them, the more the merrier and the sooner the better, and most of all any that strike you as right for the gymnasium and colonnade. For in this department, I get so carried away by passion that I must have help from you and (ahem) criticism from others.

Sometimes (as we saw with Townley and the *Discus Thrower* 1,800 years later), there were hitches. On one occasion Cicero writes to another trusted agent, not only complaining about the price of the sculptures he has secured, but also dismayed by their unsuitability: 'What good is a statue of Mars to *me*, the Author of Peace?'[16] No doubt about it, collecting at Rome was always a nerve-racking business: a Cicero could lose money he didn't have and, in the race for prestige, one false choice or an undignified ensemble (a Bacchic reveller installed in the library? a woman in ecstasy among the books?) might forfeit his whole stake in sculpture culture.

The 'Villa of the Papyri': from Herculaneum to Malibu

None of Cicero's own installations survives. But just outside Herculaneum, the so-called 'Villa of the Papyri' (one of the first sites of the city to be burrowed into, and emptied, from 1750) gives us some idea of how rich, and how elaborately planned, the sculpture collections of a grand private estate might be (Maps and Plans 5). This extraordinary place takes its name from the masses of papyrus rolls—ancient books—found there; but no less extraordinary finds of sculpture were also made. There were 51 bronzes and 24 statues in marble: the largest haul from any one ancient house. The excavation could not be systematic; the sculptures were pulled through makeshift tunnels hacked into the rock-hard lava that covered the town (the villa itself is still buried). But the excavator, Karl Weber, did keep plans, and findspots were more or less noted. It is clear that the main sculptures lined a peristyle 100 metres long; they were carefully themed and arranged in a giant programme, advertising a sophisticated and highly cultured 'design for life'. In this case, all the components seem to have been produced in Italy, but they refer to and reproduce the common stock of images prized across the Greek world. Between divinities on the one hand and the world of wild nature on the other (in one group Pan and a goat make love [**63**]), a line-up of Greek and Roman portraits set political and intellectual power cheek by jowl, composing a synoptic diorama of the whole classical tradition [**64**] (cf. **182**,). Precise details elude us, and it may

63

Sculptural group of *Pan and Goat* from the 'Villa of the Papyri', Herculaneum.

Discovered in 1752, this piece went straight into the 'secret cabinet' (p. 35), not to be viewed without the king's explicit permission. In 1762 Winckelmann quipped that he did not want to be the first one to ask.

be a good idea not to be too dogmatic about what the programme 'meant' (tempting as it has been to gear its message to the philosophical treatises that dominate the villa's library and are the site's main claim to fame). But the whole ensemble must stand as a model of cultivated connoisseurship and super-rich collecting, Roman-style. It is no coincidence that the original J. Paul Getty Museum at Malibu (now the Getty centre for classical antiquity) chose to replicate this very house on a still more luxurious scale [**65**]. Getty himself cele-

64

Busts from the 'Villa of the Papyri', Herculaneum: (**a**) *Demosthenes*; (**b**) *Epicurus*; (**c**) Polyclitus' *Doryphorus* ('Spear-Carrier').

These busts bring together famous Greek orators (**a**), philosophers (**b**), and canonical artworks of classical Greece (**c**); for portraits of rulers from the villa, see p. 235. The heads are all copied from full-length statues, to make a gallery of quotations from classical art and sculpture. Demosthenes and Epicurus are identified by name, the *Spear-Carrier* by comparison with other works (see **70**).

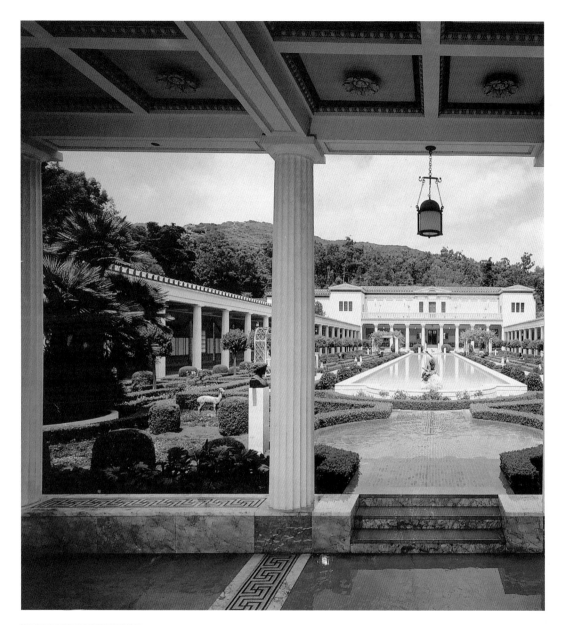

65

The J. Paul Getty Museum in Malibu. View of the main peristyle.

Classical art moves on, from Greece to Rome, through to the West Coast.

brated the connection in a novella written in the 1950s, in which the hero comes from free, pre-Roman, Corinth to work as adviser to the Villa's owner in buying up loot for Herculaneum when his own city is sacked.[17] In the story, Getty's prize statue, the *Lansdowne Hercules*, moves to the Villa of the Papyri, on the way (via Nero's Rome) to its modern findspot in Hadrian's Villa at Tivoli; in history, after its excavation, the statue moved first to the Lansdowne collection in eighteenth-century England, and then to Getty's museum in California in 1951 [**66**]. Here is a perfect illustration of self-awareness, from the supreme modern collector, of his involvement in a complex contin-

66

The *Lansdowne Hercules* (as restored).

The statue's date is disputed. Is it the pre-Roman Greek original Getty believed it to be, or a second-century CE product from the heyday of the Roman empire? Albacini's restorations to both arms were removed in 1975, and the Getty Museum literally enshrined the statue (**7**).

uum of moves in the appropriation and appreciation of classical art over more than two millennia.

The fine line between ancient collecting and looting is perfectly illustrated by Cicero's attack on his sparring partner Gaius Verres. In 70 BC Cicero brought a marvellous prosecution against Verres for his 'overenthusiastic' administration in the province of Sicily, and dredged up all the dirt that he possibly could on his victim's past, so damningly that Verres cut and ran before the prosecution was done. But, to capitalize on this as much as possible, Cicero jazzed up the devastating speeches he would have made and put them into circulation. One of his main themes was Verres' well-known penchant for amassing works of art (particularly in the Greek provinces) and the gangster methods he used to get his hands on them: robbery, ransacking, confiscation, desecration. The orator's rhetoric conjures up a 'host of ambassadors from Asia and Greece, who were in the Roman forum paying their respects to the very images of the gods that had been stolen from their own shrines back home. And as they recognized the rest of the statues and their insignia, they gazed upon them with tears in their eyes.' [18] All Verres' doing, and at first sight a devastating indictment. But we can imagine how the defence could have responded: if Verres brought these works of art back from his province, it was to adorn the city of Rome in the time-honoured fashion; if the ambassadors had been moved to tears, it was understandable nostalgia, but no proof of wrongdoing on his part; and so on. Art collecting always has its justifications, and its victims; in ancient—no less than in modern—cultural imperialism.

Cultural traffic: classical art between Greece and Rome

As we know, imperialism brings far more than a stream of imports to a capital city. To be sure, sculpture did pour into Rome, by the boatload; but many other forms of cultural exchange followed in the wake of Roman supremacy. As the remainder of this chapter will show, such exchange (and with it the processes of Imitation) worked in different ways and at different levels across the Roman empire.

a) In Greece: 'Aemilius Paullus' Victory Monument'

A classic example of how complex this could be is a monument in the Greek sanctuary city of Delphi, sponsored by the same Aemilius Paullus whose extraordinary triumphal procession we highlighted earlier. After his victory over King Perseus of Macedon in 168 BCE, Paullus sealed the propaganda war with a visit to the major religious sites of Greece. At Delphi, 'spotting a great square column, of well-dressed marble, on which a golden statue of Perseus was going to be set up, he ordered his own to be put there in its place; because it was fitting, he said, that the defeated should get out of the way of the

67

Part of the frieze from the
Monument of Aemilius
Paullus, Delphi, 168 BCE, or
soon after.

In the centre, a riderless
horse; on either side, the
distinctive armour
differentiates the combatants
(Macedonians sport ornate
circular shields; a Roman
infantryman shelters behind
an oval shield as tall as
himself).

winners.'[19] Remains of this monument still survive (but not its
crowning statue), together with a Latin inscription immortalizing
Paullus' victory over Macedon and its king; around the top of the
pillar ran a sculptured frieze, depicting mixed fighting between
infantry and mounted troops, plus the curiosity of a single, loose
horse [**67**].

Greek sculptors were certainly responsible for this monument in
both its phases. But art historians have interpreted its cultural signif-
icance in very different ways. Some see it as an essentially Greek
monument, displaying a standard Greek heroic battle-scene, simply
commandeered at the last minute by a Roman victor. Others stress
the specifically Roman imprint of the frieze, pointing to the specifics
of the armour, and referring triumphantly to the story of the battle of
Pydna being sparked off by a riderless Roman horse running amok
among the enemy lines.[20] Such attention to specifics and to a partic-
ular moment in history has traditionally been held to define a dis-
tinctively Roman approach to representation. Others again see the
frieze as a telling example of the eclecticism common in Graeco-
Roman art, a harmonized fusion of elements from both worlds.

Erected at the symbolic centre of the Greek world (it stood next
to the great temple of Apollo, in the centre of the sanctuary at
Delphi), celebrating Roman victory over Macedonians (who had ear-
lier represented themselves as conquerors of 'Greece' in the finest
Greek style they could muster), created by Greek craftsmen, working
for one patron after another, and finally for Romans: how could this,
or any such, monument ever be straightforwardly 'Greek' or 'Roman'?
Art historians often call it 'eclectic', as a way of recognizing both the
cultural elements; and see in this 'eclecticism' a settled idiom, even an
ecumenical aesthetic, which successfully fuses the two artistic tradi-
tions. But this critical move does not settle all the questions at a
stroke. Of course the frieze inextricably interweaves Greek and
Roman elements; and, of course, many sculptors throughout our
period played with the artistic possibilities that 'eclecticism' could
offer; how could it have been otherwise? But these fusions inevitably
deal in tension as much as in resolution; they do not automatically
merge Greek and Roman into a seamless continuum. Rather, there is

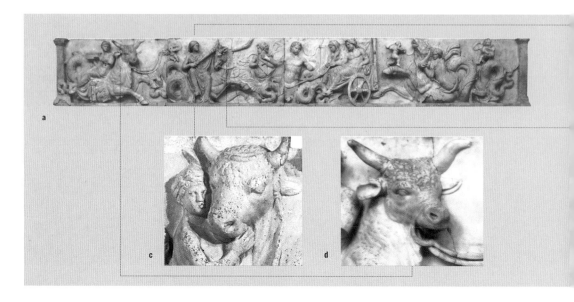

always the possibility of exploiting the energy of dissonance, and always a series of competing options for reading the visual imagery—from Roman triumphalism to respectful philhellenism on the part of Paullus. The complex multi-culture of Roman Greece and Hellenistic Rome is not to be pinned to any simple formula.

b) In Rome: the 'Altar of Domitius Ahenobarbus'

Another set of sculptured reliefs, this time discovered in Rome itself and originally put together at some point between *c.*120 and 40 BCE (the date is both widely and hotly disputed), stretches the tension between stylistic idiom and cultural setting to the full. In 1637 two friezes were unearthed at Rome during building works for a church. One depicts a swirling set of sea-creatures and sea-gods, the wedding of Neptune and the nymph Amphitrite; the other shows the ceremony of the Roman census [**68**]. Both friezes were bought by a relative of Napoleon in 1811 and put up for sale again in the aftermath of Napoleon's defeat: the sea-scene was acquired by the Sculpture Gallery at Munich, while the census wound up in the Louvre. The distance between Munich and Paris neatly captures the enormous difference in style between the two friezes: the one an extravagantly Hellenistic creation reminiscent of some of the work we shall see in Pergamum (p. 154–5, 158–9), the other a decidedly low-key and much more down-to-earth representation. In fact, you would never even think of putting them together—were it not absolutely certain that they formed part of the same monument, a large rectangular base (persistently but wrongly called an 'altar') which probably supported a large group of sculpture. The sea-scene took three sides, the census one of the longer sides.

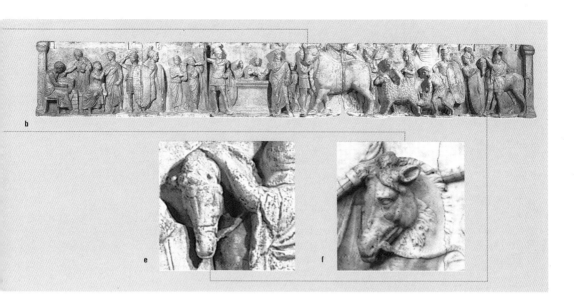

b

e

f

An enormous amount of energy has gone into identifying and dating these friezes. Pliny has been raided (inconclusively) for a monument to fit the bill; the Roman elite has been scoured to find a suitable patron, who might plausibly have commissioned a base of both seascape and census (a censor who won a sea-battle?). But even more energy has been devoted to 'explaining' the violent jarring of styles within the same piece. Some people see this as an early, brutish mismatch between the Hellenistic verve of Neptune and co. and the schematic naivety of the Roman citizens lined up with their god: an awkward combination of the products of two quite different sculptural workshops, perhaps? In fact, one view holds that the seascape is not Roman at all, but an entirely Greek production, brought to Rome as spoil from the East, and built into the new monument with no attempt at assimilation (the marble of the two friezes is different enough to support the idea that they were made separately). Others take the bull by the horns and ask whether the two friezes really are so different in style. Once you get past first impressions of the ensemble, you may find the treatment of many details so strikingly similar that all four sides could easily be the product of the same workshop, splendidly adapting style to subject matter [**68 (c–f)**]. On these lines, you can even argue that there is nothing specifically 'Roman' about the sculpture of this monument at all; and that every idiom adopted by the sculptors stems from the Greek repertoire in its broadest sense.

These stylistic debates are instructive in themselves: a dramatic illustration of just how contested stylistic labels and analysis are, even when the differences appear so great. It is perfectly possible to see a monument such as this as fundamentally homogeneous (if you search out the similarities between the slabs), as radically incoherent (a

glaring failure in its clash of styles), or—though this point is rarely made—as a masterly demonstration of technical and expressive command of the stylistic repertoire, an essay in juxtaposition and contrast. Any of these readings would be put into sharper focus if we knew what statue, or statue group, once stood on the base; regarded as a frame for the lost sculpture, rather than as independent artwork, our base must have served to challenge viewers to react, to agree and disagree about the stylistic message.

Imitation and classical art

From these enigmatic reliefs in Rome itself to the Victory Monument of Aemilius Paullus at Delphi, we are dealing with essentially the same cultural agenda, firmly set in Winckelmann's 'Age of the Imitators'. Whether it engaged with the masterpieces of classical art, or with their Hellenistic successors, imitation was a fundamental principle of Roman art as an institution. Imitation is, as we have seen, a creative process; it is not confined to passive or robotic copying. In the case of Hellenistic Greece and Rome, both worlds prized, developed, and rethought the same canon of great works and stylistic repertoires, finding their own expressive possibilities in the labyrinth of reproduction. The Hellenistic sculptural tradition was as much part of the seamless process of imitation as was the Roman. In the case of classical Greek masterpieces, as we saw with Myron's *Discus Thrower*, it is only through the complex patterns of imitation that many works are known at all. So much of our gallery of 'classic art' consists of sculptures produced in the cultures that came along afterwards, where the canon was worshipped, propagated, varied, and played with. So little that we can view is indisputably the product of earlier times, and so much of the life of those acclaimed works belongs to the millennium before the end of classical antiquity, and then to the half millennium since the Renaissance.

It is scarcely an exaggeration to claim that our access to 'Greek art' takes the form of statues and textual references produced in the Roman empire. No book on 'Greek art', however purist in intent, can ever avoid this issue. Even if Winckelmann had taken up the opportunities he undoubtedly had to visit Athens and Greece, he would still have found himself stocking his periods of Greek sublimity and beauty with Hellenistic and later versions of the classical canon, and with the fresh creations they in turn inspired. All ancient sculpture is caught up in the logic of the copy.

Spot the original: the 'Hermes of Praxiteles'

This is not simply a general theoretical point, but a vital factor in our understanding of individual pieces; it matters crucially to the way we go about making sense of each and every work we study. We find a

spectacular instance of this in the only full-length figure that survives attributed to the fourth-century genius Praxiteles. It is a marble sculpture of the god Hermes, excavated in the temple of Hera at Olympia in 1877, at the very spot where the second-century CE travel writer Pausanias tells us that he saw, amidst a whole host of other, yet more remarkable, art treasures: 'a marble Hermes carrying the baby Dionysus, a work of Praxiteles' [**69**].[21] It was a perfect match. Right at the centre of the Greek world, in a temple that had long since become a shrine to Greek art as much as to its deity, at Olympia, the cradle and nirvana of pan-Hellenism, was found, *in situ*, a statue by one of the most famous classical sculptors ever—and all authenticated by the account of an ancient eye-witness. Just one problem. The Hermes statue looks for all the world like a 'Roman copy', complete with those tell-tale supporting struts that we usually regard as sure signs of imitation, the give-away that an 'original' bronze has been copied in stone.

Many stories have been told about this statue: that it really is a Praxitelean original (and only looks like a copy); that Pausanias (honest or gullible?) was misled, taking a mere copy to be the original itself; that we have mistaken Pausanias' 'Praxiteles' for the

69

Hermes with the infant Dionysus, attributed to the fourth-century BCE sculptor Praxiteles. From the temple of Hera at Olympia, in southern Greece.

An original of the fourth century BCE – or a copy of the first century BCE?

fourth-century master (when in fact he meant a later sculptor trading under the same name); that Praxiteles' original was at some point reworked, so that (whatever Pausanias saw) our statue is bound to bear the marks of later workmanship. Scholars still argue the toss, and come up with yet more inventive solutions to the puzzle. But the point to hang on to is that even an optimally authenticated 'original' can confound our ability to distinguish a work of the fourth century BCE from a version or 'copy' produced up to six hundred years later. The Hermes of Praxiteles is the limit case of the seamless continuity between copy and original.

The production of copies: merchandising classical art

In a culture of imitation, copies proliferated. Consumer, patron, and artist could choose between ambitious versions, novel variants, telling excerpts, and smart recombinations of Greek masterpieces; between carefully exact replicas, routine reproductions, and (naturally) downright duds. Supplying all this was a complex infrastructure. We catch a glimpse of this in the extraordinary cache of fragmentary plaster casts of some 'classic' Greek statues that turned up at Baiae on the Bay of Naples in 1952; evidently part of the equipment of a Roman sculptor's workshop. The business could presumably deliver a production line of greatest hits, as well as select variations on classical themes for the discerning eye. Either way, there was a Mediterranean-wide distribution of 'old masters'; and anywhere with pretensions to civilization, whether city or stately home, needed its standard livery—plenty of busts and worthy headcounts, scaled-down statuelettes and the greatest hits of art, full-size. You could stock a disaster movie with *Wounded Amazons*, and enrol a regular army of Polyclitus' *Spear-Carriers* [**70**] (cf. **64 (c)**). Then as now, a veneer of classical art could gloss cultural pretensions. And so Juvenal the Roman satirist reminds us, when he lambasts 'the uninformed—their houses crammed with plaster casts of Chrysippus'; as if images of philosophers could bestow in themselves culture and respectability, and conceal a multitude of sins.[22]

The world of art at your fingertips: 'Hadrian's Villa' at Tivoli

The most spectacular display of cultivated taste from the Age of Imitation was once to be found in a vast imperial palace just outside Rome—the so-called 'villa' of the emperor Hadrian at Tivoli (see Maps and Plans 16). It was one of the greatest concentrations of sculpture in the ancient world, on a scale of opulence that beggared even the Golden House of Nero, and it entertained rulers of the civilized world for a century after Hadrian's death. Here an enormous site, twice the size of Pompeii, linked one palatial complex after another, with a vast service industry of purpose-built aqueducts and

70

Roman version of the *Doryphorus* ('Spear-Carrier') by the fifth-century BCE sculptor Polyclitus.

71 G. B. Piranesi

Ruins of a Sculpture Gallery in the Villa Adriana at Tivoli, Etching from *Vedute di Roma,* 1770.

The scene shows what is now identified as the central room of the Larger Baths at Hadrian's Villa. Characteristically, Piranesi insists on the strength of the architectural shell of the ancient masonry while intensifying the overgrowth that will bring it down in time. Despondent gloom is matched with keen-eyed awe.

piping to cool this paradise, and an underground world of supply tunnels, concealed storage, and servants' quarters to make this heaven on earth. (Over 900 rooms and corridors are so far known, across 30 ha, perhaps 10–20 per cent of the full area, perhaps none of it the main part of the palace!) It was to these ruins and the excavations around them, just as much as to the Golden House, that artists flocked from the sixteenth century onwards—to draw, copy, reconstruct, and (G.-B. Piranesi and Raphael's pupil G. da Udine among them) to scratch their names on the walls (cf. pp. 61–2; cf. **71**).

The cultural icons of the empire were brought or recreated here. Virtually every major type of statue was represented, including multiple versions of the same piece—at times even displayed side by side in the same tableau, as if to parade their status as Imitation. And gathered together in one miraculous collage, Hadrian fashioned his artist's impression of the entire world of Graeco-Roman art. The count of 173 statues certainly found there (plus 105 probables) represents only a tiny fraction of what there once was. Architectural landmarks of the empire were recreated too. Alongside a precious Egyptian-style canal, polyglot populations of Greek and Roman

The *Canopus*, or scenic canal, at Hadrian's Villa, Tivoli, *c.* 125–38 CE.

This on-site reconstruction arranges modern copies of the sculpture found in the canal basin to recreate, in part, the second-century installation. Roman versions of the fifth-century caryatids from the Athenian Acropolis are shown here on the right.

statuary once lined up, more than 35 pieces, including: four versions of the fifth-century caryatids from the Athenian Acropolis; a couple of 'classical' Amazons; a version of the Scylla group we saw at Sperlonga (p. 76); a bust of Hadrian, later joined by the third-century empress Julia Domna; some appropriately Egyptian deities; and a fetching crocodile. All customizing the ultimate dreamscape, pool-side [72]. The emperor made this vast investment in artworks, and in the cultural values they represented, as a statement of intent. His Rome was out to spread its supremely cosmopolitan aspirations for a Graeco-Roman partnership of intellect and power world-wide. Outside or inside the city of Rome, in Hadrian's beloved Athens, Alexandria, or Antioch, civilization arose from sensitivity to a common tradition, founded in admiration for, and emulation of, 'the best'.

Hadrian's Villa has had a colossal impact on us too, and on our whole image of ancient sculpture. When the grounds were first opened up in the sixteenth century, their riches soon began to enhance aristocratic homes nearby and palatial galleries in Rome. Excavations have continued to deliver sculptural bonanzas, even though well over half of the site still remains underground. From here, the treasures have moved on to find new homes in private houses, galleries, museums; they are now dispersed across more than 50 collections world-wide, from the Villa of Winckelmann's employer, Cardinal Albani, in Rome to the Townley collection in the

British Museum; from the Hermitage in St Petersburg to the Getty Museum in California. The paradox is that Hadrian's extravagant attempt to represent the world and its icons in one vast cultural synthesis has been turned on its head, as his collection has recolonized a larger empire than Hadrian could ever have imagined. Not to mention the whole chain of reproduction that it has generated: all the modern casts, replicas, and creative variations that stem from (and look back to) Tivoli now spread across the globe. Together Nero's Golden House and Hadrian's Villa at Tivoli take pride of place in the genealogy of the display of classical art: key contributors to the invention of the modern sculptural *collection*, and the primary matrix for the modelling and organization of culture through Imitation; an invitation, in fact, to see the history of culture *as* the history of Imitation.

Sensuality, Sexuality, and the Love of Art

3

Classical art has been a battleground for competing notions of sophisticated attraction and brutal lust from ancient times to the present. Whether as ideals of beauty or as travesties of perversity, these images have played crucial roles in the lives of critics and viewers; they have licensed not only forms of behaviour (from masturbation to bestiality), but also modes of response to the viewing of art (from sensuality to sublimation). In this chapter we shall be exploring a series of images which, in their very different ways, prompt strong reactions in their viewers, whether by stimulating passionate thinking or by provoking physical arousal.

Loving Antinous

Hadrian's investment in art took its own very special form; distraught, so ancient sources tell, over the mysterious death of his teenage boyfriend Antinous in 130 CE, the 54-year-old emperor carpeted the Roman world, from Tivoli to the eastern borders of the empire, with his images. A city was founded on the spot where he drowned in the Nile (Antinoopolis), and temples were built to house the cult of Antinous as a new god. If modern identifications can be trusted, more than 100 sculptures of the boy have survived from antiquity [**74, 75**], ranging from colossal statues to slick miniatures, not to mention the coins, gems, and medallions that carried his image. It is a very clear case of the projection of desire into marble; of fixing an erotic charge in stone.

Among the 20 or so versions of Antinous found at Hadrian's Villa at Tivoli was a sultry panel that came into the possession of Cardinal Albani and by 1762 had been installed in a room of its own at his palace in Rome, where it has remained to this day (apart from a brief excursion to Napoleon's Louvre: p. 83 [**76**]). Winckelmann paired it with an outsize head of Antinous—'Next to the Vatican [*Belvedere*] Apollo and the Laocoon, the most beautiful work which has come down to us'—observing how 'Antinous is always portrayed with a look that has a certain melancholy, … with large and well-defined eyes, a sweet slope to the profile, and a mouth and chin in which is

73 a, b
Collage: (a) derrière of *Apollo Belvedere* (see **77**); (b) detail of *Golden Venus of Rags* (= **80**).

Head of Antinous, as Dionysus
(or Apollo).

Pouting lips and sultry gaze
are the basis of all statues
identified as Antinous – here
more than anywhere.

Antinous goes Egyptian, from
Hadrian's Villa, Tivoli.

expressed what is truly beautiful'.[1] When he posed for his own portrait, Albani's art guru chose a print of his patron's panel as his chief prop, prominently displayed on the desk in front of him, beside his quivering pen [50].

Winckelmann's pride and joy

Perhaps it will come as no surprise to learn that, in addition to his other claims to fame, Winckelmann was taken up by late twentieth-century historians of sexuality—to be lionized by gay activists as a trailblazer, but vilified by others as the source of a particular vision of classical beauty, bound to the terms of homoerotic desire. Throughout his decade in Rome, the scholarly librarian enjoyed his share of adventures with a string of young men in a secret sex-life that eventually cost him his life, stabbed for his purse on a date that went horribly wrong.

No reading of a statue of Antinous can stand clear of the erotic narrative of Hadrian and his young lover; it is embodied in the very identification of the piece as Antinous. No critics or historians can hope to avoid the issue—whether they write themselves into the homoerotic discourse of the emperor and his plaything, appropriate the liaison for their own particular sexual-political cause, or reveal their own implication by more or less crass denial. But does it make sense to generalize from the case of Antinous? How far is Winckelmann's response to this relief paradigmatic of his, or any-one's, investment in the erotics of ancient sculpture? What theories and construals of desire should we be prepared to find in the art of the ancient world? And how much notice should we take of them—or their modern clones?

76
Relief sculpture of Antinous (the 'Albani Relief'), from Hadrian's Villa, Tivoli; engraving from J. J. Winckelmann, *Monumenti Inediti* (1767).

Despite his enthusiasm for this piece, Winckelmann also protested that it had been wrongly restored after its excavation in the 1730s. It was a scene of apotheosis, he argued, and Antinous should be holding reins, not flowers, in his left hand, for he is boarding a chariot which will take him to join the gods in heaven.

Apollo Belvedere: the pin-up

Sharing the limelight with Laocoon in Napoleon's triumphal proces-
sion which took the masterpieces of Italy to his new museum in Paris
was a statue of the god Apollo, known as the *Apollo Belvedere* (after
that courtyard in the Vatican designed to house it: **77**, cf. p. 68–72).
Discovered before the beginning of the sixteenth century, it attracted
a knot of rival theories and stories along with extraordinary fame.
The god's pose was variously identified, and restoration provided to
match—did the missing left hand hold a bow [**78**]? Had Apollo just
victoriously shot his dragon, or another in his long line of legendary
victims? Or does he brandish his bow in one hand, and a branch of
bay (bundled together with woollen ties, the ends just visible perhaps
on the tree trunk) in the other, as symbols of his equal mastery of the
arts of war and of peace?

The findspot was also disputed. Somewhere in Italy—but was it
from a public space, an imperial villa, or a private niche? So too, both
date and context of production were in dispute. Was it made in Italy?
Or fetched as loot from the Greek East? And could close analysis
diagnose a Roman copy or prove it a Greek original? If fragments of
casts found in the 1950s at the ancient workshop at Baiae (p. 102)
really do match the *Apollo*, then in all likelihood we are dealing with
a copy. But how plausibly can it be identified with any masterpiece—
bronze or marble—mentioned in Pliny or Pausanias, how firmly
associated with the style of some famous sculptor? And what are we
to make of the fact that (casts or no casts) no other version is actually
known from antiquity? Enormous energy and ingenuity have gone
into suggesting answers to these questions; but for centuries the con-
sensus was that the statue truly merited the outpourings of admira-
tion and love it inspired, as perhaps the most beautiful of all works of
art. The eighteenth-century Romantic Friedrich Schiller claimed
that 'No son of this earth could describe this heavenly mixture of

The statue of *Apollo* is the most sublime of all the statues of antiquity which escaped destruction. …An eternal spring, such as reigned in the blessed Elysian fields, clothes the attractive manliness of full-blown maturity with delectable youth, and plays about the majestic frame of his limbs with soft tenderness. Pass with your spirit into the kingdom of incorporeal beauties and try to become a creator of a heavenly nature, to fill your spirit with beauty that rises above nature: for there is nothing mortal here, nothing that human appetite demands. No veins, no sinews, heat and stir his body, but a heavenly spirit, which diffuses like a soft stream, fills, as it were, the whole outline of the wondrous figure. …His delicate hair plays about the divine head, like the slender and waving tendrils of a noble vine, stirred, as it were, by a soft breeze; it seems to be anointed with the oil of the gods, and fastened by the Graces on the crown of his head with charming splendour. I forget all else at the sight of this miracle of art. …My breast seems to enlarge and swell with reverence …How is it possible to paint and describe it!

amiability and severity, benevolence and gravity, majesty and mild-ness';[2] and in *Childe Harold's Pilgrimage*, Byron's loving spoof on the training of an English milord, we slide from Apollo's vengeance—'in his eye/ And nostril beautiful disdain, and might / And majesty, flash their full lightnings by, / Developing in that one glance the Deity'— to the sensuality of 'his delicate form—a dream of Love, / Shaped by some solitary nymph, whose breast / Long'd for a deathless lover from above'.[3] But inevitably Winckelmann produced the most fluent and florid write-up of them all (*see box*).

We have already touched on the challenges of interpreting the phallic imagery of Pompeii (pp. 31–5). Here we are dealing with yet more layers of complexity as we seek to align our own responses to the naked display of Apollo with the written responses of earlier crit-ics, as well as with the ancient context of viewing. It is much harder to pigeon-hole Winckelmann's (or anyone's) response to this statue than is generally allowed. Many modern readers have seen barely disguised eroticism in the language of Winckelmann's description of Apollo. Some have simply assumed that his passionate enthusiasm for the statue was a direct transcription of his own sexuality. It would be obviously naive to exclude any such connection at all—to imagine that Winckelmann's agenda was purely the love of art, his aim noth-ing more than to capture the essence of ancient divinity. But it would be equally naive to impose a tidy equivalence between erotics and rhetoric; and wrong to reduce Winckelmann's writing to a coded celebration of his own homoerotic desire.

Heroic nudity: thoughts sacred and profane

We confront similar dilemmas when we try to understand the statue itself in its ancient context. Nakedness certainly signified differently in ancient societies from our own. On the one hand, the display of male-

ness unclothed at baths, gymnasia, and athletic competitions made bare flesh a mundane and unremarkable part of the everyday world. On the other, the conventions of ancient representation, in all media, gave nakedness a role as a costume of power—the 'heroic nudity' which clothed deities, emperors, and other would-be supermen. Turn back, for example, to **36 (b)** and **39 (b)**, and see how Perseus flies down to rescue Andromeda, in all his glory. He is not supposed to turn us on. Nor, so it is argued, are most of the 'heroically nude' statues—whose impact is delivered by the whole body (the taut muscles and firm outline of classical form), rather than concentrated on the erogenous zones or fixated on the (generally understated) genitals.

Both these perspectives must feature in any critique of the *Apollo Belvedere*. Yet, even in combination, they cannot divest such images of their erotic potency. The very act of describing the sculpture is bound to elicit a sensual rhetoric, whether we emphasize its naturalistic appeal or respond to its idealized beauty. We know, too, that however differently ancient society configured its sexualities, and however differently such images functioned in ancient culture, it was always an option for Graeco-Roman viewers to locate the message squarely in the realm of sexuality. When Ovid, the Roman poet of sex and myth, pictures the god shooting his dragon at Delphi, he goes on to tell how Apollo was at once himself shot by Cupid's arrow and inflamed with desire for the nymph Daphne; as she flees and he gives chase, he begs her to stop and take a look at the catch she has made, but in terror she prays to escape the rapist, and turns into the bay tree, which then becomes Apollo's favourite attribute.[5] Thus bow and bay (as often restored on the *Belvedere*) signal the divine power to kill and triumph in majesty, but at the same time they dramatize traumatic desire, and tell of erotic paradox at the heart of Apollo's presence in physical form.

Likewise, whatever the protocols of 'heroic nudity', no account of Perseus' arrival to save Andromeda from her monster can possibly refuse to view him also as her prospective bridegroom, while she is the lovely prize that will match and mirror his irresistible heroism in bed. And art of course always supplied ancient desire with the repertoire of images it lived and loved on. Greek novels such as Chariton's *Erotic Tales of Chaereas and Callirhoe* (*c.*50 BCE–*c.*50 CE (?)) present their characters in exactly these terms:

An amazing miracle of a maiden, icon/delight [the Greek word *agalma* has both senses] of all Sicily—her beauty was not human but divine, not that of a sea- or mountain-nymph but Aphrodite the Maiden's very own … He was a well-formed lad, superior to all others, the sort of Achilles or Nireus or Alcibiades that sculptors and painters show off.[6]

Lucian, the second-century CE satirist and up-market entertainer,

even wrote a teasing skit (*In Defence of Images*) in which a drooling panegyrist defends his likening of a luscious lady to Aphrodite from any charge of blasphemy, by stressing (as sexily as he can manage) that he had specified a statue, not the goddess herself.[7] As we shall see, plenty more ancient discourse along such lines asserts, vindicates, and exploits an unbreakable linkage between gods, images, and sex.

But how do these issues relate to the undoubted demise of the *Belvedere*'s fame in modern times? For unlike many of the star pieces we have featured in earlier chapters (Laocoon, for example: pp. 65–8, 72–4), *Apollo* has not retained the celebrity he enjoyed in (and just after) the Renaissance. 'A scraped turnip' was the insult thrown at the statue by French art students at the end of the eighteenth century; and since then it has become something of a sport to satirize Apollo's icy heroism, his vapid effeminacy, the precious top-knot, and those dreadful sandals. In part, the very conventionality which gives classical art its fame also makes it vulnerable to mockery. But in this particular case there are other factors at work. Its lack of a findspot, a place in the ancient sources, a date, and a creator have all conspired to marginalize the *Apollo* in the last 200 years of scholarship on ancient art, and to exclude it from histories of classical sculpture, which depend on chronological and contextual precision—or at least a semblance of it, however spurious. Cutting across all this, however, are the vagaries of erotic investment in the statue. It has always been hard to account for the *Apollo Belvedere* without oscillating between awe and arousal: awe in the presence of lethal divinity, arousal at its lyrical vision of budding manhood. Today we must speculate whether Apollo has lost out to different protocols of respectability or been replaced as *the* emblem of desire by its Renaissance descendant, Michelangelo's *David* [**79**].

The nude

The nude figure is the icon of classical sculpture—principally not the male nudes we have been looking at so far in the chapter, but the nude female. It is above all the naked form of Aphrodite or Venus (the Greek and Roman 'goddesses of love') that has come to represent classicism in art and the values of the elite culture of the West since the Renaissance. And, at the same time, critical discussion of classical art is the ultimate source of the now conventional distinction between the 'naked' and the 'nude'; and it is this, in part, which has put the Graeco-Roman Venus on her pedestal. The nude as an art form is a legacy of classical antiquity.

Literally thousands of unclothed Aphrodites and Venuses survive from the ancient world in all shapes and sizes, from tiny bronze figurines to colossal monuments in marble. Some sport particular attributes associated with the goddess, while others can be tied to a

79 Michelangelo Buonarroti
David, 1501–4.
Michelangelo's Goliath of a David: at more than five metres, this is western art's first colossal statue since antiquity.

Golden Venus of Rags,
1967–71.

The tension between the
gilded 'Venus' and the pile of
rags prompts a variety of
responses. The clear contrast,
at first sight, between the
riches of the classical past and
the detritus of modern culture
is soon undermined: for both
are clichés, waste products of
the West.

context in cult or myth; but most of them carry no identification, only a general family resemblance to one another. The effect of the label 'Aphrodite' or 'Venus', which we slap almost automatically on any exposed female body from antiquity, is both to dignify this anonymity with a worthy title and to hand viewers a respectable alibi (in this case religion) for their voyeurism. Such alibis are always available, and were certainly invoked in the ancient world as well. Yet they never work cleanly. In this case, the crucial fact that in both Greek and Latin the name of the goddess in ordinary parlance covered the whole spectrum of meanings from divinity through desire and lust to physical sex makes it impossible to peg any representation to religion alone. As we shall see, ancient responses to even those statues with the strongest religious credentials constantly turn on the erotic potential locked into the carnality of the image.

The 'classical Venus': goddess and sex-goddess

Most modern viewers will find themselves caught between active voyeurism and dulled over-familiarity with these images whose iconic status has made them conventional rather than transgressive. As a group, they blur into each other, with, in most cases, only the slightest differences apparent in pose or type (a hand lower here, a more 'modest' stance there). And that indeed, for us, is their point. The 'classical Venus', whether in museums, on billboards, or even outside a casino, can easily come across as a generic image, closed and finished in its effect; an icon to stand for eternal loveliness, sublime aesthetics—or, from a different perspective, the burden of the past, or wealth and privilege [**80**]. She could work as a familiar, instant symbol in the Roman world too, as we see in one of a run of statues, where a fulsome Venus-body is capped by the incongruously stern features of a Roman matron (complete with the latest hairpiece) [**177**].

On the other hand, since the Renaissance this whole category of sculptures has been minutely differentiated by art historians; and a litany of nicknames has been foisted on them ('Capitoline' Venus, Venus 'of Arles', Aphrodite 'Anadyomene', 'Esquiline' and 'Crouching' Venuses, even Venus 'in a bikini' [**81**]) to signal particular poses, types, or contexts. Pedantry and connoisseurship, no doubt; but sometimes even relatively minor distinctions will have made all the difference in an ancient context. In the Graeco-Roman world the representation of a particular deity (Venus as much as any other; the same would apply to Apollo) always involved tension between a generic image of the god or goddess and a whole repertoire of local variants, with differently loaded interpretations weaving to and fro between them. (Venus in Pompeii, for example, was *their* Venus, the patron deity of the city, characteristically shown clothed and crowned—as well as being the Pompeians' stake in the generic

Statue of Venus from the
tablinum of the House of Julia
Felix, Pompeii (see Maps and
Plans 3 (c)).

The goddess of love heads for
a bath, with a phallic statuette
of Priapus for her prop, while
tiny Cupid tugs at her sandal.

divinity whose power, and images, spread across the Roman world.)
Other distinctions not only figure in the modern industry of
systematic classification, but alert us to the quite separate histories
that attach to the various types of Venus; and, despite their general
similarity, to changes in fashion and popularity between them. For
over the centuries the female nude, just as much as the male, has had
winners and losers in the game of fame; as we shall now see.

The 'Medici Venus'

When Winckelmann wrote his *History of Art of Antiquity* (1764), the
female nude that rivalled *Apollo Belvedere* in prestige was a statue of
Venus, then displayed in pride of place in the Tribuna of the Uffizi
Gallery in Florence: the so-called *Venus de' Medici*, one of the most
copied sculptures of all time [**82, 83**]. Winckelmann's own eulogy of
the piece, almost as electric as his ecstasies over the *Belvedere* (p. 111),
was one of a long series of glowing tributes sprayed over the sculpture
from the Renaissance to the early nineteenth century.

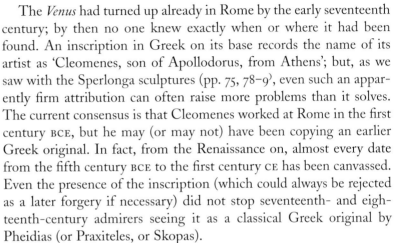

Winckelmann's effusion on the *Venus de' Medici*[8]

The *Venus de' Medici* in Florence is like a rose that appears in the train of a beautiful dawn, and which opens up at the rising of the sun. She is entering into that age when the limbs begin to take on shape, and when the breast develops. When I contemplate her in her pose, I imagine her as that Laïs whom Apelles instructed in the mysteries of Love; I fancy I see her the way she appeared when she was required for the first time to shed her clothes, and offer herself naked to the eyes of the artist in his ecstasy.

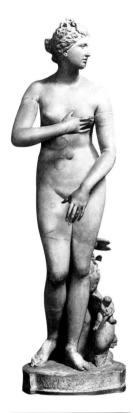

82

Statue of Venus (*Venus de' Medici*).

Enthusiastically admired up to the early nineteenth century, the *Venus de' Medici* drew crowds of Grand Tourists. One claimed to have visited her a hundred times, another to have spent ten solid hours gazing at her. Byron's *Childe Harold* lavishes five whole stanzas on this 'unruffled mirror of the loveliest dream'.

The *Venus* had turned up already in Rome by the early seventeenth century; by then no one knew exactly when or where it had been found. An inscription in Greek on its base records the name of its artist as 'Cleomenes, son of Apollodorus, from Athens'; but, as we saw with the Sperlonga sculptures (pp. 75, 78–9), even such an apparently firm attribution can often raise more problems than it solves. The current consensus is that Cleomenes worked at Rome in the first century BCE, but he may (or may not) have been copying an earlier Greek original. In fact, from the Renaissance on, almost every date from the fifth century BCE to the first century CE has been canvassed. Even the presence of the inscription (which could always be rejected as a later forgery if necessary) did not stop seventeenth- and eighteenth-century admirers seeing it as a classical Greek original by Pheidias (or Praxiteles, or Skopas).

This 'Grecian Venus', as she was sometimes known, was taken by the Medici family in 1677 from their Roman villa to their gallery in the Uffizi at Florence (in the teeth of protests from art lovers in Rome, legend has it). There she presided over the other world-famous treasures ancient and modern in the Tribuna, in an ensemble which put Florence on the map for lovers of 'the antique', and made this 'the most famous room in the world' [**83**]. Not surprisingly, Napoleon made sure that the 'Medici Venus' went to Paris, to crown his new museum (p. 83). The sculptor Canova did his best to console Florence with his replacement *Venere Italica* (Venus of Italy), but in the event the vacancy was a short one. The adored Medicean was soon repatriated, back to Florence and the Uffizi, where she remains to this day.

But she has lost her fame. After her repatriation, the occasional doubts about her pre-eminent quality that had already been whispered (even Winckelmann thought her navel too deep) became a chorus: the restoration of the arms was deemed particularly awkward, and the overall impression 'insipid'. Twentieth-century writers followed suit: 'no more than a drawing-room ornament'; 'trivially coquettish'; 'among the most charmless remnants of antiquity'. In many ways, the story of her fall from grace matches the story of the *Apollo Belvedere*; and many of the same factors, no doubt,

83 Johann Zoffany

The Tribuna degli Uffizi,
1772–8.

Rival groups of connoisseurs
in the *Tribuna* in Florence (a
famous ceiling-lit octagonal
gallery, installed in the *Uffizi*
1581–8). A multi-layered
display of the complexities of
art connoisseurship and
production: on the right, one
group peers at the Medici
Venus; the *Arrotino* crouches
at front left, looking on;
behind, Zoffany himself holds
up a Raphael *Madonna and
Child*, to show off to another
group. (See further Matthew
Craske's *Art in Europe,
1700–1830* in the present
series, pp. 175–80.)

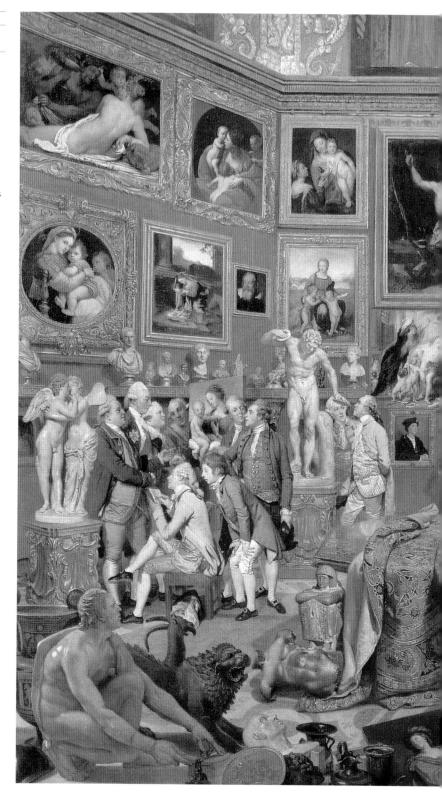

explain it (lack of firm date and context, for example). But there is an extra ingredient in the case of the *Venus*: that is, the sensational rise in popular and scholarly esteem of a new star, who was to take her place in the Louvre. The *Venus de' Medici* was brusquely upstaged by the latest sex-goddess, the *Venus de Milo*.

Venus de Milo

Just five years after the return of the Medici Venus from Paris, a spectacular discovery was made in 1820 on the Greek island of Melos (hence 'Milo', from the modern Greek pronunciation): various pieces of marble, supposedly dug up by a local peasant, which, when reassembled, made up a half-naked Venus [**84, front cover**]. After a scuffle on the beach between some Turkish and French soldiers (who were both claiming the prize), she fell into the hands of the French—eager for antiquities to fill their rapidly emptying Louvre, and desperate not to fall behind in the race for cultural plunder (the British Museum had just acquired the Parthenon marbles from Lord Elgin, and the crown prince of Bavaria had just bought the sculptures from the Temple of Aphaia on the island of Aegina for his new gallery in Munich).

Although the *Venus de Milo* was found relatively late in the history of classical discoveries, the fraught circumstances of international rivalry in the wake of the Napoleonic wars, combined with the usual disputes over legitimate ownership and the fervent hype that surrounded its unearthing (and presentation to the new king of France), make it as difficult as ever to pin down the details of its excavation and archaeological context. There were various, more or less compelling, claims: that, for example, a broken inscription naming the artist ('[Ages?]andros son of Menides, from Antioch on the river Maeander') had been found—and then conveniently 'lost', because the artist was unacceptably obscure; that yet another inscription showed that it had been the gift of a local benefactor to a civic gymnasium (where it stood in a niche—hence its apparently unfinished back); or again that one of its arms did in fact survive, an apple in hand to mark her out as the island's patron goddess (the Greeks derived the name of Melos from their word for apple). The usual struggle to assign the statue its rightful place in the hierarchy of classical art ensued, with all the usual suspects put forward as its creator (Pheidias, Praxiteles, Skopas).

Throughout the nineteenth century and later the *Venus de Milo* prompted eulogies of the kind enjoyed by the Medici statue a century earlier. Poets all over Europe celebrated her beauty ('You step forward, proud and naked, and the world trembles', ran one verse of a particularly ecstatic effusion),[9] while the sculptor Rodin exclaimed, 'Behold, the marvel of marvels … This work is the expression of the

84

Statue of Venus, from Melos
(*Venus de Milo*).

At the height of its fame, this
was commonly regarded as
the only original fifth-century
BCE free-standing female
statue to have survived
complete with her head. No
new evidence has come to
light; but today the consensus
is (on essentially stylistic
grounds) that it is a work of the
late second or first century BCE.

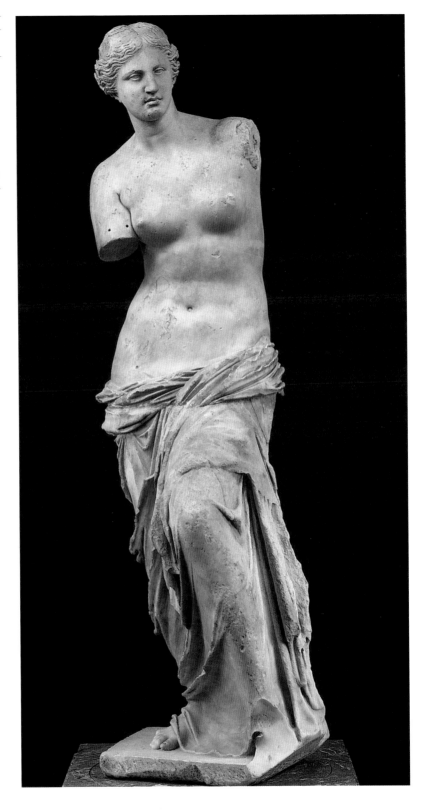

(a) After C. A. d'A. Bertall *Die Frage der Venus von Milo* ('The question of the *Venus de Milo*'), cartoon from *Le Journal Illustré* 5 July 1874.

This cartoon mocks the many attempts to restore the *Venus de Milo*.

REVUE D'ACTUALITÉ, PAR BERTALL

greatest antique inspiration; it is voluptuousness regulated by restraint, it is the joy of life cadenced, moderated by reason.'[10] Of course the French puffed 'La Vénus de Milo' energetically; she was to be their own icon of classicism. But her fame did not simply depend on loud rhetoric and nationalistic marketing. It so happened that this damaged beauty appeared on the scene at the very moment when the full flood of Romantic sentiment was cultivating the nostalgia of the fragment and the ideal of the ruin. Here was an object ready-made for nineteenth-century aesthetics. She was a creature of her time.

She also caught the wave of the ever-intensifying preoccupation with technical expertise and would-be scientific analysis among classical archaeologists in the nineteenth century. Her fragmentary condition was not simply a focus of Romantic admiration; it was also a grand art historical puzzle to be solved by all the apparatus of scholarship. What exactly had her missing arms been doing? Reconstructions multiplied, based on minute observation of the statue itself or intricate comparison with closely related works. Was she looking in a mirror and fixing her hair? Or holding up a shield that commemorated the victory of Greeks over Persians? Or was she part of a group, with her opposite number and mythical lover, Mars, god of war? Each different version of the restoration prompted a

different understanding of the statue's function, which in turn fed (or denied) its particular fantasy of eroticism [85].

Behind her back: 'Callipygian Venus'

We see this process at its starkest in the case of another classic Venus, the so-called *Venus Kallipygos* ('Beautiful-Bum'). In this notorious statue, we catch the goddess glancing over her shoulder to admire her own finely sculpted buttocks; an explicitly erotic attitude of carnal exhibitionism which is hard to reconcile with any exalted reading in terms of religion alone [86]. But in fact, when it was discovered, the statue's head was missing. Its distinctive pose is, therefore, the result of restoration which created a whole 'masterpiece' in place of a fragment, as well as finding a rationale for the statue's naked buttocks. It was a neat confection based on two dubious scraps of ancient fiction: the first naughtily alleging that 'Kallipygos' was a cult title of Venus (its origin lying in a picturesque showdown between two peasant girls, who once upon a time called in a passer-by to decide whose bum was the sexier); second, a titillating allusion to whores partying together, and drunkenly disputing which of them had the best buttocks. On this line it may not matter very much whether we see the figure as Venus herself (her cult statue?) or as one of the peasant girls ('La Bergère grecque', as she was commonly called in the eighteenth century). The important point is that the statue as we have it is modern interpretation. Different restorations would produce very different erotic effects: a differently angled head, for example, would instantly remove the definitive narcissism of the pose—leaving us with a female showing off a beautiful body. Whether goddess, dancer, whore, or none of these, who can say?

Aphrodite of Cnidus

The *Venus de Milo* has not followed the *de' Medici* into obscurity. Thousands of visitors still come to worship at her feet, and gawp all round her, each year in the Louvre, while the trademark mutilation of her armless torso makes powerful advertising material for products as diverse as perfumes and pencils. On the other hand, in the mainstream of technical art history, both Venuses have been eclipsed by a rival: the *Aphrodite of Cnidus*, who will be the centrepiece of this chapter. As James Joyce has his *Artist as a Young Man* put it, referring to this very statue, 'You say that art must not excite desire. I told you that one day I wrote my name with a pencil on the backside of the Venus of Praxiteles in the Museum. Was that not desire?'[11]

The statue of Aphrodite made by the early fourth-century BCE sculptor Praxiteles, installed in her temple at Cnidus on the coast of modern Turkey, and (as we shall see) extravagantly hyped by ancient writers, has not itself survived; it is supposed to have been one of the

86 a, b

(a) *Venus Kallipygos*
('Beautiful-Bum').
This statue, like the *Laocoon*
and with no more justification,
was reputedly found in Nero's
Golden House; legend held
that even Canova did not dare
complete the marble, in case
he couldn't live up to the work
of the ancient craftsman. It
was restored (in effect,
created) by the late
eighteenth-century bravura of
the great Carlo Albacini.

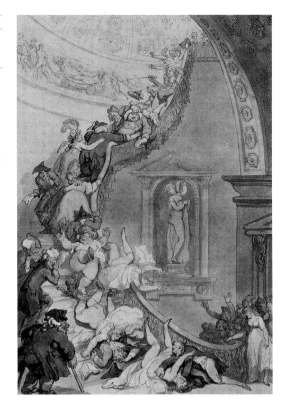

hordes of masterpieces whisked off to adorn Constantinople, only to go up in smoke there in 476 CE. Through the centuries, however, several 'Venus types', every one of them produced in the Hellenistic and Roman period, have been claimed as faithful copies, or imaginative versions, of this famous fourth-century BCE 'original'. Today there is general agreement that our best bet is a type known in no fewer than 60 different versions, from full-scale statues to miniature replicas, turning up everywhere from Spain to Syria, from the centre of Rome to the bottom of the Mediterranean (in the Anticythera wreck) [**87**]. At Hadrian's Villa a battered version (missing its head, as well as the arms and pot which define the type) has been found in what is often proclaimed a Hadrianic replica of Aphrodite's temple at Cnidus itself—on the supposition that the emperor cloned the monument, as well as its world-famous cult statue, to complete his panorama of ancient art. A plausible enough hypothesis, but in fact a circular argument; for the ruined shrine at Cnidus itself has been identified largely on the basis of its supposed similarity to this 'replica' at Tivoli.

This Aphrodite has cast her spell over recent discussions of Graeco-Roman art partly on the basis of the account in Pliny's encyclopaedia. This not only gives us all the 'information'—of location, context, date, and artist—which guarantees her a place, 'copy' or not, in any history of classical art; more than an equal for Laocoon (pp.

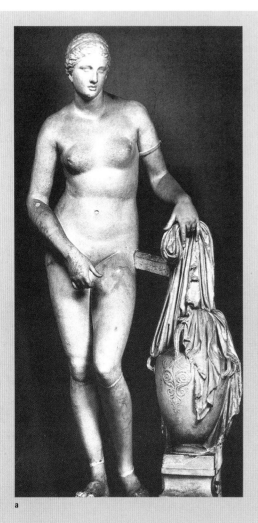

a

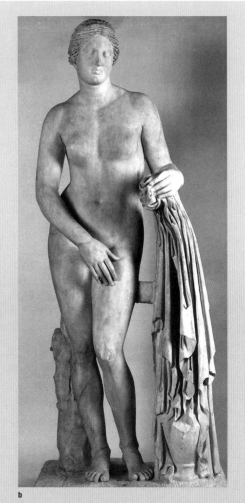

b

c

87 a, b, c

The principal versions of Cnidian Aphrodite: **(a)** 'Colonna', from Rome; **(b)** 'Belvedere', from Rome.

Characteristic features of the Cnidian type are the 'pin-up' pose (euphemized by one ancient account as 'she unobtrusively hid her modesty with one hand'), and the robe she holds above a vase to one side.

(c) Bronze coin of Cnidus. 211–18 CE, apparently showing the *Aphrodite of Cnidus.*

Coins, minted at Cnidus when the original Aphrodite was already more than half a millennium old, may offer our best independent evidence for her pose.

65–8). It also tells an evocative story of how the statue came to land up in Cnidus. Praxiteles, so the tale went,[12] had produced two *Aphrodites*, one naked and one draped, both on sale for the same price. The people of the nearby island of Cos took the clothed one (for propriety's sake), while Cnidus bought the nude. This text has often been taken to mean that the Cnidian Aphrodite was the first naked statue of the goddess in classical times. Pliny in fact says absolutely nothing of the sort; and it is hard, in any case, to see how you could ever prove such a claim. (What, after all, is to count as 'nude' or even 'naked'? It must be more than just the amount of flesh exposed.) Yet most modern accounts still sensationally write her up as nothing less than the originary moment of the nude in the grand story of western art.

'Cnidian' Aphrodite: the original nude?

The notion that 'Cnidian' Aphrodite was revolutionary in her nakedness has raised a series of further questions. How was it, for example, that Praxiteles got away with such daring? Was it justified by the statue's role as a cult object—in tune with the myth of her birth from the sea-foam, perhaps? Did he carefully insert an alibi for the viewer's gaze—in the shape of the robe and water pot, which serve to make her nakedness functional (she is no exhibitionist; we have simply come across her bathing)? But more important is the crucial role she has been given in the stylistic history of these Venus-types. If she is the first completely naked image, then she provides a pivotal point around which we imagine we can rank and order the others. Since the early nineteenth century, art historians have seriously proposed that Aphrodite went through a whole sequence of development, as she was progressively undressed by one sculptor after another. Starting off in full garb in the Athens of Pheidias, she came to sport an increasingly diaphanous wardrobe or half-stripped (as with the *Venus de Milo*, which some have thus claimed for a pre-Praxitelean date). She then went the whole way with Praxiteles, before dropping the robe altogether [**88**] and finally loosening up in a 'decadent' Hellenistic series of more daring poses, where she crouches down—whether to hide a body that is now totally vulnerable to our lusting gaze [**89**], or to wring out her wet hair, oblivious, heedless, or shame-free [**90**].

Sounds silly? In this book, we have already come across several different attempts to fix the chronology of a set of products from Winckelmann's 'Age of the Imitators'; and we have seen how the logic of imitation in this period always risks exposing such schemes to ridicule. In the case of our *Aphrodites*, none of the claims to relative priority between the different statue types has proved persuasive. You might, after all, equally well maintain that the semi-naked *Venus de Milo* comes after Praxiteles had tried total nudity, a sophisticated experiment in the sensuous potential of half-concealment and the

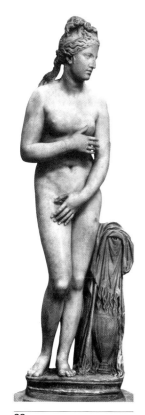

88

Statue of Venus (*Capitoline Venus*), from Rome.

She has dropped her robe altogether, but covers up (and draws attention to?) her breasts.

89

Statue of Venus (*Crouching Venus*), from Hadrian's Villa, Tivoli.

This fragmentary statue has been variously restored. Traces of another figure once attached to Venus' back show that this was formerly a group of the goddess with her infant son Cupid—at least in some versions.

90

Statuette of Aphrodite, from Rhodes.

A chance find in 1923, this highly polished Venus is one of the few to have survived apparently intact.

erotic tension of precarious drapery; or alternatively that, though later, she has been dolled up again, to take us back to the good old days before Praxiteles removed the last veil—or at least pretend to take us back. But these options, along with all the rest, are always predicated on the centrality of Praxiteles' masterpiece in the 'story of the nude'.

Saturation sex: the stain on the statue

Pliny's account of 'Cnidian' Aphrodite also includes brief mention of an ancient scandal attaching to her: the story of a man who tried to make love to the statue for real, and left behind the 'tell-tale stain of desire' between her legs. This odd aside plays a major part in the statue's current fame. A much more sensational version of the story is dreamed up in a steamy essay-cum-playlet preserved among the voluminous works of Lucian. The *Erotes* (a title that covers everything from 'Cupids' to 'Copulation') stages a provocative debate between a bisexual and a celibate on the best kind of sex. In the course of this, an earlier discussion between two Greek male stereotypes is fed in: one of them a Corinthian, who advocates the love of women; the other one from Athens, and into boys. The essay has long played a key role in studies of Praxiteles' statue,[13] but in the late twentieth century it became a crucial text for the history of Greek erotics, the body and personal politics (featuring notably in Michel Foucault's controversial *History of Sexuality*).[14] The statue gets discussed at length when the celibate tells how he once put in at the peninsula of Cnidus, along

When our rush of wonder had peaked, we saw on one thigh a mark, like a stain on clothing. The otherwise bright luminosity of the stone was proof of its unsightliness. For my part, I made a likely guess at the truth and reckoned that what we could see was the physical nature of the stone: even things like this are not exempt from trauma, and luck many a time handicaps potentially unadulterated specimens of beauty. Supposing it a natural black mark, a physical stain, I felt wonder at Praxiteles for this as well—for hiding away the unsightly part of the stone among the parts with less potential for being put to proof. But the woman on the temple staff standing near us delivered a strange tale that confounded belief. She said a young man from a far from obscure family—his deed hushed up his name—had the rotten luck, through paying many visits to the precinct, of lusting for the goddess; spending all day in the shrine, he at first gave an impression of god-fearing worship, as he long anticipated sunrise, coming to visit from his bed at dawn, and after sunset going back home unwillingly. ... As the trauma progressively aggravated, every wall was scribbled on and the bark of every yielding tree heralded 'APHRODITE—BEAUTY'. Praxiteles was paid honour by him on a par with Zeus and whatever prepossessing treasure was kept safe in his home, every one, became the goddess's offering. Finally, the intense strain of all the longing inside him reached despair, and bravado was improvised, to play pander to desire: when the sun was sinking toward setting, quietly and without the people there noticing, he slid in behind the door and, standing unseen in the innermost sanctum, he froze, not even drawing breath; when the temple staff locked the door from the outside in the usual way, the new Anchises was locked inside—but why am I (chatterbox) telling you in scrupulous detail the story of the unspeakable night of bravado? These traces of the clinches of lust were spotted when daylight returned; the goddess had the stain to prove the traumas she had been through. As for the young man himself, so the talk of the town tells, either (they say) he was launched down a rockface or else plunged down the ocean wave—and totally disappeared.

with the Corinthian and the Athenian: they had made a bee-line for the temple, where they enthused and quarrelled over the statue[15]—and over the famous story about the erotic adventure of that earlier visitor. As the focal image in Lucian's essay, 'Cnidian' Aphrodite has provided eager art historians with their richest example of an ancient viewer's reading of any work of art.

The tragic story of the young man's passion for Aphrodite provides the clearest instance ever of the love of art unmasked (or traduced?) as carnality displaced onto marble: the mauling of the masterpiece. Such anecdotal assaults are doubtless part of every culture's discourse of art—Pliny himself adds the 'twin' legend, which has a male from Rhodes 'leaving a similar imprint of love' on a statue of Eros by the same sculptor, Praxiteles.[17] And in one agreeable twist the young Oscar Wilde has his 'ardent amorous idolator', Charmides, creep into the Parthenon one night, undress the statue of the virgin goddess Athena, and 'paddle' with her polished throat, in a suicidal kiss that

If as a lonely bachelor who disapproves of women
You carve the perfect specimen out of snow-white ivory
And fall in love with your masterpiece and make love to her
(Or try to), stroking, fondling, whispering, kissing, nervous
In case you bruise ivory like flesh with prodding fingers,
And bring sea-shells, shiny pebbles, song-birds, colourful wild
Flowers, amber-beads, orchids, beach-balls as her presents,
And put real women's clothes, wedding rings, ear-rings, long
Necklaces, a brassiere on the statue, then undress her
And lay her in your bed, her head on the feathery pillows
As if to sleep like a girlfriend, your dream may come true
And she warms and softens and you are kissing actual lips
And she blushes as she takes you in, the light of her eyes,
And her veins pulse under your thumb to the end of the dream
When she breaks out in a cold sweat that trickles into pools
And drips from her hair dissolving it and her fingers and toes,
Watering down her wrists, shoulders, rib-cage, breasts until
There is nothing left of her for anyone to hug or hold.

M. Longley, 'Ivory and Water'

took all night.[18] The most prolific amongst such stories of projected desire is the myth of Pygmalion and Galatea, in which the (male) artist creates a loving image of his ideal woman, who then exceeds his wildest dreams by coming to life, and into his arms. It is a theme of frisson and anxiety that pervades western art and literature to this day.

What makes Lucian's Cnidian tale of manic debauchery especially transgressive, and yet compelling, follows from its inextricable intermingling of sex, religion, and creativity. Not only is the statue situated in a temple, but the story is narrated by the temple warden, and the object of desire, as carved on the trees, is the goddess herself—'lovely Aphrodite'. At the same time the sculptor, the great Praxiteles, is bound into the story of veneration and desirē: as Aphrodite's maker, he is valued by the lover on a par with almighty Zeus. Charm, obsession, and invention all mark the power of the goddess Sex. Her fatal attraction.

Connoisseurship also has its slice of the story, and a share in the satire. Our visitors make sure to inspect the statue from every angle, the correct behaviour for anyone who knows how to appreciate Hellenistic sculpture 'in the round'; the temple is specially provided with two doors so that the most devoted art lovers can have access to the view from the back as well as the front. (Pliny's incompatible account has the temple 'open on all sides' to achieve the same effect.) After two bouts of ecstasy—the Corinthian swooning over her front, the Athenian going into raptures over her behind—they notice that tell-tale mark 'on one thigh'. The celibate deduces a technical coup by

Praxiteles, who must have brilliantly contrived to fashion his image in such a way that the blemish in the stone occurs at the point of minimum visibility; only the closest scrutiny could ever spot the mark tucked away high up between Aphrodite's legs—for that is where we must imagine it to be, given that (as we shall see) their argument will turn on the fact that the stain is equally compatible with sexual assault from behind or in front. The bite of Lucian's wit is that our real (celibate) connoisseur is professionally obliged to stare long and hard right between the legs of the goddess—the cost (for some it would be the pay-off) of a proper appraisal of any statue of Venus.

The art of satire—and desire

In Lucian's essay the (bizarre, fantasy, or perhaps satirical) story of the stain leads into a full-scale argument between the spokesmen for the two kinds of love. When the Corinthian claims the tale as clinching proof of the attraction of women (even a stone female can turn men

on), the Athenian counters with a telling (?) objection: the young man, he maintained, had clearly tried sex with the statue from behind, as if she were a boy.[20] A lively and prurient discussion follows, as each side talks up the virtues of different forms of desire, across the whole range of options.[21] The celibate comes down on the side of marriage for the general run of men, but reserves pederastic love of boys as a particular privilege for philosophers.[22] True to type, he trades on Plato's famous endorsement of this model of pedagogy, which accepted that philosophical mentors would be fuelled by desire in training their prize pupils, but ruled out anything physical. Lucian's discussion, however, doesn't end there.

The very last salvo in the *Erotes* comes from the bisexual, who has had to listen to all this. He protests that all 'philosophical' sublimation is just plain masochistic self-tantalization and hot air—since the pleasures of the flesh are what govern every species of love; desire first looks and listens, then fingertips touch, kissing starts, hands fumble through clothing to breasts and belly, then—the bull's-eye. Once foreplay has raised the temperature, he tells the celibate in no uncertain terms, sex 'starts from the thighs, and as some comic poet puts it, hits the ultimate target'. This final contribution brings us right back to the Cnidian statue and those thighs; yes, he says, all this breaks the bounds of modesty, 'but *in the name of Aphrodite of Cnidus* it is the truth'.[23] The whole dialogue has been under the spell of 'Cnidian' Aphrodite, universal goddess of erotics. The satirist may well perpetrate the least reliable, and most perverse, interpretation of Praxitelean artistry ever; but whether his art criticism fools, amuses, or shocks, he certainly manages to stir all the discourse on desire together into one pulsating epiphany of lust. If we learn anything from the *Erotes*, it must be that the power of Venus holds sway over every form of carnality—not least the love of art.

The Louvre lover

Hellenistic sculpture did indeed set out explicitly to combine all forms of sexual desire in a single image. One of the most erotic encounters in store for visitors to the Louvre is with the irresistible piece of marble you see in **92**, sprawled across a luxurious mattress in a resplendent show of sinuous flesh. If ever classical antiquity produced a tantalizing work of sheer seduction, this must be it: half-lost in reverie, an exotic creature, legs chafing under a skein of tangled sheet—already aroused, and ready for a lover? Or needing no other, and turning on to the body's pleasure in itself?

But there's a surprise or two in store for the visitor. It's not just that the mattress, which so softly cushions its delicate burden, is not in fact a creation of antiquity at all, but a masterpiece from the seventeenth century (p. 86). More to the point is the treat that awaits anyone

92

A Sleeping Hermaphrodite
(the *Louvre Hermaphrodite*),
from Rome; mattress by G. L.
Bernini, 1620.

The mattress was dreamed up
by Bernini soon after the
statue's discovery (*c*.1610),
and has satisfied customers
ever since as a perfect match
for the fantasy it supports (p.
86). Napoleon bought it and
brought it to Paris.

intrigued enough to venture a peek from the other side. Here [**93**], as well as the fully developed breasts, a healthy set of male genitalia takes centre-stage. A surprise yes, but also a challenge. What kind of experience has this been? A technical joke on sculptural design? For if it is a trademark of many Hellenistic statues that they can only be properly appreciated in the round, here is one where a different viewpoint delivers a fundamentally different message. Or is it a clever play with mythology—an uncanny encounter with that strangest of mythical characters, the androgynous offspring of Hermes and Aphrodite, divine Hermaphroditos? Or a sophisticated erotic provocation that disturbs the familiar components of desire? Or, more sordidly, kinky exploitation just made for an art market with money to burn?

This is, however, only the beginning of the story. The Louvre Hermaphrodite was no one-off: in addition to a whole catalogue of Hermaphrodites in a welter of types and attitudes from both painting and sculpture, we have several figures in just this pose (seven, to count only those that are relatively complete, with findspots right across the Mediterranean, from the late Hellenistic and Roman periods). They must derive ultimately from a common prototype, but (as ever) no two are absolutely identical. In fact, these pieces achieve spectacularly different effects from tiny adjustments of detail. Most notably, the slightest difference in size and position of the penis can confirm or refute the constructions of desire we attribute to the figure. How aroused is the 'man' in the hermaphrodite? Would you call it an erection or not? Is this twitching the onset of a wet dream? Or is it over now? Are we here to stare? One version, in particular, presses

93

The *Louvre Hermaphrodite*
from the far side.

A different, more challenging,
message.

these questions to the limit: a *Sleeping Hermaphrodite* from Athens is just like the rest in all other respects—but for the fact that it has no male genitals at all.

These statues surely prompted all kinds of reaction: from learned curiosity, through credulous wonder and stunned disbelief, to prurient slavering. But as a group they inevitably focus attention not only on the nature of sexuality and desire (what constitutes gender division? how far does the difference between men and women reside in genital difference?), but also on the very basics of sexual arousal. No viewer can escape the question of whether that penis is erect; these statues invite you to home in on their genitalia—as if to fix the whole story of sex there. At the same time, as we have emphasized, our first sight of this sleeping beauty cued us to signals of sexual arousal, diffused from top to toe. Which signal is the stronger? And does the statue tell the same story of arousal to male and female viewers, whatever their different sexualities?

Enter Pan

The viewer's dilemma is acted out in a series of images, in painting, sculpture, and mosaic, that present the hypersexual male figure of Pan, or a satyr, as the assailant (or would-be lover) of a hermaphrodite. Compare **94 (a)** with **94 (b)**. At first sight, two very similar groups: in the first group, a nymph tussles with a satyr who grabs her from behind; in the second, the nymph holds off her attacker at arm's length. But the viewer who walks round this second pair will discover (what the satyr cannot see) that the nymph is in fact a hermaphrodite—and, as such, the last thing that the satyr is look-

94 a, b, c

(a) Statue group of *Satyr and Nymph*, from near Tivoli. From the collection of Charles Townley (**48**).

a

(b) Statue group of *Satyr and Hermaphrodite*, from Rome. A popular group found in many versions, the *Satyr and Hermaphrodite* exploits to the full the idea of sculpture in the round, with its ever-shifting viewpoints. Sometimes two copies, one in reverse, were paired in the same room, redoubling the effect.

b

(c) *Satyr and Hermaphrodite*, wall painting from Pompeii

c

95 a, b

(a) *Pan unveils Hermaphrodite* (?), wall painting from Pompeii.

Pan's hand expresses his horror and tells us to stay away; at the same time, his hand expresses his wonder and is our 'come-on' cue.

ing for. Visual horror is emphatically cued by the hermaphrodite's hand, which thrusts the satyr's face away in order to block out both the satyr's sight and the sight of the satyr.

In painting, the visual point is redoubled for the viewer by the simple fact that we cannot walk round the image. A wall painting from Pompeii [**94 (c)**] is such a close match for our second sculptural group that anyone who already knows the sculpture is bound to see the 'victim' in the painting as androgyne not nymph. But the two-dimensionality of the mural makes it impossible to determine the gender of the figure for sure, so shifting the significance of the ges-

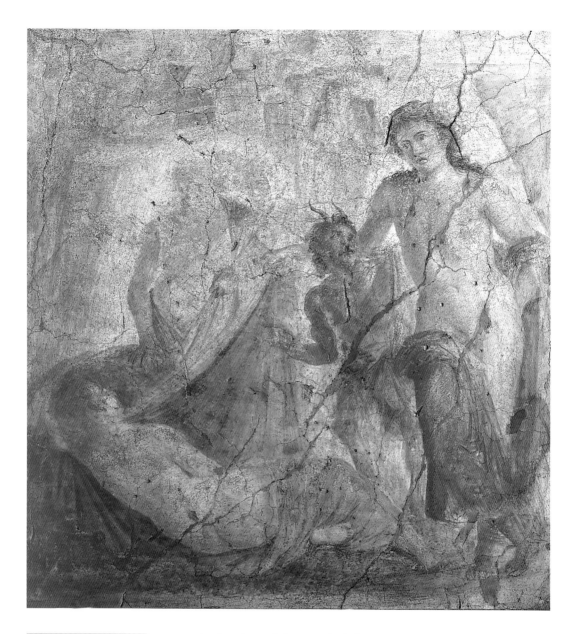

The pose of Pan and the sleeping figure is much the same as in **(a)**, but the presence of Dionysus ensures that we read this as Ariadne, rather than Hermaphrodite.

tures: the barring of the satyr's sight now signals the total impasse in visual comprehension, as much as the horror of what he is not allowed to see.

In another painting from Pompeii [**95 (a)**], Pan unveils a sleeping beauty. She is much as we first met her in the Louvre, and would, on many a Pompeian wall, have been recognized as the abandoned Ariadne, unaware in her slumbers of the approach of her divine lover Dionysus [**95 (b)**]. Pan's gesture speaks of what he has seen, at the same time as it insists that he can see and that we cannot. The joke is, of course, that we can guess all too easily what our eyes are denied;

Statue group of *Aphrodite,*
Pan, and Eros, from Delos.
This group was found in the
basement of a 'club house' on
Delos – presumably fallen
through from a room above, in
living quarters thought to be
lodgings and suites for guests.
It is tempting to regard this as
'motel art' for ancient
businessmen, but we do not
really know how to assess its
pretensions.

the painterly gesture amounts to a visual imperative to do our best, do
our worst—to enter into the image, and to imagine.

The viewer as voyeur

Pan is a member of another, notorious, sculptural group—a late sec-
ond-century BCE creation from the island of Delos [**96**], where we
find him (in a strikingly goaty version) coming on strong with a par-
ticularly ripe—'Medicean'—Aphrodite (cf. **82**). This gives us a dif-
ferent angle on how the addition of a second figure serves to
dramatize the problems of viewing and desire.

Delos was the island of free trade in the late Hellenistic period, set
up as the commercial hub of traffic in the eastern part of Rome's
growing empire. This particular sculpture was excavated in the early
twentieth century from what has been called the 'club house' of a
group of merchants from Berytus (modern Beirut), known as the
'Poseidoniasts' because of their association with Poseidon, god of the
sea. The group raises many of the issues of interpretation that we have
already discussed. Some try hard to see it as a specifically religious
object. Whatever we are to make of Pan, the figure of Aphrodite here
has been taken to represent the erotic and exotic form of the goddess,
known in the East as Astarte (the inscription on the base tells us that
the sculpture was dedicated by a family from Berytus to their 'ances-
tral gods'). Some home in on what they see as the 'bad taste' of the
piece (her ridiculous nipples and his leery grin have made it one of the
most disliked statues in scholarship), and try to connect that with the
commercial, nouveau-riche world of the Delian traders. Others
explore the narrative dimension of the scene. Are Pan's advances wel-
come or unwelcome to the goddess? Is the blow she is about to deliver
with her sandal a playful bit of flirtation or a serious attempt to send
him packing? Is baby Eros the naughty matchmaker, or doing his best
to protect his mum?

Our concern, however, is with the relationship of this piece to the
Aphrodite of Cnidus, and all of her sisters. The stance of the goddess
in the Delos group, and in particular the definitive 'gesture of mod-
esty', encourages us to see her as a variation on the famous Cnidia
(Delos is just across the Aegean from Cnidus; and, predictably
enough, several versions of 'Cnidian' Aphrodite have been found
there). Once you have seen the connection, you will find that Pan's
role is to animate the famous statue, and at the same time to play the
part of the viewer in the work. Pan's move to prise the goddess's hand
away from her crotch must focus attention on how we are to under-
stand this (or any) 'gesture of modesty' in the first place. We have
already argued that Aphrodite's hand calls attention to, as much as it
covers up, her sex. Pan shows us what the hand guards against and
also invites. But his presence serves as well to act out, visually, a story

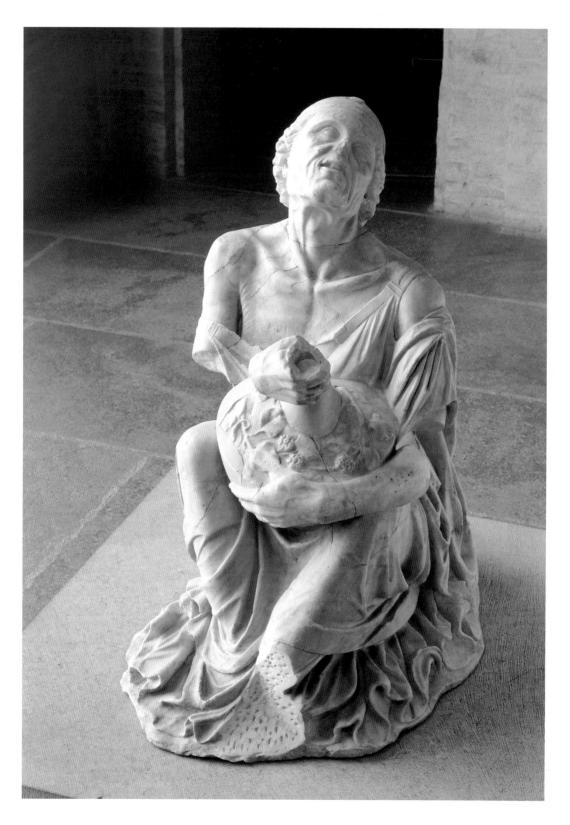

This is the best-preserved version of the type. Coming to light sometime before 1700, it went to Germany as a lavish gift in the early eighteenth century, but in 1830 was refused house room in the brand new Sculpture Gallery in Munich, because it travestied 'the Greek Ideal'. When it was finally put before the public in 1895, it was segregated from the Greek masterpieces, 'demoted' to the Roman section of the Gallery. Today it has star rating.

which works with very much the same erotic dynamics as the textual narrative told by Lucian about the Cnidia. Appropriate response to the allure of the goddess of desire is figured this time as the extreme of heterosexual male lust: to touch, interfere, enter the artwork—and have her. And so the role of the viewer is figured as lustfully male. On the other hand, the statue emphatically reminds us that no viewer can simply put himself in the place of Pan, and that he is as much excluded from as he is included in this scene. On behalf of Aphrodite, Eros points to Pan's splendid horns (a sign of animality that must forever separate him from humankind), while bringing together the couple into a mutual gaze that locks all others out. While these two erotic superpowers negotiate the stakes of (their) desire, we are left to think through an(other) advanced lesson in the art of love—as viewers, not participants.

When love is ugly

With Pan, we have run into the brute fact that the art of desire is not synonymous with the art of beauty. The ugliness of Pan for once makes explicit the response that is always implied by the glamour of any statue of Aphrodite; her power is to be measured in terms of the horny, animal, male lust it commands. Such is the logic of the female 'sex object'. This interaction between beauty and ugliness, at the very heart of visual desire, is captured by the famous grotesque known as the *Drunken Old Woman* [**97**]. This is another case where the Roman sculptures that survive have been linked to a masterpiece of Greek art mentioned by Pliny and have generated a long-standing debate about the date and style of their lost 'original'. No one today accepts that the *Drunken Old Woman* we have was carved by the fifth-century sculptor Myron;[24] it is now generally thought to belong to the third or second centuries BCE, and labelled a prime example of so-called 'Hellenistic realism'.

There have been all kinds of competing identification of this figure. In the eighteenth century, she was seen as an enraptured old devotee of the god Dionysus, gazing up to heaven in prayer, and her wine jar was imaginatively restored as a flaming lamp. More recently, she has been typecast as an elderly whore (spot the strap slipping from her shoulder, and the fingers loaded with rings). Speculations about her original production have included the idea that she was a dedication to Dionysus (his symbol, ivy, is prominently displayed on the jar). And a particularly powerful modern myth has it that the precise shape of the wine jar she hugs ties her to a precise festival of the god at Alexandria in Egypt: she hugs a *lagunos* and in Egypt they celebrate the '*Lagunophoria*' (literally 'the Carrying of Lagunoi') by swigging straight from the *lagunos* in honour of Dionysus; hence the pose. Unfortunately, the word *lagunos* is regularly used in Greek for

any kind of wine vessel, and the one ancient text that mentions this festival says merely that it involved bringing your own *lagunos* from home—for a street party![25]

But, more fundamentally than this, all such attempts to fix the identification of the woman have diverted attention from the visual challenges posed by the sculpture. Does the hag laugh—can we tell? Is she grimacing in pain? Is she drinking in the bouquet of the precious vintage—or alternatively catching every last sniff of the dregs at the bottom of the flagon she has drained? More generally, are we meant to pity this derelict grandmother, reduced to squatting in the street? Or would that be a characteristically modern response, utterly at odds with ancient sentiments, which would expect to enjoy amused contempt at the expense of such a futile piece of human refuse? Is there any way around that stark choice between pathos and derision? One possibility is that we should treat this statue as part of a subtle intellectual game. In that case the figure could present a riddle based on a well-known ancient maxim that aligned wine with life, life with wine—prodding us to wonder, for a start, whether the less we have left (of either), the more precious it gets.

But the figure also cues into an equally well-known visual maxim of desire. The *Drunken Old Woman*, one shoulder strap slipped tantalizingly close to her breast and experienced hand lewdly gripping the phallic spout, is begging to be seen as a subversive variant on the theme of the 'goddess with water pot' that we explored earlier in this chapter. You could say that we are looking once more upon *Aphrodite of Cnidus*, now long past her prime and collapsed over a version of the vessel (here a wine jar) that used to stand by her feet. It is an exploration of the ravages of time, bringing to centre-stage an object that was once just a side-lined attribute of the goddess, and lowering to the ground the incarnation of desire. A thought-provoking image within the visual language of Hellenistic art.

For ourselves, we do not suppose that the *Drunken Old Woman* ever adorned a sacred or civic space. But when we wonder what it was that induced some Hellenistic prince or millionaire to want this unlovely specimen in his possession (amongst the specimens of beauty), it is not too difficult to see how she could be squeezed in— as a joke about beauty itself, and its desirability; a put-down for women, no doubt, but also a sneer at male desire. But why some other well-known masterpieces of our period were so highly prized, so desired by their collectors, needs to be teased out yet more subtly.

The art of innocence

So far in this chapter we have discussed the links between desire and art largely in terms of sexual attraction and attractiveness. In fact, as we have already hinted, the love of art presides over a whole empire

a

b

Statue groups of *Boy and Goose*, from Rome.

The boy seems to be clutching his bird to eternity for no good reason. Do such pointless subjects promise 'art for art's sake'? Or is this a perfect example of art turning the tables on power?

of desire—the desire to own or possess, the pleasures of looking and response, the investment in connoisseurship and the obsession with collecting. Just how far we should ultimately construe any, or all, of this multi-level discourse of art in erotic terms is always the question that faces the 'art lover'. With this thought in mind, we turn now to the final objects of this chapter, which will take us a little further from the realm of what is explicitly—and stereotypically—erotic.

A group that survives in several versions shows an infant boy with a full-grown goose, almost matching in size [**98**]. In erotic terms, we are bound to view the composition as a playful attempt to evoke the lusty embrace of a nude male (this time, in contrast to the *Drunken Old Woman*, the years have been stripped off), arms around his chosen pet; there are cherubic echoes too of the god Eros, often repre sented as a pudgy toddler [**99**]. But when we consider what made this a favourite marble group in antiquity, we shall find that this cannot be the whole story. At one extreme it is possible to argue for a religious dimension: a votive offering to the god of healing by parents elated at the recovery of their beloved son. (Unlikely as this may sound, one earthy poem of the third century BCE has just such a piece mentioned in a list of artworks dedicated in the temple of the healing god Asklepios.)[26] At the other, there is a mock heroic struggle here served up for intellectualizing urban culture: the myth of baby Hercules' miraculous strangulation of the deadly serpents sent to

destroy him in his cradle is here parodied, in a knowingly domesticated form, as the little boy next door getting to grips with his pet bird. In particular, the game of wondering whether the infant knows his mind, whether he is hugging, wrestling with, or strangling the goose, and whether he (or we) can know the difference, must be at the centre of any interpretation of the group—and must lie somewhere near the core of its 'charm'. An important moment is when the thought occurs, as it will, that this is expensive stone lavished on a throwaway subject. The very same loving craftsmanship went to make gorgeous gods and goddesses, compelling rulers and magnates, and kitsch kids and children with domestic fowl.

Art, glamour, charisma

In the rest of this book we shall meet a gargantuan array of figures of power, few of whom will strike you as beautiful, let alone erotic. Nevertheless, in considering how the images of Hellenistic and Roman potentates and autocrats aimed to be attractive and charismatic, we shall never be far from the investment of desire in the work of art—far, that is, from the art of love.

99

Statuette of *Sleeping Eros*.
This piece seems to gush sentimentality; but harmless innocence may always be a gloss on infantile irresponsibility. If Cupid were to wake up grumpy, runs the thought, he could throw a calamitous tantrum on the grandest cosmic scale.

Sizing up Power: Masters of Art

4

Extremes of scale lie at the heart of ancient political culture—from gigantic parades of artistic skill and extravagant architectural design to exquisite works of craftsmanship in precious metal and cameo; from miniaturism to the colossal. Earlier chapters concentrated on individual works of art or assemblages within more or less grandiose domestic settings. Now we turn to whole cityscapes, planned and executed as deliberate expressions of political power within the cosmopolitan Hellenistic and Roman world after Alexander the Great; and to the processes of imitation that animated the art of the Roman empire, between centre and periphery, capital and provinces. We shall be exploring the complex relationship between power politics and material culture, where grandeur and 'hype' are always two sides of the same coin; and where the biggest bids for glory and prestige in marble not only are the most likely to succeed, but also run the greatest risk of subversion, ridicule, and even ruin.

The stories behind these colossal monuments are far from dead and buried. Here we are, in the main, dealing with sites uncovered by modern archaeology over the last 100 years or so; and in one case with a sensational discovery from excavations that are still under way and throwing up new challenges to our understanding of Hellenistic and Roman art. As we shall see, the possession and display of such ancient treasures figured in twentieth-century narratives of dictatorship and imperialism. The race to appropriate the kudos of classical art—whether looted, stolen, dug up, or confiscated—did not stop with papal princes or with Napoleon. The twentieth century had its own 'masters of art': Mussolini, Hitler, and Stalin.

Wonder of the world: the *Great Altar* of Pergamum

Our first monument was listed by one Roman author as a 'wonder of the world':[1] the so-called *Great Altar* of Pergamum (in modern Turkey). Built by the local dynasty (of the Attalids), which, during the third and second centuries BCE, poured its money into transforming lowly Pergamum into a showcase capital city, the *Altar* is an unapologetic exercise in hyperbole. Most altars were relatively small-scale structures set up in front of temples or in their own modest

100
Herkules the Landmark of Kassel: see **146**.

101

Sculptural programme of the
Great Altar of Pergamum.
The doted line marks the limit
of the reconstruction of the
exterior frieze in the museum.

102

Reconstruction of the east
side of the *Great Altar*.
The surviving fragments of the
frieze with gods and giants are
here shown in bold; the upper
storey represents an
imaginative reconstruction.

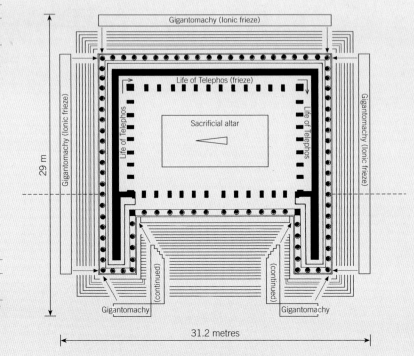

Gigantomachy (Ionic frieze)

Gigantomachy (Ionic frieze)

Gigantomachy (Ionic frieze)

Life of Telephos (frieze)

Life of Telephos

Life of Telephos

Sacrificial altar

29 m

(continued)

Gigantomachy

(continued)

Gigantomachy

31.2 metres

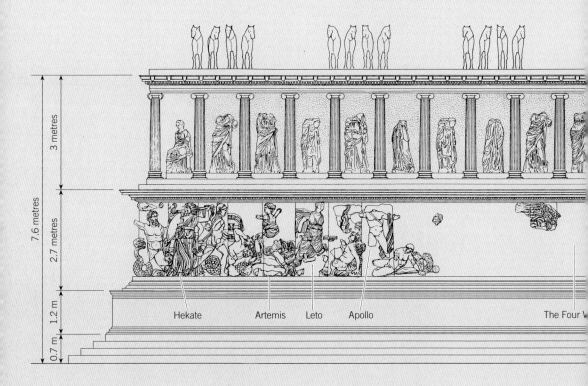

3 metres

7.6 metres

2.7 metres

1.2 m

0.7 m

Hekate Artemis Leto Apollo The Four W

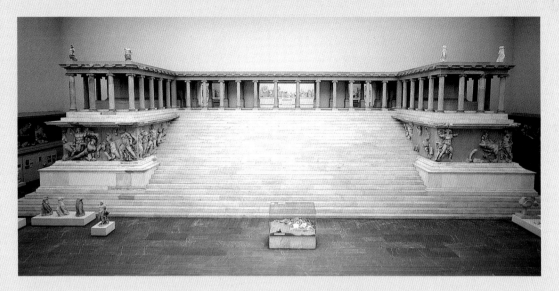

103

The west side of the *Great Altar* at Pergamum, as reconstructed in the Pergamonmuseum, Berlin.

The museum reconstruction includes only about half of the monument (**101**). Where possible, the *Gigantomachy* is mounted on a mock-up of the Altar, but the greater part of this outer frieze is now mounted around the gallery walls. Visitors thus experience much of the sculptural programme inside out.

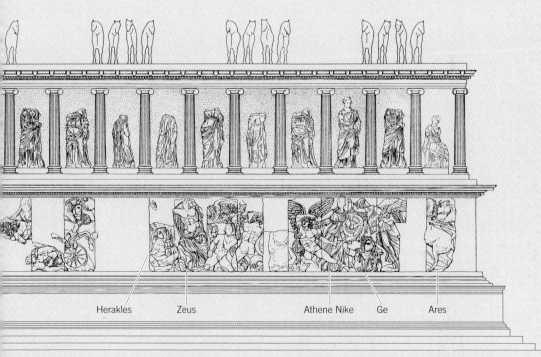

Herakles Zeus Athene Nike Ge Ares

precincts. Here though, as in a number of other cities in Asia Minor during the Hellenistic period, the altar precinct was deliberately inflated, to equal the size of the very biggest Greek temples. It dwarfed the Temple of Athena (with which it was exactly aligned) that looked out from the steep hillside just above (see Maps and Plans 17; [101]). No expense spared, the work certainly took decades: and this fact alone tells against the many attempts to fix it to the reign of one particular Attalid king rather than another.

Visitors to the precinct approached the forbidding east side, with its continuous colonnade above and its vast unbroken frieze below, the armies of writhing gods and giants at each others' throats [102]. Whichever way you chose to go, whether north or south, the same pattern was repeated; until you came to the west side, where a huge staircase, 20 metres wide, led up through the tangled ranks of gods and giants who flanked the steps on each side to the colonnaded courtyard at first-floor level [103]. In the centre of the marble-paved court stood the 'sacrificial altar' itself (so called to distinguish it from the altar complex as a whole), while behind the inner colonnade lurked a second sacred frieze—this time telling the story of Telephus, the mythical founding hero of Pergamum.

The *Great Altar* of Berlin

This colossal monument was recovered in the late nineteenth century. Isolated pieces of its sculpture had been picked up earlier and had found their fraught way, unrecognized, into art collections as far away as Henley-on-Thames and Worksop in England. But systematic excavation only started in the 1870s when Carl Humann, a German engineer employed by the Ottoman empire to run transport systems through western Turkey, learned that Hellenistic marbles were going into the local lime-kilns, and plunged into a crusade to retrieve whatever remains of the great Attalid city lay beneath the bewildering rubble of late antique, Byzantine, and Turkish fortifications. Joining forces with the museum directors in Berlin, Humann conducted a series of excavations on the site through the 1870s and 1880s, and the vast majority of the finds were shipped off to Berlin. The prospect of acquiring for the newly unified Germany a vast Greek 'original', to rival anything the capital of the British empire could boast, caused a tremendous stir (notwithstanding its post-classical date, irretrievably pinned to Winckelmann's 'Age of Imitators'). Royal blessing followed, plus the funds required for a brand new, customized museum. At the peak of enthusiasm for the *Altar*, in 1886, a bizarre 'Pergamene Celebration' was held in Berlin, featuring 1500 artists in fancy dress re-enacting an Attalid victory parade for their triumph over Gallic invaders of Asia Minor (a blatant analogue for recent Prussian victories over the French). The

Altar was to inspire architectural grandiosity in the twentieth century world-wide, most notoriously in Albert Speer's Nuremberg *Zeppelinfeld* and Nazified Berlin [**104**].

The work of reconstructing the Attalid city, dramatically perched on a series of terraces hacked out of the sheer rock, was an immense jigsaw. The *Altar* itself did not survive above its base; and those sculptures that had not been destroyed—thousands of fragments in all—were widely scattered, preserved as the building blocks for later walls, houses, and even pavements. But the precision of the Greek masons' marks found on many of the *Altar* fragments allowed the original layout of the design to be recovered, and the names of individual gods and giants inscribed on the borders above and below the main frieze helped to place several of the chief combatants; so the reconstruction is built on rather more than guesswork. Even so, not surprisingly, numerous gaps and uncertainties remain; and the problems are intensified by the sheer length of the *Gigantomachy* (*Battle of Gods and Giants*) that wraps right round the *Altar*, creating an unparalleled demand for more, and ever more arcane, mythological characters to fill up its space. Once the game of hyperbole extends to showing and naming every conceivable monster, the chances of being able to identify each individual specimen inevitably recede.

The first museum built to house this outsize frieze, inaugurated in 1901 but demolished in 1908, was a scandal of architectural incompetence and never up to the challenge of displaying the vast *Altar*, with all the associated finds. Its successor took 20 years to build. The crowning glory was a complete reconstruction of the monumental staircase on the west side: visitors climbed up to pass through the colonnade and beyond, into a room at first floor level, dedicated to the *Telephus Frieze*. With the reunification of Germany in the 1990s there was a major conservation programme, but the display remains broadly the same [**103**].

This apparent continuity conceals the fact that, between 1939 and 1959, the *Great Altar* survived hair-raising adventures of its own. During World War II it was crated up and carted off to a high-security bank vault, then on to the bomb-proof bunker beneath a vast fortress-tower, strategically placed in the local zoo. When the Soviet

spearhead arrived in Berlin in 1945, the Red Army had a frantic month to collect as much treasure as they might before the rest of the Allied forces could dash in to dispute the spoils. The *Great Altar* was packed off to the Hermitage Museum in Leningrad, where it stayed in store until 1958, when it was briefly put on view before being presented to East Germany, and returned in 1959 to the position it had occupied between 1930 and the war.

Art and power: from Pergamum to Rome via Athens

The *Great Altar* of Pergamum had from the first been part of an international power game. The Attalid dynasty came from nowhere. Their power base (such as it was) derived straight from Alexander the Great's conquest of Asia. One of Alexander's generals deposited his share of the loot in the citadel of Pergamum, in the care of one of his staff, who soon decided to go it alone. Over the next century and a half, he and his descendants (now trading as the Attalid dynasty) invested the money in transforming their township into what looked like a major player in the Hellenistic world, launching Pergamum into the circus of prestige and influence which occupied the successors of Alexander's fragmented empire through the third century BCE. For a time, the Attalids' extraordinary game-plan paid off handsomely; but their decision to back the Romans—arriving from the West in what soon proved to be an irresistible drive to world domination—was a policy that contained the seeds of its own destruction. In 133 BCE, the fourth and last Attalid princeling, King Attalus III, amid mounting crisis at home and abroad, sensibly anticipated the

105
The 'Stoa of Attalus' (mid second-century BCE) as reconstructed in the Agora of Athens, 1956.

Twenty-one 'shops' on each of two storeys lie behind the elongated double colonnade of the Stoa, (re-)built to house the archaeological finds recovered from the Agora. In the foreground are remains of the Roman Odeum (a covered auditorium), built by Augustus' generalissimo Agrippa (p. 225) to dominate Athens' centre of civic life. The site has become a multi-layered monument to two-and-a-half millennia of devotion to classical Athens, as well as to the complex history of cultural imperialism in western civilization.

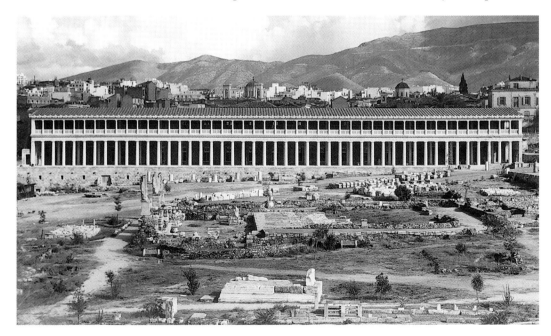

inevitable by bequeathing his kingdom to the Roman People in his last will and testament. Or so Roman history has it.

The Attalids' construction of Pergamum is a paradigm for the central concern of this chapter: the relationship between art and power. They did not merely use art, architecture, and visual imagery as an expression of their power; art lay at the core of their bid for ascendancy in the stakes of cultural and political power. The Attalids literally built and carved themselves into prominence; Pergamene power was (indistinguishable from) Pergamene style.

This bid for importance turned the citadel of Pergamum itself into a fantasy world of intertwining temples and palace complexes, in a virtuoso display of exuberant engineering. It also involved dramatic incursions into the cityscapes of some of the most evocative and politically loaded spots in the Greek world. Besides dedications at centres of Hellenism, such as Delphi and the island of Delos, Attalus II presented the people of Athens with what amounted to a glorified shopping mall ('The Stoa of Attalus'), whose vast colonnades lined one side of the ancient agora (market place) in the very heart of the city. In ancient times, this grabbed a major part of the Athenian sky-line—though it was not unrivalled by other imposing benefactions (and eyesores). The irony is that the history of modern excavation has fulfilled Attalus' ambitions beyond his wildest hopes. When the American excavators of the agora required a museum to house their finds, they hit on the ingenious idea of reconstructing one of the ancient buildings they had uncovered; the Stoa of Attalus was the only one sufficiently well preserved for a replica to be possible, and on a grand enough scale to cope with the volume of ancient artefacts. Today the preternaturally sparkling Stoa (c.150 BCE–1956 CE) lords it over a pathetic wasteland of antique ruins [105].

Hellenizing Asia: from the Parthenon to the *Great Altar*

The fundamental aim of the *Great Altar* itself, along with the rest of the Attalid showcase, had been to reconstruct the classical world on Pergamene territory—and on Pergamene terms. The point was to import and implant the unmistakable signs of Greekness, to appropriate and naturalize Greek cultural forms. But a difference did need to be established, and a superior model of Hellenism engineered, ready for re-exportation and eventual colonization of the old centres of the Greek heritage. In the case of the *Great Altar*, it is not just that the overall form and the size engage with the conventions of Hellenism, aggressively outbidding the parameters of their models; details too play loudly with the kudos of their antecedents. Visitors approaching the main frieze from the east would have taken in at once the conventionalities of the subject (the conflict of gods and giants was a theme that hardly any Greek temple was ever able to

106 a, b

(a) Apollo from the east frieze of the Great Altar of Pergamum; (b) Lapith and Centaur metope from the south side of the Parthenon, Athens.

Apollo's giant is a mirror-image of the *Dying Gaul*, traditionally claimed as a Pergamene masterpiece (**110**).

a

b

107a

resist), the bravura of its massive scale, and at least some aspects of the imaginative play with canonical images of the classical past. Two scenes would have sounded particularly strong echoes: towards the left of the east frieze, Apollo standing triumphant over a giant [**106 (a)**]; towards the right, Zeus and Athena against an army of adversaries [**107 (a)**].

Apollo precisely replicates the distinctive open pose of a heroic figure from the Parthenon, Athena's famous temple on the Acropolis at Athens: his giant underfoot is in place of the original's battling centaur [**106 (b)**]. This echo is one clear signal that the new cosmic struggle is to be imagined as a fresh episode in the long saga of mythic

107 a, b

(a) Zeus and Athena on the
east frieze of the Great Altar of
Pergamum.
On the left Zeus, king of the
gods, battles with three giants
at once; on the right his
favourite daughter, Athene,
mortally separates another
from the protecting arms of his
Mother, Earth.

Note how Zeus' eagle (now
fragmentary; cf. **56**) once
rhymed with the air-borne
goddess Victory (*far right*),
both on the side of the angels;
but the wings of Athena's poor
young victim (*centre*) interfere
with the triumphalism, as he
writhes in piteous pain, caught
in the toils of her serpents.

(b) J. Carrey, *Athena and
Poseidon Compete for Athens
on the West Pediment of the
Parthenon*, c.1674.
The central figures from both
Parthenon gables are now
lost. But we have a good
drawing of what was still
visible at the west end in the
seventeenth century (*right*).

107b

showdowns between Good and Evil, here fought out in an outpost of
Hellenism on the foothills of the Asian East. The juxtaposition of
Zeus and Athena, by contrast, insists on our working through a
complex double-take effect that turns on reminiscences of the
Parthenon's pediments. Dominating the gable above the entrance
there, Zeus sat enthroned, while his daughter Athena sprang full-
grown from his head (as the myth went); on the panels immediately
below, the Olympian gods fought it out with the giants. At the
centre of the other gable, facing visitors on their approach, Athena
and Poseidon disputed the ownership of Athens and its surrounding
territory, and they were represented, between two chariot teams,

recoiling dramatically from each other [**107 (b)**]. Their distinctive pose is clearly echoed in the figures of Zeus and Athena in the Pergamene frieze.

The mental gymnastics involved in this allusion are particularly important for reading the *Altar* as a whole. Not only are the Pergamene figures the mirror image of those on the Parthenon, but, by replacing Poseidon with Zeus, the sculptors have redoubled the allusion and have compacted the primal scenes of both pediments into a single synthesis. The upshot is that the iconography of Athens' grandest monument is harnessed to the task of certifying Pergamum's links with the purest Hellenism of all; while the key emblematic scenes of the Parthenon are here submerged in this new Gigantomachy's maelstrom—mere elements in the giant frieze. To be sure, the frieze's artful association dignifies Pergamene Athena, whose temple lay directly above the *Altar* (see Maps and Plans 17), as companion-in-arms of her father Zeus, at this founding moment that secured the Olympian gods' rule over the planet. Nevertheless, in visual terms the frieze plunges both divinities into a baffling choreography of overwrought bodies and wings. Complex menace vies with simple decisiveness as the amplified message of all this marble enormity.

Pergamum through the *Telephus Frieze*

The prime function of the outer frieze is to prepare visitors for their climb to the paved courtyard within. Around the sacrificial altar inside, the inner frieze tells the story of Telephus, founding father of the city of Pergamum. Here Hercules, who appeared on the outer frieze fighting at the right hand of his own father Zeus, was shown as Telephus' father—to begin a typical narrative of the birth, exploits, and eventual consecration of a Greek hero. The myth of Telephus went back centuries before the Attalids, but for them it proved an ideal story for pushing their claims to a place at the forefront of Hellenism. Not only did this hero have a bona fide Greek mythic pedigree, as the son of Hercules and a priestess of Tegea in Arcadia, in the heart of the Peloponnese; he also played a crucial role (or so it could be presented) in the Trojan War, rubbing shoulders with the likes of Agamemnon and Achilles. By saving his city from destruction, he earned worship as the patron hero of Pergamum.

The *Telephus Frieze* is much more fragmentary than the *Gigantomachy*. According to the most recent reconstruction, the frieze contrives to show the viewer a series of scenarios which document the hero's progress to cult status: born to the virgin priestess of the sanctuary of Athena in Arcadia; thrown out to die—but accidentally discovered by his mighty father [**108 (a)**]; installed as pious ruler of Pergamum, where his persecuted mother too had washed up;

finally, it seems, witnessed passing through death to heroized immortality. All in all, a magnificent visual deployment of myth to sanctify the hilltop city, to trumpet its credentials throughout the civilized world.

Yet the very energy that went into delivering the visitor to this would-be crowning glory of the *Great Altar* also dooms the inner frieze to anticlimax. After the surging frenzy of the *Gigantomachy* and the grand swagger of the stairway, the dreamy *Telephus Frieze* was—necessarily—diminutive (about two-thirds life size), cramped in its court, bitty, and hard to take in. Besides, the story itself risks delivering a quite different message, or no coherent message at all. For all its claims to mainstream Hellenism, the Telephus myth links Pergamum directly with no more than an unglamorous mountain township in the wilds of Arcadia. Moreover its connections with the saga of the Trojan War are quirky at best, surreal and subversive at worst. The closest Telephus came to having a part in the fighting 'at Troy' was the dubious honour of being wounded in the thigh by Achilles in an abortive run-up to the real conflict, when (believe it or not) the Greeks had somehow mistaken Pergamum for Troy. In the next episode [**108 (b)**], he makes his way to Agamemnon's court looking for a cure for his festering leg. In the happy outcome, he takes on the role of much-needed guide and successfully leads the Greeks to Troy. This last part of the story had traditionally served to instal Pergamum, however precariously, amongst the paragons of Greece; but it was sure to embarrass a dynasty keen to align itself with Rome,

Aphrodite on the north side of
the *Great Altar* of Pergamum
(detail).

A delicate divine foot
transformed into a
melodramatic jackboot of war.
Aphrodite treads down on a
giant's head – stooping, not to
adjust her sandal (see **81**), but
to pull out the spear lodged in
his corpse.

since the national legend of the new superpower claimed direct
descent from Trojan Aeneas and the other survivors of the Greek sack
of Troy.

In the strain to build an unbeatable sum of cosmic, heroic, and
human valour, the *Great Altar* can stand for any and every state's aspi-
rations for glory, self-glorification, vainglory—as much the triumph
of barbarism as triumph *over* barbarism [**109**]. Efforts to meld the
awful power of divine authority across the universe both with the
political pull of symbolic capital in the international stakes, and with
the vital charge of the communal identity grounded in specifically
local tradition, generally prove as risky as they are necessary. If mas-
tery is the prize of cultural display, then bathos is its booby.

'Pergamene style'?

In our introduction we explained that identifying particular regional
idioms of Hellenistic art takes far too much conjecture to be
worthwhile. Yet in the case of Pergamum most art historians have put
enormous emphasis on a distinctive local style, characterized by an
intensity of rendering, a mood of overwrought passion, and, as the
pay-off for its florid exuberance, the melodrama of pathos, all-out
assault on the emotions. This is the so-called 'Pergamene Baroque';
and it has played such a dominant role in the conceptualization of
classical art from Greece to Rome that it demands all our attention.
For the very idea of a distinctive Pergamene style has crucial implica-
tions not only for our understanding of artistic production in this
period (who actually created the *Great Altar*? was there a Pergamene
'school' of sculptors?), but also for the stylistic history of sculpture
well into the Roman empire. As we saw with Laocoon and the 'Cave

of Tiberius' at Sperlonga (p. 82), Pergamene Baroque has been invoked as the common ancestor of some of the central pieces of ancient sculpture, and a major component in what we have come to think of as 'Roman' art.

At its most extreme, the Pergamene school is seen as a hotbed of innovation, under the inspired guidance of a single artistic genius, working hand in hand with cultivated royal patrons. It is true that the name of one particular artist, 'Epigonos, son of Charios, from Pergamum', survives on an impressive number of statue-bases from the city; and Pliny's *Natural History* gives a certain 'Epigonos' honourable mention, albeit amongst the second rank of artists in bronze, as a 'master imitator in pretty well all genres, [who] broke new ground with his *Trumpeter*, and with his *Infant Pitifully Fondling the Corpse of its Slain Mother*.'[2] But Pliny does not mention Epigonos in his list of artists who celebrated the Attalid dynasty (unless you 'correct' the name 'Isigonos' that does appear in the list);[3] and there is no ancient warrant at all for Epigonos masterminding the *Great Altar*, let alone the whole Pergamene makeover.

Pliny's list, in fact, has exactly the same multinational flavour as the team of sculptors who, we think, worked on the *Great Altar*. Only tantalizing bits and pieces survive from the names of the different artists, which were once inscribed, along with their nationalities, in the border of the *Gigantomachy*. There are traces of perhaps a dozen of an original 40 or so names, which have been energetically reconstructed in the search for the school of Pergamene artists, or even the presiding genius of the whole ensemble. It has been a desperate search. The favourite candidate for the *Altar*'s chief sculptor and guru, one 'Menecrates', has been conjured up out of the words ' ...ates, son of ...necrates' (with the help of a garbled anecdote in Pliny about a certain 'Menecrates', adopted father or mentor of two sculptors).[4] And, while we have evidence of sculptors from Athens and probably Tralles in Asia Minor, the nearest we come to finding undeniably Pergamene artists is an isolated scrap of three letters, '... eno ...', which may or may not have belonged to the word 'Pergamenos'. Hardly enough for a theory, let alone a history, of Pergamene artistry.

A more judicious view of 'Pergamene style' accepts that its origins were international; but that the cosmopolitan gathering of artists for these major Attalid commissions, working within the common language of Hellenistic sculpture, fashioned a perceptibly novel idiom. This was 'Pergamene' in the sense that it was disseminated from Pergamum and poured back into the stylistic mainstream. A plausible enough outline, no doubt. Yet firm evidence to tie in any particular works of art repeatedly eludes us. We have already seen (pp. 73–4), for example, how impossible it has proved to pin down the precise nature of Laocoon's connection with earlier Pergamene (or

Pergamene-derived) models, for all the compelling similarity in mood and composition between the Laocoon group and the death-struggle of Athena's adversary on the *Gigantomachy* [**49, 107 (a)**].

But it is far more than a problem of evidence or the lack of it. For artistic production in the fragmented Hellenistic world post-Alexander made it a cardinal principle to baffle any attempt to map out simple linear genealogies, as works of art aimed to outbid each other as rivals in the same market. Besides, this was a world where the leading artists criss-crossed the Mediterranean from one bravura commission to another, and where a ring of largely interchangeable dynasts, not only the Attalids, was pouring resources into art patronage across the international stage; all of which undermines still further the idea of particular local schools. This is why we earlier scotched the notion that Rhodes was the essential link in a chain of stylistic development leading from Pergamum to Rome (pp. 75, 78, 82). Art history has seen successive attempts to conjure up a 'Rhodian School' as a conduit for delivering Pergamene Baroque to Rome. The elusive 'Menecrates' has played his part here too, for Pliny's anecdote has been wilfully misread to make Menecrates a Rhodian.

Classical art and the *Dying Gauls*

The precariousness of the category of 'Pergamene' art can be seen even in its most definitive icons: a cluster of barbarian warriors, found in Rome and Italy, regularly known as *Dying* (or *Dead*) *Gauls*. These are universally regarded as versions of Pergamene originals, adapted from monuments set up to commemorate Attalid victories over the Galatians (the Gallic tribesmen, ethnically related to the Gauls of France, who over the third and second centuries BCE terrorized parts of Greece and Asia Minor, even getting as far as Delphi).

The most famous of these [**110**] is an over life-size warrior, found in the city of Rome probably in the early seventeenth century, and bought by the pope in 1737. It quickly became one of the canonical pieces of ancient sculpture. Michelangelo was reputedly called in to restore the right arm (shades of the Laocoon); there was the obligatory trip to Napoleonic Paris along with the other treasures of Rome; and the predictable drool from Byron's *Childe Harold* ('through his

Pausanias on Athens

By the South Wall [of the Athenian Acropolis], Attalus set up a dedication comprising: the legendary War of the Giants who once inhabited Thrace and the Isthmus of Pallene; Battle of Athenians against Amazons; the exploit at Marathon against Persians; the destruction of Galatians in Mysia—each one about two cubits [= say 1 metre].[6]

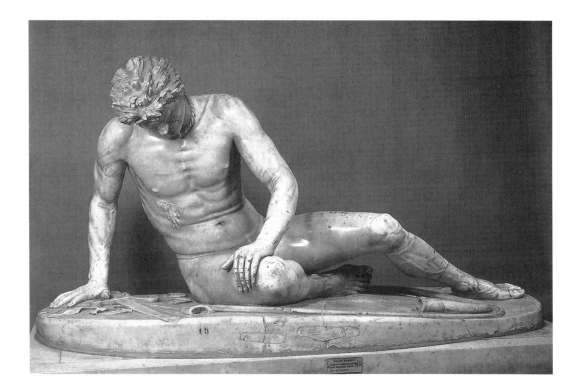

110

Dying Gaul, almost certainly
from Rome.

The statue was glamorized
soon after its discovery as a
'Dying Gladiator' – 'Butcher'd
to make a Roman holiday', as
Byron puts it in *Childe Harold*.
Winckelmann saw some
'Herald' from Greek
mythology, so explaining the
trumpet over which the figure
collapses. But it has long been
recognized, above all from the
characteristic Gallic torque
around the neck, as a *Dying
Gaul*.

side the last drops, ebbing slow / From the red gash, fall heavy,
one by one').[5] Other statues have been associated with this *Dying
Gaul*. Apparently found around the same time and in the same
area of Rome (many art historians have seen them as part of the
same monument) is a group which is now usually interpreted as a
Gallic chieftain and his wife, bravely pre-empting capture by
suicide [**111**].

Also connected by theme are half a dozen or so similar figures
found in Rome. These are on a much smaller scale (about half
life-size), collapsing, dying, or dead: more Celts, plus an Amazon, a
couple of Persians, and (albeit on a puzzling Lilliputian scale) a little
Giant [**112**]. These in turn have been linked to a larger miscellany of
20 or so diminutive statues on similar themes also found in Italy,
though now dispersed through the museums of western Europe.

On the standard assumption that all these statues are Roman
'copies' of earlier Greek work, the subject of defeated Gauls points
unerringly to a Pergamene prototype in some form of Attalid 'victory
monument'. In the case of smaller Gauls and other victims, a passage
from Pausanias' description of the sights and antiquities of Athens
provides a compelling candidate for their original location (p. 160).

The half-size figures Pausanias refers to, and the range of subjects
depicted, cry out to be tied in to our small series. In the case of the
larger statues (the *Dying Gaul* and the *Suicides*) there is no such

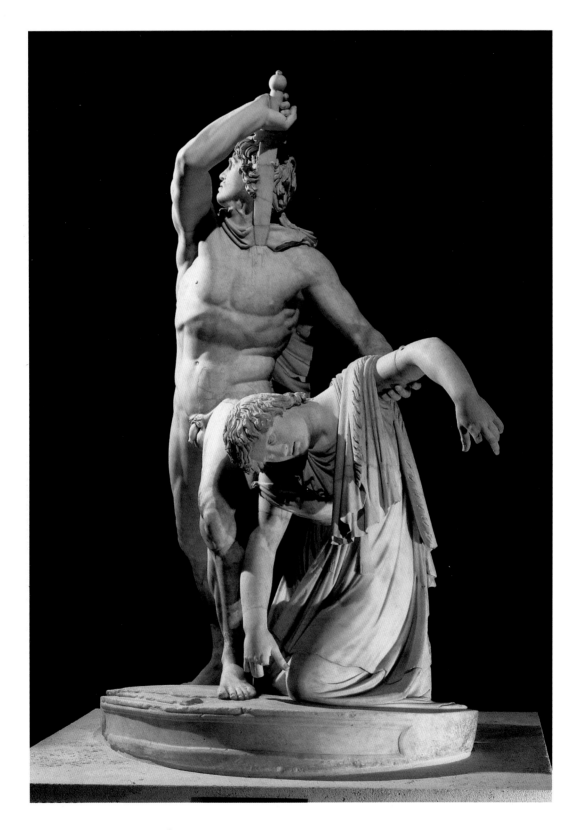

111

Statue group of Suicidal Celts (the *Ludovisi Gaul*), almost certainly from Rome.

This group was long seen as the suicide of a noble Roman couple, 'Paetus and Arria', while Winckelmann characteristically backed the idea of an arcane episode in Greek myth. Recent speculation proposes that the bronze originals of this piece and their dying comrade (**110**) once adorned the great octagonal dining suite in Nero's Golden House: according to Pliny, Nero fetched the best Pergamene works there in 64 CE.

112

Group of four statues, from Rome. From top left: *Dying Celt, Dead Giant, Dead Amazon, Dead Persian.*

A miscellany of nine miniature 'victims' was excavated in Rome's Campus Martius in the sixteenth century. These four were chosen as samples of each type for the Farnese collection, now in Naples (p. 11).

convenient literary reference. But they have been plausibly connected with a couple of monumental bases from the sanctuary of Athena 'Bringer of Victory' in Pergamum itself, just above the *Great Altar*. As their surviving inscriptions make clear, these bases once carried statues (presumably in bronze) showing off local victories over the Gauls. The sculptor Epigonos comes in again at this point. Not only has his famous *Trumpeter* been identified with our *Dying Gaul*, but both monuments proclaim themselves 'works of Epigonos'—or so the fragmentary inscriptions have plausibly been restored. What neater home for the *Dying Gaul*? Or, for that matter, for the *Suicides*?

The trail that these statues set is tantalizing, and the prospect of tying together these powerful groups from Rome with Pergamene commissions in Athens and the Greek East almost irresistible. But the links prove to be more tenuous and fraught than the usual story suggests. For a start, there is no way to be sure what once stood on any of those bases in Pergamum, or where else in their city any original Attalid Gauls might have been placed (one recent claim has even put the originals of the diminutive series back in Pergamum, right on top of the 'sacrificial altar' in the *Great Altar* complex). As for Epigonos, whose name on the monumental bases is at best fragmentary, the link between his *Trumpeter* as reported by Pliny and our *Dying Gaul* is desperately thin. The trumpet is hardly noticeable, and apparently not in working order; but, in any case, why on earth doesn't Pliny specify that the trumpeter was a Gaul—and 'Dying' at that?

But consideration of Pausanias' precise description of Attalus' dedication leads directly to the overarching issues of copying and imitation that are at the heart of this book. At first glance, his phrase 'the destruction of Galatians' squares well with our group of figures: a set of victims without victors. But the run of his text surely leads us to envisage a series of gods to battle against our giants (as on the *Great Altar*), and, similarly, some Athenians to crush both the Persians and

(as on the Parthenon) the Amazons. Why can we point to no sculptures as candidates for the winning squads?

Two answers have been floated. First, despite Pausanias, there were no victors in this victory monument; the scenario was exclusively devoted to victims. This, it is argued (in a neat circle), both fits the figures we have, and chimes perfectly with the dominant twentieth-century stereotype of 'Pergamene style': namely, its promotion of pathos into the first rank of artistic effects and achievements. Never mind what Pausanias says. Alternatively, the copyists for whatever reason were only attracted to the defeated in each battle scenario; Pausanias' description accurately reflects the balance of power on the original monument, but the sculptors had an agenda of their own and made their selection accordingly.

This second suggestion alerts us, once again, to the key issue; namely, the gap that must exist between originals and any later versions, and the fragility of any attempt to reconstruct the prototype from the copy. As we saw with painting (in Chapter 1), the business of selection, adaptation, and recombination opens up complications which must defy any attempt to treat such versions as straight replicas, no more no less.

But the translation of Pergamum's defeated Gauls into the Roman landscape adds a particularly memorable twist to that general point. At no period in Roman history could you have imported any image of a defeated Galatian, kitted out in distinctively Celtic costume, without delivering a specifically Roman message, and in some sense turning Attalid conflicts into Roman struggles against their northern neighbours: from the Gallic sack of Rome in the fourth century BCE, through Julius Caesar's lightning conquest of France, to the Roman empire's perennial anxiety about its Rhine frontier. If we accept a Pergamene origin for these statues, we must focus all the more on the changes of orientation and interpretation brought about as the world 'went Roman'. For Roman conquests were necessarily mapped onto, and realized in, all the multifarious imperialist imagery they could mop up from the repertoire of earlier victors, now their victims. Such is the logic of artistic triumphalism within world domination.

Rome: wonder of the ancient world

The monuments of imperial Rome outstripped even the grandest efforts of Hellenistic monarchs. Pliny strains to find language to capture the massive spectacle of the superpower's skyline:

every time one of the wonders of Rome is put into words it will encapsulate the eight hundred year conquest of the planet—and, suppose the entirety is piled up and gathered into a single heap, then the enormity that will arise in the telling will be nothing short of some alternative universe compressed in a single spot.[7]

Among the wonders of the capital that he singles out as 'the loveliest buildings the world has ever seen'[8] was the first emperor's most vaunted architectural legacy to Rome: the 'Forum of Augustus' (formally dedicated in 2 BCE).

The 'Forum of Augustus'

This 'forum' ('piazza' conveys something of the meaning) comprised a soaring temple of the god of war, here under the name of *Mars Ultor* ('the Avenger'), dominating a square paved with shimmering white marble [113]. It was flanked by twin colonnades which boasted the loudest colours that the quarries of the empire could deliver [114].

Suetonius, in his *Life of Augustus* written in the early second century CE, claims to know the reason for building the Forum:

the teeming population and all the legal cases they generated (far too many for existing facilities to handle). The Temple itself was erected in fulfilment of a vow made by the future emperor Augustus for vengeance on the assassins of his adoptive father Julius Caesar; and he ordained it the place for debating war and awarding triumphs, the point of departure for those going on military command abroad, and where (upon their victorious return) they should dedicate the symbols of their successful campaigns.[9]

113

The Forum of Augustus, Rome.

This much-reproduced plan diagrams Paul Zanker's interpretation of this monument as the most powerful self-image that the imperial Rome of Augustus could design. The site is not the grandest in the chapter, but has played a paramount role in the political and cultural art history of classical Rome.

114

Coloured marbles from the *Forum Augustum*: (**a**) Phrygian purple (*pavonazzetto*) from central Turkey; (**b**) Lucullan red/black (*africano*) from western Turkey; (**c**) Numidian yellow (*giallo antico*) from Tunisia; (**d**) Carystian green (*cipollino*) from Euboea, Greece.

a b

c d

115

Detail of the Forum of Augustus, Rome.

Since the 1960s, and largely through the impetus of the visionary art historian Paul Zanker, the Forum of Augustus has emerged as the crucial monument for understanding the power of images in the Roman empire [**115**]; and it is for this reason that we shall explore its many facets more closely than any other cityscape in the book. The literary evidence for the Forum—which ranges from stray details about its construction to an extended exploration in the poetry of

Ovid (writing soon after its completion)[10]—has always been well known. Zanker's achievement has been to put that together with the archaeological evidence and so to resurrect the original artistic programme. His work showed how the Forum of Augustus was calculated to serve as the paradigm of Augustan political culture, a monument where aesthetics and ideology were perfectly fused, in a harmonious synthesis of civic pride, autocratic power, and artistic perfection. Just as Pliny struggled to suggest (p. 164): the complete realization of politics as art.

Let it sink in. This vast complex covered more than double the area of the whole *Altar* terrace at Pergamum; the *Great Altar* itself would easily have fitted three times over into the Forum's piazza. Not that in Roman terms it was completely out of scale with the lavish building of the previous century. (Already in the 50s BCE Pompey the Great, loser in the Civil War against Julius Caesar, had splashed out on a huge, but now vanished, development on Rome's Campus Martius: temple, theatre, senate house, and a piazza with colonnades stretching almost 200 metres.) But Augustus' Forum was adjacent to the old political core of the Republican city, the Forum Romanum—supplementing it (as Suetonius claimed), but at the same time blatantly upstaging it. No longer was the cluttered, unplanned, antiquated square an appropriate image for the power of the Roman state. Only a unified grand design would do, using the most lavish materials money could afford and vast dimensions to boot: the columns of the temple are almost 18 metres tall, rearing up from a high podium; the back wall still soars to a height of 33 metres. As Suetonius elsewhere trots out (no doubt the official line):

as Rome was not embellished in a style befitting its imperial status, and was at risk of damage by flood and fire, he took such care with its improvement that his boast was justified: 'I took in charge a city of brick, I leave it a city of marble.'[11]

The enormous power of the emperor made such architectural miracles possible, not least because of his control over the raw materials of the empire. The huge quantities of dazzling white marble that were the building blocks of the new Forum came from the quarries of Carrara in the north of Italy, which were first systematically exploited by Augustus (and have supplied Italian masons and sculptors ever since); contrast the local limestone and tufa of the old Forum. The loud presence of exotic coloured stone signalled world domination, no less.

Roman myth and Augustan triumph

Even more than this architectural livery, cultural historians relish the dramatic orchestration of the host of images that decked the monu-

ment: the history of Rome set out in stone, the profusion of artistic styles, the precise geometry of loaded contrasts and strategic juxtapositions—all making up a brilliantly attuned 'ideological message'. In the temple itself, the cult statue of *Mars Ultor* shared a podium with the military standards that had been lost in one of the most shameful Roman defeats ever (by the Parthians on the eastern frontier in 53 BCE), and recovered by Augustus in a bloodless show of diplomacy. This is where Augustus chose to advertise his new regime of salvation, overwriting memories of civil strife with glorious revenge on the great national enemy. Outside upon the temple gable was a symmetrical array of figures: Mars, father of Romulus, in the centre, flanked by the goddesses Venus, mother of Aeneas, and Fortuna; then Romulus, founder of the city of Rome itself, balanced by a personification of the city of Rome on the other side; and in the extreme corners the symbolic figures of the Palatine hill in Rome and the river Tiber [**113**]. Zanker explains that this grouping makes sense (and only makes sense) in terms of the relationship of each figure to the emperor. For example, Venus is here as Augustus' mythical ancestress; the Palatine hill was both the centre of Romulus' first city and the site of Augustus' palace. A bold inscription running along the architrave underneath the gable, and declaring the temple a dedication by Augustus, would have sealed the association—and the emperor's centrality.

But it is in the rows of sculptures lining the colonnades and side-apses (*exedrae*) that the ideological programme of the Forum delivers most impact on modern discussions of the Augustan revolution and its self-presentation. In the central niche of the northern apse wall stood a statue of Aeneas, the Trojan refugee and founder of the New Troy in Italy, celebrated in the new national epic, Virgil's *Aeneid*. To left and to right, he was attended by his descendants—from the first Trojan kings in Italy, through the long line of the Julian clan, to Augustus' adoptive father, Julius Caesar. It was this pedigree that linked the emperor to Aeneas, and through him to Venus and so to Jupiter, king of the gods. Mirroring them in the apse opposite perched Romulus, carrying spoils of war to be dedicated in triumph; around him a choice selection of great heroes of the Republic. Between them the two *exedrae* reaffirmed the dual origin of Rome (its twin founders and hallowed father figures, Aeneas and Romulus), while simultaneously asserting Augustus' claim to combine the two main models of the genealogy of power—on the one hand, the privileges of birth (underpinned by divine origins); on the other, the authority of political pre-eminence (legitimated by the civic traditions of Rome).

Down the length of both colonnades, niches held still more statues of Republican heroes, setting in stone the historical pageant of

Rome immortalized by classic Latin texts, from the poet Ennius to the historian Livy, the poet and satirist Horace, and Virgil. Each one, like the figures in the *exedrae*, was accompanied by an inscription, detailing his achievements; Pliny even entertained the idea that Augustus was personally responsible for the wording.[12] In the centre of the piazza, by decree of the senate, the pivotal statue of the emperor himself rode triumphant in his chariot; and underneath was inscribed the title he was officially granted in 2 BCE, 'Father of the Fatherland'. If in the temple gable Augustus was the implicit centre-point of the design, here at ground level he was paraded, and labelled, as the linch-pin of the entire synthesis of Roman history and power enshrined in the Forum. Augustus presides over galleries of Roman heritage, the culmination of the traditions of the Republic, while transcending the past by gathering it all into his own extended family.

Every single part of the decorative scheme of the Forum was put to work in the creation of 'Augustan ideology'. Above the colon-nades, a band of caryatids (scale models of the famous fifth-century BCE figures from the Athenian Acropolis, cf. **72**) alternated with roundels featuring the outlandish ram-horned god of the Sahara, Jupiter 'Ammon' [**116**]. This amounted to a subtle interweaving of the traditions of Athenian classicism with the mystic aura of Alexander the Great—grandly proclaimed Jupiter Ammon's son (cf. **173 (b)**). Throughout, you would find resonances of Alexander, the world conqueror. 'In the most crowded part of the Forum', according to Pliny, two paintings by the renowned artist Apelles were on display, both starring Alexander—in one alongside the goddess Victory, in the other aboard a triumphal chariot (with the figure of 'War' as his prisoner). The story was that the emperor (and reputed fool) Claudius [**164 (a)**] later saw the point and replaced the face of

116

Reconstruction of the caryatids flanking a shield with the head of Jupiter Ammon on the upper storey of the porticoes of the Forum of Augustus.

The caryatids and the shield have been (re-)created by fitting together surviving fragments from the statues and roundels thought to have lined up, in a series of repeat versions, along the upper storey of the porticoes.

Alexander with that of Augustus.[13] And no glance at the temple facade could have missed a weird pair of bronze statues, two of the figures reputedly used by Alexander as his tent-poles.[14] At every turn this Forum teemed with images of power.

Roman history and Augustan bathos

For all the adulation that modern critics habitually lavish on the Forum of Augustus, it is susceptible to the same battery of subversive arguments that we noted in our analysis of the *Great Altar* of Pergamum. No matter how breathtaking, a monument on this scale could never have avoided accusations of bombast and aggressive hyperbole. No matter how artful the mythological design, there were inevitable tensions that could not be smoothed or wished away. The temple gable blazoned the juxtaposition of Venus and Mars, the founding deities of the Roman race; as we shall see, the pairing may have been repeated inside the temple. But who could have failed to recall the famous song in Homer's *Odyssey* that told of the adulterous affair between the goddess of sex and the incarnation of the warrior— ultimately caught (at it) by her long-suffering, crippled husband, the god Vulcan?[15] The poet Ovid, in fact, when exiled by Augustus, explicitly presses this reading, when he protests to the emperor that any Roman who goes inside the temple of Mars, 'your gift to the world', will find Venus standing 'coupled' with 'the Avenger', while cuckold Vulcan is left outside the door.[16] (Cf. **117**.)

Far graver ironies are raised by the train of Roman heroes in the colonnades. They do make all history lead up to Augustus, but this only underlines the fact that Augustus was the end product of civil war; and that the consequence of his rule was precisely to dwarf and sideline the great men who built the Republic. Distinguishing features ironed out, each in his identical niche, and kitted out with a standard inscription, these soldiers have been homogenized and reduced to a decorative backdrop for the autocrat who now holds centre stage. Besides, it could only be at the expense of the very tradition embodied by these heroes that Augustus could bask forever in the title of 'Father of the Fatherland'.

A monument to projection?

The Forum of Augustus, as it survives, is a quite different kind of monument from the *Great Altar*. There we were dealing with a stupendous feat of reconstruction, which reassembled many of the original components into something like their original form. Visitors to Berlin can approach the frieze and climb that staircase, much as ancient worshippers and tourists once did in Pergamum itself. By contrast, what we have so far shown you of the Forum of Augustus has been a 1:50 scale model, produced in the 1930s [**115**, **118**], and a

similarly modern mock-up of a small section of the upper storey of
the colonnade, which incorporates surviving chunks of caryatid and
Jupiter roundel [**116**]. For very little of the Forum remains: just part
of the back wall, together with three columns from one side of the
temple still standing on the podium (these had been built into the
later monastery of San Basilio); large sections of the walls enclosing
the two *exedrae*; assorted pieces of smashed columns, marble flooring,
and other architectural details; plus a few, pitifully fragmentary and
ruinously worn, remains of statuary and accompanying inscriptions.
We have almost nothing of the piazza and colonnades below the
exedrae (not to mention Augustus' chariot), because more than half
the site is buried under a sweeping highway constructed in the early
1930s, to become the favourite avenue for Mussolini's Fascist parades
[**119**] (see Maps and Plans ii (b)). The only systematic excavation of
the temple itself and its immediate surroundings took place in the
1920s, when the monastery and adjacent buildings were demolished;
but the results have not yet been fully published. This century will
learn the results of fresh excavations on both sides of the roadway.

The Forum of Augustus as we 'know' it is, in fact, a monument to projection; it is a classic case of the ingenious recovery of an architectural design and its sculptural programme through translation of scattered hints supplied by texts, and through a determined search for reflections of the major monuments of the capital in copies and reproductions throughout the Roman empire. Thus our notion of the cult statue (or statues) derives from Zanker's creative combination of a reference in Ovid and an altar found in North Africa [**120**]: Ovid's joke about the 'coupling' of Mars and Venus in the temple, taken together with the altar's design, is held to show that this trio of cult images shared the limelight with the Parthian standards. We shall see later in this chapter (p. 186) that it may not be out of the question to posit such a direct connection between the Forum of Augustus and a group of miniature figures displayed on an altar on the other side of the Mediterranean. On the other hand, it should give us pause that the reconstruction depends on treating the poet's risqué jibe in an uncomfortably literal way, as if everything he talks about derives directly from the sculptural decoration. Are we supposed to make Ovid's cuckolded 'Vulcan outside the door' a statue too (p. 170)?

The rest of the Forum depends on similar processes of reconstruction. Our conception of the statues in the gable is derived solely from what is probably a miniature version of the temple facade, shown as a back-drop to a scene of sacrifice on a later set of relief sculptures [**121**]. As for the caryatids and roundels on the upper storey, only a dozen or so fragments survive. The majority are incorporated into the single impressionistic montage that is reproduced whenever the Forum of Augustus is discussed [**116**]. In fact, this is not so much a

120

Relief sculpture on a Roman altar (the *Algiers Relief*), from Carthage.

The figures represent Venus, Mars, and (probably) the deified Julius Caesar. They have been taken to show the cult images from the temple of *Mars Ultor* in Rome: note how they stand on pedestals.

121

Relief sculpture on the 'Altar of Piety', Rome (plaster recomposition).

Here the facade of the Temple of *Mars Ultor* in the Forum of Augustus serves as the background for a scene of state sacrifice in Rome.

reconstruction as a composite pastiche. We have no real clue how much of the building was decorated in this way, as nothing survives from the porticoes beyond the *exedrae*. Nor—suppose we were to grant a series of roundels—could we be sure that they all showed the same head, whether or not that of Jupiter Ammon. Rival views propose different identifications: a row of barbarian heads, trophies presumably of Roman conquest; or gods interspersed (alternating?) with imperial victims.

The single most ambitious achievement of our visualization of Augustus' Forum, and the one which has made the most impact on our conception of Augustan culture, is the scheme of the *exedrae* and colonnades [113]. The notion of a salient symmetry between Aeneas and the Julian clan to the north, and Romulus surrounded by Republican worthies to the south, is based on two slender arguments. First, we have rough findspots for scraps from perhaps half a dozen inscriptions belonging to each of these groups. By and large, those commemorating Aeneas and his descendants are concentrated in the north, the others in the south. Second, we have an impressively detailed imaginary visit to the Forum, in the course of Ovid's generous celebration of the anniversary of its dedication.[17] The poetic conceit is that Mars surveys 'his' Forum, as it would look from his place on the gable:[18]

Over here he sees Aeneas laden with the burden of love
 And the roll-call of grandsires of the Julian lineage;
Over here he sees the son of Ilia bearing on his shoulders a marshal's arms
 And sees that bright achievements underpin the serried ranks of
 heroes.

122 a, b

Aeneas and Romulus, from the doorposts of the Fullery of Ululutremulus, Pompeii (see Maps and Plans 3 (q)).

To one side, that is, in the northern apse, Mars sees Aeneas (carrying his father from the ruins of Troy, as the myth had it); to the other, in the southern, Romulus brandishing the spoils he has stripped from an enemy chieftain—statues which are thought to be reflected, to take just one example, in a pair of paintings from Pompeii [**122**]. According to the grand theory, then, Ovid has homed in on the key principle of ideological dialectic, made concrete in the spatial logic of Augustus' Forum.

In fact, although Ovid's text does allow the reading of Aeneas and co. to the right, and Romulus and the rest to the left (looking as Mars would from the gable), 'over here (*hinc*) … over here (*hinc*)' need not indicate any opposition between two groups of statuary, and cannot clinch any particular recreation of the overall design. Nor can any of the other assorted pieces of literary evidence, which repeatedly point in contrary and even irreconcilable directions. Suetonius remarks that Augustus put statues of leading men 'in both porticoes of his Forum', which could mean the *exedrae*, the colonnades, or both;[19] a later biographer of the emperors speaks of Augustus placing marble statues of 'great men' in the Forum,[20] whereas the historian Dio Cassius, writing in the early third century CE, had referred to bronze figures of victorious generals on the day of its inauguration;[21] and so on.

The standard reconstruction of the Forum works by sifting through the surviving material, both the remains on the ground and the literary evidence, to produce a single version of the design. It is a process of selection, of preferring some pieces of evidence to others, of discarding what does not easily fit. The gain is a triumphant evocation of arguably the most important 'lost' monument of the ancient world; the cost, inevitable oversimplification and a public building sanitized of all the garish clutter and proliferating mess of a living social space. In the single-minded pursuit of schematic coherence, major and well-documented themes in the original design must be lost to view. One Roman writer picks out a display of conquered peoples (including the provinces of Spain) as a feature of the Forum;[22] and one of the few things to survive intact from there is the complete text of an eloquent inscription which records the dedication of a statue in honour of Augustus, 'Father of the Fatherland', made on behalf of one of the provinces in Spain, in thanks for his 'pacification' of their region—a statue made out of '*a hundred pounds of gold*', as the text boasts.[23] If you were to foreground this element, the Forum would have a very different flavour.

But, in the process of reconstruction, far more important is the exclusion of history from the Forum. We have stressed throughout this book that the works of art we are exploring exist through time, and the moment of their production is only the beginning of their

story. By focusing exclusively on the inauguration of the monument and its paradigmatic role in the ideology of the Augustan principate, we lose sight of the developments in its appearance and significance over the centuries that followed. Yet virtually all the literary evidence and a good deal of the archaeology is, of course, post-Augustan. Under the emperor Tiberius, a pair of commemorative arches was built, one at either side of the temple of Mars;[24] repair work under Hadrian gave the Forum a face-lift;[25] most striking of all, to celebrate the emperor Nero's response to a Parthian invasion which never came, the senate is reported to have honoured him with a statue inside the temple 'the same size as Mars'.[26] Its canonical encapsulation of Augustan culture is one major aspect of the Forum; but what mattered in the long term was precisely its capacity to incorporate and represent the unfolding saga of Roman power.

Rome as monument and ruin

That saga has continued through the centuries since the collapse of the Roman empire and its political order. Rome has been a major city occupied continuously since antiquity, its ancient monuments exploited and adapted for one regime after another, or discarded and replaced by successive developers. The Forum of Augustus is caught up in this history. What remains is thanks to the medieval Christian church, which turned the trio of columns into support for a bell-tower, preserving them in the process. On the other hand, the obliteration of the colonnades is the by-product of twentieth-century dictatorship and its super-charged road scheme. Similar stories lie behind the

123 a, b

The Pantheon, Rome, early second century CE: **(a)** facade; **(b)** vault and 'eye' (p. 176).

(a) A weird and unprecedented temple dedicated to 'All the Gods' (in Greek, *Pantheon*). The second-century CE builders emblazoned across its porch *"Maker: Marcus Agrippa, thrice consul"*, to commemorate the original foundation of a temple on the site by Agrippa (p. 225) in 27 BCE, the year of his third consulship. Hadrian's rebuilding is thus 'modestly' represented as a restoration; but, since 27 BCE was commonly taken to date the inception of the rule of the Caesars, Hadrian also tacitly associates himself with the very founding of the imperial order.

124 a (pp. 178–9), **b, c**

Trajan's Column, Rome, *c*.113 CE (see Maps and Plans 11(b)).

The former bell-tower of the church of S. Nicola de Columna – *Trajan's Column*. **(a)** As it is today (still challenging the Roman skyline, but rivalled by the modern monument to Vittorio Emanuele II); **(b)** an axonometric reconstruction of the Forum complex, showing the column as enclosed within the complex and a recent interpretation of the much debated north-west façade; **(c)** gold coin of Trajan, 112/14 CE (despite its enclosed position, the column is here imagined in splendid isolation).

preservation or destruction of every other monument of imperial Rome: the emperor Hadrian's cosmic 'Pantheon' still soars to its full height, courtesy of its conversion into a church in 608 CE [123] (see Maps and Plans 13); 11 battered columns of the temple dedicated to Hadrian himself, after his death, now frame one wall of the building that houses the Roman stock exchange. Rome's greatest temple, to Jupiter 'Best and Greatest', has, on the other hand, been almost totally lost beneath Michelangelo's palatial city hall on the Capitoline hill.

An odd remnant: *Trajan's Column*

One of the most extraordinary survivals, and a monument that has become emblematic of classical Rome, stands only a few metres away from the Forum of Augustus. *Trajan's Column* was originally designed as a tour de force to top off the mammoth Forum of Trajan, the largest in the series of imperial fora, which were all laid out in a row as one ruler after another sought to outdo his predecessors. The culmination came in the early second century CE, with Trajan's complex extravaganza boasting basilica, libraries, and markets plus colonnaded piazza and two pairs of *exedrae* stacked with sculpture. It was probably all capped, under his adopted son and successor Hadrian, with a Temple of the Deified Trajan (this is a fixed feature on many modern plans, but recent excavations have found no definite trace of it; see Maps and Plans 11 (b)). More than three times the size of Augustus' Forum, this too once staggered under the weight of marble fetched from all over the known world and vast galleries of statuary. Trajan meant to have the last word in imperial megalomania—successfully it seems, at least for a while. When the fourth-century emperor Constantius came to Rome for the first time in 357 CE, a contemporary historian captured his reactions to the Forum, among the other wonders of the city: 'he was thunderstruck and stopped in his tracks, mentally traversing the gigantic designs all around; they were impossible to express in words and would never again be within the reach of mortal ambition'.[27] Now there is little to see but the *Column* [124].

This *Column* has led a charmed life. Acting for centuries as an overblown bell-tower for a tiny medieval church planted at its base, it was the first relic of ancient Rome to be treated by the Renaissance as an archaeological monument; and in 1588 the pope stuck the specially commissioned bronze statue of St Peter on the top (where originally Trajan had perched, though lost since antiquity [124 (c)]). At the moment of its creation, the *Column* was an extraordinary innovation, a more-or-less unprecedented reach for the sky. But in Roman times it did not stand in anything like the stark isolation on which its iconic status today rests. Instead it served as the pivot around which the giant buildings of Trajan's Forum clustered.

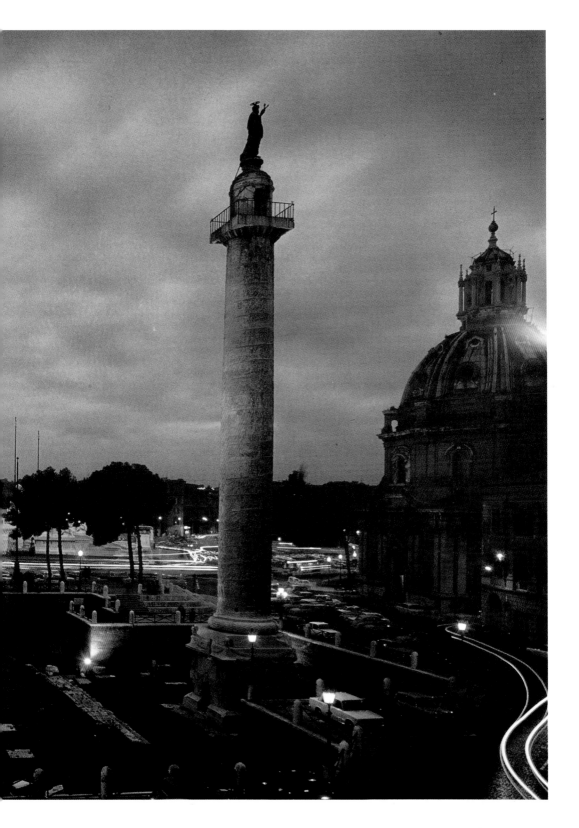

125

Detail of *Trajan's Column*,
Rome.

River Danube gives a helping
hand to the Roman army
marching out of their fort/out
of the Column: section of the
lowest register of the frieze.

Reading *Trajan's Column*

Many modern discussions of the *Column* get entirely preoccupied with the inspiration for the maddening helix of sculpture [125] wound 24 times round the shaft from base to parapet. Was it, for example, a fantastically magnified Roman book-roll? Or a stunt adapting the decorated obelisks of eastern potentates? Plenty of other critics home in on the problems of 'reading' this pictorial text in stone, most of which fades into an indistinguishable blur from ground level. Were there perhaps viewing platforms up in the imperial libraries that flanked it? Would the application of paint have made it all much clearer to pick out? Were ancient viewers supposed to follow the story of Trajan's Dacian Wars round and round the column, in a dizzying helical spin?

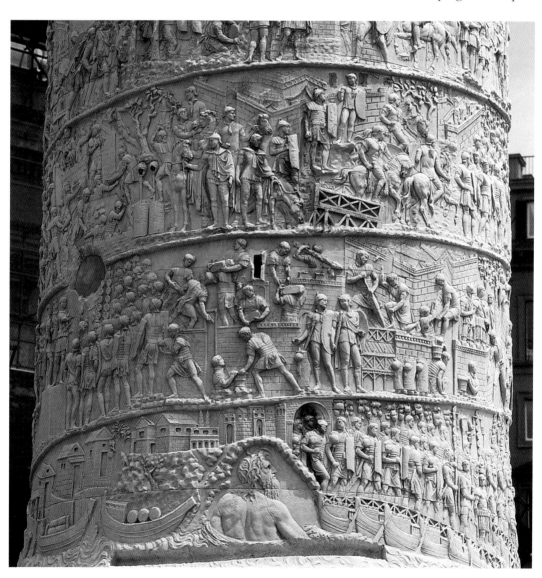

126

Reading *Trajan's Column* vertically.

A diagram of some vertical connections (?) visible on the column. Trajans are in black, the king of the Dacians shaded.

Or could you stand in one place, resist the cartoon-strip pull of the narrative, concentrate on the telling symmetries and correspondences that work up and down the column, vertically across the bands [**126**]—and ignore the crick in your neck? Almost everyone who has studied the column seizes the opportunity to celebrate its distinctively Roman idiom: a sustained narrative just over 200 metres in length, with 2,639 figures (including 59 Trajans!) in over 150 scenes, each one packed with authentic details of Roman armour and military engineering, hordes of barbarian victims, and the whole panoply of all-conquering imperial triumphalism.

Ancient commentators, however, prompt different lines of thought. Dio Cassius stresses that the *Column* was meant to mark Trajan's grave,[28] and the ashes may once have been enshrined there, deposited in a gold urn 'beneath the column'. (Were they really stored on a shelf in the chamber within the base that was opened up in 1906 and published as 'Trajan's Tomb'?) With his colossal bronze statue towering almost 40 metres above ground level, the monument literally enacts the emperor's ascension to the heavens. Dio adds that the *Column* advertises the feat of engineering represented by Trajan's Forum, echoing the words of the Latin inscription still displayed on the base of the monument: 'this is to show the great height of the hill that has been excavated and the scale of the works required to clear the site'. Likely story or not, we are encouraged to think of titanic labours, mountains moved, empires built—the same godlike power of Rome and its emperor as bridged the Danube and conquered the steppes of Dacia. Close reading of the sculpture's intricate narrative is confounded by the very scale of the gargantuan project. The sheer spectacle of all this precision stonework (264 m²) soaring beyond the reach of any human eye is surely the essence of this archetypal *folie de grandeur*.

Reach for the skyline: the column after Trajan

Sky-scraping or stumpy, the column has been in fashion ever since, as *the* symbol of bravura magnificence (and with the built-in advantage of requiring the minimum of ground area, always at a premium in city centres, for the maximum of impact on the horizon). Less than 50 years after Trajan's death, another Roman emperor wound up atop a second column, one built to match Trajan's. The Column of Marcus Aurelius, built after his death in 180 CE, was the same height, decorated with the same scheme of helical reliefs (this time celebrating Marcus' wars against the Germans), and imposed the same message of transcendent Roman glory. In 1589, Pope Sixtus V twinned them still more closely, when he crowned Marcus' column with a statue of St Paul—to pair with his St Peter, on top of Trajan's [**5 (g)**]. The tradition was continued in the New Rome of Constantinople (p. 89), where the short-lived prince Arcadius joined in the game, with a ver-

sion commemorating his victory over the Goths, an effort that stayed vertical from the early fifth century into the seventeenth century. But the column is most familiar in our lives from the capital cities of modern Europe: nineteenth-century France dropped the plan of dismantling *Trajan's Column* itself and hauling it off to Paris; instead the Place Vendôme saw Napoleon, dressed as a Roman emperor, surmounting a brand new French clone more than 40 metres high, and festooned with spiralling sculptures of victories of his own 'Great Army'. Appropriately enough, it was an act of political revolution that tore this column down in 1871 [**127**]. Nelson, on the other hand, is still up aloft with the pigeons in central London: his plain granite column, uncluttered by any triumphal narrative, sets him over 50 metres up above the grand piazza below. Sadly, a 1999 millennial proposal to install a giant marble pigeon (8 metres long) in Trafalgar Square below Admiral Nelson came to nothing.

Towards the Marble Arch

Roman architecture has given the modern world a still more characteristic and easily replicable monument of power: the marble arch [**128**]. The particular form of the 'triumphal arch' (erected in grand celebration of military victory) can be traced back to the Republic. Augustus typically developed the pattern to suit his new political regime, combining the commemoration of military success with the glorification of his own dynasty. So, for example, an inscription recently discovered in Spain details the whole range of state honours voted by the senate in memory of the dashing prince Germanicus

129
Napoleon steals the chariot group from the top of the Brandenburg Gate, Berlin, 1806.

130
Roman *denarius* of 19 BCE, showing the (lost) Arch of Augustus, Rome.

(the great white hope of the dynasty, apparently poisoned in 19 CE on active service out East), including no fewer than three triumphal arches: one in the heart of the capital; one in Syria where he fought and died; the third on the bank of the Rhine where his father had perished. On top of the arch in Rome the senate decreed a whole family group, presumably in bronze, showing not only Germanicus himself in a triumphal chariot, but also his father, mother, wife, sister, and brother (the future emperor Claudius), plus his sons and daughters—perhaps a dozen figures in all.[29] As always the arch served as a giant pedestal [**129**]. Like the column, it lifted the conquering general way above the mundane world below; not so high maybe, but the arch, spanning the street, obliged ordinary folk literally to pass beneath the general's feet [**130**].

Ascension at the Arch of Titus

Of the 34 known triumphal arches in ancient Rome, the earliest to survive is the Arch of Titus, put up in the reign of his brother and successor, Domitian, in the early 80s CE [**131–2**; see Maps and Plans II (a)]. Always one of the main landmarks of the city, what we see today is the result of a thorough makeover in the early nineteenth

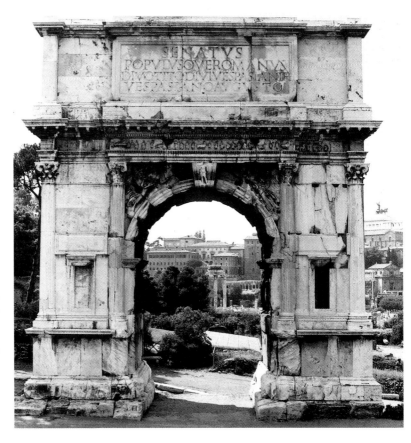

131
The Arch of Titus, *Forum Romanum*, Rome, *c*.81 CE, as restored.
The arch was carefully dismantled by G. Valadier in 1822 and heavily restored, to be put back on proud display as a free-standing highlight of imperial Rome.

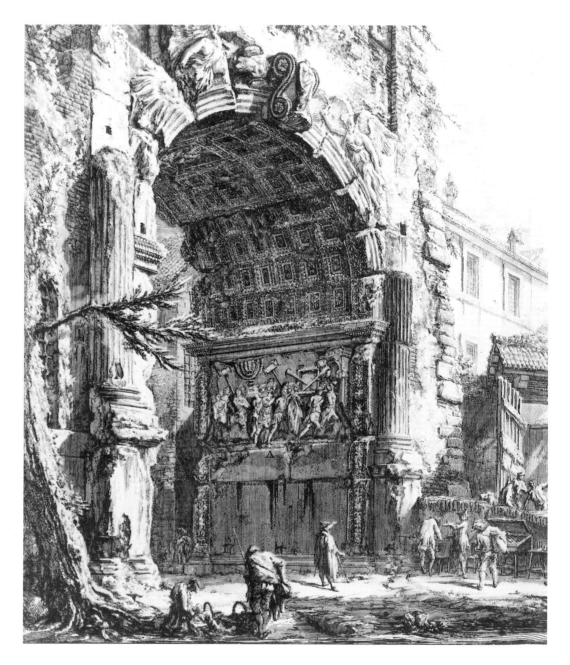

132 G. B. Piranesi

View of the Arch of Titus, etching from *Vedute di Roma,* 1760.

In this view, the arch is still topped by the medieval superstructure which protected it through the centuries.

century, when the arch was disentangled from its medieval surround. Dominating one end of the old Roman Forum, this massive marble gateway, over 14 metres high, must originally have been festooned with sculpture from head to foot; the 'roof' will almost certainly have sported the characteristic bronze statue of the triumphal prince aloft in his chariot. The ambitious relief panels that survive in the passage beneath the arch itself still celebrate the emperor Titus' great triumph [**133**].

133 a, b

Marble reliefs from the passage of the Arch of Titus, showing **(a)** triumphal procession; **(b)** spoils from the sack of Jerusalem (70–1 CE).

(a) Titus (now dead and deified) rides in his triumph 'over the Jews'. His team of horses wheels out towards the viewer, proudly breaking the flat plane of the marble (better preserved in **132**).

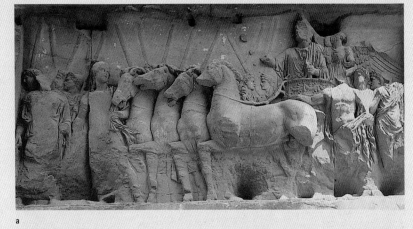

a

(b) Titus' legions march in the triumph. They brandish the pick of their loot from the Temple, the leaders apparently marching back into the depths of the monument – through, precisely, a marble arch of their own. This triumph of perspective shows off the technical bravura of ancient sculpture at its most daring.

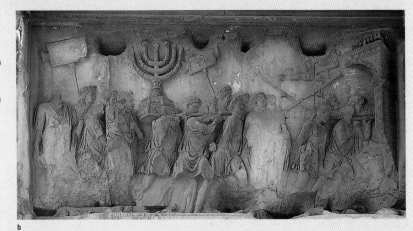

b

134

Relief panel in the vault of the Arch of Titus, showing the emperor's ascension.

But here too there is a sting in the tail. For any Romans who chose to stare right up to the ceiling as they walked through the passage, the monster arch offered another sacred image of imperial power [134]. At the apex of the vault you could see a mighty eagle carrying the emperor Titus clinging on its back—out of Rome, heavenward. In another audacious coup of artistic illusion, the sky seems to part and reveal the bird in flight, his talons, legs, and underbelly exactly as they would appear from below; while his passenger, the emperor-god, peers straight down his aquiline nose at us, over the beak. A striking conceit. Yet, at the same time, it exposes another of those inherent paradoxes within the rhetoric of power: not on this occasion a case of brute size risking collapse into bathos (as we saw at Pergamum), it is rather the problem of metaphor under strain. It is one thing to put the story of the emperor's miraculous apotheosis into words, or even to act out his separation from humankind just in sight, 40 metres up a pillar in the clouds. It is quite another to dare to embody and literalize his flight from human to divine condition. Holding tight, on the back of this all too powerfully 'real' predator, he can look much more like the victim of abduction than the majestic hero cruising serenely on his way to his appointed place in heaven. More a Ganymede than a god (cf. **56**).

Writing Rome all over the Empire

When we were exploring the reconstruction of the Forum of Augustus, we saw how the design of an altar from the city of Carthage had been used to recreate a group of cult statues in the temple of *Mars Ultor*. This is a more plausible manoeuvre than it might seem on the face of it. Not only does the panel from the other side of this very altar carry an image which seems to reproduce a surviving sculpture from the *Ara Pacis* ('Altar of Peace') at Rome [135] (see Maps and Plans 10, 11 (a)); but, in general, it is clear that there was heavy traffic in images and iconography between the capital city and its ring of provinces, and that images were themselves a strategic and high-profile medium of Roman imperialism. Those arches which the senate voted in memory of Germanicus (p. 182–3) spanned the Roman world, from the mountains of Syria to the river Rhine. And, as we shall see in the next chapter, centrally approved likenesses of successive emperors turned up in every province of the empire: stylized portraits that ranged from showpiece statues on a colossal scale, to the myriads of tiny imperial heads stamped on the small change which saturated urban life under the Caesars. Rome was an empire of images.

The impact of this dissemination of the emblems of imperial power, as well as the complexities involved, comes sharply into focus if we turn to one particular category of visual display: written

135

Italy (or Earth), relief sculpture on a Roman altar from Carthage.

Compare the relief on the Altar of Peace (**136**).

inscriptions, monuments of words. For *writing* played a massive part in forming the visual environment; not all of it a masterpiece of calligraphy, but a crucial part of the impact (aesthetic and political) of the architecture and sculpture of each and every city of the Graeco-Roman world. We have already seen the connection in the Forum of Augustus between the statues of heroes and their inscribed bases (pp. 168–9, 173), and, in addition to Germanicus' arches themselves, copies of the senatorial decree which authorized them were sent out across the empire and written up on sheets of bronze for public display.

<div style="background:black;color:white;padding:4px;">

Ara Pacis

</div>

The Altar of 'Augustan Peace' at Rome marked Augustus's return from conquest in Gaul and Spain in 13 BCE. Dedicated in 9 BCE, it marked the renaming of the Roman empire as world 'pacification'.

Originally built on the Campus Martius beside the road to the north (*Via Flaminia*), it consisted of a precinct wall surrounding a sacrificial altar. Sacrificial motifs adorned both the altar and the inside walls of the surround. A series of panel reliefs on the outside showed founders of the city and divine figures of national plenty—Aeneas and Romulus; Rome and Italy (or Earth, or Peace [**136**]). On the sides unbroken by entrances, a pair of processions massed up to 50 inhabitants of Rome each— the extended imperial family on one side, following Augustus and Agrippa accompanied by priests, attendants, and magistrates [**172**], and on the other, more priests and magistrates, with a train of citizens. Two centuries later, the monument was encircled by a further protective wall, since ground level had been raised three metres.

Odd pieces had turned up earlier, but the bulk of the buried and shattered altar was extricated from the foundations of a modern building in the 1930s, by an elaborate process in which the water-logged ground was frozen solid. Mussolini had the fragments reassembled (and heavily restored), and encased the results in its own glass box, beside the Mausoleum of Augustus, in a newly cleared piazza devoted to Augustus: a copy of the emperor's *Achievements* is still incised on the side of the shed, facing the mausoleum where Augustus had himself arranged to display the text on bronze columns beside its entrance.

136

The 'eastern' face of the Ara Pacis, Rome, showing Italy (or Earth) on left of entrance.

137

The outside wall of the Temple of Rome and Augustus, Ankara, *c.*15 CE.

The text splashed across the wall has deteriorated through exposure in the twentieth century. But impressions of the text ('squeezes') taken by Humann (who in 1881 talked his way into the houses that were then abutting, and so protecting, the inscription) are now the best record of Augustus' *Achievements*; still safely housed in Berlin.

The paradigm case of a text monumentalized, displayed, and disseminated outwards from Rome is Augustus' own account of *His Achievements* (his equivalent of *Mein Kampf*). According to Suetonius, Augustus left instructions for this to be inscribed on bronze pillars outside his royal tomb in the centre of Rome.[30] These do not survive; but we do have versions from three very different monuments, all in Asia Minor. The most fully preserved was inscribed on the walls of the temple of 'Rome and Augustus' in Ancyra (modern Ankara): in Latin on either side-wall of the entrance, and in Greek paraphrase virtually taking over one of the outside walls [**137**]. The others, now much more fragmentary, are from two cities in the same provincial backwater: Apollonia, where a Greek version was emblazoned across a wall or statue-base of some kind, perhaps designed to carry images of key members of the imperial family, whose names may have appeared in a row above the text; and the nearby town of Antioch in Pisidia, where the Latin version—energetically smashed to pieces later in antiquity—seems to have been inscribed on the ornamental gateway that straddled the stepped approach to another stylish Augustan temple, set in a precinct that matches *Mars Ultor*'s in Rome for size (see Maps and Plans 18). On the one hand, the bulky text engraves the emperor's power into the very fabric of these farflung provincial cities; the Ankara version even has a heading which explicitly defines what follows as a 'copy' of the original back in the metropolis. On the other, the different contexts of each of these versions demonstrate the scope

The view from the temple, still buried beneath a modern house, to the monumental gateway. The finds from the arcade, stretching over 90 metres, already represent the largest single haul of Roman sculpture ever made. So far roughly half of the original 190 slabs of the sculptural decoration have been reassembled, often from smashed fragments. The building suffered throughout its history (even during construction) from damage by successive earthquakes.

for adaptation possible even within the regime of word-for-word transcription. Augustus' aggressive assertion of world mastery was itself reappropriated and deployed afresh in devising an individual slant for each city, within a common language of art and power.

The world of art at Aphrodisias

Now for the most spectacular recent discovery of Roman imagery—also in Asia Minor, hundreds of miles away from the capital itself. Here we shall find these issues of replication, played out between central authority and local initiative, inflated to a gigantic scale.

In the course of on-going excavations at the Hellenistic and Roman city of Aphrodisias in south-west Turkey (named after its patron goddess, Aphrodite) an elaborate processional arcade has been unearthed. It leads up to a temple almost certainly dedicated jointly to Aphrodite herself and the divine imperial family of Rome—in Greek, 'Theoi Sebastoi'. The whole complex, sponsored by two families of local magnates, was built during the first half of the first century CE, in marble from nearby quarries [**138**]. Each portico carried two bands of sculptured panels on the upper storeys. The ground floor had an open colonnade, giving on to shops or stores behind. On one side, the topmost register showed emperors and

members of the imperial family, interset with Olympian gods and a welter of other supernatural figures [**139**]. Below, a long row of mythical scenes stretched from one end to the other, many still instantly recognizable (such as Aeneas carrying his father out of Troy, or the Three Graces), others thoroughly opaque (for example, using the excavator's working titles, 'Three heroes with bitch', 'Seated hero with dog'). Facing them from the other, now gravely depleted, side, allegorical personifications—cosmic entities?—seem to have lined up (only 'Ocean' and 'Day' survive) above the parade of 50 panels on the storey below. Each of these carried a single standing female statue, upon an inscribed plinth, to represent a tribe, nation, or island which had felt the wrath and might of Rome under Augustus. These ranged from fresh conquests to newly reorganized territories, from famous adversaries of the empire (the Dacians and the Jews) to the frankly arcane (the 'Trumpil[in]i' were an obscure Alpine tribe that almost nobody in Rome, let alone Aphrodisias, would ever have heard of).

In some stretches of the porticoes we can be confident in recognizing an interplay between different panels. One of the figures of Augustus, in the topmost register, is shown directly above the flight of his ancestor Aeneas from Troy; elsewhere a Victory is flanked by

139 a, b

(a) Relief panel from the south portico of the 'Sebasteion' at Aphrodisias.

Augustus the cosmocrat, ruling land and sea.

a

(b) Relief panel from the south portico of the 'Sebasteion' at Aphrodisias.

The Roman emperor Claudius supportively despatches his victim Britannia.

Claudius triumphant over the province Britannia on one side [**139 (b)**] and his successor Nero, with a submissive (presumed dead) Armenia on the other. Overall, however, not quite enough survives, and the artistic language draws on too many different idioms (from traditional mythology, Greek or Roman, to intellectualizing abstraction and imperial portraiture), for us to be able to make out some grand design for the whole artistic programme. What is clear is that the visitor was put through a claustrophobic procession of masterful images of power. The effect, in short, approached saturation bombing of the visual field.

This massive investment immortalized its sponsors, the two local families we mentioned. It is as clear an indication as you could wish that art and power intersected at the level of local prestige and politics, and that provincial communities could be active partners in the world-

wide traffic of images between centre and periphery. The message no doubt concerned the grand strategy of Rome and its imperial rulers, but the chance to launch this message in their home town was an ideal opportunity for self-promotion and self-advertisement on the part of the donors. The same mixed motives surely lay behind the choice of images and design. In some respects, the arcade display must have been the product of information and instigation from the capital: the imperial portraiture and atlas of far-flung conquered tribes presumably derived from central models; the dedication would have needed the blessing of senate or emperor; and Roman governors of the province would no doubt have become involved. But other features—the specific plan and its landscaping; all this local stone, money, and craftsmanship; the gallery of traditional themes in Greek art—point to initiative and creativity from the Aphrodisians themselves.

As usual, we cannot document reactions to the edifice. Visitors could hardly avoid speculating what imperial lessons it might mean to inculcate, but would also form their own impressions. Was this a garish monstrosity imposed by Big Brother? Was their noble old city showing brute Roman militarists how a tribute to urbane culture should look? And, above all, perhaps: what about those images of conquered provinces? Provincial subjects might not mind identifying with the row of matronly marble figures which paraded Augustus' foreign 'successes'. But what could they make of the pitiful nakedness of Britannia or Armenia, at the mercy of their imperial captors [**139 (b)**]? Whose side should they think they were on? And was this responsible imperialism, naked aggression, or Rome's promise to police the civilized world?

Small is beautiful too

So far our exploration of images of power has kept to massive scale: vast intrusions into the cityscape, colossal elevations into the sky. But, as we saw in Chapter 3 (pp. 142–5), mastery comes in diminutive form too. Power can pour into precious detail and swagger through extravaganzas in miniature, its images reaching into dining rooms, boudoirs, wardrobes, at home in any domestic niche.

As Chapter 1 proposed, the best place in the Hellenistic and Roman world to capture the texture and apparatus of the ancient household is in Pompeii and the other sites buried by Vesuvius in 79 CE. In fact relatively few portable objects made in precious materials have been discovered there; naturally enough, as people fled for their lives they would have taken what valuables they could carry with them (cf. **165**). But in a couple of cases, people decided to sit on their treasure, or stash it away in the hope of returning later, and these caches stayed undisturbed until they were turned up by modern excavators.

Tragedy at Boscoreale: the 'Silver Cups'

One extraordinary collection, of silverware, gold jewellery, and a bag full of a thousand gold coins, was discovered at a working farmhouse on an estate a few kilometres outside Pompeii, at the modern village of Boscoreale (see Maps and Plans 6). The story goes that the bulk of the haul was found in 1895 in a cramped wine tank two metres below ground, together with the corpse of a man who had holed up with it. After shady dealing of one sort or another, most of the silver was bought by the millionaire Baron Edmond de Rothschild for the Louvre in Paris.

This collection includes all sorts of objects, from simple spoons and elegant mirrors to showpiece goblets and plate for bravura display. To what extent the nucleus of the treasure is to be seen as a coherent set of tableware, let alone a single dinner service, is far from clear. Most probably it was assembled in the course of the first century of the empire, including specially commissioned, brand new, second-hand, and antique pieces: indeed, successive owners of one particular pair of vessels have been recognized in the names engraved on their base. Amongst the many pieces whose design invokes the practices of Roman wining and dining (baskets of fruit, clusters of olives, garlands, and game ready for the table), two immensely learned cups stand out. These contrive to gather onto a surface you could hold in your hand all the store of urbane culture and party-goers' philosophy that a full-scale gallery, such as we saw at the Villa of the Papyri at Herculaneum (pp. 93–4) would struggle to accommodate [140].

An utterly different mood is struck by another pair of drinking vessels in the hoard. These had particularly exciting adventures in the twentieth century: originally reserved by Rothschild for his own private collection, they did not resurface to join the rest of the silver for 90 years. In the meantime, they were rumoured lost, destroyed, or worse. This pair manages to shrink down four scenes from the repertoire of imperial state sculpture, wrapped around the cups in relief [141]. Most art historians, in fact, feel that the cups look so much like monumental marble reliefs that they must be direct 'copies' of a specific imperial arch or frieze, marvellous feats of miniaturist realism. If this were so (there is no firm evidence either way), it would give one more twist to the tale of Imitation that has been such a major theme in this book.

The fact that this spread of imperial images finds its way into the domestic lives of the Pompeian elite matters far more than the question of whether it is a faithful copy, or an impressionistic evocation, of large-scale monumental art. The power of the emperor worked no less at the level of private possessions and personal treasures, in households all over the Roman world, than at the level of mighty

140

One of the 'Skeleton Cups' from Boscoreale.

Two (skeletal) Greek philosophers: 'Zeno of Athens' on the left, pointing at 'Epicurus of Athens', who stretches his hand towards a large cake (?); above his hand, his motto, 'Pleasure is the goal of life.' Elsewhere on the cups, uproarious skeletons live it up (just like the 'real-life' guests, attended by a – suitably smaller – skeleton staff). Some funsters do without names, but others (as here) are labelled as Greece's greatest sages and bards; more wisecracks and wise words are neatly pricked out around them –'Life is a stage', 'This is man', 'Respect this shit' (inscribed next to one skeleton pouring a libation over a neat pile of bones of another). A message for any party.

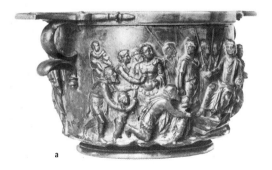

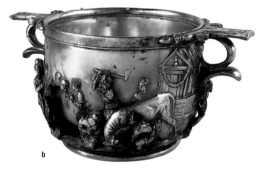

141 a, b

The 'Boscoreale Cups'.

(a) The emperor Augustus receives submission and soaks up adoration; on the other side, he reappears, enthroned as cosmocrat, flanked by the obligatory Venus and Mars.

(b) A public sacrifice before a temple; on the other side, a Caesar in triumphal procession.

piles of masonry raised by the majesty of the Caesars to dominate the cityscape. A banquet could put emperors into the hands of guests, a commanding presence even in drunken conviviality; a few centimetres tall, perhaps, but here was the head of state invading his subjects' private lives and casting as ever a severe eye over their every move. Yet, as we saw both in the Forum of Augustus and at Aphrodisias, plenty of other reactions were possible. Given the particular mixture of images represented in the silver from Boscoreale, there must have been many a reveller who wondered in his cups whether planetary ruler and jolly skeletons were not blurring together, wiping out all sober distinctions between high and low.

The crown in the jewel: the *Great Cameo of France*

There are other contexts in which we find a miniature display of imperial images. We shall be looking at individual portraits on coinage and gems in our final chapter, but here we shall concentrate on one of a small group of overwrought early imperial cameos. This strange object (about 30 by 25 centimetres), now generally known as the *Great Cameo of France*, was crafted from sardonyx—a natural precious stone with layers of different hue, which can be cut away to produce scenes with dramatic colour contrast between figures and background [142]. It has always been taken to be an extravagant piece of courtly luxury, part of the spectacular ambience of the palace, or perhaps intended as a lavish presentation piece to or from the emperor himself. A celebration of its own costly virtuosity, the *Cameo* declares itself a precious object for safe-keeping, a security risk outside treasury or bank vault; and this must be the secret of its survival. In the Middle Ages it was one of the prize objects of the Treasury of the Church of Sainte-Chapelle in Paris, supposedly one of the treasures of imperial Rome brought back by Crusaders from Constantinople.

There has been a huge debate about what is pictured on this cameo. Until the seventeenth century, it was identified as the biblical scene of 'Joseph at the Court of Pharaoh'; in modern times it has universally been seen as a miniature portrayal of the early imperial court of Rome, and regularly presumed to be a reduced version of some major (and lost) state monument. The most striking aspect of this gem is its ambitious bid to represent the complexities of evolving dynastic power within such a tiny field. There is no call to invent any original large-scale version. And more important than the precise identification of the individual figures is the mapping of the imperial regime as a hierarchy of three layers: heaven, Roman court, and subjugated Other. This amounts to setting out an exuberantly aggressive bid for immortal status on behalf of the first dynasty of emperors and their political system, and involves excluding Roman citizens and

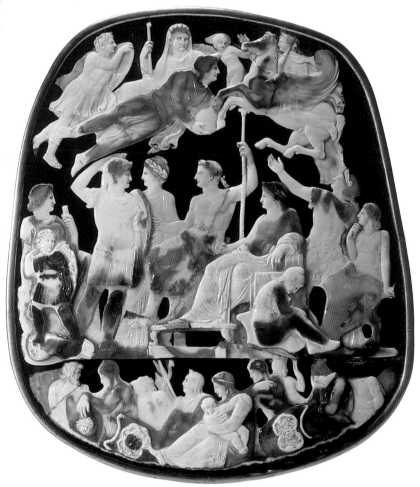

Great Cameo of France.
Exactly which emperor and which members of the royal family are depicted is interminably disputed. One plausible interpretation has the emperor Tiberius enthroned *à la* Jupiter in the centre of the gem, directly underneath his predecessor Augustus aboard an 'angel' in the heavens, already a god. On either side two imperial princelings mount to heaven, one surfing his shield, the other aboard a winged horse. On the lowest register defeated barbarians huddle at the feet of their conqueror.

society entirely from view. It is as if the only things that count in this ideological projection are mundane, once and for all, domination of the enemies of Rome (any further obligations of governance and administration are ruled out by the blank separation of the two lower registers). That and celestial traffic between the power of the emperor and the power of the gods.

The *Great* (Big) *Cameo* does indeed give a daring diagram of dynasty, a *jeu d'esprit* trading on the strengths of its precious compactness to make explicit some of the largest claims imaginable about imperial power and its relations with the divine. But, as we have seen repeatedly in this chapter, the rhetorical weight, stress, and pressure that go along with the superlatives required by panegyric have a nasty habit of lurching towards the unstable, and even toppling into the ridiculous. Here, for instance, the claptrap of imperial apotheosis has to dream up an eye-catching Oriental 'angel' to play the divine Augustus' 'cloud' in heaven—and let it steal the show. Such risks of

bathos are not restricted to the colossal. Here the very miniaturism which licenses the simplifications of this jewel's diagram of power itself frames a tension between the vastness of the claims and the scale on which they are realized: all this pomp and bluster, but now on an incongruously tiny scale.

Table Hercules

The dynamics of scale, along the entire spectrum from minute compression to towering expansion, was a brute determinant of the impact any image-bearing artefact or monument was likely to make, particularly on first impression. A very large proportion of the artworks featured in this book were reproductions, versions, and variations which involved alteration of their inspirations' size. (Books themselves are, of course, not least effective as quintessential engines of reduction: with the best will in the world, no emperor can be more than a thumbkin in our photographs.) We find ancient artists revelled in playing drastic games with dimensions. A particularly explicit example of this crops up when two Roman poets working in the later first century CE congratulate a courtier and art collector for his coup in displaying a (semi-) precious statuette of Hercules, the strongman among Roman gods, at a dinner party. Martial, in a pair of his epigrams (appropriately enough miniature poems),[31] lauds the feat of representation involved: this divine guest was truly 'a vast god in a drop of bronze'. Statius, in a suavely casual 'after-dinner' poem,[32] enthuses with gusto on the illusionism involved: 'Such mighty glory was the work's, majesty locked up within restricted limits—a god he *is*, a god!—… seen small, but felt tall, a miracle of measurement standing less than one foot high' (*et cetera, et cetera*). Once the property of Alexander the Great (so both poets pretend), and boasting Alexander's favourite sculptor, Lysippus (pp. 226–7), as its maker, this statue sits Hercules down to join the banquet. His thuggish voracity was legendary—tanking up between monsters and missions to world's end—but this pocket Hercules could safely stand on the table. The god would still bring his reminder of those heroic feats to the feast, yet diminutive scale made sure that his chief function was to bestow festive hilarity.

We have plenty of images which might pass muster as versions of a Lysippan dwarf *Hercules at Table* (20 statuettes alone). But one specially intriguing version is twice lifesize. This monster turned up in 1960, when excavations at Alba Fucens, in the hills of central Italy, revealed what was identified as a smallish shrine, with its fallen idol embedded in pieces on the floor [143]. This raises interesting questions of scale. Whatever the origins of this *Hercules Epitrapezios* ('at Table'), and whatever his cultic significance, most critics reckon that by the Hellenistic period both a colossal and a miniature

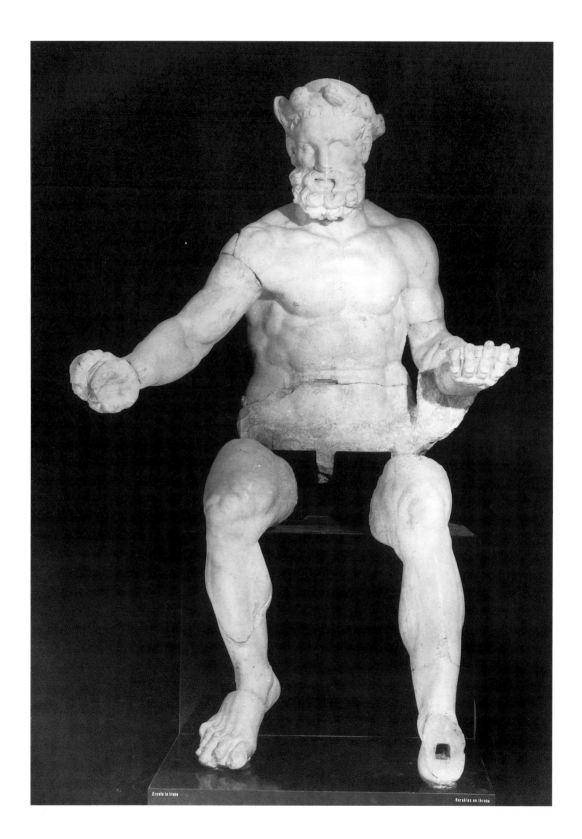

Hercules in much the same pose were widely known, both of them attached to the name Lysippus. If one game was to reduce the giant hero to pint-size (at a stroke transforming *Hercules at Table* into *Hercules on the Table*), this in turn created the possibility for reinflating the image. It set up a two-way relation between miniature and colossus: now the 'pint-size' is not automatically to be taken for a reduced copy of the 'heavyweight'; the colossal can enter the picture as an inflated copy of the miniature. Such play with reduction and enlargement in the Age of Imitation—variation in copying between statuette and colossus—did more than deconstruct the proprieties of scale. To make the point that any representation could be awarded or denied sheer, or mere, size was to locate power, not at the beck of a baron, but in the gift of the artist.

The *Farnese Hercules*

Hercules' bulk makes him the classical world's clearest subject for sculptural grandeur and grandiosity. Lysippus' *Weary Hercules* was a masterpiece which provoked imitations across the Hellenistic and Roman worlds. Over 80 efforts survive; we have already come across versions from the shipwreck of sculpture at Anticythera [**62 (a)**] and on the *Telephus Frieze* at Pergamum [**108 (a)**]. But it is thanks to a marble version more than three metres high, the *Farnese Hercules*—so called after the Farnese family who dug it up from the Baths of Caracalla in Rome in the sixteenth century, and whose new palace it was to decorate [**144**]—that it stayed one of the canonical images of masterful Antiquity throughout the second millennium [**145**]. Quite apart from the earlier controversies over its anatomical naturalism (or lack of it), recent criticism has mixed admiration for Hercules' magnificence with ridicule for his muscle-bound ponderousness. But this has never dampened the enthusiasm of megalomaniacs or strongmen for the piece. Big men all over modern Europe have continued to inflate (and debase) the currency. The copper version, at 9.2 metres three times the size of the *Farnese*, that still sags over an eighteenth-century park outside Kassel in Germany, atop a pyramid base 63 metres high, must surely hold the record [**146**].

All the same, the *Farnese* is not short of subtlety, and in the dramatization of physique 'at rest' it conscripts the viewer into its delicate calibration of might versus precariousness. The pose of the body and the angle of the head both lean to the left, where Hercules' brawny arm is improbably propped on the upturned club (or crutch) and cushioned by the lion skin: a weird sum of raw muscle, titanic savagery, exhausted fragility, and feral brutality. Meanwhile Hercules' right arm does not just show off his rippling torso. It is emphatically hiding something behind the massive trunk: not a weapon, for Hercules is 'at ease', disarmed; rather, as you see if you move round

144

The *Farnese (Weary) Hercules.* Marble, from the Baths of Caracalla, Rome (*detail*: sixteenth-century legs by G. della Porta).

This monster is another miracle of restoration. On discovery he lacked a left hand and both legs below the knee. There was even a question mark about his head, which popular mythology held had been found the other side of Rome down a well. Michelangelo, then in charge of building the Farnese palace, recommended one of his pupils to supply some replacement legs; these were so good (see *detail*) that, when the originals were found not long afterwards, no one could bear to make the substitution. Only in 1787, when the Farnese collection was taken to Naples (p. 11), was the restoration we see today finally put together, by the audacious Albacini – complete with the original legs.

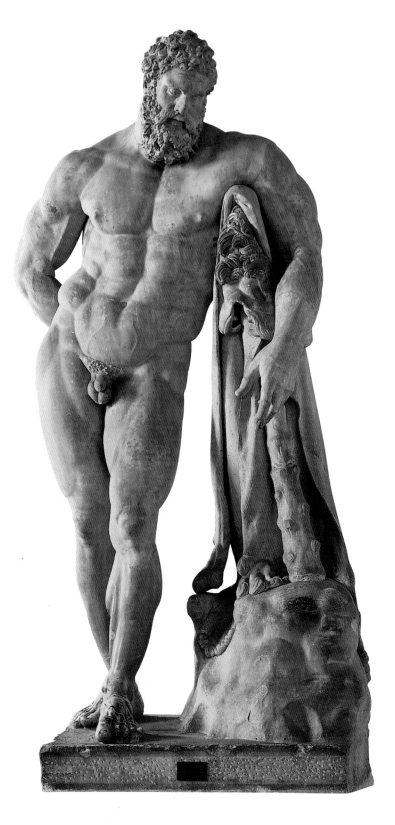

the statue, his sweaty palm clutches the golden apples he has fetched from the ends of the earth (**36c**; p.45)—in many versions the last in his litany of labours, and so an artfully concealed signal that Hercules' toil is done.

The lure of the iconography combines with the virtuoso display of Hercules as a feat of engineering, as this weight of solid stone balances gingerly between the perilously aligned footing and the unconvincing assemblage that stands in for the standard 'stump' that all large-scale marble statues need, simply in order to remain upright. (Compare the pot plus robe of Cnidian Aphrodite, **87**; p. 127.) Within the same basic formula, competing versions of the type can play

146 Anthoni of Augsburg

Herkules the Landmark of Kassel, the Park Wilhelmshöhe, Kassel, Westphalia, 1713–17.

High upon a hill, this vast version of the *Farnese Hercules* in copper, mounted on a pyramid, crowns a mock-castle, 'The Oktogon', and releases a spectacular cascade (cf. **100**). Here is a modern bid to rival the tallest ancient statues, such as Nero's notorious Colossus (topping 30 m, it was said); or the legendary Colossus of Rhodes, which stood astride the entrance of the city's harbour. But all are long gone.

endlessly with this leaning tower of massiveness—in a calculus of degrees of exhaustion expressed as degrees of angle past the vertical.

In Antiquity, variants of the *Weary Hercules* were produced on all conceivable scales, and in every available medium, whether in two or three dimensions. They were fêted too right across the Graeco-Roman world, as images appearing on objects as diverse as coins, sarcophagi, and column capitals. Ordinary humans could pet their very own figurines and prize their statuettes—miniaturism here bringing Hercules within the reach of all, as well as deflecting any charge of vulgar grandiosity. But wherever any such Hercules has ever gone, the nagging thought has always gone too: the bigger they are, the harder they fall. As indeed with all the masterful images in this chapter [**147**]. But, in art anyhow, size isn't everything.

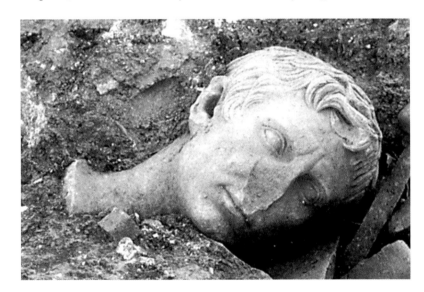

Facing up to Antiquity: Art to the Life

From the moment of discovery, the special attraction of Pompeii has been the immediate plunge into human catastrophe. As we saw in Chapter 1 (p. 11), the thrill has always been that, amongst the murals, mosaics, and bric-a-brac of everyday life, we can still glimpse a ghastly population of victims caught in their death throes by the volcanic ash. In the Villa of the Mysteries (pp. 45–7) three women are trapped upstairs (one, a young girl, still hangs onto her bronze mirror); downstairs the porter dies in his lodge and another girl gets as far as the door before she succumbs. Elsewhere one family is overcome just as the father is handing their child over into its mother's arms, while in the gladiators' barracks 60 or more of the inmates will never get out out alive—least of all the two who are still chained up in their prison cell. Most famously of all, the obligatory faithful watchdog dies on the mounting pile of scorching ash, asphyxiated literally at the end of its tether (cf. **10**). A classic mixture of pathos and the macabre [**149**].

In fact the 'authenticity' of these holograms of horror is much more elusive than it might seem at first sight. For the victims that we can see are as much artefacts as any of the objects we have looked at in this book, produced by a specially devised technique of filling with plaster the spaces left vacant by the flesh as it burnt and decomposed. These are no corpses, no human remains, barely skeletons; they are *anti*-bodies. The paradox is that, at the very moment when we feel most touched by common humanity, what we are actually facing is modern plaster.

This chapter is about the search for authenticity, about our ever renewed desire to animate the ancient world with living people, and about our intense investment in meeting antiquity face to face by combining the precious remains of material culture with a collective effort of the imagination. In what follows we shall be taking more orthodox examples: not the excruciating contradiction of death agonies fashioned out of thin air, but the images that modern viewers have read as ancient 'portraits', some of the most familiar (and favourite) specimens of Graeco-Roman art amongst them. We shall be rethinking the history of ancient 'portraiture' by opening

148 Detail of mummy of Artemidorus (**179**)

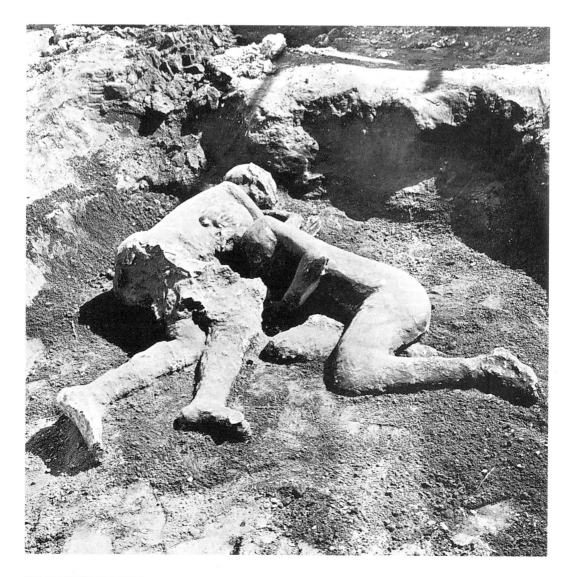

149

Plaster casts of volcano victims at Pompeii: a male and a female.

The real thing: a couple of heart-wrenching corpses huddle together still. The process of casting the corpses still continues in Pompeii, though up-to-the-minute (and slightly transparent) epoxy resin has now replaced plaster.

up the question of what counts as an image 'to the life' and exploring the power of 'likeness' in public and domestic culture. We shall see how the single-minded quest for individualized and authentic portraits, from the assortment of heads and full-length statues that survive, has obscured the much wider engagement of the sculpted or painted face in the classical world; so strong is the will to squeeze life from art.

At the same time, our discussion of the classical 'portrait' will pull together themes that have run through the earlier chapters of this book: the quest for originality; the impulse to imitate; the charisma of power; the refinement of desire; the tradition of classical art from Greece to Rome. We shall find that we are drawn back to the first face we identified in Chapter 1 [**12**] (p. 14), that of Alexander the

150

The 'Azara Alexander' herm, from near Tivoli.

Perhaps the most famous sculpted face of Alexander the Great, and inscribed with his name. Presented to Napoleon by the Chevalier Azara (whose name is inscribed on one side).

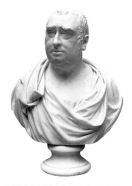

151 J. Nollekens

Bust of Charles James Fox, 1805.

Great, whose death traditionally defines the birth of the Hellenistic period of classical civilization [**150**].

A sea of heads

So far in this book we have largely focused on star items of classical art, including some of the most famous paintings and sculptures of all time. Now we turn our attention to the regular stock-in-trade of any collection of ancient sculpture: heads and portrait busts. In display galleries and museum basements across the world, the legacy of classical antiquity is a deluge of portraits in stone. Every major classical museum counts its portrait heads in hundreds, while in the museums of Rome and the Vatican City there are literally thousands.

It is thanks to this classical tradition that it is still an honour to truncate the torsoes of great men in all their varieties, as if the armless bust were a perfectly natural form, created to line any corridor, top every library shelf—or dominate a desert skyline: in South Dakota, the (four) 'Good Presidents' of the USA are just giant heads, carved out of Mount Rushmore. Meanwhile, any self-respecting stately home of Europe makes sure that genuine Greeks and real Romans rub shoulders with modern worthies, portraits of princes, generals, and politicians dressed to play the part in toga or cuirass [**151**].

It was an emphatically Roman, rather than Greek, drive to surround available living-space with armies of abbreviated figures of prestige—heads or busts; and to leave the western world with a collective acceptance of the convention of representing persons from the neck up. In fact, one of the regular processes of Roman copying was to take Greek statues, and, so to speak, cut them down to size in this way, bringing them within the reach of many more customers, and turning them into a customized livery for homes and for palaces of culture. In part, this Roman enthusiasm for the head was the consequence of mass-marketing, which went hand in hand with the canonization of taste across the Mediterranean. It was also, as we shall see, a by-product of autocratic power in the wake of Alexander and of the saturation of the world with 'portraits' of successive rulers.

None the less, the marble images that stock our museums are a tiny proportion of the ancient repertoire of human faces, and far from a representative sample. We do have a few 'portraits' in other media: some prized examples painted on the walls, or set into the floors, at Pompeii [**152**] (cf. **24**, **180**); and from the sands of Egypt, as we shall shortly explain, a startling gallery of painted faces [**148**, **179**, **181**]. But these treasures can only hint at what must have been a rich panoply of likenesses in two dimensions, including easel paintings or illustrations in books. Even with sculpture itself (as we emphasized in Chapter 2), drastically selective patterns of survival have interfered with our whole picture of artistic production. Again, most heads cast

in metal have literally melted away, bronze as well as the rarer pieces in silver and gold [**153**]. It was not only a question of the convenient reuse of a rare commodity, but had a political dimension too. In his *Achievements*, Augustus boasts of his modesty in getting rid of no fewer than 80 silver statues of himself from the cityscape of Rome.[1] To be immortalized in precious materials was a powerful stake in the battle for prestige, and by the same token it was controversial and provocative.

But, as always, modern expectations and modern interventions have also played their part in stereotyping the ancient 'portrait' into the regulation marble head or bust. This entirely fails to do justice to the wide diversity of herms and heads, masks and busts, that each had their niche in the portrait culture of the Graeco-Roman world. In particular, the common ancient category of the portrait herm, in which a head topped a plain block or pillar, often with male genitals as the only other bodily feature, has been marginalized [**154**]. Modern recreations

b

153 a, b

(a) Silver platter from the Boscoreale Treasure; **(b)** silver head torn from a lost platter (the pair of the first).

How we want these to be portraits of the villa's owners – the Boscoreale Silver Couple!

a

of the herm, unlike those of busts, are rare, and scarcely ever include genitalia. Besides, among the heads on display in our museums, some will have once belonged to full-length statues—their original bodies long since broken away, lost or forgotten in museum stores. Restorers have regularly reset them in modern shoulders, to turn them into yet more classical busts. All in all, the modern world has outdone even the Romans themselves in its zeal for the formula of 'portraits without legs'. The result is to exaggerate their uniformity and deaden their impact as individually crafted works of art.

Putting a name to a face: which 'Pompey the Great'?

Yet a name can make all the difference to even the most routinized portrait. Most of the busts on show in museums and galleries come with a name attached. That is what we all want; for gazing on the face of 'Socrates' or 'Alexander', 'Augustus' or his empress 'Livia', has a frisson of authenticity that no 'Unknown Greek' or 'Unidentified Roman' can ever touch. But these labels are, of course, modern additions. Scarcely any busts come down to us from antiquity complete with an identification, and those that do are more likely to be the result of an ancient demand (little different from ours) for famous names than the product of any reliable knowledge. So where did the identifications on our museum labels come from?

154

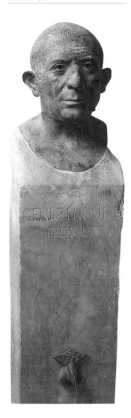

154
Herm of Lucius (Caecilius
Iucundus?), from the House of
Caecilius Iucundus, Pompeii
(see Maps and Plans 3 (d)).

The portraits of Julius Caesar's rival and victim Pompey 'the Great' provide a fascinating insight into how art historians have gone about putting a name to a face, and how subject to fashion their identifications prove. The most famous Pompey today is a head regularly known as the *Ny Carlsberg Pompey*, after the museum in Copenhagen where it went following its discovery in Rome in the 1880s [**155**]. On the basis of various details of the sculptural technique, it is normally dated to the first century CE, perhaps a hundred years after Pompey's assassination in 48 BCE. The question of why anyone at that date should have commissioned a statue of such a notorious loser is often answered by pointing to its supposed findspot: the tomb of his prestigious descendants, the Licinii. We can imagine that they still cherished the memory of their ancestor, whose spectacular demise (he was stabbed and then decapitated by an Egyptian eunuch on the shore of the Nile delta) had made him a martyr in the cause of Republican freedom. In fact, the alleged findspot is largely a fabrication, designed to mask the shady circumstances of the excavation and dispersal of a sizeable cache of ancient sculpture. The problem of whom or what this Pompey was for remains a puzzle.

Modern reactions to the portrait have ranged from admiration to derision. But our concern here is with how the head was identified as Pompey in the first place; it carries no name. At a very general level, surviving descriptions of Pompey have been brought into play, particularly Plutarch's sketch at the outset of his *Life* of Pompey, which emphasizes his 'fly-away quiff of hair' and 'melting look about the eyes'[2]. But to play the game of matching up such pen portraits with portraits in stone is as treacherous as it is seductive; inevitably other ancient authors describe Pompey in quite different terms, which do not match anything like so well. Much more weight has been placed on comparisons with a series of images of Pompey that do undeniably carry his name: heads on gems and coins [**156**]. On some of these (for example [**b**]), the portrait of Pompey the Great bears a striking resemblance to the *Ny Carlsberg* head. Admittedly there are all kinds of difficulties in comparing tiny stereotyped silhouettes with life-size sculpture in the round; but hardly anyone finds a problem with the idea that coins and bust represent one and the same individual. Though neither was made in his lifetime, it is supposed that both go back to some, now lost, likeness that was made then, and so deliver what we want: the living features of Pompey.

This process of matching up ancient images to produce a gallery of named classical worthies has a long pedigree. It stretches back to the very beginnings of art history in the sixteenth century, when Fulvio Orsini published a massively influential compilation of antique *Portraits*, identifying major historical characters on the basis of a scholarly comparison between coin and sculptured images.[3] This had

155

The *Ny Carlsberg Head* of
Gnaeus Pompeius Magnus,
from Rome.

Does this idealizing piece
perfectly capture Pompey's
aspirations to be the Roman
Alexander (pp. 226–7)?
Or is this a throwback to the
hoary Roman tradition of
'hyper-realistic' portraiture,
warts and all (**176**)?

Some people find him plain
funny, puffy cheeks and piggy
eyes making a ludicrous
caricature of the world-
conquering 'Great' hero. Not
to mention the irrepressibly
macabre thought that the
(severed) portrait head suits
Pompey all too well.

a

b

c

156 a, b, c

(a) Red jasper intaglio, with oval ringstone: portrait of Pompey the Great.

Identified as Pompey by his quiff, which gave him a resemblance to Alexander – even if, according to Plutarch, 'more talked about than real'.

(b) Bronze coin with portrait of Pompey the Great, 46–45 BCE.

Pompey's son, continuing the fight against Caesar and his heir (the future emperor Augustus), paid his soldiers with coins celebrating his father.

(c) Bronze coin with portrait of Pompey the Great as one of the god Janus' two heads, 45–44 BCE.

Minted by Pompey's younger son. 'MAGNUS' is stamped above the head(s).

enormous repercussions both on how art history is practised and on how we have come to picture the ancient world and its inhabitants. Yet its success must rest on a strategy of systematic exclusion and frankly circular argumentation. In the case of Pompey it means setting aside those coin images which are inconveniently less like the favoured *Ny Carlsberg* head [**156 (c)**]; and it means assembling a repertoire of similar statues (the similarity on occasion improved by sensitive restoration), while effacing those likenesses which will not fit the preferred type. The way this exclusion works here can best be seen by standing back a couple of centuries, and looking at the image of Pompey in **157**.

This statue was discovered sometime in the sixteenth century, reputedly in the area of Rome most closely associated with Pompey's name, where his theatre, senate house and vast porticoes once stood (cf. p. 167). It came to be confidently identified as the prize full-length portrait of the generalissimo; comparison between its head and portraits of Pompey on coins and medals convinced many experts (but not, however, Winckelmann).[4] Some even believed it to be the very statue of Pompey that once stood outside his senate house, and at the feet of which Julius Caesar was assassinated. For two centuries it reigned supreme as *the* image of Pompey; and it was still treated as such by the greatest nineteenth-century authority on Roman portraits, in a weighty tome published just shortly before the *Ny Carlsberg Pompey* came to light.[5] But by that stage the saga of this *Pompey* had already taken a different turn.

The statue is unusual in one particular respect: in the 450 years since its discovery it has stood in the same mansion in Rome, known since the seventeenth century as the Palazzo Spada. Only once has it left the premises: in late September 1798, to appear in a starring role at the Theatre of Apollo in Rome, for Voltaire's *Death of Caesar*, as the statue near which the dictator was stabbed on the Ides of March. In the course of the move it was found that the head was attached to the body with a wooden peg; and this was to spark a spectacularly bitter feud over the statue's identification, history, and authenticity. The quarrel came to a head in the last year of the Napoleonic occupation of Rome, and indeed saved *Pompey* from the mass exodus of art to Paris. By the twentieth century, as the *Ny Carlsberg* type stole the limelight, the *Palazzo Spada Pompey* was entirely written off: at best, a pastiche combining two quite separate ancient pieces, a head and a body; at worst, a fraud consisting of a modern head imposed on an antique body. A face that was once taken for Pompey 'to the life' has now ceased to interest anybody. Fame in the portrait gallery can be as insecure as in life itself.

157

The *Palazzo Spada Pompey*.
Vivid imaginations once
spotted splashes of blood on
the statue's left leg.

The *Louvre Augustus*
(= the *Velletri Augustus*).
This is now thought to be
largely a product of
eighteenth-century
restoration.

The face of Augustus

In the early years after its discovery, before the identification as Pompey had solidified, the Palazzo Spada statue was sometimes claimed to be Augustus. If it is hard for us to find the statue a plausible Pompey, it is now inconceivable that it could possibly portray the first emperor. This is because, since the late nineteenth century at least, art historians, archaeologists, and historians have documented a portrait type in so many media and pegged to such precise contexts that there can be no doubt at all that it is the image of Augustus (whether or not it is a 'true likeness' of the first emperor is another story, as we shall see). Of all the figures of antiquity, his image is the most instantly and widely recognizable [**142, 147, 160–2, 168–72**], and forms a crucial fixed point in the whole modern typology of Roman portraiture.

Not that there wasn't an earlier history of identifications in the case of Augustus too. When Napoleon came to bag a statue of the first emperor of Rome for his new museum, he picked on a recent purchase by the pope [**158**]. At the time this was acclaimed as a pre-

Art historians now classify this as an imperial prince dressed in the costume of a 'spirit of abundance' (*genius*). A bizarre moment of belated fame came in 1937–8, when Mussolini celebrated the two thousandth anniversary of Augustus' birth with a huge *Augustan Exhibition of Roman Culture* (*Mostra Augustea della Romanità*), including replicas of all the prize pieces. A copy of the colossal *Genius* was the star turn, flanked by replicas of **160 (a)** and **161**.

cious full-length *Augustus*. But it has now (like the *Spada Pompey*) fallen from fame, written off as an awkward hybrid: an alien head (possibly the emperor's) crudely stuck onto a handy headless statue by the audacious eighteenth-century restorer Carlo Albacini. Napoleon did not take the pope's other recently purchased *Augustus* [**159**]. This giant portrait was once given the ultimate accolade of admission to the Vatican's Belvedere Courtyard (pp. 68, 72), and was later moved to another of the museum's show rooms, the Sala Rotunda. But today he leaves us cold. All we can see is a false identification, not an Augustus at all. Since the late nineteenth century there has been no doubt about the classic image of Augustus: an imposing full-length statue in prime condition, uncovered at a site with strong Augustan associations, loaded with specifically Augustan iconography, and crowned with a head that tallies closely with the Augustan portrait type.

This statue was found on 20 April 1863 at the site of the sumptuous Roman villa at Prima Porta, traditionally identified as Augustus' own (pp. 54–5) [**160 (a)**]. Here the emperor's armour makes him a soldier; yet he stands barefoot and his support is a Cupid astride a

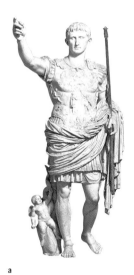

a

160 a, b

(a) Statue of the emperor Augustus, from Prima Porta. The elaborate decoration of the cuirass features in the centre the symbolic return of a Roman standard captured by the Parthians (p. 168). Allegorical figures crowd all round, to diagram the cosmic and worldwide scale of his victories.

(b) L. Alma-Tadema, *An Audience at Agrippa's*. 1875.

Agrippa (p. 225) and his train descend the steps; in the foreground a queue of exotic petitioners wait. One question that the painting poses is: where does Roman power lie? With the ageless and expressionless emblem of the emperor paraded watching over the entrance? Or with the wrinkled, behind-the-scenes fixer handling the demands of real life?

dolphin (a mythological conceit that hints at the descent of Augustus' family from the goddess of love).

Many details are obscure: the exact findspot on the imperial estate; the relationship of this marble version with any bronze original (there is even some speculation that the original once stood in the sanctuary of Athena at Pergamum, where a statue-base survives with foot settings that more or less correspond to those of the Prima Porta statue); the attributes, if any, of the hands (spear, laurel wreath?—the famous pointing finger is a restoration); the date of this version (after the diplomatic coup with the Parthians in 20 BCE—but how long after?). But for all these loose ends, the Prima Porta statue achieved iconic status as an image of Augustus from the moment of its discovery, when it was hailed as a fitting symbol of the newly united Italy and hauled off for display in the Vatican, where it still stands.

In no time at all Alma-Tadema incorporated it in his paintings as a trademark of Augustan Rome [**160 (b)**]. And in the 1930s, replicas of the statue played an important part in Mussolini's recreation of imperial Rome: one of them, with an inscription proudly proclaiming it as an inspirational work of the Fascist era, keeps watch to this day over the Forum of Augustus, on the roadside. Certainly, no other image is lodged more firmly at the heart of today's scholarship on the art and power of Rome, no imperial face more indelibly imprinted on the art historical imagination.

Emperors galore: everywhere *Augustus*

The images of Rome's first emperor are indeed in a class of their own, and the conditions that apply to them are quite different from those that apply to the portraits of a Pompey—or of virtually anyone else in the ancient world. In terms of sheer numbers, Augustus easily beats the rest: a recent count of his surviving heads, busts, and full-length statues reached more than 200, and recent estimates of ancient production guess at 25,000–50,000 portraits in stone all told. Every corner of the Roman empire has turned up portraits of Augustus, adapted to the multifarious aspects of the emperor's role: generalissimo [**160**], priest [**161**], beatific monarch [**162**] (cf. **141 (a)**, **142**, **171**, **172**), fantasy cosmocrat [**139 (a)**], or *Wunderkind* [**169**, **170**]. In Egypt that meant playing the role of Pharoah and looking the part—to us unrecognizable, but securely identified by the inscription [**163**].

The image of Augustus cast its shadow over all his successors: first, in the sense that his statues continued to be displayed throughout imperial history, and their production did not stop with his death; second, in the sense that he set an iconographic pattern for the future. Successive Roman rulers kept his name, *'Imperator Caesar Augustus'*, as their title and forged their own individual identities with reference to the iconography of power established in his reign, each one

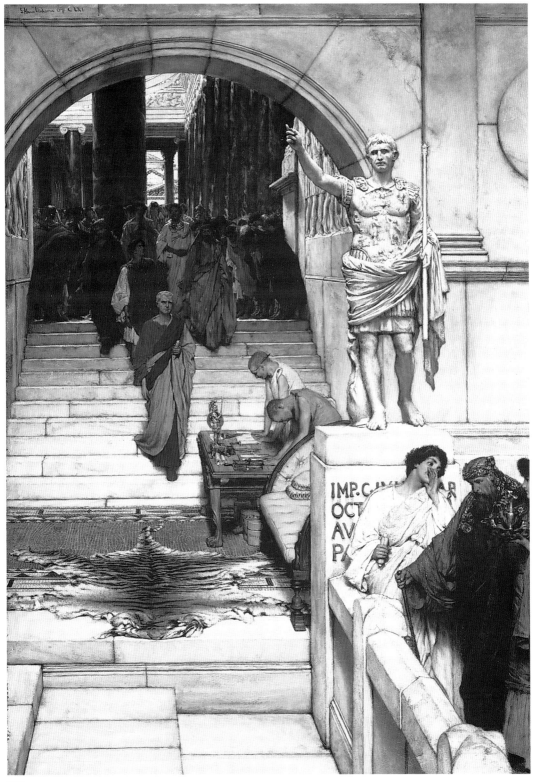

160b

developing his own particular variants on the Augustan matrix [**164**]. Following the practice established by the first emperor, his successors were made real for their millions of subjects across the Mediterranean and beyond in all shapes, sizes, formats, and materials—marble and bronze, basalt and silver [**165**].

Mass-production of Caesars

Historians and art historians have puzzled about the processes that lay behind this extraordinary dissemination of likenesses. One way of approaching the problem is to turn to a particular medium where even more, this time literally hundreds of thousands, imperial images survive: that is, coinage. We have already seen how individual likenesses on coins have been used to identify anonymous heads in marble. Now we shall see how the medium as a whole provides a powerful blueprint for the processes of copying and imitation that underlie the production of imperial statues. It is largely through coinage that we get our most direct impression of how art rendered unto Caesar the power that was Caesar's, putting an imperial icon into every purse.

The modern world may take for granted the idea of 'heads and tails', of coins showing the miniature faces that emblematize the power of the state. In Rome this was a startling innovation of autocracy. Only with the reign of Augustus did heads of the living become a standard feature of the coinage, in line with the practice of some monarchies in Hellenistic Greece [**166**]. Imperial Rome minted and disseminated tens of millions of coins each year, displaying the official image of the emperor, an exact reproduction mechanically stamped onto coin after coin.

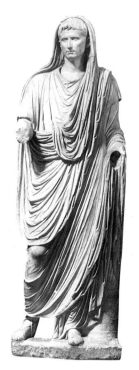

161

The *Via Labicana Augustus*; portrait statue of Augustus, dressed for ritual, found in Rome.

162

Fragment of a portrait statue of Augustus, found off Euboea in the north Aegean Sea, 1979.

An amazing feat of multi-layered welding and polychromy. We can only imagine the horse on which the emperor once sat.

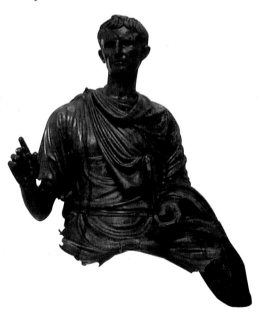

163
Detail of the *Stela of Augustus*, from the Bucheum at Hermonthis, Egypt.

164 a, b, c
(a) Portrait statue of Claudius as Jupiter, from Lanuvium, near Rome; **(b)** portrait statue of Trajan as *imperator*, from Ostia; **(c)** portrait statue of Hadrian, from Rome.

We know that the Caesars took control of mines and mints and the right to issue coins. Most scholars have assumed that they also took an interest in the miniature portraiture which told the world who they were, and how they meant to be regarded. The idea is, although we are short on evidence actually to prove it, that some form of official model image of the ruler must have been produced and distributed to the key points of coin production. The image was then churned out by the million, until an updated version arrived—or the next emperor emerged.

Coinage, then, provides an extremely powerful pattern for imagining how artistic energy and political clout joined forces within a world-wide network of control. And it puts a new slant on 'the Age of Imitation'. With coinage it was possible to proliferate replicas on a massive scale, and so instantly to transmit right across the empire new phases or fresh nuances of imperial ideology. On the one hand it was a process that involved handing down low-profile propaganda, utterly familiarized to one and all—who after all takes any notice of a head on a coin? On the other, it could on occasion incorporate unmistakable innovations that positively clamoured for everyone's attention— as when the teenage Nero and his mother Agrippina shared the sensational golden coins issued to commemorate his accession, nose to nose [**167**].

a b c

165

Silver portrait bust of the emperor Galba, Herculaneum.

Found in 1874, in the street outside, and at the level of, the 'House of Galba'. Is this loot, dropped in the panic? Galba was emperor at the age of 73, for seven months in 69 CE, before his decapitation in Rome.

 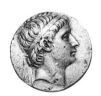 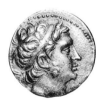 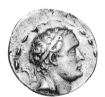 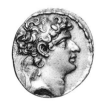

a b c d e

166 a, b, c, d, e

Coins from Seleucid Syria

(a) Head of Seleucus I of Syria, with bull's horn (reigned 311–281 BCE); **(b)** head of Seleucus II Kallinikos of Syria, with bull's horn (reigned 264–225 BCE);

(c) head of Seleucus III Soter of Syria (reigned 225–223 BCE); **(d)** head of Seleucus IV Philopator of Syria (reigned 182–175 BCE);

(e) head of Seleucus VI Epiphanes Nikator of Syria (reigned (?) 96–95 BCE). (NB: Seleucus V 'reigned' in 125.)

Nero and his mother Agrippina share a gold coin (*aureus*), 54 CE.

This image hinted at an outrageous parity between Nero and Agrippina. But it also involuntarily prophesied a rift. Would the growing emperor not soon need the same head room as other Caesars? Would the Roman world (any more than its coinage) ever be big enough for the both of them?

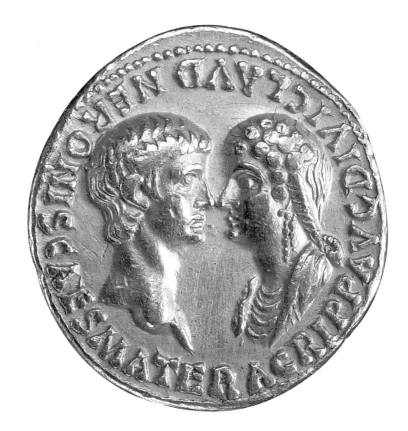

In other media, images of the emperor can never have been reproduced so mechanically or with such centralized control. It is perfectly clear from what we have seen already that particular craftsmen had a fair degree of freedom to work out their own designs for how their Caesar should look (e.g. **139 (a)**, **141 (a)**). Nevertheless, the portraits of each Roman ruler seem homogeneous enough to suggest that artists across the empire were indeed following an approved model: wherever you went in the Roman world, you could recognize a Nero as a Nero, tell a Titus from a Domitian, and so on. Presumably, it is argued, the imperial regime circulated prototype statues, establishing the emperor's officially approved image—and maybe, in a long reign, issued revised versions from time to time to suit the political climate.

Prototypes of Augustus

The portraiture of Augustus has fired art historians' most strenuous efforts to sort out how exactly the imperial image was constructed and adjusted over the 40 years of his reign. From the late nineteenth century on, and using a classic late nineteenth-century 'scientific' method, they have looked to recover a succession of lost Augustus prototypes by comparing and classifying the heads that survive. The idea is to discount overall appearance, and instead to privilege the

The modern sorting of 'Augustus Types' turns on differences in the detail of hair styling [**168**].

1 2 3

168

1. The 'Octavian', 'Actium', or 'Alcudia' Type. This originated in the 30s BCE, before Octavian (the future emperor Augustus) won his decisive battle against Antony and Cleopatra at Actium in 31. It is normally seen as reminiscent of the portraits of Hellenistic rulers after Alexander. Comparison with coin portraits is used to confirm the chronology [**169**].

2. The 'Prima Porta' Type [**160**]. This is the canonical portrait (known in about 150 instances), harking back to the Greek classicism of the fifth century BCE. It is tied as closely as may decently be argued to coins from the inaugural years of the reign, when Augustus took his new name in 27 BCE or soon afterwards, as the new political order took shape. One bronze head of the type, torn from a full-length statue, may provide a firm date for the type of 'not later than 25 BCE'; found at Meroe in upper Egypt, it was probably part of the plunder taken by Ethiopians after victory over the Romans in 24 BCE [**170**].

3. The 'Forbes' Type. This more dubious category is variously seen as either a relatively unsuccessful successor to the 'Prima Porta', or its transitional and transitory forerunner. Some doubt it as a worthwhile grouping at all [**171**].

telling minor details that are supposed to lead us most directly to the key differences between the various 'original' models. In this case, it has meant minute analysis of the forelocks that fringe Augustus' brow.

Most schemes identify three main types of Augustus portrait. These are seen as successive phases in the emperor's iconography and linked to the changing political aims of the 'propaganda machine'. Crucially, the shift from the more 'Hellenistic' Type 1 to the 'Classical' Type 2 is taken to coincide with a change of emphasis in the emperor's public image, more generally: from victor in civil war to responsible *princeps* or 'first citizen'.

In many ways this set of arguments raises as many problems as it solves. Remember that the existence of these prototypes is deduced solely from formal similarities between the portraits that survive. There is no other evidence for them at all—for what they might have been made of (clay, wax?), or for how they might have been despatched to the artists of the empire. And in practice the similarities that define the types are not so clear as is often claimed. The main and most recognizable portrait-type (Type 2, 'Prima Porta') is brought into precise focus only by discounting over 80 per cent of the supposed 'versions'. As with the portraits of Pompey, homogeneity is the product of exclusion; and the Prima Porta stereotype is reinforced

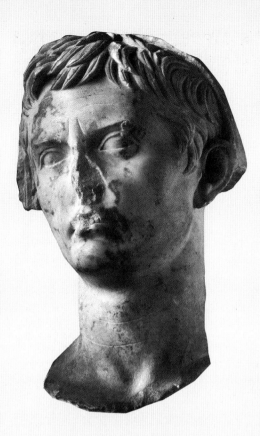

169
The *Alcudia Head* of Augustus.
Found at Alcudia on Majorca (the ancient Roman colony of Pollentia).

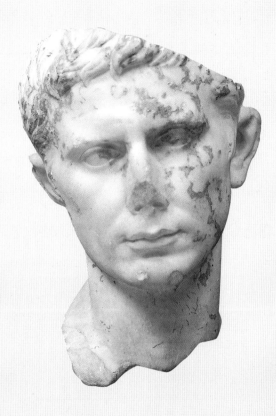

170 *(left)*
Head of Augustus, found at Meroe, south Sudan.
The story goes that the head was ripped from a statue and buried by tribesmen under the steps of a temple of victory, which carried pictures of bound captives: thus entry was over the prisoners' bodies and the head of the emperor.

171 *(above)*
The *Forbes Head* of Augustus.
This head is named for a modern donor.

by our tendency always to reproduce and dwell on the favoured pieces. Besides, considerations of chronology cut across the formal analysis. We hardly ever know when any portrait of Augustus was made. But some were definitely produced after his death, and there are good reasons to suppose that there was a market for images of the first emperor for the rest of Roman time. These can hardly have been dependent on prototypes despatched from the palace.

There are fundamental issues at stake here about the circulation of images around the Roman world, and the control of that circulation that could be imposed by the centre. But they remain tantalizingly elusive. It is worth emphasizing, though, that this standard modern approach to imperial portraiture takes one stage further the 'culture of imitation' that has been a major theme in this book. What is actually being proposed is that none of the major statues of Augustus that we have (nor for that matter whatever bronze 'original' may have lain behind the Prima Porta statue) was an 'original' in the strict sense of the word.

The age of Augustus: founding a dynasty

There is, however, one more absolutely basic point about the portraits of Augustus, and it has implications for the rest of Roman imperial portraiture. So far in this book we have shown you a dozen of his heads, and it will not have escaped you that the image of Rome's first emperor was remarkably stable. The reason that we have not tried to settle arguments about chronology by appealing (as might seem the obvious tactic) to Augustus' age in any particular piece is quite simply that his image does not age, but remains preternaturally young right through the 40 years of his reign. All the debates about differences, developments, and variant models should not obscure the central fact that this is an idealized image, more striking for its continuing homogeneity than for anything else.

The overriding consideration was to create a permanent guarantee of political stability for the new order. This outweighed any incentive to maintain 'likeness' between portraits and the ruler himself. The revolution brought about by Augustus, once achieved, was to be set in stone. This did not mean a frozen monolith: far from it. The adaptability of the portrait depended much more on the changing contexts within which it was set than on the changing details of the emperor's fringe. For it is never enough for a monarch to be seen in splendid isolation. Every image of power needs a setting. We have already seen how the same physiognomy can take on different roles if given a different costume (cuirass or toga); and we have seen how the (same) face of Augustus says one thing in his Forum at Rome, quite another out at Aphrodisias (pp. 169, 190). We have not so far brought into the reckoning the company a portrait keeps.

The ancient location of most imperial portraits is entirely unknown; but we can be sure that they were regularly designed for ensembles, and displayed in family groups which drew together parents and children, spouses and siblings, honoured ancestors and favoured successors. In this respect, free-standing portraiture has much in common with relief sculpture, where we have seen the emperor cheek by jowl with family, courtiers, and retainers [**172**] (cf. **133**, **141 (a)**, **167**). This is a sharp reminder of how 'relational' portraiture is. In particular, from the reign of Augustus on, it had a vital role to play in the politics of dynasty and succession, on which the whole imperial enterprise depended. The face of the emperor might never change; but his entourage was under constant revision, to meet each new contingency—births and deaths, marriage, divorce, and faction. Sculpture quite literally foregrounded the ones who counted in the scheme of things. Portraiture always transcended the individual emperor to diagram a *dynasty*.

172

Detail of the south frieze of the Altar of Peace in Rome, showing Augustus and Agrippa, dedicated 9 BCE. Augustus (third from left) leads the procession towards sacrifice; behind him follow priests. His son-in-law Agrippa heads the group of the royal family. He literally stands out (in high relief) as second only to Augustus – but such are the ironies of dynastic planning that he was dead by the time the altar was dedicated (cf. pp. 152, 175, 216).

The 'portrait commission' from Alexander to Augustus

We have left aside so far the question of who made these images. Whatever model of imperial portraiture we adopt, it ought to astonish us that we have no information whatsoever on the identity of any artist responsible for any of Augustus' portraits. Not only do we have no hard facts, but there is a deafening silence where we could expect a welter of anecdotes and asides. There are no tales of sittings in the palace, of royal favouritism and intrigue, let alone canny reflections

and rueful retorts from the artists who could dispense immortality in bronze, paint, stone, or (as the case may be) waxen prototypes. We have no idea who it was that put the face on Augustus.

This is all the more amazing since it is to the intimate circle of the Augustan court that we owe the most precious evidence we have for a classical notion of the business of portraiture for a monarch. In a lengthy and complex verse letter addressed to Augustus, the poet Horace explores the conditions that face creative artists in the ambience of a world-ruler. He trails along the way a cryptic analogy between the emperor and his most obvious precedent and forerunner, Alexander the Great, who had, he claimed, 'publicly banned all but the genius Apelles from painting him, and barred any other artist but Lysippus from modelling his face in bronze'.[6] The high-profile relationship between Lysippus and his most famous patron (and client) has provided a major turning-point in the history of western art.[7] With the face of Alexander, the first we confronted in our first chapter [12], 'portraiture' was born: at least in the sense that for the first time in the history of Greek art, we can identify any living subject 'sitting' for a named artist, charged to produce his likeness. Although art historians no longer credit the idea of Lysippus' monopoly on the image of Alexander, it has become the mythical origin of the patron–client scenario, the commission granted a chosen artist to produce the ruler-portrait directly taken from life.[8]

It is then another remarkable irony that, among the many images of Alexander that we have, not one can be plausibly traced to his lifetime. Coins certainly showed his head very soon after his death, first in Egypt and then in other parts of his dismembered empire, as it became a globally recognized pledge of 'Hellenic' value. But there are no grounds for thinking that these posthumous likenesses do more than conjure up an impression of how the boy wonder ought to have looked [173]. Nor are we on any firmer ground with the surviving marble heads. It has proved impossible to pin down the output of Lysippus, or of the other artists who, despite the story of a monopoly granted by royal charter, must have rendered Alexander's image before and after death. In fact only one thing is certain: there is not a single image of Alexander that can confidently be ascribed to any particular sculptor, let alone be shown to be taken from life.

We need not imagine that the 'real' Alexander, any more than the 'real' Augustus, actually looked like his 'portraits'. The point is that at some stage, whether during or after his lifetime, a distinctive type was established as the image of Alexander. It was an idealizing portrayal of a divinely inspired monarch, and it inaugurated the era of the portrait as an image of power. Thereafter, the would-be great rulers of classical antiquity were inevitably fashioned in Alexander's shadow. About 120 sculpted heads survive of the kings (around 80 in all) who

a

b

173 a, b

(a) A coin from Pergamum, with the head of Alexander the Great; **(b)** a round gem, with the head of Alexander the Great. For the ram's horns, cf. p. 169.

ruled their mini-empires in the eastern Mediterranean between 300 and 30 BCE; and we have many more, of course, on coins. For us they can only seem a run of clones, virtually impossible to tell apart, still less name. On the other hand almost all of them broadcast their affiliation to the image of Alexander [**166**, **174**]. This pedigree carries on, through the comically unconvincing Pompey [**155**, **156**], right down to Augustus, who both used (as we have seen in his early portraits: **169**, **170**) and transcended his Hellenistic predecessor. The trajectory of this image of power is neatly summed up by a story in Suetonius. He tells how, in the course of his reign, Augustus went through three different images in turn for the design of his signet ring—the symbol that stamped his imperial authority on official documents and correspondence. The first showed a sphinx; the next the face of Alexander; the third an image of himself. It was this last ring that was kept and used as the imperial seal by each successive 'Caesar Augustus'.[9]

Where did portraiture begin?

Lysippus' portraits of Alexander have often been taken as the origin of the genre as a whole, stretching far beyond the images of kings and rulers. Of course, how plausible this seems will depend on what we choose to count as a 'portrait'. Certainly there were representations of historical persons long before the time of Alexander. One well-known sculpture group, singled out by Pliny, stood in the heart of Athens from early in the fifth century BCE: commemorative statues of Harmodius and Aristogiton, a pair of lovers who in 514 had assassinated a prominent member of the clan who had seized control of the city—after he had tried to seduce Harmodius, or so the story has it [**175**].[10] But modern art historians have seen these as idealizing representations of exemplary civic heroes, rather than a pair of specific persons caught in the act; not portraits, that is, in our accepted sense of the term. And in general, the various claims by ancient writers that portraits of individuals could be espied on Greek monuments before Alexander cut no ice in modern studies of classical art. However ancient viewers may have looked on them (and whatever criteria they may have deployed in recognizing the 'individual' in what seems to us a 'stereotyped' image), no pre-Hellenistic images are allowed to figure in our story of the origin of the portrait.

'Verism' at Rome: the beginning of naturalistic portraiture

Of course, by a similar logic you could equally well exclude the idealizing image of Alexander from 'portraiture' as we now understand it. For portraiture in its strongest sense—that is, the faithfully recaptured looks of distinctive individuals, something approaching authentic snapshots—we must, it is often argued, move on to Rome. It is there that we find not only artistic traditions honed to the production of docu-

174

The *Terme* (or *Hellenistic*) *Ruler.*

The only full-length, full-scale Hellenistic ruler portrait to survive: many of the heads we have must derive from such full-length figures. Even here, where the facial features are not strikingly similar, art historians have tried to trace the royal pose back to a supposed original of Alexander. Competing identifications of the *Terme Ruler* abound: Antiochus II, Philip V, Perseus, Demetrius I of Syria, Alexander Balas, Flamininus, Sulla, Lucullus, Agrippa, etc.

175

Harmodius and *Aristogiton* (the *Tyrannicides*). Marble copies from Hadrian's Villa at Tivoli.

This is a Roman version of the Athenian monument which commemorated the legendary first move in what became the drive towards the foundation of democracy. Loftily heroic or sordidly bathetic, it blessed revolutionary liberation by direct action (in the distance of ancient history).

mentary, naturalistic likenesses, but also the particular cultural context that would foster such images. For many art historians, portraiture is the one genre that springs essentially from *native* Roman, Italic culture.

So far the Roman portraits we have shown you do not fit this bill. The image devised for Augustus presents a 'classicizing' look, calculated to evoke a stylistic return to fifth-century BCE Athens, no less idealizing than the image of Alexander. But this can be understood as a conscious turn away from earlier traditions of Roman portraiture, often dubbed 'veristic'. Old, wrinkled, and blemished, surely these images are as close to the life as you could possibly come [**176**].

Opinions differ on how to imagine the conditions under which this (in)famous verism became the characteristic mode of Roman representation. Does it really spring from a native Roman tradition? Should we really separate it off from Greek styles and expertise? One

position holds that it was Greek artists, at least in the early period, who provided the technical skill which produced these distinctive images of Romans, and the dramatically convincing faces which are so inseparable from all our ideas of Rome. One of the consequences of empire, in other words, was that Roman grandees could hire Greek sculptors to represent themselves in the way they chose. Another view has it that, for all its Italic credentials, veristic representation was actually the product of a drive within Greek aesthetics itself towards attention to surface and texture. Moreover, Hellenistic art had moved beyond the range of idealizing classical youth to explore the extremes of age, as we saw with *Seneca* [1], the *Drunken Old Woman* [97], *Sleeping Eros* [99], and the boys and their birds [98 (a, b)].

But to make fine discriminations here between the roles played by Greek skill and Roman demand is to miss the point. We have already seen in Chapter 2 how Roman art was always a product of negotiation with Greek input. Besides, the idea of 'verism' raises problems at an altogether different level. The term itself, coined from the Latin word for 'true', is founded on the notion that an image could faithfully transcribe reality—no more, no less. Something of this sort underlies many of our commonsensical approaches to viewing—when, for example, we applaud a 'lifelike' picture as a 'spitting image'. But it is misleading, for it obscures the ideological dimension of all representation. In the case of verism, we can have no idea how close a likeness these statues were to their subjects. But that is not the important point. For when anyone demands to be depicted 'warts and all' (as Oliver Cromwell knew, when he coined the phrase) they are

176 a, b

The face of Rome (mid-first century BCE).

Generally seen as the prime visual markers of Romanness, such images both made a bid for the kudos of palpable seniority, and paraded the all-important good faith of an honest citizen in unconcealed, and unconcealing, veracity.

177
Portrait of a Flavian Roman matron as sex goddess, from central Italy, *c.*90 CE.

making a statement *about* themselves, not asking for a replication *of* themselves. And when we characterize any image as 'realistic', we are not responding to some inherent property, but rather talking about how we have chosen to view it. 'Realism', no less than 'idealism', is itself a strategy of representation and response.

The reasons why Greek rulers liked to fix their portraits as if somewhere in their 20s, while great Romans of the Republic froze at 50 or so, are to do not with how they looked, but with how they wanted to be portrayed; not with how skilfully artists could capture reality, but with how powerfully they could deliver the images valued in their society. Roman culture gave exaggerated prestige to seniority and experience; Roman men needed all those lines and wrinkles in the contest for political clout. At the same time, for all Rome's admiration of Greek art and culture, there was a profound ambivalence about how Greek a Roman could afford to be [**177**]. Cultural identity was also at stake. Romans were caught between wanting to look cultured and not wanting to resemble the peoples they had conquered *too* closely. Bullnecks, jug ears and warts could all sustain a claim to Romanness, in resistance to the idealizing self-portrayal of the Greeks. But, of course, in its own way that was no less idealizing, and no less ideological. There could be no better proof of just how ideological it was than the revolutionary 'image of Augustus'. In rejecting the gnarled appearance of so many of his predecessors, and choosing a portrayal which harked back to fifth-century classicism, Augustus was bidding to supersede the values embodied by Republican verism. For politics is always inscribed in art.

Faces of death

Nevertheless, the hunt has always been on for what made Rome the culture of the portrait head *par excellence*. What instititions or social custom could explain Rome's enthusiasm for portraiture and, traditionally, for veristic portraiture in particular?

One particularly influential scenario has looked to funerals and their associated rituals as a key factor in accounting for the origin, centrality, and character of portraiture at Rome. Ancient writers tell us that in the *atrium* of elite Roman houses, masks of the family's ancestors were stored in cupboards and played an important part in the funerary ritual of family members. Polybius, writing in the second century BCE, describes the custom:[11]

The likeness is a mask specially made for resemblance in terms of both shape and colouring. They open up these masks during public festivals and compete in decorating them; and whenever a distinguished member of the family dies they introduce them into the funeral procession, putting them on people who seem most like them in build and the rest of their profile.

178

The *Barberini Portrait*
(*Togatus Barberini*).
With the help of a convenient
palm-trunk, this toga-clad
Roman carries two weighty
portrait busts. Ironically his
own head does not 'belong' to
the statue – but is another
ancient portrait used by
restorers to complete the
piece. The group was in the
collection of the Barberini
family from the early
eighteenth century, hence its
modern title.

Many details elude us here. But it is clear enough that we are dealing with a distinctively Roman practice in which likeness plays a crucial part. The public parade of ancestors must have contributed to the centrality of portraiture as a genre.

It has, however, proved hard to resist the temptation to press this connection further. For reasons that are not difficult to understand, the context of the funeral has prompted historians to see Polybius' 'masks' as literal death masks (implying a macabre spectacle of deathbed manhandling, as pious families pressed wax face-packs on the corpse). In the strongest version of this reconstruction, these masks have been identified as the direct ancestors of the whole veristic tradition. The lined faces and sunken cheeks of the classic Roman face are thus explained as the translation into marble of wax masks taken directly from the dead body. In fact no ancient text supports this fantasy; inevitably, none of the masks survives for us to determine how they were made; and the one statue that has most often been called upon to illustrate the (death-)mask tradition is in fact carrying standard Roman busts, not masks at all [**178**]. As we have shown, the longing to see Romans as Romans saw themselves, and each other, has for centuries driven classicists to seize on any and every opportunity to ground the images we have in bona fide, authentic copying from life; the funereal mask (just like the plaster cast of a corpse) has provided irresistible bait.

Death on the Nile

In another part of the Roman world the rituals of death and burial have preserved a stunning collection of portraits—not in sculpture, but painted on wood and linen. A population of more than 1,000 mummies from the Fayum and other areas of the Roman province of Egypt displays painted faces, hauntingly compelling, attached to the mummy case just where the face would belong [**179**].

They make a striking contrast with the gnarled and worn visages of the Roman stereotype. But they raise many of the same kinds of problems. Were they painted just after death, specially to commemorate the deceased, as part of the funerary ritual? Or were they favourite images of the dead that were painted earlier in their lives and once hung on the walls of their homes? The evidence points in different directions: some of the skeletons match closely the apparent age of the painted faces; in other examples the skeleton is certainly much older. In this case far more hangs on the question of whether these 'Fayum portraits' are an exclusively Egyptian phenomenon. The answer must be 'yes', if what we mean is a burial ground full of mummies, with portraits bound into their casing and preserved through millennia in dry sand; but 'no', if we mean an ancient tradition of individual likenesses executed in paint. Enough traces remain

Mummy of Artemidorus, from Hawara, Egypt.

The inscription in Greek says: 'Artemidorus, farewell.'

180

Miniature portrait on glass, from Pompeii.

at Pompeii to show that portraiture of this kind was widespread, certainly not confined to Egypt and its burial practices [24, 152, 180].

That said, this huge concentration of unforgettable faces—particularly when they are detached from their mummy cases, and hung on the gallery wall—makes an overwhelming impact on viewers today. It is very easy to slide into accepting the notion that these images do straightforwardly capture the person to the life. Of course it is, for the art of likeness is founded on the willing suspension of disbelief. The challenge to figurative art is to metaphorize human beings convincingly, from pigment on wood, or—as it may be—from glass or plaster, cast metal or carved stone. The ideology of the portrait depends on this ability to carry conviction [181].

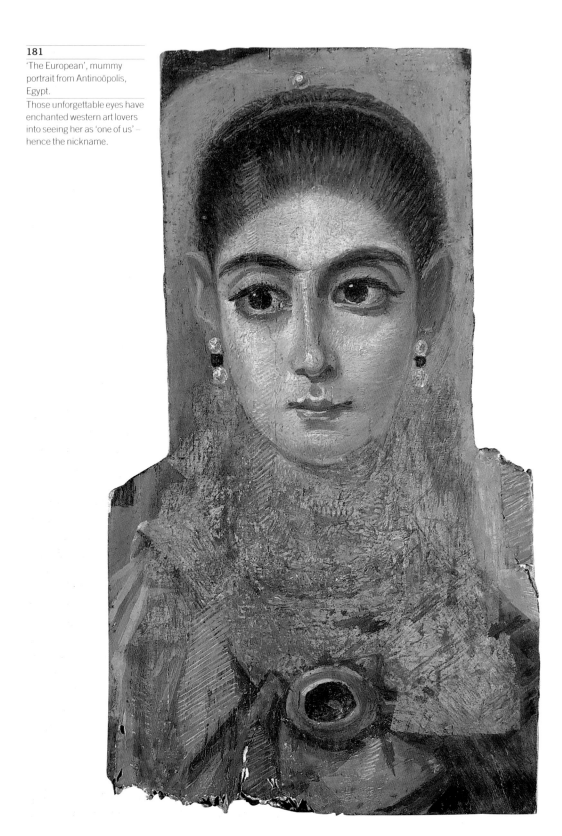

181

'The European', mummy portrait from Antinoöpolis, Egypt.

Those unforgettable eyes have enchanted western art lovers into seeing her as 'one of us' – hence the nickname.

Rogues' gallery: the 'Villa of the Papyri'

The primary importance of the face in ancient culture of our period comes across most strongly of all in the profusion of marble heads with which the Romans in particular surrounded themselves. They loved to build galleries of faces from the past, all the way back through the heroes of old to Homer, founding father of Hellenism. These images are often kept separate from the specialist study of Roman portraiture in the strict sense. The simple reason for this is that very many of them have long been recognized to be purely imaginary; not likenesses but standardized faces invented to match up to the reputation of the character concerned. We end this chapter by bringing these two traditions together and looking briefly at the richest gallery of busts and herms that we have. This will return us to the issues of identification which we raised earlier in this chapter; but it will also show how portraiture helped the Romans, just as it helps us, to face the cultural past head on.

When we explored the extraordinary art treasures retrieved by Karl Weber from the Villa of the Papyri at Herculaneum (pp. 93–4; see Maps and Plans 5), we outlined the sculptural programme discovered in the mock stadium there. It was a palatial environment probably installed wholesale, anything up to half a century before it was buried by the lava. The total collection numbers some 80 pieces. Around 40 of them are 'portraits' of Greeks—busts, herms, bronzes, and marbles—assembling a whole panorama of ancient faces, staking out a cultural history of antiquity and bringing it before the owner's eyes. The subjects include only one portrait that has been recognized in other versions: the ubiquitous wizened face traditionally dubbed 'Seneca', here on a bronze bust. The haul of ten Hellenistic ruler portraits—five bronze herms, five marble busts—is easily our most important single cache of the type. No names are inscribed, and only three precise identifications seem reasonably secure (on the basis of similarities to coins: one each from Macedon, Syria, and Egypt). There are orators and poets here too, including some oddly eccentric choices [182] (cf. 64 (a)). But the Villa's greatest prize has been its cluster of bearded philosophers (three marble herms and eight bronzes; cf. 64 (b)). A few are named. But for the most part we can only guess who exactly they are supposed to be, and a vast amount of effort and ingenuity has gone into the competition to name that sage. What matters, however, is that this battery of philosophers offers a rival map of images of power, to set against the rulers of merely mundane empires.

Tracking down Socrates

In no single instance can a plausible case be made out for thinking that any of these pieces is, or is copied from, a portrait carved to the

182

Herm of Panyassis. Marble, from the Villa of the Papyri, Herculaneum, 1757.

The inscription reads: 'Panyassis the poet. He is the worst pain of all.'

a

183 a, b, c, d

Portraits of Socrates: **(a)** 'Type A' head, marble, from Italy; **(b)** 'Type B' head, marble, from Italy; **(c)** statuette, alabaster, from Alexandria; **(d)** fragmentary statuette, from Athens.

The herm **(b)** is inscribed with a slightly idiosyncratic version of a quotation from Plato, where Socrates eerily intones from death row: 'I am not now for the first time but always someone who follows nothing I have, other than the reasoning that seems best to me as I reason.' The combination of text and image aims to make an unforgettable impression. Imagine, too, the thrill of finding the statuette in Athens **(d)**, and wondering if it marks the spot where Socrates drank the hemlock.

life. Only in fantasy can these faces hand us a direct gaze into the eyes and minds of these forbidding culture heroes and obstinate eggheads. Suppose that we turn from the Villa to track down Socrates, perhaps the most longed-for face of a historical person in all Antiquity. Images aplenty of this seminal and iconic guru do survive, both in truncated form as heads and herms (from Rome, from the Vesuvian towns, and from elsewhere in the empire), and in the shape of one full-length marble mini-statuette from Alexandria and, perhaps, another battered version from Athens [**183**].

Art historians have tried their hardest to believe that one of our portrait types, at least indirectly, taps into first-hand acquaintance with the fifth-century BCE guru. In fact, the very same sculptor we met in the story of the image of Alexander has served as the vital link between the real-life Socrates and the vivid portraits that survive. The anecdote collector Diogenes Laertius (writing in the third century CE) claimed that Lysippus made a statue of Socrates for the city of Athens once they had repented of putting the philosopher to death.[12] The problems of chronology here are almost overwhelming: certainly, if Lysippus was busy casting the image of Alexander in the 320s BCE, any 'portrait' he made of Socrates, who died in 399, could hardly have derived from some meeting with the great man. But that has not stopped a whole series of modern studies trying to square the circle, pushing the date of Lysippus himself back as far as possible,

and picking out one or other of our statues as a direct descendant of the Lysippan. It is one of the clearest examples of our longing to face our idols head on.

Once again, we can safely assume that all these sculptors, Lysippus included, could only dream what Socrates 'must have' looked like. What was wanted, and what they supplied, was a picture of the Socrates they read about in the works of the philosopher Plato, where he stars as gad-fly, theorist, critic of the establishment, and ultimately martyr for the truth. Plato took care to detail a pen portrait of his master, emphasizing, feature by feature, his famously subhuman physiognomy, which Plato likens to the stock mythical figures of Silenus or Satyr. A clear blueprint for reader and portrait artist alike.

But Plato's agenda went much further than merely providing a realistic description of Socrates. His first objective is to set his master apart from the rest of humanity. Second, he hands us the paradox that the wisest of men resembles most the bestial creatures of myth. And finally, this paradox of representation itself raises a crucial (perhaps *the* crucial) philosophical point: the nature of *reality* and its images. The trap that Plato sets for us is this: he encourages us to imagine what Socrates was like, but at the same time radically undermines the status of anything in our visual world. For in Platonic philosophy what is real lies in a world beyond the merely physical; the real Socrates is not accessible to our eyes.

This has dramatic implications for our understanding of portraits of Socrates, and puts a particular philosophical spin on the logic that governs 'realism' in all forms of portraiture. The image of Socrates is not to be confused with the real Socrates; in Platonic terms, the image of Socrates tells us that. Why? Because it is precisely *an image*, and images are neither reality nor reliable guides to it. The paradox is that, in coming face to face with one of the most individual physiognomies of them all, we are also confronted by a portrait that was designed to remind us how contested the relationship is between how people look (or are made to look) and how they 'really' are. Metaphysics aside, portraits always raise the question of how far the truth of a person—heart, mind, or soul—can be captured for the eye.

The missing person
But to prize Socrates' presence above all the rest is to miss the total absence from our text of all mention of the ancient citizen from our period who has made the most impact on human history—a subject of Augustus, then of Tiberius Caesar. His significance beggars that of any emperor or philosopher, and the continuous role of Rome itself as the hub of western history is in large part his legacy. No, there is not one image of Jesus of Nazareth that can be dated closer to Pontius Pilate's governorship of the Roman province of Judaea than two

centuries [**184**]. When images do come, they will be separated from Jesus' lifetime by enormous changes in the organization of the Empire, in the idioms and styles of artistic production, and in the visual and cultural experience of every subject within the Roman world. In a strong sense (for millions, to an ecstatic degree), all images of Christ always combine supernal deity with fleshly materiality: such is god made man. And they bring a new dimension to the problematic relationship between portraiture and reality. They are 'portraits' which constitute a new paradigm with incalculable consequences for the practice of representation up to the present day.

With the hindsight of history, a wry concluding thought is (let's face it) irresistible. The blank absence of Jesus from the visual repertoire of these first two centuries of the common era surely ranks as the single most striking fact about the portraiture of classical art from Greece to Rome.

184

Graffito from Rome.
A man worships an ass-headed figure (seen from behind) on a cross? The Greek writing seems to say: '*Alexamenos worships god.*' For the advent of images of Christ, see Robin Cormack's *Byzantine Art* in this series.

Notes

Introduction

1. Tacitus, *Annals* 15. 61–5.
2. F. Raguenet, *Les Monuments de Rome* (Rome, 1700), pp. 44–5.

Chapter 1. Painting Antiquity: Rediscovering Art

1. Pliny, *Natural History* 35. 110.
2. Ptolemy Hephaestion, cited by Photius, *Library*, cod. 190: 149b, lines 30–3.
3. Vitruvius, *Architecture* 7. 3. 10.
4. Pliny the Younger, *Letters* 6. 20, to the historian Tacitus.
5. Pliny *Natural History* 35. 134.
6. Pliny, *Natural History* 36. 29.
7. Pliny, *Natural History* 35. 136.
8. Antiphilus of Byzantium, *Palatine Anthology* 16 (= *Planudean Anthology*), 136.
9. Stendhal, *Rome, Naples and Florence* (London, 1959, trans. R. N. Coe, from *Rome, Naples et Florence en 1817*, Paris, 1817), p. 399: Naples, 5 April 1817.
10. J. W. Goethe, *Italian Journey, 1786–8* (Harmondsworth, 1970, trans W. H. Auden and E. Mayer), p. 211: Sunday 18 March 1787.
11. Homer, *Odyssey* 10. 80–132.

Chapter 2. Moving Statues: Art in the Age of Imitation

1. Pliny, *Natural History* 36. 37.
2. J. J. Winckelmann, *Monumenti Antichi Inediti* (Rome, 1767), i, p. 50.
3. J. J. Winckelmann, *History of Art of Antiquity* (1764), VI, ch. VI. 49–51 (= *Histoire de l'Art chez les Anciens, par Winckelmann*, Paris, 1802, trans. anon., i, i. 1–2).
4. Pausanias *Guidebook* 10. 7. 1.
5. Tacitus, *Annals* 4. 59.
6. Suetonius, *Life of Tiberius* 39.
7. Faustinus Felix: a 10-line Latin poem (*c*.80–95 CE ?) in epic hexameters on the display in the 'Cave of Tiberius' at Sperlonga (on a plaque found in a niche at the cave (G. Iacopi, *L'antro di Tiberio a Sperlonga* (Rome, 1963), 42)).

8. Pliny, *Natural History* 34. 36.
9. Pliny, *Natural History* 34. 57–8 (cf. Quintilian, *Training of the Orator* 2. 13. 10).
10. Plutarch, *Life of Aemilius Paullus* 32. 2–4.
11. Strabo, *Geography* 8. 6. 23.
12. Pausanias, *Guidebook* 9. 27. 3–4.
13. Pliny, *Natural History* 34. 54.
14. Pliny, *Natural History* 13. 53.
15. Cicero, *Letters to Atticus* 1. 8. 2.
16. Cicero, *Letters to Associates* 7. 23. 2.
17. J. P. Getty, *A Journey to Corinth*, in E. Le Vane and J. P. Getty, *Collector's Choice: The Chronicle of an Artistic Odyssey through Europe* (London, 1955), pp. 286–329.
18. Cicero, *Prosecution of Verres II*, 1. 59.
19. Plutarch, *Life of Aemilius Paullus* 28. 4.
20. Plutarch, *Life of Aemilius Paullus* 18. 1 has a horse, in a stratagem of Paullus; Livy 44. 40. 7–8 has a 'beast of burden', and Chance at work.
21. Pausanias, *Guidebook* 5. 17. 3.
22. Juvenal, *Satires* 2. 4–5.

Chapter 3. Sensuality, Sexuality, and the Love of Art

1. J. J. Winckelmann, *Monumenti Antichi Inediti* (Rome, 1767), pp. 235–7, on nos. 179–80.
2. F. Schiller, 'Brief eines reisenden Dänen (Der Antikensaal zu Mannheim)', in B. von Wiese (ed.), *Schillers Werke, Nationalausgabe Bd. 20, Philosophische Schriften* (Weimar, 1962), 1 Teil, p. 103: this on viewing a cast!
3. Byron, *Childe Harold* IV. clxi–cxlii.
4. J. J. Winckelmann, *History of Art of Antiquity* (1764), VI, ch. VI. 50 (= *Histoire de l'Art chez les Anciens, par Winckelmann*, Paris, 1802, trans. anon., II. 427–8).
5. Ovid, *Metamorphoses* I. 441–567.
6. Chariton, *Erotic Tales of Chaereas and Callirhoe* I. 1. 2, 3.
7. Lucian, *In Defence of Images* 23.
8. Winckelmann, *History of Art*, IV. ch. II. 70 (= II. 397).
9. A poet: Leconte de Lisle, 'Venus de Milo', stanza 7 ('Tu marches, fière et nue, et le monde

palpite, / Et le monde est a toi, Déesse aux larges flancs!'), in *Ouevres de Leconte de Lisle, Poèmes Antiques* (Paris, 1908), p. 135.

10. A. Rodin, 'At the Louvre', in P. Gsell (ed.), *Rodin on Art* (New York, 1971; trans. R. Fedden, 1912), pp. 213–14.

11. J. Joyce, *A Portrait of the Artist as a Young Man* (Harmondsworth, 1960), p. 205.

12. Pliny, *Natural History* 36. 20–1.

13. K. Clark, *The Nude. A Study of Ideal Art* (London, 1956), p. 73.

14. M. Foucault, *The Care of the Self* (London, 1986, trans. from *Le Souci de Soi*, Paris, 1984), pp. 211–27.

15. Lucian, *Erotes* 11–14.

16. Lucian, *Erotes* 15–16.

17. Pliny, *Natural History* 36. 22.

18. O. Wilde, 'Charmides 1', in *Works* (Ware, 1994), pp. 49–57.

19. M. Longley, 'Ivory and Water', after Ovid, *Metamorphoses* 10. 243–97, in M. Hofmann and J. Lasdun (eds), *After Ovid: New Metamorphoses* (London, 1994), p. 240.

20. Lucian, *Erotes* 17.

21. Lucian, *Erotes* 19–28, 29–49.

22. Lucian, *Erotes* 51.

23. Lucian, *Erotes* 53–5.

24. Pliny, *Natural History* 36. 32.

25. Athenaeus, *Deipnosophistae* 7. 276 b–c.

26. Herodas, *Iambic Mimes* 4. 31.

Chapter 4. Sizing up Power: Masters of Art

1. Ampelius, *Book of Memorable Facts* 8. 14.

2. Pliny, *Natural History* 34. 88.

3. Pliny, *Natural History* 34. 84.

4. Pliny, *Natural History* 36. 34.

5. Byron, *Childe Harold* iv. cxl.

6. Pausanias, *Guidebook* 1. 25. 2.

7. Pliny, *Natural History* 36. 101–2.

8. Pliny, *Natural History* 36. 102.

9. Suetonius, *Life of Augustus* 29. 1.

10. Ovid, *Calendar Poem* 5. 545–98.

11. Suetonius, *Life of Augustus* 28. 3.

12. Pliny, *Natural History* 22. 13.

13. Pliny, *Natural History* 35. 93–4.

14. Pliny, *Natural History* 34. 48.

15. Homer, *Odyssey* 8. 266–366.

16. Ovid, *Melancholy* 2. 295–6.

17. Ovid, *Calendar Poem* 5. 545–98.

18. Ovid, *Calendar Poem* 5. 563–6.

19. Suetonius, *Life of Augustus* 31. 5.

20. SHA (*History of the Roman Emperors*) *Alexander Severus* 28. 6.

21. Dio Cassius, *Roman History* 55. 10. 3.

22. Velleius Paterculus, *Roman History* 2. 39. 2.

23. CIL 6. 31267.

24. Tacitus, *Annals* 2. 64, CIL 6. 911.

25. SHA (*History of the Roman Emperors*) *Hadrian* 19. 10.

26. Tacitus, *Annals* 13. 8.

27. Ammianus Marcellinus, *History* 16. 10. 5.

28. Dio Cassius, *Roman History* 68. 16. 3.

29. *Tabula Siarensis*, frag. 1 (*AE* (1984) 138)

30. Suetonius, *Life of Augustus* 101. 4.

31. Martial, *Epigrams* 9. 43–4.

32. Statius, *Rough Work* 1. 6.

Chapter 5. Facing up to Antiquity: Art to the Life

1. Augustus, *Achievements* 24. 2.

2. Plutarch, *Life of Pompey* 2.

3. F. Orsini, *Imagines et Elogia Virorum Illustrium* (Rome, 1570).

4. J. J. Winckelmann, *History of Art of Antiquity* (1764), vi, ch. v. 26–7 (= *Histoire de l'Art chez les Anciens, par Winckelmann*, Paris, 1802, trans. anon., ii. 382).

5. J. J. Bernouilli, *Römische Ikonographie. Erster Teil. Die Bildnisse berühmter Römer* (Stuttgart, 1882), pp. 112–18: marginally overriding doubts whether the portrait is of Pompey.

6. Horace, *Letters* 2. 1. 229–43.

7. Pliny, *Natural History* 34. 63.

8. For Lysippus as inventor of the technique of taking plaster moulds from the sitter's face, and so of 'likenesses': Pliny, *Natural History* 35. 153; on his depictions of Alexander: Velleius Paterculus, *Roman History* 1. 11. 4, Pliny, *Natural History* 34. 63, Plutarch, *Life of Alexander* 4. 1, *On the Bravery or Courage of Alexander* 1. 335a–b.

9. Suetonius, *Life of Augustus* 50.

10. Pliny, *Natural History* 34. 17.

11. Polybius, *Histories* 6. 53. 5–6.

12. Diogenes Laertius, *Lives of the Philosophers* 2. 43.

Maps and Plans

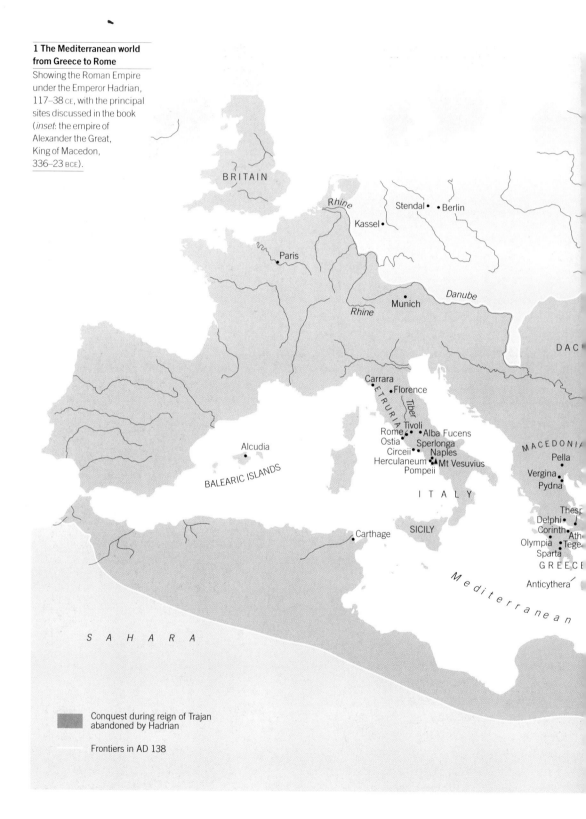

1 The Mediterranean world from Greece to Rome

Showing the Roman Empire under the Emperor Hadrian, 117–38 CE, with the principal sites discussed in the book (*inset*: the empire of Alexander the Great, King of Macedon, 336–23 BCE).

BRITAIN

Rhine

Stendal • • Berlin

Kassel •

Paris •

Danube

Rhine • Munich

DAC

Carrara •

• Florence

ETRURIA

Tiber

• Tivoli

Rome • • Alba Fucens

Ostia • Sperlonga

Circeii • • Naples

Herculaneum • Mt Vesuvius

Pompeii

Alcudia •

BALEARIC ISLANDS

I T A L Y

MACEDONIA

• Pella

Vergina •

Pydna

Thess

Delphi •

Corinth • Ath

Olympia • • Tege

Sparta

G R E E C E

Anticythera

Carthage

SICILY

Mediterranean

S A H A R A

Mediterranean

■ Conquest during reign of Trajan abandoned by Hadrian

— Frontiers in AD 138

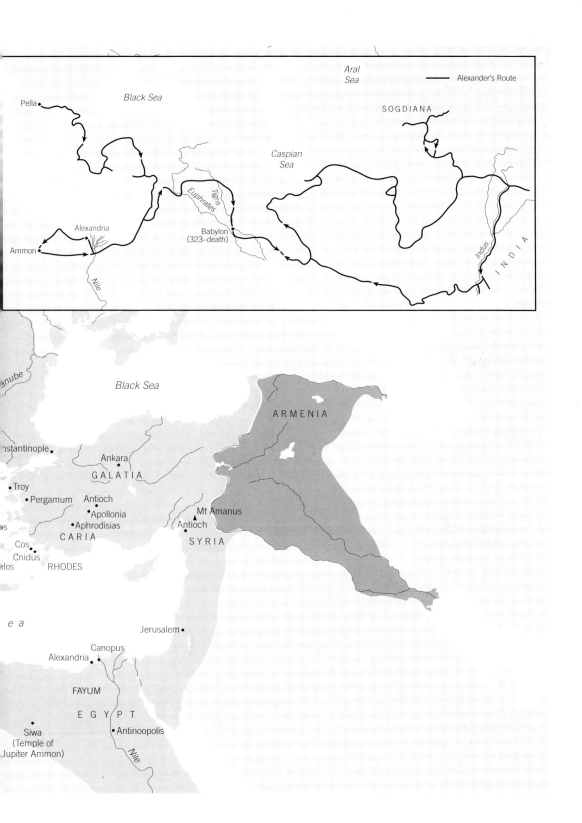

Aral Sea

—— Alexander's Route

Black Sea

SOGDIANA

Pella

Caspian Sea

Euphrates

Tigris

Alexandria

Babylon
(323–death)

Ammon

Nile

Indus

INDIA

Black Sea

Danube

ARMENIA

Constantinople

Ankara

GALATIA

Troy

Pergamum Antioch

Apollonia

Mt Amanus

Aphrodisias

Antioch

CARIA

SYRIA

Cos

Cnidus

los

RHODES

e a

Jerusalem

Canopus

Alexandria

FAYUM

EGYPT

Siwa
(Temple of
Jupiter Ammon)

Antinoopolis

Nile

2 **The area around Vesuvius**

Showing the area affected by
the hail of pumice stones in
the eruption of Vesuvius in
79 CE, with the relative depth
of ash deposited.

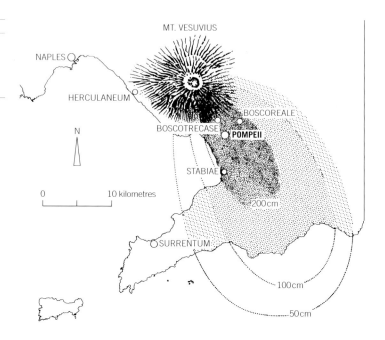

3 **The city and houses of
Pompeii**

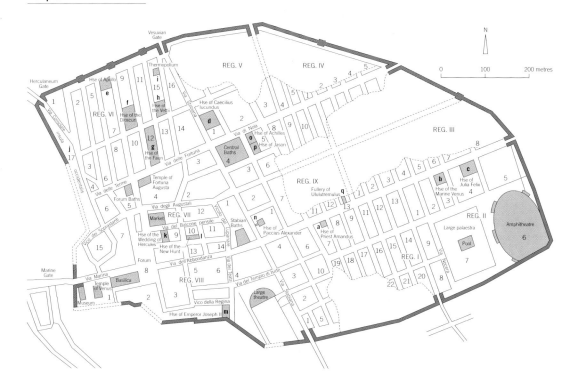

triclinium

c
b d
a

peristyle

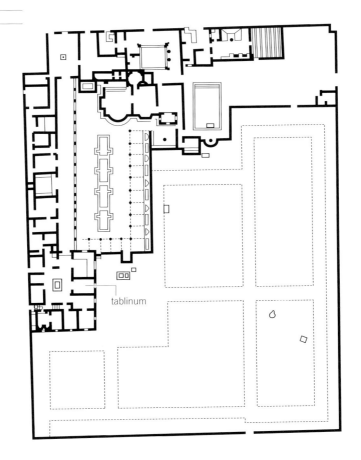

tablinum

0 10 20 30 metres

3d House of Caecilius Iucundus

triclinium o

cubiculum p

peristyle

3e House of Apollo

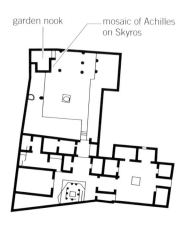

garden nook

mosaic of Achilles on Skyros

3f House of the Dioscuri

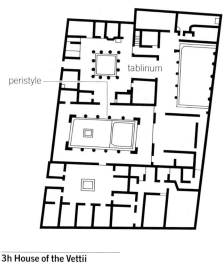

peristyle

tablinum

3g House of the Faun

peristyle gardens

atria

vestibule

3h House of the Vettii

triclinium

vestibule

0 10 20 30 metres

**3i Thermopolium
(VI, 15, 13–15)**

tablinum

3l House of the New Hunt

tablinum

**3k House of the Wedding
of Hercules**

tablinum

**3m House of Emperor
Joseph II**

bakery

**3n House of Paccius
Alexander**

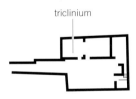

triclinium

3o House of Achilles

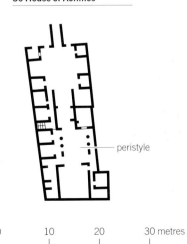

peristyle

3p House of Jason

a c
b

cubiculum e

0 10 20 30 metres

4–8 The environs of Pompeii

4 The Villa of the Mysteries, outside Pompeii

Showing *oecus* ('room') 5, with the megalographic wall-painting of 'The Mysteries'.

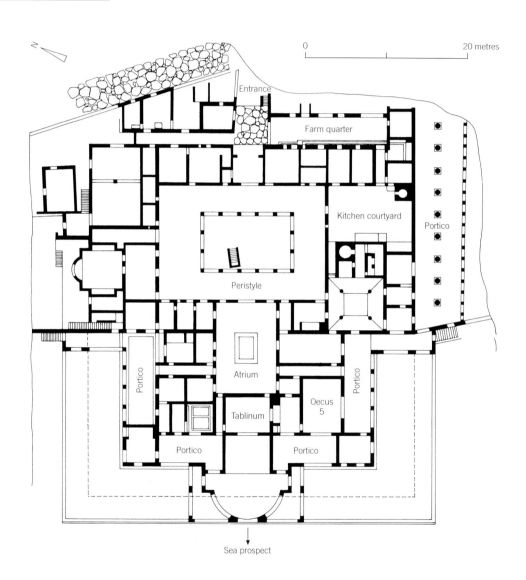

N

0 20 metres

Entrance

Farm quarter

Kitchen courtyard

Portico

Peristyle

Portico

Portico

Atrium

Oecus 5

Tablinum

Portico

Portico

Sea prospect

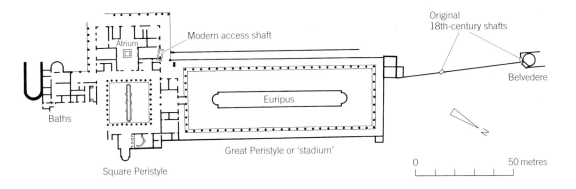

Atrium

Modern access shaft

Original
18th-century shafts

Belvedere

Euripus

Baths

N

Great Peristyle or 'stadium'

0 50 metres

Square Peristyle

**5 The Villa of the Papyri,
Herculaneum**

**6 The Villa della Pisanella,
Boscoreale**

Strada Sette Termini

Pompeii

Wine-tank
and findspot
of silver hoard

20 metres

15

10

5

0

N

7 The Villa of P. Fannius Synistor, Boscoreale

Axonometric plan

Cubiculum M

0 5 10 metres

8 The Imperial Villa at Boscotrecase

Axonometric plan

0 5 10 metres

The Black Room

The Red Room

(b) E. Wall – Perseus and Andromeda

(a) W. Wall – Polyphemus and Galatea

The Mythological Room

9–13 Rome

9 The Villa della Farnesina

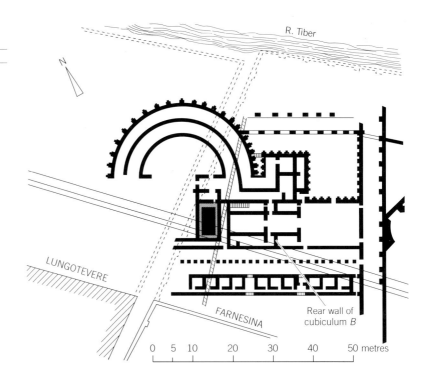

R. Tiber

N

LUNGOTEVERE

FARNESINA

Rear wall of cubiculum *B*

0 5 10 20 30 40 50 metres

10 The *Ara Pacis*

Roma (East) Italy (or Earth)

(North) Procession

(South) Procession
(Augustus and Agrippa)

ALTAR

Lupercal Aeneas

(West)

0 1 2 3 4 5 metres

11a, b

(**a**) The City of Rome;
(**b**) the *Imperial Fora*, with the
Via dell' Impero (today *Via dei Fori Imperiali*)

a

b

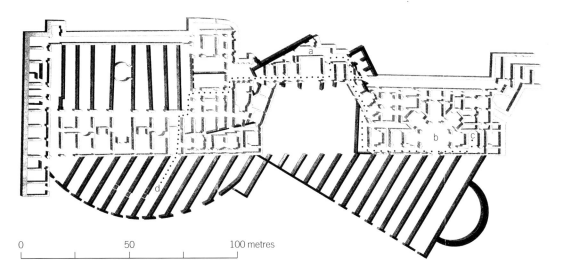

12 (above)
The *Golden House* of Nero
(with the superstructure of
the Baths of Trajan)

Showing (**a**) corridor 79
(formerly 'room 61'); (**b**) the
octagonal imperial dining-
room (**128**, 'the Octagon');
(**c**) the 'Room of Hector and
Andromache' (**129**); (**d**)
modern entrance with tourist
route marked.

13 The Pantheon

Showing (**a**) porch;
(**b**) rotunda.

0 10 metres

14 The Cave of Tiberius, Sperlonga

Showing featured sculptures: (**a**) 'The Argo'; (**b**) Menelaus rescuing the body of Patroclus; (**c**) Ajax and Odysseus steal the Palladium; (**d**) Scylla attacking Odysseus' crew; (**e**) Polyphemus blinded by Odysseus and his crew.

0 10 metres

15 'Livia's Villa' at Prima Porta

0 40 metres

Via Flaminia

The underground 'Garden Room'

Via Tiberina

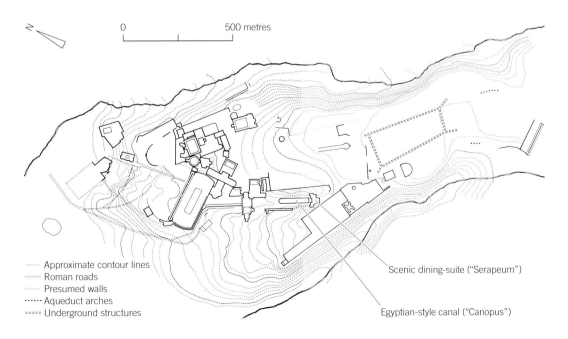

16 Hadrian's Villa at Tivoli

N

0 500 metres

Scenic dining-suite ("Serapeum")

Egyptian-style canal ("Canopus")

----- Approximate contour lines
......... Roman roads
——— Presumed walls
••••• Aqueduct arches
===== Underground structures

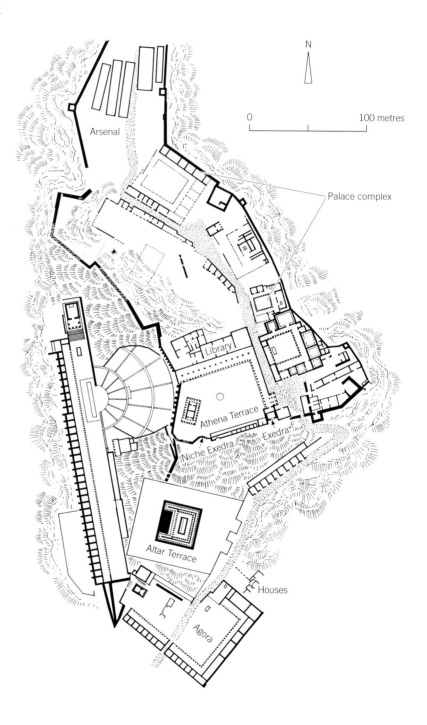

N

0 100 metres

Arsenal

Palace complex

Library

Athena Terrace

Niche Exedra

Exedra

Altar Terrace

Houses

Agora

The imperial sanctuary at Antioch in Pisidia, with the *Achievements of Augustus* (*c.* 14 CE) displayed in the passage of a gateway leading to the Temple of (?) Augustus and Rome (*c.* 2 BCE)

About forty-three columns were placed here

0 10 20 metres

	800	700	600	500
			Early Roman monarchy **750–500** BCE	
			Archaic Greece **750–500** BCE	
				Classical Greece **500–323** BCE
				Republican Rome **500–31** BCE

Politics and power

753 Traditional date of foundation of Rome **c.750** Emergence of independent city-states in the Greek world	Earliest traces of settlement at Pompeii	**590s** Legendary organization of Athens and its political institutions (attributed to law-giver Solon) **546** *Coup d'état*, Athens **514** Harmodius and Aristogiton assassinate Hipparchus, a member of the ruling junta **510** Traditional date of the expulsion of the last 'king' of Rome; Republic established	**480–479** Persian invasion of Greece defeated	

Writing and culture

776 Traditional date of first Olympic Games	**c.700** Presumed oral circulation of 'Homeric' epics, *Iliad* and *Odyssey* (later canonized in written form)	**c.550** Beginning of philosophical and scientific speculation in the Greek world	**c.485–c.405** Tragedies of Aeschylus, Sophocles, and Euripides **c.440–c.430** Herodotus, 'the Father of History', writes account of the clash between Greece and Persia	

Art, architecture, and material culture

	c.650 Earliest large-scale Greek marble sculpture	**c.510** Temple of Jupiter, Juno, and Minerva established on Capitoline Hill, Rome	**470s** Statue group of Harmodius and Aristogiton, Athens (probably replacing an earlier version destroyed in Persian invasion) **c.450** Myron's *Discus Thrower* **447–c.430** Parthenon built in Athens; sculptural programme directed by Phidias **c.440** Polyclitus' *Spear Carrier*	

Attalid dynasty of Pergamum **282–133** BCE

Hellenistic Greece **323–31**

399 Socrates put to death
338 Decisive defeat of free Greek city-states by King Philip of Macedon
336–323 Alexander the Great of Macedon conquers eastern Mediterranean world and the Persian empire as far as India
331 City of Alexandria founded

282 First Attalid takes control of Pergamum
279 Galatians (Gauls) sack Delphi
230s Attalids drive Galatians back into interior of Asia Minor

200–146 Main period of Roman conquest of Greece
168 Aemilius Paullus defeats King Perseus of Macedon
146 Romans sack Corinth and Carthage
133 The last king of the Attalids 'bequeaths' Pergamum to Rome

91–89 Pompeii captured by Sulla in the 'Social War' between Rome and a confederacy of Italian cities
80 Pompeii resettled by Sulla's veterans as a Roman colony
58–50 Julius Caesar's conquest of Gaul
53 Parthians defeat Romans at Carrhae and capture Roman standards

49–48 Caesar defeats Pompey in civil war; death of Pompey
44 Caesar assassinated
43 Cicero liquidated by junta of Antony, Octavian Caesar (Julius' adoptive heir), and Lepidus

*c.***385**–*c.***350** Plato's philosophical dialogues (with his teacher Socrates as main character)

*c.***300**–*c.***270** Epicurus develops philosophical doctrine on pleasure as the goal of life
*c.***210**–*c.***200** First Roman historian, Fabius Pictor, writes account of Rome from its origins (in Greek)

170s Ennius' epic poem on the *History of Rome*
167–*c.***118** Polybius' *Histories*

70 Cicero's speech *Prosecution of Verres*

*c.***350** Praxiteles' *Hermes* at Olympia and *Aphrodite* at Cnidus
*c.***350**–*c.***330** Scopas, prolific sculptor, active (associated with the Mausoleum of Halicarnassus and Temple of Athena Alea at Tegea)
*c.***330**–*c.***320** Lysippus' portraits of Alexander and *Weary Herakles*

168–7 Victory monument of Aemilius Paullus, Delphi
*c.***150** Stoa of Attalus, Athens
pre-133 *Great Altar* of Pergamum built

*c.***100** Sculptural group of *Aphrodite, Pan, and Eros*, Delos
*c.***100**–*c.***80** Ship laden with sculpture wrecked off Anticythera, Greece
*c.***55** Pompey's theatre, temple, senate house, and forum, Rome
*c.***50** Villa of Mysteries decorated
40s Timomachus of Byzantium paints *Medea* and *Ajax*

46 Julius Caesar dedicates the Temple of Venus Genetrix, Rome

31 BCE	20 BCE	14 CE	

Emperor Augustus **31 BCE–14 CE**

Julio-Claudian dynasty **14 CE–68**

Politics and power

31 Octavian defeats Antony and Cleopatra at Actium; establishes Rome's first dynasty of Caesars **27** Octavian takes the title 'Augustus' **25–24** Ethiopian raids on Roman outposts in Egypt	**20** Parthians return captured Roman standards; they are installed in the temple of *Mars Ultor* (the 'Avenger') **4** Jesus of Nazareth born in Roman Judaea **2** Augustus is given the title 'Father of the Fatherland'	**14–37** Reign of Tiberius **26** Rockfall almost crushes Tiberius at Sperlonga **37–41** Reign of Gaius (Caligula) **41–54** Reign of Claudius **43** Invasion of Britain **54–68** Reign of Nero; his mother Agrippina and tutor Seneca at first his chief advisers	**58** (Temporary) Roman subjugation of Armenia **62** Severe earthquake damages the district around Pompeii **64** Fire destroys much of the city of Rome **65** Suicide of Seneca **68** Nero is deposed and kills himself; a chaotic year of civil war follows, before Vespasian's forces take over the empire

Writing and culture

c.31 BCE–17 CE Livy's *History of Rome* **23–c.13** Horace's *Odes* and verse *Letter* to Augustus about imperial patronage **c.20** Vitruvius' *Architecture* **19** Virgil dies; his epic poem, the *Aeneid*, is posthumously published	**c.10 BCE–17 CE** Ovid's epic poem, the *Metamorphoses*; his *Calendar Poem*; and (from exile in Romania) *Melancholy*	**14–15** Augustus' *Achievements* set up outside his Mausoleum in Rome and elsewhere in the empire (the main surviving copy from Ankara in modern Turkey)	

Art, architecture, and material culture

Late 30s or 20s Gaius Sosius rebuilds Temple of Apollo, Rome **28** Building of Augustus' Mausoleum **25–24** Head of statue of Augustus buried under steps of an Ethiopian temple of victory at Meroe, Egypt	**20** Roman standards returned by Parthians installed in temple of *Mars Ultor*, Rome **13–9** *Ara Pacis* built in Rome **2** Formal dedication of Forum of Augustus and temple of *Mars Ultor*	**19** Arches decreed to commemorate Germanicus Caesar **c.25–c.65** Sebasteion built at Aphrodisias **c.50?** *Great Cameo of France* **62–79** Final phase of Pompeian painting; House of Vettii and many others redecorated after earthquake **64–8** Golden House of Nero, Rome	

Flavian dynasty **69–96**

Ulpian dynasty 96–138

Later Roman history and beyond

69–79 Reign of
Vespasian
70 Sack of Jerusalem
79 Eruption of
Vesuvius buries towns
on Bay of Naples
79–81 Reign of Titus
81–96 Reign of
Domitian

96–8 Reign of Nerva
98–117 Reign of
Trajan
101–6 Trajan's
conquest of Dacia
117–38 Reign of
Hadrian
130 Antinous drowns
in the Nile

312–37 Reign of
Constantine, first
emperor to be baptised a
Christian
330 'New Rome'
founded at
Constantinople
357 Emperor
Constantius visits Rome
***c.*500–*c.*600** Collapse
of Roman empire in
West (though empire in
East continues as
Byzantine empire)

77 Pliny dedicates his
encyclopedia, the
Natural History, to the
emperor-apparent Titus
***c.*80–101** Martial's
Epigrams
***c.*93–6** Statius' *Rough
Work*

***c.*100–*c.*120**
Plutarch's *Lives*
***c.*103–*c.*113** Pliny the
Younger's *Letters*
***c.*105–*c.*130** Juvenal's
Satires
***c.*110–*c.*120** Tacitus'
history of Rome under
the Julio-Claudians,
the *Annals*
***c.*118–*c.*122**
Suetonius' *Lives of the
Twelve Caesars*

***c.*150–*c.*190** Lucian's
satirical sketches
(the *Erotes* preserved
among these, but
perhaps composed
later by an imitator)
***c.*160** Pausanias'
Guidebook to Greece
***c.*201–29** Dio's *Roman
History*

80 Inauguration of
Colosseum
81 Arch of Titus in
Rome

104–9 Baths of Trajan
built over Nero's
Golden House
***c.*110–*c.*113** *Trajan's
Column* and Forum
under construction,
Rome
118–25 Pantheon
built, Rome
***c.*125–38** Hadrian's
palatial villa built at
Tivoli

145 Temple of Hadrian,
Rome
***c.*180–*c.*192** Column of
Marcus Aurelius, Rome
***c.*200–*c.*220** *Farnese
Hercules*, Rome
212–16 Baths of
emperor Caracalla,
Rome
***c.*405** Column of
Arcadius,
Constantinople
475 Fire destroys the
Aphrodite of Cnidus in
Constantinople

Timeline

1300	1400	1500	1600

The Italian Renaissance **1300–1600**

Politics and power

1453 Constantinople ('New Rome') falls to the Ottoman Turks

Writing and culture

1314–21 Dante's *Divine Comedy*
1386–1400 Chaucer's *Canterbury Tales*

*c.***1478** Botticelli's *Primavera*
1495–97 Leonardo's *Last Supper*

1501–4 Michelangelo's *David*
*c.***1519** Painting of Vatican *Loggetta* by Raphael and G. da Udine

Discovery, rediscovery, excavations, and museums

Start of digging at Hadrian's Villa
Late fifteenth century *Apollo Belvedere* found in Italy
*c.***1490s** Nero's Golden House discovered

1506 Laocoon found in Rome
1546 *Farnese Hercules* found in Baths of Caracalla, Rome
*c.***1550** Palazzo Spada Pompey found in Rome
1588 St Peter put on top of *Trajan's Column*
1589 St Paul put on top of Marcus Aurelius' Column
Pre-1598 *Venus de' Medici* found in ? Rome

1776 American
Declaration of
Independence
1789 French
Revolution
1795–1815 Napoleonic
Wars
1797 Treaty of
Tolentino between
Napoleon and the pope

1713–17 *Herkules,
the Landmark of Kassel*

1753 British Museum
founded
*c.***1755** Panini's *Roma
Antica*
1756 Piranesi's
Antichità Romane
1764 Winckelmann's
*Geschichte der Kunst
des Alterthums*
(*History of Art of
Antiquity*)
1766 Lessing's
Laocoon

1767 Winckelmann's
*Monumenti Antichi
Inediti* (*Unpublished
Antiquities*)
1768–88 Goethe's
Italian tour, and *Italian
Journey*
1772–8 Zoffany's
Tribuna
1791 Brandenburg
Gate, Berlin

*c.***1600** 'Aldobrandini
Wedding' discovered in
Rome
*c.***1610** Discovery of
Louvre *Hermaphrodite*
1620 Bernini's
mattress for Louvre
Hermaphrodite
1637 The 'Altar of
Domitius Ahenobarbus'
found in Rome

1677 *Venus de' Medici*
moved from Rome to
the Uffizi in Florence
Pre-1700 *Drunken Old
Woman* found in Rome

1738–9 Excavations at
Herculaneum; Charles
III, king of Naples,
builds summer palace
on the site at Portici
1747 *Praying Boy* of
Berlin bought by Kaiser
Friedrich the Great
of Prussia
1748 Systematic
excavations of Pompeii
begin

1750 Villa of the
Papyri outside
Herculaneum
discovered and
excavated
1762 Antinous relief
from Tivoli installed at
the Villa Albani
1781 Discovery of
Lancellotti Discobolus
1787 Farnese
collection acquired by
King of Naples
1791 *Lansdowne
Hercules* found at Tivoli

1792 Copy of Myron's
Discus Thrower, found
at Tivoli, bought by
Charles Townley
1797 Napoleon seizes
artworks from Italy
under the Treaty of
Tolentino

1800	1850

Politics and power

1804 Napoleon crowned emperor of France
1805 Nelson's victory over Napoleon at Trafalgar
1815 Wellington's victory over Napoleon at Waterloo
1821–32 Greek War of Independence from Turkey

1870 Unified state of Italy established under Victor Emmanuel II
1871 Unified state of Germany established under Kaiser Wilhelm I

Writing and culture

1803–5 Canova's portrait statue of Napoleon
1806 Napoleon's Column in Place Vendôme, Paris
1812–18 Byron's *Childe Harold*
1839–42 Nelson's Column in Trafalgar Square, London

1871 Napoleon's Column pulled down (a replica soon installed)
1873 Alma-Tadema's *An Audience with Agrippa*
1880s Mau's analysis of the 'Four Styles' of Pompeian decor
1881 Oscar Wilde's 'Charmides'

Art, architecture, and material culture

1801 Archaeological Museum at Naples open to the public for the first time
1815 Following Waterloo, a good deal of Napoleon's plunder returned
1820 *Venus de Milo* found on Greek island of Melos

1830 *Drunken Old Woman* installed in new section of Munich Glyptothek; *Dancing Faun* found at House of the Faun, Pompeii
1831 *Alexander Mosaic* discovered in House of the Faun

*c.*1850 *Odyssey* Landscapes discovered in Rome
1863 Statue of Augustus found at the imperial villa at Prima Porta
1871 Schliemann begins to dig at Troy
1877 (Copy of?) the Hermes of Praxiteles found in excavations at Olympia

1878–86 Carl Humann excavates in Pergamum
1879 La Farnesina villa discovered in course of repairs to Tiber bank, Rome
1880s *Ny Carlsberg Head* of Pompey found in Rome
1895 Silver hoard discovered in the Villa at Boscoreale, near Pompeii

1914–18 World War I
1922–43 Mussolini's
'March' on Rome, and
his Fascist regime in
Italy
1939–45 World War II

1916 James Joyce's
*Portrait of the Artist as
a Young Man*
1928 Mussolini's *Via
dell'Impero*, Rome
1936–7 Leni
Riefensthal films of the
Berlin Olympic Games
1937–8 Mostra
Augustea ('Augustan
Exhibition'), Rome

1960s Paul Zanker
working Forum of
Augustus
1967–71 Pistoletto's
Golden Venus in Rags
1984 Foucault's *Le
Souci de Soi* (*Care of
the Self = History of
Sexuality*, vol. III)

1901 Ancient wreck
salvaged off
Anticythera
1901–8 First museum
built to house *Great
Altar* in Berlin
1902 Villa discovered
at Boscotrecase
1904 Statue group of
*Aphrodite, Pan, and
Eros* found on Delos

1905 Laocoon's right
arm discovered
1909 *Villa of Mysteries*
discovered, Pompeii
1910 Augustus' head
discovered at Meroe
1945 Sovietsremove
Great Altar to USSR

1951 J. Paul Getty
buys the *Lansdowne
Hercules*
1952 An ancient
copyist's studio found
at Baiae
1956 Stoa of Attalus
(re)built in Athens
1957 Cave of Tiberius
discovered at
Sperlonga, south of
Rome; Magi restores
Laocoon's arm
1958 *Great Altar*
returned to Berlin

1960 Alba Fucens
Hercules discovered
1974 J. Paul Getty
Museum built at
Malibu, California

1979 Bronze statue of
Augustus found in the
Aegean Sea;
Sebasteion discovered
at Aphrodisias, Turkey
1990 Two silver cups
lost from the
Boscoreale hoard
rediscovered

Further Reading

Introduction and General Bibliography

There are many handbooks of Greek and Roman art, usually covering either the 'Hellenistic' or the 'Roman' part of our period. On painting, sculpture, and other media: **C. M. Robertson**, *A History of Greek Art*, 2 vols (Cambridge, 1975), adapted as *A Shorter History of Greek Art* (Cambridge, 1981); **J. J. Pollitt**, *Art in the Hellenistic Age* (Cambridge, 1986); **R. Bianchi Bandinelli**, *Rome, the Center of Power: Roman Art from 500 B.C–A.D. 200* (New York, 1970); **R. Brilliant**, *Roman Art: From the Republic to Constantine* (London, 1974); **D. Strong**, *Roman Art* (2nd edn, rev. R. Ling, Harmondsworth, 1988). On sculpture: **A. F. Stewart**, *Greek Sculpture: An Exploration*, 2 vols (New Haven, 1990); **B. S. Ridgway**, *Hellenistic Sculpture I* (Bristol, 1990) and *Fourth-Century Styles in Greek Sculpture* (Madison, 1997); **R. R. R. Smith**, *Hellenistic Sculpture: A Handbook* (London, 1991); **N. Spivey**, *Understanding Greek Sculpture* (London, 1996); **D. E. E. Kleiner**, *Roman Sculpture* (New Haven, 1992). On painting: **R. Ling**, *Roman Painting* (Cambridge, 1991). On earlier Greek and later Roman material: **R. G. Osborne**, *Archaic and Classical Greek Art* (Oxford, 1998); **J. Elsner**, *Imperial Rome and Christian Triumph* (Oxford, 1998)—the neighbouring books in this series. Useful selections of Greek and Roman writing on art and material culture: **J. J. Pollitt**, *The Art of Greece 1400 B.C.–31 B.C.: Sources and Documents* (Englewood Cliffs, N.J., 1965; revised as *The Art of Ancient Greece: Sources and Documents*, Cambridge, 1990); **J. J. Pollitt**, *The Art of Rome c.753 B.C.–A.D. 337: Sources and Documents* (Englewood Cliffs, N.J., 1968; repr. Cambridge, 1983). Where we offer no specific bibliography below on the themes or works of art we discuss, further material can usually be found through these reference books.

Other books explore important themes in the art history of the period, and are relevant to several of our chapters: **E. D'Ambra** (ed.), *Roman Art in Context* (Englewood Cliffs, N.J., 1993); **O. Palagia and J. J. Pollitt**, *Personal Styles in Greek Sculpture* (*Yale Classical Studies* 30; Cambridge, 1996); **J. Elsner** (ed.), *Art and Text in Roman Culture* (Cambridge, 1996). **P. Zanker**, *The Power of Images in the Age of Augustus* (Ann Arbor, 1988), and the essays packed into the massive exhibition catalogue *Kaiser Augustus und die verlorene Republik* (Mainz, 1988) are concerned specifically with the art of Augustan Rome, but they have helped to reshape the whole field of Graeco-Roman art.

Guidebooks to the sites and museums of Rome are also key reference works and provide further information and reading on all the various monuments of Rome discussed in this book: **A. Claridge**, *Rome* (Oxford, 1998), the best up-to-date guidebook; **W. Helbig**, *Führer durch die öffentlichen Sammlungen klassischer Altertümer in Rom*, 1–4 (4th edn, Tübingen, 1963–72), a handbook of Roman museum collections; **L. Richardson**, *A New Topographical Dictionary of Ancient Rome* (Baltimore, 1992); **E. M. Steinby**, *Lexikon Topographicum Urbis Romae*, 1–VI (Rome, 1993–2000), a vast, multilingual encyclopaedia of the ancient city of Rome.

Introductions to the history of the period: the Greek East, **P. Green**, *Alexander to Actium: The Historical Evolution of the Hellenistic Age* (Berkeley, 1990); Rome from Republic to empire, **M. Beard and M. Crawford**, *Rome in the Late Republic* (London, 1985; 2nd edn, 2000), **A. Wallace-Hadrill**, *Augustan Rome* (London, 1993), **F. Millar**, *The Roman Empire and its Neighbours* (2nd edn, London, 1981). The interface between Greece and Rome: **S. E. Alcock**, *Graecia Capta: The Landscapes of Roman Greece* (Cambridge, 1993); **G. Woolf**, 'Becoming Roman, staying Greek: culture, identity, and the civilizing process in the Roman East', *Proceedings of the Cambridge Philological Society* 40 (1994), 116–43.

Our book emphasizes the importance of the discovery, display, and modern history of ancient works of art. A crucial reference work is **F. Haskell and N. Penny**, *Taste and the Antique: The Lure of Classical Sculpture 1500–1900* (New Haven, 1981), which documents the discovery and reception of many of the sculptures we discuss. For different aspects of classical art in modern Europe, **C. Moatti**, *The Search for Ancient Rome* (London, 1993); **M. Craske**, *Art in Europe 1700–1830* (Oxford, 1997); **D. Irwin**, *Neoclassicism* (London, 1997); **S. B. McHam** (ed.), *Looking at Italian Renaissance Sculpture* (Cambridge, 1998); **H. Joyce**, 'Grasping at shadows: ancient paintings in Renaissance and baroque Rome', *Art Bulletin* 74. 2 (1992), 219–46; **S. L. Marchand**, *Down from Olympus: Archaeology and Philhellenism in Germany, 1750–1970* (Princeton, 1996); **W. Arenhövel**, *Berlin und die Antike: Architektur, Kunstgewerbe, Malerei, Skulptur, Theater und Wissenschaft vom 16. Jahrhundert bis heute* (exhibition catalogue, Berlin, 1979); and many works cited below, esp. Chapter 1 ('Rediscovery of Pompeii and Herculaneum', 'Naples Museum'), Chapter 2 ('Cardinal Albani', 'Belvedere Court', 'Napoleon's seizures', etc.), Chapter 3 ('Antinous'), Chapter 4 ('Via dell'Impero', 'Piazzale Augusto'), Chapter 5 ('The Roman head').

p. 1–3 'Seneca': **H. P. Laubscher**, *Fischer und Landleute* (Mainz, 1982).

p. 3 Other art traditions: **N. Spivey**, *Etruscan Art* (London, 1997).

p. 4 The history of art history: **V. H. Minor**, *Art History's History* (Englewood Cliffs, N.J., 1994); **D. Preziosi** (ed.), *The Art of Art History: A Critical Anthology* (Oxford, 1998).

pp. 4 The *Praying Boy* of Berlin: **R. Kabus-Preisshofen**, 'Der "betende Knabe" in Berlin. Schicksal einer antiken Grossbronze und das Problem ihrer Deutung', *Archäologischer Anzeiger* (1988), 497–523; essays in **G. Zimmer and N. Hackländer** (eds), *Der Betende Knabe. Original und Experiment* (Frankfurt am Main, 1997).

pp. 6–7 Panini: **A. Wilton and I. Bignamini** (eds), *Grand Tour: The Lure of Italy in the Eighteenth Century* (London, 1996), esp. p. 277.

Chapter 1. Painting Antiquity: Rediscovering Art

The best introduction to the story of Pompeii

is **P. Zanker**, *Pompeii: Public and Private Life* (Cambridge, Mass., 1999); shorter accounts are **S. Nappo**, *Pompeii: Guide to the Lost City* (London, 1998) and (focusing on the discovery of the city) **R. Etienne**, *Pompeii, the Day a City Died* (London, 1992). Still excellent value is the exhibition catalogue by **J. Ward-Perkins and A. Claridge**, *Pompeii A.D. 79* (London, 1976). Also indispensable are the more recent catalogues which give lively accounts of many topics we cover in the chapter: **B. Conticello** (ed.), *Rediscovering Pompeii* (Rome, 1992); **M. Borriello, A. d'Ambrosio, S. De Caro, and P. G. Guzzo**, *Pompei: abitare sotto il Vesuvio* (Ferrara, 1996), with detailed inventories of finds from particular houses, including the House of the Faun; and *À l'Ombre du Vésuve: collections du Musée national d'archéologie de Naples* (Paris, 1995), a stunning introduction to every aspect of the museum at Naples. The multi-volume encyclopedia edited by **G. P. Carratelli**, *Pompei: pitture e mosaici* (Rome, 1990–), systematically documents all paintings and mosaics from Pompeii.

In addition to **R. Ling**, *Roman Painting* (Cambridge, 1991), excellent illustrations and stimulating essays are found in another exhibition catalogue, **A. Donati** (ed.), *Romana Pictura: la pittura romana dalle origini all'età bizantina* (Naples, 1998).

p. 11 Rediscovery of Pompeii and Herculaneum: **C. P. Parslow**, *Rediscovering Antiquity: Karl Weber and the Excavation of Herculaneum, Pompeii, and Stabiae* (Cambridge, 1998).

p. 12 Naples Museum: **S. de Caro**, *The National Archaeological Museum of Naples* (Naples, 1996); cf. **N. Himmelmann**, 'Les antiquités de Naples et l'Europe', in *À l'Ombre du Vésuve*, 37–50.

pp. 13–23 Alexander mosaic and House of the Faun: **A. Cohen**, *The Alexander Mosaic: Stories of Victory and Defeat* (Cambridge, 1997), the only extended account in English, but wayward and disappointing overall; for particular aspects of the mosaic installation, **M. Donderer**, 'Das pompeianische Alexandermosaik—Ein östliches Importstück?', in **C. Börker** and **M. Donderer** (eds), *Das antike Rom und der Osten: Festschrift für Klaus Parlasca zum 65. Geburtstag* (Erlangen, 1990), 19–31, and **A. Laidlaw**, 'A reconstruction of the First Style decoration in the Alexander exedra of the House of the Faun', in **B. Andreae and H. Kyrieleis** (eds), *Neue Forschungen*

in Pompeji (Recklinghausen, 1975), 39–52;
the mosaic in the context of the house in
general, **F. Zevi**, 'Die Casa del Fauno in
Pompeji und das Alexandermosaik',
*Mitteilungen des Deutschen Archäologischen
Instituts (Röm. Abt.)* 105 (1998), 21–65 (a
shorter Italian version appears in
Borriello et al. (eds), *Pompei: abitare sotto
il Vesuvio*).

p.16 Mosaics: **K. Dunbabin**, *Mosaics of the
Greek and Roman World* (Cambridge,
1999); **R. Ling**, *Ancient Mosaics* (London,
1998).

pp.18–21 Show houses at Pompeii: essays in
E. K. Gazda (ed.), *Roman Art in the
Private Sphere: New Perspectives on the
Architecture and Decor of the Domus, Villa,
and Insula* (Ann Arbor, 1991), esp.
E. Bartman, 'Sculptural collecting and
display in the private realm', 71–88;
J. R. Clarke, *The Houses of Roman Italy 10
B.C.–A.D. 250: ritual, space, decoration*
(Berkeley, 1991).

pp.24–5 The Villa della Farnesina:
I. Braganti and M. de Vos (eds), *Museo
Nazionale Romano, Le Pitture, II. 1: le
decorazioni della villa romana della
Farnesina* (Rome, 1982); **M. R. S. Di
Mino** (ed.), *La Villa della Farnesina in
Palazzo Massimo alle Terme* (Rome, 1998);
A. La Regina (ed.), *Palazzo Massimo alle
Terme* (Rome, 1998), 215–36.

pp.24–5 Vergina: **M. Andronikos**, *Vergina:
The Royal Tombs and the Ancient City*
(Athens, 1984).

pp.25–6 Pliny, *Natural History*: excerpted
text, translation, and commentary in
K. Jex-Blake and E. Sellers, *The Elder
Pliny's Chapters on the History of Art*
(London, 1896; repr. Chicago, 1968);
general study, **J. Isager**, *Pliny on Art and
Society: The Elder Pliny's Chapters on the
History of Art* (London, 1991). For an
insightful analysis, exploring the logic of
Pliny's account of art history, **S. Settis**,
'Did the ancients have an antiquity? The
idea of renaissance in the history of
classical art', in **A. Brown** (ed.), *Language
and Images of Renaissance Italy* (Oxford,
1995), 27–50.

pp.26–9 Achilles on Skyros: **R. A. Smith**,
*Poetic Allusion and Poetic Embrace in Ovid
and Virgil* (Ann Arbor, 1997), 78–83; for
the character of the House of Apollo, see
Zanker, *Pompeii*, 156–60.

pp.29–31 Medea: see 'House of Jason', below.

pp.31–2 Generic painting. Portraits:
D. L. Thompson, 'Painted portraiture at
Pompeii', in *Pompeii and the Vesuvian
Landscape* (Washington, D.C., 1979),
78–92, and see Chapter 5. Landscapes:
B. Bergmann, 'Painted perspectives of a
villa visit: landscape as status and
metaphor', in **Gazda** (ed.), *Roman Art in
the Private Sphere*, 49–70; **W. J. Peters**,
*Landscape in Romano-Campanian Mural
Painting* (Assen, 1963). Idyllic scenes and
seaside views: **E. W. Leach**, *The Rhetoric
of Space: Literary and Artistic Represent-
ations of Landscape in Republican and
Augustan Rome* (Princeton, 1988), chs 4–5;
Garden painting and still life:
N. Bryson, *Looking at the Overlooked: Four
Essays on Still Life Painting* (London,
1990), ch. 1; **W. F. Jashemski**, *The Gardens
of Pompeii, Herculaneum and the Villas
Destroyed by Vesuvius* (New York, 1979,
1993), vol. 1, 55–87, vol. 2, 313–404; and see
'The Garden Room of the Villa at Prima
Porta', below.

pp.31–5 Sex and pornography: **J. R. Clarke**,
*Looking at Lovemaking: Constructions of
Sexuality in Roman Art 100 B.C.–A.D. 250*
(Berkeley, 1998); recent discoveries in
L. Jacobelli, *Le pitture erotiche delle Terme
Suburbane di Pompei* (Rome, 1995); and see
Chapter 3.

p.35 The 'secret cabinet': **M. Grant**, *Eros à
Pompéi: le cabinet secret du Musée de Naples*
(Paris, 1975); '**Le Colonel Famin**' (ed.),
*Le Cabinet Secret du Musée royal de Naples:
peintures, bronzes et statues érotiques* (Paris,
1857, facsimile 1995).

p.36 'Pompeian style' and Alma-Tadema:
E. Becker and E. Prettejohn (eds), *Sir
Lawrence Alma-Tadema* (exhibition
catalogue, Amsterdam, 1996), ch. 1; in US,
M. L. Anderson, 'Pompeii and America',
in **Conticello** (ed.), *Rediscovering Pompeii*,
92–103.

pp.37–8 Domestic space: **A. Wallace-
Hadrill**, *Houses and Society in Pompeii and
Herculaneum* (Princeton, 1994); **A. M.
Riggsby**, '"Public" and "private" in Roman
culture: the case of the cubiculum', *Journal
of Roman Archaeology* 10 (1997), 36–56;
Y. Thébert, 'Private and public spaces: the
components of the domus', in **D'Ambra**
(ed.), *Roman Art in Context*, 213–37;
R. Laurence and A. Wallace-Hadrill,
*Domestic Space in the Roman World:
Pompeii and Beyond* (*Journal of Roman
Archaeology*, Supplement 22, 1997).

p.38–40 Mau's 'four styles': **A. Mau**,
*Geschichte der decorativen Wandmalerei in
Pompeji* (Berlin, 1882); with a more popular

presentation in English translation, in *Pompeii: Its Life and Art* (New York, 1899). For a detailed reassessment, **A. Barbet**, *La peinture murale romaine: les styles décoratifs pompéiens* (Paris, 1985); more critically, E. M. **Moorman**, 'La pittura romana fra costruzione architettonica e arte figurativa', in **Donati** (ed.), *Romana Pictura*, 14–32.

pp. 40–5 Programmatic suites of images and implied narratives: **B. Bergmann**, 'The Roman house as memory-theater: the House of the Tragic Poet in Pompeii', *Art Bulletin* 76. 2 (1995), 225–56; **M. L. Thompson**, 'The monumental and literary evidence for programmatic painting in Antiquity', Marsyas 9 (1960–1), 36–77; **R. Brilliant**, *Visual Narratives: Storytelling in Etruscan and Roman Art* (Ithaca, N.Y., 1984).

pp. 40–1 House of the Dioscuri: L. **Richardson, Jr**, *Pompeii: The Casa dei Dioscuri and its Painters* (= *Memoirs of the American Academy in Rome*, 23, Rome, 1955).

pp. 43–4 Thetis and the arms of Achilles: **M. Gury**, 'Le forge du destin. À propos d'une série de peintures pompéiennes du IVᵉ style', *Mélanges d'Archéologie et d'Histoire de l'École Française de Rome*, 98 (1986), 427–89.

pp. 44–5 The House of Jason: **B. Bergmann**, 'The pregnant moment: tragic wives in the Roman interior', in **N. B. Kampen** (ed.), *Sexuality in Ancient Art* (Cambridge, 1996), 199–218.

pp. 44–5 The House of the Priest Amandus: **A. Maiur**i, 'Le Pitture delle Case di "M. Fabius Amandus" e del "Sacerdos Amandus"' (= *Monumenti di Pittura* 6, ser. 3, Pompei, fasc. 2, Rome, 1938).

pp. 45–7 The Villa of the Mysteries: for a full publication, **A. Maiuri**, *La Villa dei Misteri* (Rome, 1931); for various interpretations, see **R. A. S. Seaford**, 'The Mysteries of Dionysos at Pompeii', in **H. W. Stubbs** (ed.), *Pegasus: Classical Essays from the University of Exeter* (Exeter, 1981), 52–68, **J. Henderson**, 'Footnote: representation in the Villa of the Mysteries', in **J. R. Elsner** (ed.), *Art and Text in Roman Culture* (Cambridge, 1996), 235–76 (erratic), and **P. Veyne**, 'La fresque dite des Mystères à Pompéi', in **P. Veyne, F. Lissarrague, and F. Frontisi-Ducroux**, *Les Mystères du Gynécée* (Paris, 1998), 13–153.

pp. 48–53 The Villa at Boscotrecase:

M. L. Anderson, Pompeian Frescoes in the Metropolitan Museum of Art (New York, 1987); **P. H. von Blanckenhagen and C. Alexander**, *The Augustan Villa at Boscotrecase* (= *Deutsches Archäologisches Institut (Röm. Abt.) Sonderschriften* 8, Mainz, 1990).

pp. 53–4 The '*Odyssey* Landscapes': **P. H. von Blanckenhagen**, 'The Odyssey Frieze', *Mitteilungen des Deutschen Archäologischen Instituts (Röm. Abt.)* 70 (1963), 100–46; for the colours after cleaning, see **R. Biering**, *Die Odysseefresken von Esquilin* (Munich, 1995).

pp. 54–7 The Garden Room of the Villa at Prima Porta: **M. M. Gabriel**, *Livia's Garden Room at Prima Porta* (New York, 1955); **B. A. Kellum**, 'The construction of landscape in Augustan Rome: the Garden Room at the villa Ad Gallinas', *Art Bulletin* 76.2 (1994), 211–24; **La Regina** (ed.), *Palazzo Massimo alle Terme*, 209–14.

p. 58 Painting before and after Pompeii: **Ling**, *Roman Painting*, chs 1 and 9; **Clarke**, *Houses of Roman Italy*, chs 6–8 (on Ostia).

pp. 58–60 The 'Aldobrandini Wedding': **G. Fusconi**, *La Fortuna delle Nozze Aldobrandini* (Rome, 1994); **F. G. J. M. Müller**, *The Aldobrandini Wedding* (Amsterdam, 1994).

pp. 60–3 Nero's Golden House: **A. Boethius**, *The Golden House of Nero: Some Aspects of Roman Architecture* (Ann Arbor, 1960), ch. 3; **L. F. Ball**, 'A reappraisal of Nero's Domus Aurea', in **L. La Follette et al.**, *Rome Papers: The Baths of Trajan Decius, Iside e Serapide nel Palazzo, A Late Domus on the Palatine, and Nero's Golden House* (*Journal of Roman Archaeology* Supplement 11, 1994), 183–251; **I. Iacopi**, *Domus Aurea* (Rome, 1999).

pp. 61–2 Raphael's Vatican loggias: **N. Dacos**, *Le Loggie di Raffaello* (Rome, 1977); **N. Dacos**, *La Découverte de la Domus Aurea et la Formation des Grotesques à la Renaissance* (London, 1969).

Chapter 2. Moving Statues: Art in the Age of Imitation

Two interconnecting themes run through this chapter. The first is the tradition of replication, copying, and creative imitation of sculpture, an area of particularly exciting recent work: **C. H. Hallett**, '*Kopienkritik* and the works of Polykleitos', in **W. G. Moon** (ed.), *Polykleitos, the Doryphoros, and Tradition*, (Madison, 1995), 121–60; **M. Marvin**,

'Copying in Roman sculpture: the replica series', in **D'Ambra** (ed.), *Roman Art in Context*, 161–88, and 'Roman sculptural reproductions or Polykleitos: the sequel', in **E. Ranfft and A. Hughes** (eds), *Sculpture and its Reproductions* (London, 1997), 7–28; **E. K. Gazda**, 'Roman sculpture and the ethos of emulation: reconsidering repetition', *Harvard Studies in Classical Philology* 97 (1995), 121–56; **E. Bartman**, '*Decor et duplicatio*: pendants in Roman sculptural display', *American Journal of Archaeology* 92 (1988), 211–25; **B. S. Ridgway**, *Roman Copies of Greek Sculpture: The Problem of the Originals* (Ann Arbor, 1984).

The second is the enormous impact of the art-historical theorizing of **J. J. Winckelmann**, author of *Geschichte der Kunst des Alterthums* (1764; English trans. by G. H. Lodge, Boston, 1872) and *Monumenti Antichi Inediti* (Rome, 1767); abridged translations in **D. Irwin** (ed.), *Winckelmann: Writings on Art* (London, 1972). Important recent studies include: **A. Potts**, *Flesh and the Ideal: Winckelmann and the Origins of Art History*, New Haven, 1984); **A. A. Donohue**, 'Winckelmann's history of art and Polyclitus', in **Moon** (ed.), *Polykleitos*, 327–51; *Winckelmann: la naissance de l'Histoire de l'Art à l'époque des lumières* (Paris, 1991); **N. Himmelmann**, 'Winckelmann's hermeneutic', in *Reading Greek Art* (Princeton, 1998), 217–36.

pp. 65–8 Laocoon: **M. Bieber**, *Laocoon: The Influence of the Group since its Rediscovery* (2nd edn, Detroit, 1967); **S. Richter**, *Laocoon's Body and the Aesthetics of Pain: Winckelmann, Lessing, Herder, Moritz, Goethe* (Detroit, 1992); on the debated findspot, **C. C. van Essen**, 'La découverte de Laocoon', *Mededelingen der koninklijke nederlandse Akademie van Wetenskappen* 18 (1955), 291–308 (cf. **E. La Rocca**, 'Artisti rodii negli horti romani', in **Cima and La Rocca** (eds), *Horti Romani*, 203–74, who suggests that it originally adorned a 'cave installation' near the Baths of Trajan); the discovery of the 'original' arm, **L. Pollak**, 'Der rechte Arm des Laokoon', *Rheinisches Museum* 20 (1905), 277–82; the 1950s restoration, **F. Magi**, *Il Ripristino del Laocoonte* (= *Atti della Pontificia Accademia Romana di Archeologia*, Serie III, Memorie volume IX, Rome, 1960). **Lessing**'s famous essay is translated as *Laocöon: An Essay on the Limits of Painting and Poetry* (Baltimore, 1984).

pp. 68–9 Cardinal Albani: **E. Debenedetti** (ed.), *Alessandro Albani patrono delle arti: architettura, pittura, e collezionismo nella Roma del '700* (Studi sul Settecento Romano, 9; Rome, 1993); **H. Beck and P. C. Bol**, *Forschungen zur Villa Albani: antike Kunst und die Epoche der Aufklärung* (Berlin, 1982).

p. 68 Belvedere Court: **H. H. Brummer**, *The Statue Court in the Vatican Belvedere* (Stockholm, 1970); **B. Andreae, K. Anger, M. G. Granino, J. Köhler, P. Liverani, and G. Spinola**, *Bildkatalog der Skulpturen des Vatikanischen Museums. Band II. Museo Pio-Clementino Cortile Ottagono* (Berlin, 1997).

pp. 74–82 The Cave of Tiberius at Sperlonga: **A. F. Stewart**, 'To entertain an emperor: Sperlonga, Laokoon and Tiberius at the dinner-table', *Journal of Roman Studies* 67 (1977), 76–90 (largely focused on the Tiberian setting); **G. Iacopi**, *I Ritrovamenti dell' Antro cosiddetto 'di Tiberio' a Sperlonga* (Rome, 1958), and *L'Antro di Tiberio a Sperlonga* (= *I Monumenti Romani* IV) (Rome, 1963); on the excavation, **G. Säflund**, *The Polyphemus and Scylla Groups at Sperlonga* (Stockholm, 1972), 9–12; the modern reconstruction, **B. Conticello and B. Andreae**, *Die Skulpturen von Sperlonga* (= *Antike Plastik* XIV, Berlin, 1974). A similar seaside installation, connected with Emperor Claudius, has been found at Baiae: **F. Zevi**, 'Gli scavi sottomarini di Baia', *Parola del Passato* 203 (1982), 114–56; **H. Lavagne**, *Operosa antra: recherches sur la grotte à Rome de Sylla à Hadrien* (Rome, 1988), 573–7.

p. 78 'Rhodian school' of sculpture: **J. Isager**, 'The lack of evidence for a Rhodian school', *Mitteilungen des Deutschen Archäologischen Instituts (Röm. Abt.)* 102 (1995), 115–31.

p. 83 Napoleon's seizures: **P. Wescher**, *Kunstraub unter Napoleon* (2nd edn, Berlin, 1976); *Dominique-Vivant Denon: l'oeil de Napoléon*. Paris, Musée du Louvre 20 octobre 1999–17 janvier 2000 (exhibition catalogue; Paris, 1999); **A. McClellan**, *Inventing the Louvre: Art, Politics, and the Origins of the Modern Museum in Eighteenth-century Paris* (Cambridge, 1994); **P. Malgouyres**, *Le Musée Napoléon* (Paris, 1999).

p. 83 Cast-collecting and drawing: **P. Connor**, 'Cast-collecting in the nineteenth century: scholarship,

aesthetics, connoisseurship', in
G. W. Clark (ed.), *Rediscovering
Hellenism: The Hellenic Inheritance and the
English Imagination* (Cambridge, 1989),
187–235; **C. Goldstein**, *Teaching Art:
Academies and Schools from Vasari to Albers*
(Cambridge, 1996), esp. ch. 7, 'The
Antique'; **S. C. Hutchison**, *The History of
the Royal Academy 1768–1986* (2nd edn,
London, 1986).

p. 84 The variety of ancient sculpture:
bronzes, **C. C. Mattusch**, *Classical
Bronzes: The Art and Craft of Greek and
Roman Statuary* (Ithaca, N.Y., 1996), and
the exhibition catalogue, **Mattusch** (ed.),
*The Fire of Hephaistos: Large Classical
Bronzes from North American Collections*
(Cambridge, Mass., 1996); coloured
statues and coloured marbles, **J. Gage**,
*Colour and Culture: Practice and Meaning
from Antiquity to Abstraction* (London,
1993), 11–27; **R. M. Schneider**, *Bunte
Barbaren: Orientalstatuen aus farbigem
Marmor in der römischen
Repräsentationskunst* (Worms, 1986).

pp. 86–7 'Restoration' of classical sculpture:
S. Howard, *Bartolomeo Cavaceppi,
Eighteenth-century Restorer* (New York,
1982); documenting restoration in specific
collections, **A. Giuliano** (ed.), *La
Collezione Boncompagni Ludovisi: Algardi,
Bernini e la fortuna dell'Antico* (Venice,
1992), **A.-M. L. Touati**, *Ancient Sculptures
in the Royal Museum: The Eighteenth-
century Collection in Stockholm*, vol. 1
(Stockholm, 1998).

pp. 87–8 Townley and his collection:
B. F. Cook, *The Townley Marbles*
(London, 1985); Clytie: **M. Jones** (ed.),
Fake? The Art of Deception (London, 1990),
32–3; the Discus Thrower: ibid. 140–2, **S.
Howard**, *Antiquity Restored: Essays on the
Afterlife of the Antique* (Vienna, 1990),
70–7.

p. 89 Wealth, power, art funnelled to Rome:
C. J. Howgego, 'The supply and use of
money in the Roman world 200 B.C. to
A.D. 300', *Journal of Roman Studies* 82
(1992), 1–31.

pp. 89–90 Roman loot: **E. S. Gruen**, *Culture
and National Identity in Republican Rome*
(London, 1993), ch. 3; **C. C. Vermeule, III**,
*Greek Sculpture and Roman Taste:
The Purpose and Setting of Graeco-Roman
Art in Italy and the Greek Imperial East*
(Ann Arbor, 1977); **A. Corso**, 'Love as
suffering: the Eros of Thespiae of
Praxiteles', *Bulletin of the Institute of*

Classical Studies 42 (1997–8), 63–77.

pp. 90–1 Apollo Sosianus: **E. La Rocca**,
'Der Apollo-Sosianus-Tempel', in *Kaiser
Augustus*, 121–36.

pp. 91–2 Shipwrecks: at Anticythera,
P. C. Bol, *Die Skulpturen des Schiffsfundes
von Antikythera* (= *Mitteilungen des
Deutschen Archäologischen Instituts (Athen.
Abt.)* 2 Beiheft, Berlin, 1972); more
generally, **G. H. Sallies, H.-H. von
Prittwitz und Gaffron, and G.
Bauchheuss**, *Das Wrack: der Antike
Schiffsfund von Mahdia* (Cologne, 1994).

pp. 91–3 Roman collectors: **E. W. Leach**,
'The politics of self-representation: Pliny's
Letters and Roman portrait sculpture',
Classical Antiquity 9 (1990), 14–39. Cicero:
A. Leen, 'Cicero and the rhetoric of art',
American Journal of Philology 112 (1991),
229–45.

pp. 93–4 Villa of the Papyri: **M. R. Wocjik**,
La Villa dei Papiri ad Ercolano (Rome,
1986); **P. G. Warden and D. G. Romano**,
'The course of glory: Greek art in a Roman
context at the Villa of the Papyri at
Herculaneum', *Art History* 17 (1994),
228–54.

p. 94–6 The J. Paul Getty Museum and the
Lansdowne Hercules: *The J. Paul Getty
Museum Guide to the Villa and its Gardens*
(Malibu, 1992); **S. Howard**, *The
Lansdowne Herakles* (2nd edn,
Los Angeles, 1978).

pp. 96–8 Aemilius Paullus' Victory
Monument: **H. Kähler**, *Der Fries vom
Reiterdenkmal des Aemilius Paullus in
Delphi* (*Monumenta Artis Romanae* 5,
Berlin, 1965).

pp. 98–100 The 'Altar of Domitius
Ahenobarbus': **H. Kähler**, *Seethiasos und
Census: die Reliefs aus dem Palazzo Santa
Croce in Rom* (*Monumenta Artis Romanae*
6, Berlin, 1966); **F. Coarelli**, 'L' "ara di
Domizio Enobarbo" e la cultura artistica
in Roma nel II Secolo a. C.', *Dialoghi di
Archeologia* 2 (1968), 302–68; **A. Kuttner**,
'Some new grounds for narrative: Marcus
Antonius's Base (the Ara Domitii
Ahenobarbi) and republican biographies',
in **P. J. Holliday** (ed.), *Narrative and
Event in Ancient Art* (Cambridge, 1993),
198–229.

p. 100–2 Hermes of Praxiteles: **A. Ajootian**,
'Praxiteles', in **O. Palagia and J. J. Pollitt**,
Personal Styles in Greek Sculpture (*Yale
Classical Studies* 30; Cambridge, 1996),
91–129 (esp. 103–10); and see **R. G.
Osborne**, *Archaic and Classical Greek Art*,

(Oxford, 1998), 228–30.

p. 102 Baiae workshop: **C. Casparini**, 'L'officina dei Calchi di Baia: sulla produzione copistica di età Romana in area flegrea', *Mitteilungen des Deutschen Archäologischen Instituts (Röm. Abt.)* 102 (1995), 173–87; **C. Von Lees-Landwehr**, *Griechische Meisterwerke in römischen Abgüssen: der Fund von Baia; zur Technik antiker Kopisten* (Frankfurt, 1982).

pp.102–5 Hadrian's Villa at Tivoli: **W. L. MacDonald and J. A. Pinto**, *Hadrian's Villa and its Legacy* (New Haven, 1995); a catalogue of sculptural finds from the villa, **J. Raeder**, *Die statuarische Ausstattung der Villa Hadriana bei Tivoli* (Frankfurt, 1983).

p. 105 Dissemination of classical sculpture: **C. C. Vermeule, III**, *Greek and Roman Sculpture in America: Masterpieces from Public Collections in the United States and Canada* (Los Angeles, 1981).

Chapter 3. Sensuality, Sexuality, and the Love of Art

There is no shortage of material on artful desire in the ancient visual repertoire: **C. Johns**, *Sex or Symbol: Erotic Images of Greece and Rome* (London, 1982), takes a hearty line; as does **J. Boardman and E. La Rocca**, *Eros in Greece* (London, 1978), and **M. Grant**, *Eros à Pompéi: le cabinet secret du Musée de Naples* (Paris, 1975). **J. R. Clarke**, *Looking at Lovemaking: Constructions of Sexuality in Roman Art, 100 B.C.–A.D. 250* (Berkeley, 1998), as its title suggests, is a more nuanced exploration of gender and sexuality in Roman art. All are lavishly illustrated. Only rarely are less obvious forms of desire included along with displays of nudity and sex, but **A. Stewart**, *Art, Desire, and the Body in Ancient Greece* (Cambridge, 1997), ranges widely, and subtly (the 'Coda' explicitly discusses art of the Hellenistic period); likewise some of the essays in **N. B. Kampen** (ed.), *Sexuality in Ancient Art: Near East, Egypt, Greece, and Italy* (Cambridge, 1996), and **A. O. Koloski-Ostrow and C. L. Lyons** (eds), *Naked Truths: Women, Sexuality and Gender in Classical Art and Archaeology* (London, 1997).

pp. 107–9 Antinous: **H. Meyer**, *Antinoos: die archäologischen Denkmäler unter Einbeziehung des numismatischen und epigraphischen Materials sowie der literarischen Nachrichten* (Munich, 1991); **C. Vout**, 'Winckelmann and Antinous', in *Responding to the Antique* (Cambridge,

forthcoming); **S. Waters**, 'The most famous fairy in history: Antinous and homosexual fantasy', *Journal of the History of Sexuality* 6.2 (1995), 1–27; **R. Lambert**, *Beloved and God: The Story of Hadrian and Antinous* (London, 1984, reissued 1997); see above, Chapter 2, 'Cardinal Albani'.

pp. 110–11 Apollo Belvedere: **A. Potts**, *Flesh and the Ideal: Winckelmann and the Origins of Art History* (New Haven, 1984), 118–32.

pp. 113–15 Nakedness and nudity: **N. Salomon**, 'Making a world of difference: gender, asymmetry, and the Greek nude', in **Kolowski-Ostrow and Lyons** (eds), *Naked Truths*, 197–219; focusing largely on earlier periods, but with implications for Hellenistic art, **Stewart**, *Art, Desire and the Body*, chs 2 and 4.

pp. 115–28 Varieties of Venus: **C. M. Havelock**, *The Aphrodite of Knidos and her Successors: A Historical Review of the Female Nude in Greek Art* (Ann Arbor, 1995); **D. M. Brinkerhoff**, *Hellenistic Statues of Aphrodite* (New York, 1978). The *Aphrodite of Cnidus* has been intensely discussed: **N. Himmelmann**, 'The Knidian Aphrodite', in *Reading Greek Art* (Princeton, 1998), 187–98; **A. Ajootian**, 'Praxiteles', in **O. Palagia and J. J. Pollitt**, *Personal Styles*, (*Yale Classical Studies* 30; Cambridge, 1996), 91–129 (esp. 98–103); **C. Blinkenberg**, *Knidia* (Copenhagen, 1933); **H. Bankel**, 'Knidos: Der hellenistische Rundtempel und sein Altar. Vorbericht', *Archäologischer Anzeiger* 1997, 51–71 (a decisive critique of overoptimistic reconstructions of the Cnidian temple, as in **I. C. Love**, 'A preliminary report of the excavations at Knidos, 1970', *American Journal of Archaeology* 76 (1972), 61–76). Other types: **P. Fuller**, 'The *Venus* and "Internal Objects"' (*Venus de Milo*) in *Art and Psychoanalysis* (London, 1980), 71–129; **A. Pasquier**, *La Vénus de Milo et les Aphrodites du Louvre* (Paris, 1985); **G. Säflund**, *Aphrodite Kallipygos* (Stockholm, 1963).

pp. 128–32 Lucian, Erotes: **M. Foucault**, *Le Souci de Soi* (Paris, 1984; English trans., *The Care of the Self*, London, 1986); **S. Goldhill**, *Foucault's Virginity: Ancient Erotic Fiction and the History of Sexuality* (Cambridge, 1995), 102–9; **D. Halperin**, 'Historicizing the sexual body: sexual preferences and erotic identities in the pseudo-Lucianic Erôtes', in **J. Goldstein**

(ed.), *Foucault and the Writing of History* (Oxford, 1994), 19–34; **D. Freedberg**, *The Power of Images: Studies in the History and Theory of Response* (Chicago, 1989), 311–44 (on arousal by images).

pp. 130–1 Pygmalion and Galatea: **J. Elsner and A. Sharrock**, 'Re-viewing Pygmalion', *Ramus* 20 (1991), 149–82; **A. R. Sharrock**, 'Womanufacture', *Journal of Roman Studies* 81 (1991), 36–49.

pp. 132–9 Hermaphrodites: **A. Ajootian**, 'The only happy couple: hermaphrodites and gender', in **Kolowski-Ostrow and Lyons** (eds), *Naked Truths*, 220–42; on sleeping figures, **D. Fredrick**, 'Beyond the Atrium to Ariadne: erotic painting and visual pleasure in the Roman house', *Classical Antiquity* 14 (1995), 266–87, and **S. McNally**, 'Ariadne and others: images of sleep in Greek and early Roman art', *Classical Antiquity* 4 (1985), 152–92.

pp. 140–2 Drunken Old Woman: **P. Zanker**, *Die Trunkene Alte: das Lachen der Verhöhnten* (Frankfurt, 1989); **S. Sande**, 'An old hag and her sisters', *Symbolae Osloenses* 70 (1995), 30–53.

pp. 142–4 Children in Hellenistic art: **H. Rühfel**, *Das Kind in der griechischen Kunst: von der minoisch-mykenischen Zeit bis zum Hellenismus* (Mainz, 1984), 185–309.

Chapter 4. Sizing up Power: Masters of Art

This chapter brings together ancient images of power and the cultural politics of modern autocrats, who have seized on the precedents of Greece and Rome. Napoleon: **V. Huet**, 'Napoleon I: a new Augustus?', in **C. Edwards** (ed.), *Roman Presences: Receptions of Rome in European Culture, 1789–1945* (Cambridge, 1999), 53–69. Mussolini: **M. Stone**, *The Patron State: Art and Politics in Fascist Italy* (Princeton, 1998), and essays in **F. Liffran** (ed.), *Rome, 1920–1945: le modèle fasciste, son Duce, sa mythologie* (Paris, 1991) (esp. **A. Cederna**, 'Les délires de la troisième Rome', 55–67); on Mussolini's bimillennary exhibition of Augustan art (meant to set the seal on his refoundation of the Roman empire), **A. M. L. Silverio**, 'La Mostra Augustea della Romanità', in *Dalla Mostra al Museo: dalla Mostra archeologica del 1911 al Museo della Civiltà Romana* (Venice, 1983), 77–90, with the original catalogue, **G. Q. Giglioli** (ed.), *Mostra Augustea della Romanità: bimillenario della nascita di Augusto. 23 Settembre 1937-XV – 23 Settembre 1938-XVI* (3rd

edn, Rome, 1937). Nazi Germany: **A. Scobie**, *Hitler's State Architecture: The Impact of Classical Antiquity* (London, 1990); **V. Losemann**, 'The Nazi concept of Rome', in **Edwards** (ed.), *Roman Presences*, 221–35. In general, **D. Ades, T. Benton, D. Elliott, and I. B. Whyte**, *Art and Power: Europe under the Dictators 1930–45* (exhibition catalogue, London, 1995), is a powerful presentation of the cultural politics of modern autocrats (esp. **T. Benton**, 'Rome reclaims its empire', 120–9).

Almost all recent discussions of ancient art and power are heavily indebted to **P. Zanker**'s *The Power of Images in the Age of Augustus* (Ann Arbor, 1998); but note also the suggestive criticisms of **A. Wallace-Hadrill**, 'Rome's cultural revolution', *Journal of Roman Studies* 79 (1989), 157–64.

pp. 147–60 Pergamum: **H. Koester** (ed.), *Pergamon: Citadel of the Gods* (Harvard Theological Studies* 46, Harrisburg, Penn., 1998); **W. Radt**, *Pergamon: Geschichte und Bauten einer antiken Metropole* (Darmstadt, 1999) (cf., in English, his 'Recent research in and about Pergamon: a survey (ca. 1987–1997)', in **Koester**'s collection, 1–40). The *Great Altar*: **V. Kästner**, 'The architecture of the Great Altar of Pergamon', in **Koester** (ed.), *Pergamon*, 137–61; **E. Schulte** (ed.), *Der Pergamon Altar, entdeckt, beschrieben und gezeichnet von Carl Humann* (Dortmund, 1959); **H.-J. Schalles**, *Der Pergamonaltar: zwischen Bewertung und Verwertbarkeit* (Frankfurt, 1988); useful in English, **R. Dreyfus and E. Schraudolph** (eds), *Pergamon: The Telephos Frieze from the Great Altar, 1–2* (exhibition catalogue, San Francisco, 1996); on the identity of the sculptors, **M. Fränkel** (ed.), *Die Inschriften von Pergamon, 1. Bis zum Ende der Königzeit* (Berlin, 1890), and **D. Thimme**, 'The masters of the Pergamon Gigantomachy', *American Journal of Archaeology* 50 (1946), 345–57; the 'Henley Giant' (now in the Ashmolean Museum, Oxford), **M. Kunze**, 'The Arundel Giant', *Minerva* 10.6 (1999), 6–7.

pp. 152–3 The Stoa of Attalus: **J. M. Camp**, *The Athenian Agora: Excavations in the Heart of Classical Athens* (London, 1986), 172–5; **H. A. Thompson and R. E. Wycherley** (eds), *The Athenian Agora, vol. 14. The Agora of Athens: The History, Shape and Uses of an Ancient City Center* (Princeton, 1972), 103–7, 232–3.

pp. 164–4 Groups of Gauls: **E. Künzl**, *Die Kelten des Epigonos von Pergamon* (Würzburg, 1971); **E. Polito**, *I Galati Vinti: il trionfo sui barbari da Pergamo a Roma* (Rome, 1999); **B. Palma**, 'Il piccolo donario pergameno', *Xenia* 1 (1981), 45–84.

pp. 165–75 The Forum of Augustus: **P. Zanker**, *Forum Augustum: das Bildprogramm* (Tübingen, n.d. (1968)), revised Italian version, *Il Foro di Augusto* (Rome, 1984); **J. Ganzert and V. Kockel**, 'Augustusforum und Mars-Ultor-Tempel', in *Kaiser Augustus*, 149–99; **L. Ungaro and M. Milella** (eds), *The Places of Imperial Consensus: The Forum of Augustus; the Forum of Trajan* (Rome, 1995). Fragments: **S. R. Tufi**, 'Frammenti delle statue dei *summi uiri* nel foro di Augusto', *Dialoghi di Archeologia* (1981), 69–84. Inscriptions: **A. Degrassi** (ed.), *Inscriptiones Italiae, volumen XIII— Fasti et Elogia, fasciculus III—Elogia* (Rome, 1937).

pp. 165–7 Shining Italian marble: **J. Leivick**, *Carrara: The Marble Quarries of Tuscany* (Stanford, 1999); **E. Dolci**, '*Marmora Lunensia*: quarrying, technology and archaeological use', in **N. Herz and M. Waelkens**, *Classical Marble: Geochemistry, Technology, Trade* (Dordrecht, 1988), 77–84.

p. 167 Theatre of Pompey: **F. Coarelli**, 'Il complesso Pompeiano del Campo Marzio e la sua decorazione scultorea', *Rendiconti della Pontificia Accademia Romana di Archeologia* 44 (1971–2), 99–122.

p. 171 Via dell'Impero: **J. E. Packer**, 'Report from Rome: the imperial *fora*, a retrospective', *American Journal of Archaeology* 101 (1997), 307–30; **L. Barroero, A. Conti, A. M. Racheli, and M. Serio**, *Via dei Fori Imperiali: la zona archeologica di Roma, urbanistica, beni artistici e politica culturale* (Venice, 1983); **C. Ricci**, *Via dell'Impero* (Rome, 1933).

pp. 175–7 Pantheon: **M. T. Boatwright**, *Hadrian and the City of Rome* (Princeton, 1987), 43–51; **P. Davies, D. Hempsoll, and M. Wilson Jones**, 'The Pantheon: triumph of Rome or triumph of compromise?', *Art History* 10 (1987), 133–53.

p. 177 Temple of Hadrian: **L. Cozza** (ed.), *Il Tempio di Adriano* (Rome, 1982).

pp. 177–82 *Trajan's Column*: **S. Settis, A. La Regina, G. Agosti, and V. Farinella** (eds), *La Colonna Traiana* (Turin, 1988); in English, but resolutely devoted to Trajan's campaigns, **F. Lepper and S. Frere**, *Trajan's Column: A New Edition*

of the Cichorius Plates (Gloucester, 1988). Contrasting readings: **R. Brilliant**, *Visual Narratives: Storytelling in Etruscan and Roman Art* (Ithaca, N.Y., and London, 1984), 90–123; **V. Huet**, 'Stories one might tell of Roman art: reading Trajan's column and the Tiberius cup', in **J. Elsner** (ed.), *Art and Text in Roman Culture* (Cambridge, 1996), 8–31; for the notion that the frieze was added to the column only after Trajan's death, **A. Claridge**, 'Hadrian's Column of Trajan', *Journal of Roman Archaeology* 6 (1993), 5–22. The context of the column in the Forum of Trajan: **Ungaro and Milella** (eds), *The Places of Imperial Consensus*; **R. Meneghini**, 'L'architettura del Foro di Traiano attraversi i ritrovamenti archéologici più recenti', *Mitteilungen des Deutschen Archäologischen Instituts (Röm. Abt.)* 105 (1998), 127–48. Other columns: **G. Becatti**, *La Colonna Coclide Istoriata: problemi storici iconografici stilistici* (Rome, 1960), 11–45; **J. Scheid and V. Huet** (eds), *Autour de la colonne Aurélienne: la signification des gestes romains sur la colonne de Marc Aurèle à Rome* (Paris, 2000); Napoleon's, **M. K. Matsuda**, *The Memory of the Modern* (Oxford, 1996), 19–39.

pp. 182–6 Arch of Titus: **M. Pfanner**, *Der Titusbogen* (Mainz am Rhein, 1983); **M. Beard and J. Henderson**, 'The emperor's new body: ascension from Rome', in **M. Wyke** (ed.), *Parchments of Gender: Deciphering the Body in Antiquity* (Oxford, 1998), 191–219. Other triumphal arches: **A. Wallace-Hadrill**, 'Roman arches and Greek honours: the language of power at Rome', *Proceedings of the Cambridge Philological Society* 36 (1990), 143–81.

pp. 186–7 Altar of Peace: full publication after excavation and reassembly, **G. Moretti**, *L'Ara Pacis Augustae* (Rome, 1948); after late twentieth-century restoration, **E. La Rocca**, *Ara Pacis Augustae: in occasione del restauro della fronte orientale* (Rome, 1983); excellent overview, **S. Settis**, 'Die *Ara Pacis*', in *Kaiser Augustus*, 400–26. Interpretations: **M. Torelli**, *Typology and Structure of Roman Historical Reliefs* (Ann Arbor, 1982), 27–62; **D. E. E. Kleiner**, 'The great friezes of the *Ara Pacis Augustae*: Greek sources, Roman derivatives, and Augustan social policy', in **E. D'Ambra** (ed.), *Roman Art in Context* (Englewood Cliffs, N.J., 1993), 27–52; **J. Elsner**, 'Cult and

sculpture: sacrifice in the *Ara Pacis Augustae*', *Journal of Roman Studies* 81 (1991), 50–61. **D. A. Conlin**, *The Artists of the Ara Pacis* (Chapel Hill, 1997), is an exhaustive discussion of the sculptural technique and the artists responsible. The 1938 reconstruction was a rushed collage, leaving a remainder of over 700 fragments in the museum stores: **R. de Angelis Bertolotti**, 'Materiali dell'*Ara Pacis* presso il Museo Nazionale Romano', *Mitteilungen des Deutschen Archäologischen Instituts (Röm. Abt.)* 92 (1985), 221–34.

p. 187 Piazzale Augusto: **S. Kostof**, 'The emperor and the Duce: the planning of the *Piazzale Augusto Imperatore* in Rome', in **H. A. Millon and L. Nochlin** (eds), *Art and Architecture at the Service of Politics* (Cambridge, Mass., 1978), 270–325; cf. **J.-P. Faye**, 'Promenade autour de l'Augusteo', in **Liffran** (ed.), *Rome, 1920–1945*, 28–39.

pp. 187–8 Augustus' *Achievements*: **J. Elsner**, 'Inventing imperium: texts and the propaganda of monuments in Augustan Rome', in **Elsner** (ed.) *Art and Text*, 32–53. Ankara: **T. Mommsen** (ed.), *Monumentum Ancyranum: Res Gestae Divi Augusti* (Berlin, 1883); Apollonia: **W. H. Buckler, W. M. Calder, and W. K. C. Guthrie**, *Monumenta Asiae Minoris Antiqua*, vol. 4 (Manchester, 1933), 48–56; Antioch in Pisidia: **S. Mitchell and M. Waelkens**, *Pisidian Antioch: The Site and its Monuments* (London, 1998).

pp. 189–92 The 'Sebasteion' at Aphrodisias: **R. R. R. Smith**, 'The imperial reliefs from the Sebasteion at Aphrodisias', *Journal of Roman Studies* 77 (1987), 88–138, '*Simulacra gentium*: the *ethne* from the Sebasteion at Aphrodisias', *Journal of Roman Studies* 78 (1988), 50–77, and 'Myth and allegory in the Sebasteion', in **C. Roueché and K. T. Erim** (eds), *Aphrodisias Papers*, *Journal of Roman Archaeology* supplementary vol. 1 (1990), 89–100; **C. B. Rose**, *Dynastic Commemoration and Imperial Portraiture in the Julio-Claudian Period* (Cambridge, 1997), 164–9.

p. 192 Miniatures: **J. Kenseth**, 'The virtue of littleness: small-scale sculptures of the Italian Renaissance in ancient and baroque Rome', in **S. B. McHam** (ed.), *Looking at Italian Renaissance Sculpture* (Cambridge, 1998), 128–48.

pp. 193–5 The silver hoard from Boscoreale: **F. Baratte**, *Le Trésor d'Orfèvrerie romain de Boscoreale* (Paris, 1986); **A. Héron de**

Villefosse, 'Le trésor de Boscoreale', *Monuments et Mémoires, Fondation Eugène Piot* 5 (1899), 7–279, Paris (the first full publication); an exhaustive study of the 'imperial' cups, **A. L. Kuttner**, *Dynasty and Empire in the Age of Augustus: The Case of the Boscoreale Cups* (Berkeley, 1995); cf. **V. Huet**, 'Stories one might tell of Roman art: reading Trajan's column and the Tiberius cup', in **Elsner** (ed.), *Art and Text*, 8–31; on the skeleton cups, **K. M. Dunbabin**, '*Sic erimus cuncti ... :* The skeleton in Graeco-Roman art', *Jahrbuch des Deutschen Archäologischen Instituts* 101 (1986), 185–255, esp. 224–31.

pp. 195–7 The *Great Cameo of France*: **H. Jucker**, 'Der Grosses Pariser Kameo', *Jahrbuch des Deutschen Archäologischen Instituts* 91 (1976), 211–50.

p. 197–9 *Table Hercules*: **E. Bartman**, *Ancient Sculptural Copies in Miniature* (Leyden, 1992), ch. 4; **K. M. Coleman**, *Statius, Siluae IV. Edited with an English Translation and Commentary* (Oxford, 1988), 173–94. Alba Fucens: **F. de Visscher**, *Héraklès Epitrapézios* (Paris, 1962).

p. 199–202 The *Farnese Hercules*: **D. Krull**, *Der Herakles vom Typ Farnese* (Frankfurt, 1985); **C. M. Edwards**, 'Lysippos', in **O. Palagia and J. J. Pollitt**, *Personal Styles in Greek Sculpture* (*Yale Classical Studies* 30; Cambridge, 1996), 130–53, esp. 145–51; **C. Vermeule**, 'The *Weary Herakles* of Lysippos', *American Journal of Archaeology* 79 (1975), 323–332; **P. Moreno**, 'Il Farnese ritrovato ed altri tipi di Eracle in Riposo', *Mélanges d'Archéologie et d'Histoire de l'École Française de Rome* 94 (1982), 379–526; on the findspot, **M. Marvin**, 'Freestanding sculptures from the Baths of Caracalla', *American Journal of Archaeology* 87 (1983), 347–84, esp. 355–8; **M. Beard**, 'Le mythe (grec) à Rome: Hercule aux bains', in **S. Georgoudi and J.-P. Vernant** (eds), *Mythes grecs au figuré, de l'antiquité au baroque* (Paris, 1996), 81–104.

Chapter 5. Facing up to Antiquity: Art to the Life

Two suggestive short books on portraiture in general are **E. D'Ambra**, *Art and Identity in the Roman World* (London, 1998), and **R. Brilliant**, *Portraiture* (London, 1991), which explores both ancient and modern images. A major German initiative has been the series of Roman imperial portrait catalogues, *Das römische Herrscherbild* (first series from 1939, ed. **M. Wegner**; new series—

to cover Caesar to Nero—from 1989, eds
K. Fittschen, T. Hölscher, and P. Zanker);
note also the definitive catalogues of portraits
in museums in Rome by **K. Fittschen and P.
Zanker**, *Katalog der römischen Porträts in den
Capitolinischen Museen und den anderen
Kommunalen Sammlungen der Stadt Rom*
(Mainz, 1983). Meanwhile, there have been
important studies of the ideological dimension
of Roman sculpted faces: **R. R. R. Smith**,
'Greeks, foreigners and Roman Republican
portraiture', *Journal of Roman Studies* 71 (1981),
24–38 (an excellent exposure of the problems in
traditional accounts; unreliable for 'solutions'),
J. Fejfer, 'The Roman emperor portrait: some
problems in methodology', *Ostraka* 7 (1998),
45–56; **E. K. Gazda and A. E. Haeckl**,
'Roman portraiture: reflections on the
question of context', *Journal of Roman
Archaeology* 6 (1993), 289–302; **A. P. Gregory**,
'"Powerful images": responses to portraits and
the political uses of images in Rome', *Journal of
Roman Archaeology* 7 (1994), 80–99;
R. R. R. Smith, 'Cultural choice and political
identity in honorific portrait statues in the
Greek east in the second century A.D.', *Journal
of Roman Studies* 88 (1998), 56–93; for a
straightforward introduction, **S. Walker**,
Greek and Roman Portraits (London, 1995).

p. 207 The Roman head, the marble bust:
G. Winter, *Die Bildnisbust: Studien zu
Thema Medium Form und Entwicklungs-
geschichte* (Stuttgart, 1985); **I. Lavin**,
'On the sources and meaning of the
Renaissance portrait bust', in **S. B.
McHam** (ed.), *Looking at Italian
Renaissance Sculpture* (Cambridge, 1998),
60–78; **P. J. Ayres**, *Classical Culture and the
Idea of Rome in Eighteenth-century England*
(Cambridge, 1997), 63–75; **M. Pointon**,
*Hanging the Head: Portraiture and Social
Formation in Eighteenth-century England*
(New Haven, 1993); **G. Davies**, 'The
Albacini cast collection: character and
significance', in **G. Davies** (ed.), *Plaster
and Marble: The Classical and Neo-classical
Portrait Bust (The Edinburgh Albacini
Colloquium* (= *Journal of the History of
Collections* 3.2; Oxford, 1991)), 145–66; **G.
Vaughan**, 'Albacini and his English
patrons', ibid., 183–97; **J. Fejfer**, 'The
Roman portraits from the Ince Blundell
collection and their eighteenth-century
context', ibid., 235–54.

p. 207 Portraits at Pompeii: see Chapter 1,
'Generic painting'.

p. 208–10 The portrait herm: **H. Wrede**,

Die antike Herme (Mainz, 1985), 71–7; **E. B.
Harrison**, *The Athenian Agora, vol. XI.
Archaic and Archaistic Sculpture* (Princeton,
1965), 108–76.

pp. 209–13 Pompey the Great: **M. Bentz**,
'Zum Portrait des Pompeius', *Mitteilungen
des Deutschen Archäologischen Instituts
(Röm. Abt.)* 99 (1992), 229–46;
L. Giuliani, *Bildnis und Botschaft:
hermeneutische Untersuchungen zur
Bildniskunst der römischen Republik*
(Frankfurt, 1986); **F. Poulsen**, 'Les
portraits de Pompeius Magnus', *Révue
Archéologique* 7 (1936), 16–52; on the
findspot of the *Ny Carlsberg Pompey*,
F. Poulsen, 'Célèbres visages inconnus',
Révue Archéologique 36 (1932), 44–76, esp.
54–62; Palazzo Spada Pompey,
D. Faccenna, 'Il Pompeo di Palazzo
Spada', *Archeologia Classica* 8 (1956),
172–201.

pp. 214–25 Portraiture of Augustus:
D. Boschung, *Die Bildnisse des Augustus*
(Berlin, 1993); **R. R. R. Smith**, 'Typology
and diversity in the portraits of Augustus',
Journal of Roman Archaeology 9 (1996),
31–47; **K. Vierneisel and P. Zanker**, *Die
Bildnisse des Augustus: Herrscherbild und
Politik im kaiserlichen Rom* (Munich, 1979);
S. Walker and A. Burnett, *The Image of
Augustus* (London, 1981). Prima Porta
Augustus: **H. Kähler**, *Die Augustusstatue
von Primaporta* (Cologne, 1959); **J. Elsner**,
*Art and the Roman Viewer: The
Transformation of Art from the Pagan World
to Christianity* (Cambridge, 1995), 161–72;
J. Pollini, 'The findspot of the statue of
Augustus from Prima Porta', *Bullettino
della Commissione Archeologica Comunale in
Roma* 92 (1987–8), 103–8; its original
context, **G. Calci and G. Messineo**, *La
Villa di Livia a Prima Porta* (Rome, 1984);
and see above, Chapter 1, 'The Garden
Room of the Villa at Prima Porta'. Bronze
Augustus from the Aegean: **E. Touloupa**,
'Das bronzene Reiter Standbild des
Augustus aus dem Nordägäischen Meer',
*Mitteilungen des Deutschen Archäologischen
Instituts (Ath. Abt.)* 101 (1986), 185–205.
Augustus' empress is discussed in
E. Bartman, *Portraits of Livia: Imaging the
Imperial Women in Augustan Rome*
(Cambridge, 1998).

p. 218 Later imperial portraiture: **H. Jucker**,
'Iulisch-Claudische Kaiser- und
Prinzenporträts als "Palimpseste"',
*Jahrbuch des Deutschen Archäologischen
Instituts* 96 (1981), 236–316; **T. Pekáry**,

Das römische Kaiserbildnis in Staat, Kult und Gesellschaft (Berlin, 1985). Silver portrait of Galba: **W. Geominy**, 'Le buste d'argent de l'empereur Galba', in *À l'Ombre du Vésuve: collections du Musée national d'archéologie de Naples* (Paris, 1995), 221–6.

pp. 219–21 Ruler heads on coins: **N. Davis and C. M. Kraay**, *The Hellenistic Kingdoms: Portrait Coins and History* (London, 1973); **J. P. C. Kent**, *Roman Coins* (London, 1978); **A. Wallace-Hadrill**, 'Image and authority in the coinage of Augustus', *Journal of Roman Studies* 76 (1986), 66–87; and for wider issues in numismatics, **C. Howgego**, *Ancient History from Coins* (London, 1995). Hellenistic portraits on gems are discussed in **D. Plantzos**, *Hellenistic Engraved Gems* (Oxford, 1999).

p. 219 Prototypes and dissemination: **M. Stuart**, 'How were imperial portraits distributed throughout the Roman Empire?', *American Journal of Archaeology* 43 (1939), 601–15; see also **Fejfer**, 'The Roman emperor portrait', and **Smith**, 'Typology and diversity'.

pp. 224–5 Royal family groups: **C. B. Rose**, *Dynastic Commemoration and Imperial Portraiture in the Julio-Claudian Period* (Cambridge, 1997).

pp. 225–7 Alexander and Hellenistic ruler portraits: **R. R. R. Smith**, *Hellenistic Royal Portraits* (Oxford, 1988); **M. Bieber**, *Alexander the Great in Greek and Roman Art* (Chicago, 1964); **T. Hölscher**, *Ideal und Wirklichkeit in den Bildnissen Alexanders des Grossen* (Heidelberg, 1971); **A. Stewart**, *Faces of Power: Alexander's Image and Hellenistic Politics* (Berkeley, 1993).

p. 227–8 Harmodius and Aristogiton: **S. Brunnsåker**, *The Tyrant-Slayers of Kritios and Nesiotes* (Stockholm, 1971); **M. W. Taylor**, *Tyrant Slayers: The Heroic*
Image in Fifth-century B.C. Athenian Culture and Politics (repr. New York, 1981).

pp. 227–30 Roman 'veristic' portraiture: **S. Nodelman**, 'How to read a Roman portrait', in **E. D'Ambra** (ed.), *Roman Art in Context* (Englewood Cliffs, N.J., 1993), 10–26; and see **Smith**, 'Greeks, foreigners and Roman Republican portraiture'.

p. 230 Matron as Greek goddess of love: **E. D'Ambra**, 'The calculus of Venus: nude portraits of Roman matrons', in **Kampen** (ed.), *Sexuality in Ancient Art*, 219–32.

p. 230–2 Funeral masks and ancestors' *imagines*: **H. Flower**, *Ancestor Masks and Aristocratic Power in Roman Culture* (Oxford, 1996).

pp. 232–4 Mummy portraits from Fayum: **E. Doxiadis**, *The Mysterious Fayum Portraits: Faces from Ancient Egypt* (London, 1995); **S. Walker and M. Bierbrier**, *Ancient Faces: Mummy Portraits from Roman Egypt* (London, 1997).

p. 235 The Villa of the Papyri gallery of busts and herms: see above, Chapter 2, 'Villa of the Papyri'; **B. Schmalz**, 'Das Bildnis des Epikur und die Überlieferung griechischer Porträts', *Marburger Winckelmann-Programm* (1985), 17–56.

pp. 236–7 Portraits of Socrates: **P. Zanker**, *The Mask of Socrates: The Image of the Intellectual in Antiquity* (Berkeley, 1995); **J. Henderson**, 'Seeing through Socrates: portrait of the philosopher in sculpture culture', *Art History* 19 (1996), 327–52; **C. M. Edwards**, 'Lysippos', in **O. Palagia and J. J. Pollitt**, *Personal Styles in Greek Sculpture* (Yale Classical Studies 30; Cambridge, 1996), 130–53 (esp. 143–5).

p. 237–8 Early portraits of Christ: **A. Grabar**, *Christian Iconography: A Study of its Origins* (London, 1969) (esp. ch. 3, 'The Portrait'); **P. C. Finney**, *The Invisible God: The Earliest Christians on Art* (Oxford, 1994).

This list represents the most significant collections of artworks relevant to the text of this book.

Museums in the UK

The outstanding classical collection in the United Kingdom is housed in:

The British Museum
Great Russell Street
London
WC1B 3DG
www.thebritishmuseum.ac.uk

There are two important collections of plaster casts of classical sculpture:

Museum of Classical Archaeology
Faculty of Classics
Sidgwick Avenue
Cambridge
CB3 9DA
www.classics.cam.ac.uk/art.html

Cast Collection
Ashmolean Museum
Beaumont Street
Oxford
OX1 2PH
www.beazley.ox.ac.uk

Both the websites above offer excellent links to other classical sites.

An extraordinary museum of a notable nineteenth-century collector, preserved almost exactly as he left it, is:

The Sir John Soane Museum
13 Lincoln's Inn Fields
London
WC2A 3BP
www.soane.org

Museums and sites in the rest of Europe

Prime collections of classical material can be found throughout Greece, Italy, and Turkey, as well as the major European capital cities.

Details of museums and sites in Greece can be found at *www.culture.gr* and in Italy at *www.beniculturali.it* (so far mostly in Italian).

We have drawn particularly on collections in:

Musei Vaticani
Viale Vaticano 00165
00120 Città del Vaticano
Rome
http://christusrex.org/www1/vaticano/

Museo Archaeologico Nazionale
Piazza Museo 19
80135 Napoli
Italy
www.cib.na.cnr.it

Musée du Louvre
75058 Paris
Cedex 01
France
www.louvre.fr

National Archaeological Museum
Patission 44
Athens 10682
Greece

Pergamon Museum
Am Kupfergraben
Mitte
10178 Berlin
Germany
www.smb.spk-berlin.de

Museums in the USA

Worthy examples of classical art are found in museums across the United States, but the two richest collections are:

The J. Paul Getty Museum (The Getty Villa)
17985 Pacific Coast Highway
Malibu, CA 90265-5799
USA
www.getty.edu

The Metropolitan Museum of Art
Fifth Avenue and 82nd Street
New York NY 10028
USA
www.metmuseum.org

Excavations in progress

Many excavations now make their results known electronically. Two current projects at Pompeii are:

the Anglo-American Pompeii Project
www.brad.ac.ukacad/archschi/pompeii

the Pompeii Forum Project
http://pompeii.virginia.edu

Results of recent work at the villa at Primaporta can be found at:
www.arkeologi.uu.se/primaporta

For the excavations at Aphrodisias in Turkey, see:
www.nyu.edu/projects/aphrodisias

Resources for classical art in general

One of the most comprehensive resources for ancient (so far, predominantly Greek) art is *www.perseus.tufts.edu*

For a register of ancient works of art known in the Renaissance, with details of discovery, restoration, and publication, see *www.systemsplanning.com/census/*

A subscription is required for regular use, but a demonstration is available free.

List of Illustrations

The publisher would like to thank the following individuals and institutions who have kindly given permission to reproduce the illustrations listed below.

Abbreviations:

DAIR Deutsches Archäologisches Institut, Rome

MAN Museo Archeologico Nazionale, Naples

MNR Museo Nazionale alla Romano, Rome

1. Statue commonly known as the *Dying Seneca* or the *Louvre Fisherman*. Blackish-brown marble head and torso. First known in the Borghese Collection in the 1590s, findspot obscure. H. 118 cm. Restorations (made before the seventeenth century) include: up-turned enamelled eyes, parts of face; both arms below armpits; both legs from crotch to below knees; alabaster 'belt'; solid africano marble basin covered with red veneer to represent surface of bloodied water. Musée du Louvre (inv.MA.1354), Paris/photo © G. Dagli Orti, Paris.

2. Peter Paul Rubens, *The Death of Seneca*, *c.*1608. Oil on panel. 185 x 154.7 cm. Alte Pinakothek, Munich/photo Artothek.

3. Bronze statue, the *Praying Boy of Berlin*. Fourth – first century BCE (?). H. 128 cm. Antikensammlung (inv.SK2), Staatliche Museen zu Berlin Preussischer Kultur-besitz/photo Johannes Laurentius (a) without arms; (b) computer simulation of the construction of the inner framework, after U. Schramm, courtesy Intertec, Ingenieurschaft für Hochbau mbH, from G. Zimmer and N. Hackländer (eds), *Der Betende Knabe. Original und Experiment* (Frankfurt am Main: Peter Lang GmbH, 1997), Taf.53; (c) with restored arms.

4. The travels of the *Praying Boy*. after G. Zimmer and N. Hackländer (eds), *Der Betende Knabe. Original und Experiment* (Frankfurt am Main: Peter Lang GmbH, 1997), Abb.1.

5. Giovanni Paolo Panini, *Roma Antica*, from *Gallery of Views of Ancient Rome*, *c.*1755. Oil on canvas. 170 x 227 cm. Staatsgalerie (inv.3315), Stuttgart.

6. Lawrence Alma-Tadema, *The Picture Gallery*, 1874. Oil on canvas. 220 x 166 cm. Towneley Hall Art Gallery and Museums, Burnley/photo Bridgeman Art Library, London.

7. J. Paul Getty Museum in Malibu, California, 'Temple of Herakles' (1974), with replica of mosaic from the 'Villa of the Papyri', Herculaneum (Italian marbles in coloured triangles, giallo antico, africano, etc), and statue of Hercules (the *Lansdowne Hercules*; see 66 below). J. Paul Getty Museum, Malibu, CA/photo Julius Schulman.

8. Detail (Persian reflected in shield) from the *Alexander Mosaic* (see 12 below). Photo Paul Larsen, Lechlade.

9. *Discovery of a Skeleton in the Baths of the House of Emperor Joseph II*, engraving from F. Mazois, *Les Ruines de Pompéi* (Paris, 1812). Faculty of Classics Library, University of Cambridge.

10. Allan McCollum, *The Dog from Pompeii*. Concrete cast installation, Galería Weber, Madrid, 1991. Photo courtesy the artist, New York.

11. The House of the Faun, Pompeii (region VI.12.2); view inside from the front door, through the first peristyle and on to the second. Photo Scala, Florence.

12. The *Alexander Mosaic*, from the House of the Faun, Pompeii (region VI.12.2). *c.*100 BCE (?). 317 x 555 cm (including frame). MAN (inv.10020)/photo Luciano Pedicini, Naples.

13. Plan of the House of the Faun, Pompeii (region VI.12.2) showing the original locations of the figural mosaics: (a) Alexander Mosaic (see 12 above); (b) Nilotic scene. 64 x 600 cm. MAN (inv.9990); (c) drawing after W. Leonhard, 'Mosaikstudien zur Casa del Fauno', *Neapolis* 2 (1914), fig.13, original lost; (d) Cupid riding a tiger. 165 x 165 cm. MAN (inv.9991); (e) cat and birds. 51 x 51 cm MAN (inv.9993); (f) Nymph and Satyr (see 28 below). 39 x 37 cm. MAN (inv.27707); (g) masks,

fruit and flowers. 49 x 281 cm. MAN (inv.9994); (h) doves. 57.5 x 58.5. MAN (inv.s.n.); (i) seafood. 118 x 118 cm. MAN (inv.9997). Photos Luciano Pedicini, Naples: (a), (e), (h); Photos Paul Larsen, Lechlade: (b), (d), (f), (g), (i). Adapted from plan by Victoria I, from A. Cohen, *The Alexander Mosaic. Stories of Victory and Defeat* (Cambridge University Press, 1997), fig. 81.

14. J. H. Strack, Idealized reconstruction of the *atrium* of the House of the Faun, Pompeii (region VI.12.2), 1855. Watercolour. 30 x 34 cm. Plansammlung, Universitätsbibliothek (inv.17102), Technische Universität, Berlin/photo Antonia Weisse.

15. *Dancing Faun*, from the House of the Faun, Pompeii (region VI.12.2). Bronze statuette. H.77 cm. *c.*100 BCE (?). MAN (inv.5002)/photo Paul Larsen, Lechlade.

16. North-east wall from *cubiculum B*, Villa della Farnesina, Rome. Centrepiece shows the Infant Dionysus among the Nymphs of Nysa). *c.*20 BCE. H. 230cm. MNR, Palazzo Massimo alle Terme (inv.1118), Rome.

17. *Persephone snatched by Pluto to his Underworld Kingdom*, wall painting from Tomb 1, Vergina (north Greece. *c.*340–30 BCE. H. *c.*100 cm. Photo Ekdotike, Athens.

18. *Achilles Discovered on Skyros*, from the *tablinum* of the House of the Dioscuri, Pompeii (region VI.9.6) (incomplete). Third quarter of first century CE. Attributed to the 'Achilles Painter' (Painting A). 130 x 84 cm. MAN (inv.9110)/photo Luciano Pedicini, Naples.

19. *Achilles Discovered on Skyros*, from the peristyle of the House of Achilles in Pompeii (region IX.5.2). third quarter of first century CE. H.130 cm. MAN (inv.116085)/photo Luciano Pedicini, Naples.

20. (a) *Achilles Discovered*, mosaic in the House of Apollo, Pompeii (region VI.7.23). Third quarter of first century CE (?). 103 x 113 cm. *In situ*. (b) detail, Chiron teaches Achilles. Photo Soprintendenza Archeologica di Pompeii.

21. *Medea*, from the peristyle of the House of the Dioscuri, Pompeii (region VI.9.6). Third quarter of first century CE. Wall painting. 120 x 97 cm. Attributed to the 'Perseus Painter' (Painting B). MAN (inv.8977)/photo Luciano Pedicini, Naples.

22. *Medea*, fragment of wall painting from Herculaneum. Third quarter of first century CE (?). H.137 cm. MAN (inv.8976)/photo Paul Larsen, Lechlade.

23. *Cubiculum M* of the Villa of P. Fannius Synistor at Boscoreale, near Pompeii. Mid first century BCE. H. 2.62 m x L. 5.83 m x W. 3.34 m:

(a) the lower right-hand corner of the window-surround, with wall paintings of a bowl of fruit, and sea-side town; (b) the entire room, as reconstructed at the Metropolitan Museum of Art, New York. Photo (c) Metropolitan Museum of Art, Rogers Fund (inv.03.14.13)/Schecter Lee, New York.

24. *Portrait of a Girl*, wall painting from a house in Pompeii (region VI, 17 insula occidentalis, from 18th-century excavations on property known as 'Masseria di Cuomo'). Mid first century CE (?). Diameter 31 cm. MAN (inv.9084)/photo Luciano Pedicini, Naples.

25. 'Sacro-idyllic landscape', wall painting from Pompeii (original location unknown). *c.*15 BCE – *c.*50 CE. 40 x 50 cm. MAN (inv.9486)/photo Luciano Pedicini, Naples.

26. (a), (b) 'Villa landscapes', wall paintings from Pompeii (original location unknown). Second quarter of first century CE (?). Each 22 x 26.5 cm. MAN (inv.9406)/ photo Luciano Pedicini, Naples

27. *Venus*, wall painting in the peristyle of the House of the Marine Venus, Pompeii (region II.3.3). Third quarter of the first century BCE. H. 183 cm. *In situ*. Photo Paul Larsen, Lechlade.

28. *Nymph and Satyr*, mosaic from the House of the Faun (see 13f above).

29. Wall painting from peristyle in the House of L. Caecilius Iucundus, Pompeii (region V.1.26). 62–79 CE. 52 x 44 cm. Traces of gilding on jewellery etc. MAN (inv.110569)/photo Luciano Pedicini, Naples.

30. Priapus, from the vestibule of the House of the Vettii, Pompeii (region VI.15.1). Wall painting. 62–79 CE. 76 x 42 cm. *In situ*. Photo Luciano Pedicini, Naples.

31. The 'Pompeian Room' at Ickworth, Suffolk, completed in 1879. Architect, F. C. Penrose; decorator, J. D. Crace. Panels based on second-century CE paintings found at the Villa Negroni on the Esquiline Hill, Rome (now lost). National Trust Photo Library/ Andreas von Einsiedel.

32. *Triclinium* (dining-room) in the House of the Vettii, Pompeii (region VI.15.1). 62–79 CE. 6.40 x 3.57 m. *In situ*. (a) detail of wall paintings, left-hand corner. Photo Scala, Florence; (b) general view. Photo Alinari, Florence.

p. 39 (textbox): after A. Claridge. *Rome. An Oxford Archaeological Guide* (Oxford University Press, 1998), p. 48.

33. *Achilles' Quarrel with Agamemnon*, from the *tablinum* of the House of the Dioscuri (region VI.9.6). Damaged wall painting. Third quarter of the first century CE. Attributed to the

'Achilles Painter' (Painting B). H. 131 cm. MAN (inv.9104)/photo Paul Larsen, Lechlade.

34. Three scenes on the theme of the armour of Achilles. Two are from the peristyle of the House of Achilles (region IX.5.2). Wall paintings. Third quarter of the first century CE: (a) Thetis is shown the armour Vulcan has made for her son Achilles (east wall). 133 x 155 cm. *In situ*. Photo DAIR (48.26); (b) Thetis brings the armour to Achilles (west wall). 140 x 118 cm. *In situ*. From G.E. Rizzo, *La pittura ellenistico-romano* (Milan; Fratelli Treves Editori, 1929), tav.LXI. (c) Thetis sees herself reflected in the shield of Achilles. Detail of a wall painting from the *triclinium* of the House of Paccius Alexander, Pompeii (region IX.1.7). Third quarter of first century CE. 159 x 113 cm. MAN (inv.9529)/photo Luciano Pedicini, Naples.

35. Three wall paintings from *cubiculum e* of the House of Jason, Pompeii (region IX.5.18). First quarter of the first century CE. (a) *Medea* (west wall). 140 x 83 cm. MAN (inv.114321); (b) *Phaedra* (south wall). 115 x 83 cm. MAN (inv.114322); (c) *Paris and Helen* (north wall). 115 x 87 cm. MAN (inv.114320). Photos Paul Larsen, Lechlade.

36. Wall paintings in the *triclinium* (dining room) of the House of the Priest Amandus, Pompeii (region I.7.7). Mid first century CE (panel (c) perhaps a later re-facement). *In situ*. (a) *Polyphemus and Galatea* (south wall).132 x 80 cm. Photo Luciano Pedicini, Naples; (b) *Andromeda Rescued by Perseus* (west wall). 138 x 88 cm. Photo DAIR (66.1785); (c) *Hercules in the Garden of the Hesperides* (north wall). 125 x 82 cm. Photo Luciano Pedicini, Naples; (d) *Icarus* plummets from the sky (east wall).135 x 91 cm. Photo Alinari, Florence.

37. Wall painting in the Villa of the Mysteries, outside Pompeii. Mid first century BCE (?). H. (of frieze) 162 cm; room 7.0 x 5.0 m. *In situ*. (a) view into the room; (b) layout of the mural; (c) the bride. Photos Luciano Pedicini, Naples.

38. Wall painting from the 'Black Room' of the villa at Boscotrecase. Late first century BCE. 241 x 122 cm. Metropolitan Museum of Art, New York, Rogers Fund, 1920 (20.192.1).

39. Wall paintings from the 'Mythological Room' of the villa at Boscotrecase. Late first century BCE. (a) *Polyphemus and Galatea* (west wall) 193.7 x 128.3 cm. Metropolitan Museum of Art, New York, Rogers Fund, L920 (20.192.17). (b) *Andromeda Rescued by Perseus* (east wall). 195 x 125.7 cm. Metropolitan Museum of Art, New York, Rogers Fund, 1920 (20.192.16). (c) = (a) before restoration. Photo C. Faltermeier, from P. H. von Blanckenhagen

and C. Alexander, *The Augustan Villa at Boscotrecase* (DAIR : Sonderschriften Bd.8) (Mainz: Philipp von Zabern, 1990), pl. 72.

40. *Odysseus Under Attack from the Laestrygonians*, wall painting, 'Panel' 3 of the *Odyssey Landscapes* frieze from a house on the Via Graziosa on the Esquiline Hill, Rome. Second half of the first century BCE. H.150cm. Biblioteca Apostolica Vaticana (inv.424), Vatican City, Rome/photo Scala, Florence.

41. (a) A bird in a golden cage, detail from (b) wall painting from south wall of the 'Garden Room' in the imperial villa at Prima Porta, near Rome. *c*.40 BCE. H. 3 m (including vault 5.16 m) x L. 11.7 m. MNR, Palazzo Massimo alle Terme (inv.126373)/ Photo Archivio Electa, Elemond, S.p.A., Milan.

42. Painting from a tomb on the Esquiline Hill, Rome. *c*.300–150 BCE. H. 87 cm. Musei Capitolini (Palazzo dei Conservatori, inv.1025), Rome/photo Scala, Florence.

43. Wall painting in the House of Jupiter and Ganymede (I.4.2), Ostia. *c*.180–90 CE. H. 6m; room 6.75 x 8.75 m. *In situ*. Photo ICCD (series E no. 40949), Ministero per I Bene Culturali e Ambientali, Rome.

44. The *Aldobrandini Wedding*, wall painting from a house in Rome, *c*.30 BCE–15 CE (?). 92 x 242 cm. Biblioteca Apostolica Vaticana/photo Monumenti Musei e Gallerie Pontifichie, Rome/P. Zigrossi.

45. Corridor in the Golden House of Nero, Rome, 64 CE. *In situ*. Fototeca Unione, American Academy in Rome.

46. Raphael and Giovanni da Udine, The Vatican *Loggetta*, *c*.1519. *In situ*. Photo Scala, Florence.

47. The Golden House today: 'The Room of Hector and Andromache'. 64 CE. *In situ*. Photo Archivio Electa, Elemond S.p.A., Milan.

48. Johann Zoffany, *Charles Townley's Library at 7 Park Street, Westminster*, *c*.1781–3. Oil on canvas. 127 x 99 cm. Towneley Hall Art Gallery and Museums, Burnley/photo Bridgeman Art Library, London.

49. Marble sculpture of Laocoon and his sons. Marble, from Rome. Museo Pio-Clementino (inv.1059, 1064), Vatican City: (a) traditional restoration. H. 242 cm. Photo Alinari, Florence; (b) the twentieth-century restoration. H. 184 cm. Replacement of Laocoon's right arm; other supplements (parts of the serpents and children's arms) removed. Photo Scala, Florence; (c) G. P. Chédanne, *Domus Aurea de Neron, la salle du Laocoon*, *c*.1895. Oil on canvas. Musée des Beaux-Arts, Rouen/photo (c) G. Dagli Orti, Paris; (d) an

alternative Renaissance restoration of Laocoon's arm (reputedly by Michelangelo). Marble. Musei Vaticani (inv.1067)/photo Monumenti Musei e Gallerie Pontifichie, Rome.

50. A. von Maron, Portrait of J. J. Winckelmann, 1768. Oil on canvas. 136 x 99 cm. Kunstsammlung (inv.G.70), Weimar/photo S. Renno.

51. Marble sculpture, known as the *Arrotino* ('knife-grinder'). Greek marble, almost certainly from Rome. H. 105 cm. Restorations include: nose tip, r. edge of cloak, joint of r. hand, fingers, part of razor. Galleria degli Uffizi (inv.230), Florence/photo Alinari.

52. (a) Reconstruction drawing of the principal groups of sculpture in the 'Cave of Tiberius' at Sperlonga, after B. Conticello, V. Moriello and F. Angelelli, in B. Conticello and B. Andreae, *Die Skulpturen von Sperlonga (Antike Plastik xiv)* (Berlin: Gebr. Mann Verlag, 1974), p. 20, fig. 12; (b) the *Scylla* Group from Sperlonga, a modern reconstruction by B. Andreae and S. Bertolin. 1996. Resin and ground marble. H. 370 x L. 290 x D. 250 cm. Museo della Civiltà Romana, Rome/photo Silvia Massotti; (c) The *Polyphemus* Group at Sperlonga, plaster reconstruction. H. *c.*350 cm. Museo Archeologico Nazionale, Sperlonga/photo DAIR 72.2416; (d) Marble sculpture of the Palladium from the *Theft of the Palladium Group*. H. 82 cm. Sperlonga. Museo Archeologico Nazionale, Sperlonga; (e) marble fragments of the legs of Patroclus (or Achilles?), from the fourth main group at Sperlonga: Menelaus (or Odysseus) rescuing the corpse of a fallen comrade. Leg (without foot) 115 cm. Museo Archeologico Nazionale, Sperlonga/photo DAIR 69.1925.

53. Two heads: (a) *Laocoon* (detail of 49a); (b) the *Helmsman* from the *Scylla* Group at Sperlonga. Marble (head alone) 18 cm. Museo Archeologico Nazionale, Sperlonga/photo DAIR 64.901.

54. Bits of Scylla? Marble fragments of the Scylla Group at Sperlonga. Museo Archeologico Nazionale, Sperlonga (Magazzino), from B. Andreae, *Schönheit des Realismus (Kulturgeschichte der Antiken Welt 77)* (Mainz am Rhein: Verlag Philipp von Zabern, 1998), p. 269.

55. Marble sculpture from the cave at Sperlonga. Museo Archeologico Nazionale, Sperlonga: (a) *Maiden*. Third or second century BCE. H. 110 cm. Photo DAIR 65.1973; (b) *Venus and Cupid*. First century BCE (?). 76 x 65 cm. Photo DAIR 65.1992; (c) *Portrait head*. Late third century CE. H. 25 cm. Photo Robin

Cormack, Courtauld Institute of Art, University of London. Coloured marble (pavonazzetto) statue of *Ganymede and the Eagle*, from the cave at Sperlonga. Late first century BCE. H. 225 cm. Inset: the head in white marble, currently displayed separately, is perhaps a replacement (of the late first century CE?). Museo Archeologico Nazionale, Sperlonga.

57. E. F. Burney, *The Antique School at Old Somerset House*, 1779. Pen, ink and wash. Royal Academy of Arts, London/Photo Studios Ltd.

58. Marble statue of Mars (*Ares Ludovisi*) from Rome. Pentelic marble, from Rome. Second century CE (?). H. 156 cm. Restorations include: *Ares* – foot, hands and hilt of sword, shield-rim; *Cupid* – head, much of arms and foot. *Below*, detail of restored head of Cupid by G. L. Bernini (1622). MNR Palazzo Altemps (inv.8602)/photo Scala, Florence.

59. Female bust, commonly known as *Clytie*. Parian marble; acquired Naples, 1772. H. 57 cm. The British Museum (GR 1805.7-3.389), London.

60. *Discus Throwers*: (a) The *Townley Discobolus*. Carrara marble. From Hadrian's Villa at Tivoli. H. 172 cm. Restoration includes: antique head, attached by C. Albacini. The British Museum (Cat. Sculpture 250), London; (b) The *Lancellotti Discobolus*. Parian marble. Found in 1781 at the Villa Palombara on the Esquiline Hill, Rome. H. 155 cm. Restorations include: r. calf, l.-hand fingers, the lower half of the discus, and the base. MNR Palazzo Massimo alle Terme (inv.126371), Rome/photo Scala, Florence.

61. Pedimental sculpture from the late first-century BCE Temple of Apollo Sosianus in Rome (*c.*30–25 BCE). Greek marble. Fifth-century BCE. H. 37–161–55 cm. Museo Capitoline (inv.3291-2, 3454, 3457, 3527, 3527-33), Rome/photo Maria Teresa Natale.

62. Sculpture from the first-century BCE wreck off Anticythera in southern Greece: (a) *Weary Hercules*. Greek marble. H. 238 cm. National Museum (inv.5742), Athens. (b) *Odysseus*. Marble. H. 203 cm; (c) *Boy*. Bronze. *c.*350–30. H. 196 cm. Reassembled from fragments: base of neck, area of torso above hips, part of left thigh missing. National Museum (inv.BR 13396), Athens/photo © G. Dagli Orti, Paris; (d) *Philosopher*. Bronze. Late third century BCE (?). H. 29 cm. National Museum (BR 13400), Athens/photo Scala, Florence.

63. Sculptural group of *Pan and Goat* from the 'Villa of the Papyri', Herculaneum. Late

second century BCE (?). H. 44.4 cm x L. 60 cm x W. 31 cm. MAN (inv.27709)/photo Luciano Pedicini, Naples.

64. Bronze busts from the 'Villa of the Papyri', Herculaneum: (a) *Demosthenes*. H. 15 cm. MAN (inv.5467); (b) *Epicurus*. H. 20 cm. MAN (inv.5465); (c) Polyclitus' *Doryphorus* ('spear-carrier'), after a fifth-century original. H. 54 cm. MAN (inv.4885). Photos Luciano Pedicini, Naples.

65. The J. Paul Getty Museum in Malibu, CA. View of the main peristyle through the south porch. Architect Norman Neuerburg and others, 1974. Photo Julius Schulman.

66. The *Lansdowne Hercules* (as restored). Pentelic marble, from Hadrian's Villa at Tivoli. *c*.125–38 CE (?). H. 194 cm. Restorations include: parts of both arms (by C. Albacini), now removed. J. Paul Getty Museum (inv.70.AA.109), Malibu and Los Angles, CA.

67. Part of the frieze from the Monument of Aemilius Paullus, Delphi, 168 BCE, or soon after. Marble. H. 31 cm. Archaeological Museum, Delphi/Archaeological Receipts Fund (TAP Service), Athens.

68. The frieze traditionally known as the 'Altar of Domitius Ahenobarbus', originally cladding for the support for a sculpture or sculptural group, *c*.120–40 BCE. (a) Part of the mythical seascape featuring the wedding of the god Neptune and the nymph Amphitrite. Marble (streaked). H. 80 x L. 565 cm. Staatliche Antikensammlungen und Glyptothek (inv.G.239), Munich/photo H. Koppermann; (b) the Roman census and sacrifice. Greek marble. H. 80 x L. 565 cm. Musée du Louvre (inv.975), Paris/photo Réunion des Musées Nationaux.

69. *Hermes with the infant Dionysus*, attributed to the fourth-century BCE sculptor Praxiteles. From the temple of Hera at Olympia, in southern Greece. Greek (Parian) marble, from the Heraeum at Olympia. *c*.450–00 or copy from first century BCE (?). H. 213 cm. restorations include: Hermes' l. leg below knee, r. leg from knee to ankle. Archaeological Museum (inv.Olympia III.194ff), Olympia/photo DAIR 561.0638.

70. Roman version of the *Doryphorus* ('spear-carrier') by the fifth-century BCE sculptor Polyclitus. Marble, probably from Pompeii. Roman copy of bronze original (*c*.440 BCE). H.199 cm. Restorations include: part of the support and tip of penis. MAN (inv.6011). Photo Paul Larsen, Lechlade.

71. G.-B. Piranesi, *Ruins of a Sculpture Gallery in the Villa Adriana at Tivoli*. Etching from *Vedute di Roma*, 1770. 45 x 58 cm. Ashmolean

Museum, Oxford.

72. The *Canopus*, or scenic canal, at Hadrian's Villa, Tivoli, *c*.125–38 CE. L. of canal, 121.4 m. Reconstruction. Photo Robin Cormack, Courtauld Institute, University of London.

73. Collage: (a) derrière of *Apollo Belvedere*. Photo Scala, Florence (see 77); (b) detail of *Golden Venus of Rags* (see 80).

74. Head of Antinous, as Dionysus (or Apollo) ('Mondragone Head'). Marble, from near Frascati. *c*.130–8 CE (?). H. 95 cm. Heavily reworked in eighteenth century; possibly fragment of a colossal statue (H. 5–6 m.). Musée du Louvre (inv.1205), Paris/photo Réunion de Musées Nationaux.

75. Antinous goes Egyptian, from the 'Poikile' at Hadrian's Villa, Tivoli. Parian marble. *c*.130–38 CE (?). H. 241 cm. Restorations include: r. hand, tip of nose, parts of lips. Musei Vaticani, Museo Gregoriano-Egizio (inv.99), Vatican City/photo Alinari, Florence.

76. Relief sculpture of Antinous (the 'Albani Relief') from Hadrian's Villa, Tivoli; engraving from J. J. Winckelmann, *Monumenti Inediti* (1767). Faculty of Classics Library, University of Cambridge.

77. (a) Statue of Apollo (the *Apollo Belvedere*). Greek (Parian) marble, findspot in Italy disputed. Circa second century CE copy of a late third century BCE original (?). H. 214 cm. Restorations by G. Montorsoli (1532), removed in 1929: l. hand and forearm, fingers of r. hand. Musei Vaticani (inv.1015)/photo Alinari, Florence. (b) Anonymous, *Napoleon Bonaparte Showing the Apollo Belvedere to his Deputies*, *c*.1799. Etching with aquatint. 16 x 21 cm. Bibliothèque Nationale, Paris.

78. 'Antico' (P. J. A. Bonacolsi), Statuette of Apollo, *c*.1497. Bronze. H. 40 cm. Ca' d'Oro, Venice/photo Scala, Florence.

79. Michelangelo Buonarroti, *David*, 1501–4. Marble. H. 514 cm. Gallerie dell' Accademia, Florence/photo Alinari.

80. Michelangelo Pistoletto, *Golden Venus of Rags*, 1967–71. Concrete with mica and rags. 180 x 230 x 100 cm. Lia Rumma Gallery, Naples/courtesy the artist.

81. Statue of Venus from the *tablinum* of the House of Julia Felix (region II.4.6). Greek marble. Roman version of a (perhaps second-century BCE?) Greek original. H. 62 cm. Earrings lost; traces of multi-coloured paintwork includes: Venus – red shoes, hair and lips; eyes of glass paste; gilded filigree-style lingerie, choker, armlets, and bracelet; the Priapus – genitals and hair gilded, red shoes, the base painted black. MAN

(inv.152798)/photo Luciano Pedicini, Naples.
82. Statue of Venus (*Venus de' Medici*).
Inscribed in Greek on base 'Maker:
Cleomenes of Athens, (son) of Apollodoros'.
First century BCE/CE (?), version of a Greek
statue (*c*.200–100 BCE(?). H. 153 cm.
Restorations include: r. arm, l. arm below
elbow; part of support; numerous fractures;
head re-attached. Galleria degli Uffizi
(inv.224), Florence/photo Alinari.
83. Johann Zoffany, *The Tribuna degli Uffizi*,
1772–8. Oil on canvas. 124 x 155 cm. The Royal
Collection © 2000, Her Majesty Queen
Elizabeth II.
84. Statue of Venus (*Venus de Milo*). Greek
marble, from Melos. H. (with base) 204 cm.
Musée du Louvre (inv.MA.399), Paris/photo
Réunion des Musées Nationaux/Arnaudet/J.
Scho.
85. (a) After C. A. d' A. Bertall, *Die Frage der
Venus von Milo* ('The question of the Venus de
Milo), cartoon from *Le Journal Illustré*, 5 July
1874. (b) Various reconstructions proposed for
the Venus de Milo. After P. Fuller, *Art and
Psychoanalysis* (London: Writers and Readers
Publishing Cooperative, 1980), pp. 86–7 and
A. Pasquier, *La Vénus de Milo et les Aphrodites
du Louvre* (Paris: Editions de la Réunion des
Musées Nationaux, 1985), p. 34.
86. (a) *Venus Kallipygos* ('Beautiful-Bum').
Greek marble, found 'near' the Domus Aurea,
Rome. H. 152 cm. Restorations include: r. leg
below knee, r. shoulder and head, l. arm,
nipples. MAN (inv.6020)/photo Luciano
Pedicini, Naples. (b) Thomas Rowlandson,
The Exhibition 'Stare' Case, *c*.1800. Water-
colour and grey and brown wash over graphite
on woven paper. 45 x 30 cm. Yale Center for
British Art (Paul Mellon Collection), New
Haven, CT.
87. The principal versions of Cnidian
Aphrodite: (a) 'Colonna'. Greek marble, from
Rome. H. (without plinth) 205 cm.
Restorations include: neck, r. forearm and
hand, l. arm below armband, r. foot from
ankle; the head is ancient but from another
statue. Musei Vaticani (inv.812)/photo Hirmer
Verlag (671.9289), Munich. (b) 'Belvedere'.
Greek marble, from Rome. *Circa* mid second
century CE. H. (without plinth) 231 cm.
Restorations include: nose, little finger of r.
hand, r. leg from knee to ankle (with adjacent
support), little toe of l. foot. Musei Vaticani
(inv.4260)/photo Monumenti Musei e
Gallerie Pontifichie, Rome. (c) Bronze coin of
Cnidus. 211–18 CE, apparently showing the
Aphrodite of Cnidus (modern retooling to the
pot, apparently to match that of 'Capitoline

Venus', 88). Bibliothèque Nationale
(Cab.Mon.Med. G.454.XVII.17), Paris.
88. Statue of Venus (*Capitoline Venus*). Parian
marble, from Rome. Roman version of a
(perhaps second-century BCE?) Greek
original. H. (with plinth) 193 cm. Restorations
include: nose, parts of both hands. Musei
Capitolini (inv.409), Rome/photo DAIR
57.720.
89. Statue of Venus (*Crouching Venus*), from
Hadrian's Villa, Tivoli. East Greek marble. H.
92 cm. MNR, Palazzo Massimo alle Terme
(inv.108597), Rome/photo DAIR 66.1682.
90. Statuette of Aphrodite. Greek marble,
from Rhodes. H. (without base) 49 cm.
Archaeological Museum (inv.14808),
Rhodes/photo Alinari, Florence.
91. Jean-Léon Gérôme, *Pygmalion and
Galatea*, 1890. Oil on canvas. 88.9 x 68.6 cm.
Metropolitan Museum of Art, Gift of Louis
C. Raegner, 1927 (inv.27.200), New
York/photo © 1989 Metropolitan Museum of
Art.
92. *A Sleeping Hermaphrodite* (the *Louvre
Hermaphrodite*). Marble, from Rome, second-
century CE. Copy of a statue *c*.150–00 BCE. L.
148 cm. Mattress added by Bernini (1620).
Musée du Louvre (inv.MA.231), Paris/photo
Réunion des Musées Nationaux/H.
Lewandowski.
93. See 92.
94. (a) Statue group of *Satyr and Nymph*.
Marble, from near Tivoli. Second century
century CE (?). H. 76 cm. Restorations include:
her l. shoulder, fingers of l. hand, both
arms, head (ancient but reworked); and his
nose, feet, hair. British Museum (GR.1658). (b)
Statue group of *Satyr and Hermaphrodite*.
Marble, from Rome. Roman version of a (?)
Greek original. H. 91 cm. Restorations
include: arms and legs of both figures, crown
of Hermaphrodite's head. Staatliche
Kunstsammlungen (Skulpturensammlung
155), Dresden. (c) *Satyr and Hermaphrodite*.
Wall painting from Pompeii. Early first
century CE. 51 x 56 cm. MAN (inv.110878)/photo
Luciano Pedicini, Naples.
95. (a) *Pan Unveils Hermaphrodite* (?). Wall
painting from Pompeii. First century CE. 53 x
46.5 cm. MAN (inv.27691)/photo Luciano
Pedicini, Naples. (b) *Sleeping Ariadne
Discovered by Pan and Dionysus*. Wall painting
from the House of the New Hunt, Pompeii
(region VII.10.3). Third quarter of first century
CE. 90 x 100 cm. MAN (inv.111484)/photo
Luciano Pedicini, Naples.
96. Statue group of *Aphrodite, Pan, and Eros*.
Greek (Parian?) marble, from Delos. Late

second-century BCE. H. (without base) 132 cm.
Fragments reassembled without restoration.
National Museum (inv.3335), Athens/photo
Scala, Florence.

97. Statue of *Drunken Old Woman*. Greek
(Parian) marble, from Rome. Early first
century CE (?) copy of an original of late third
century BCE. H. 92 cm. Restorations include: r.
arm (from middle of upper arm), l. shoulder
and part of upper arm, breast and drapery, l.
foot, nose; head re-attached. Staatliche
Antikensammlung und Glyptothek (inv.437),
Munich/photo H. Koppermann.

98. Statue groups of *Boy and Goose*: (a) Greek
(Pentelic?) marble, from Rome. Roman
version of second-century BCE original. H. 85
cm. Restorations include: tip of nose, top of r.
forearm with head and neck of goose, middle
of left leg, part of left foot. Musei Capitolini
(inv.238), Rome/photo Alinari, Florence. (b)
Greek (Pentelic) marble, found at the Villa
Quintiliana, on the Via Appia, in Rome.
Roman version of second-century BCE
original. H. (without plinth) 84 cm.
Restorations include: head and wing tip.
Staatliche Antikensammlung und Glyptothek
(inv.268), Munich/photo H. Koppermann.

99. Statuette of *Sleeping Eros*. Bronze,
apparently from Rhodes. *Circa* third or second
century BCE (?). L. 85.2 cm. L. arm missing; the
rock is a modern addition. Metropolitan
Museum of Art, Rogers Fund (43.11.4), New
York.

100. *Herkules the Landmark of Kassel*.
Verwaltung der Staatlichen Schlösser und
Gärten Hessen, Bad Homburg v.d.H. (detail
of 146).

101. Sculptural programme of the *Great Altar*
of Pergamum. After Candace Smith, from A.
Stewart, *Greek Sculpture. An Explanation*, vol.
2 (New Haven and London: Yale University
Press, 1990), pl. 693.

102. Reconstruction of the east side of the
Great Altar. Drawing by J. Bosholm, from R.
Dreyfus and E. Schraudolph (eds),
*Pergamon. The Telephos Frieze from the Great
Altar*, vol. 2 (Fine Arts Museums of San
Francisco and the Staatliche Museen zu Berlin
Preussischer Kulturbesitz, 1997), fold-out 3.

103. The west side of the *Great Altar* at
Pergamum, as reconstructed in the
Pergamonmuseum, Berlin. Late third–mid
second century BCE. Antikensammlung,
Staatliche Museen zu Berlin Bildarchiv
Preussischer Kulturbesitz/photo Jürgen Liepe.

104. W. Kreis, Model for the projected
Soldatenhalle (a shrine to German military
glory), Berlin. Façade. 1937–8. Photo Albert
Speer, Heidelberg, from W. Arenhövel, *Berlin
und die Antike; Architektur, Kunstgewerbe,
Malerei, Skulptur, Theater und Wissenschaft
vom 16 Jahrhundert bis heute* (Berlin: Staatliche
Museen zu Berlin Preussischer Kulturbesitz,/
Deutsches Archäologisches Institut, 1979), p.
415, cat. 1007.

105. The 'Stoa of Attalus' (mid second-century
BCE) as reconstructed in the Agora of Athens,
1956. *In situ*. Marble. 115 x 20 m. Photo ©
Agora Excavations, American School of
Classical Studies at Athens.

106. (a) Apollo from the east frieze of the *Great
Altar* of Pergamum. Pergamonmuseum.
Antikensammlung (PM.208) Staatliche
Museen zu Berlin Preussischer Kulturbesitz;
(b) Lapith and Centaur metope from the
south side of the Parthenon, Athens. Pentelic
marble. British Museum (GRS. Metope XXVII),
London.

107. (a) Zeus and Athena on the east frieze of
the *Great Altar* of Pergamum. Pergamon-
museum. Antikensammlung, Staatliche
Museen zu Berlin Preussischer Kulturbesitz;
(b) J. Carrey, *Athena and Poseidon Compete for
Athens on the West Pediment of the Parthenon*.
Drawing (detail), *c*.1674. Bibliothèque
Nationale, Paris.

108. (a) Hercules discovers his son Telephus,
marble relief from the *Telephus Frieze* on the
Great Altar of Pergamum (panel 12). 110 x 74 x
37 cm. The lion's paw beneath the baby visible
in the photograph is now lost.
Pergamonmuseum. Antikensammlung
Museen zu Berlin Preussischer Kulturbesitz.
(b) Telephus holds Orestes at sword-point at
Agamemnon's altar. Marble relief from the
Telephus Frieze on the *Great Altar* of
Pergamum (panel 42). 93 x 97 x 28 cm.
Pergamonmuseum. Antikensammlung
(inv.T.371-72) Staatliche Museen zu
Berlin/photo Johannes Laurentius.

109. Aphrodite on the north side of the *Great
Altar* of Pergamum (detail). Pergamon-
museum. Antikensammlung Staatliche
Museen zu Berlin Preussischer Kulturbesitz/
photo Erich Lessing.

110. *Dying Gaul*. Yellowish, eastern Greek (?)
marble, almost certainly from Rome. Roman
copy of original often attributed to Epigonos
of Pergamum. *c*.220 BCE (?). H. (without
plinth) 94 cm. Restorations include: r. arm,
some locks, nose, l. thumb, toes, and r. side of
the plinth as far as the body. Musei Capitolini
(inv.747), Rome/photo Scala, Florence.

111. Statue group of *Suicidal Celts* (the Ludovisi
Gaul). Yellowish, eastern Greek (?) marble,
almost certainly from Rome. Roman copy

from an original of *c*.220 BCE (?). H. 211 cm. Restorations include: Celt's r. arm and most of sword and hilt, l. forearm, woman's nose, l. arm, lower r. arm. MNR, Palazzo Altemps (inv.8608), Rome/photo © G. Dagli Orti, Paris.

112. Four statues from a group found on the Campus Martius, Rome. Eastern Greek (?) marble. Roman copies from second century BCE originals ('Small Pergamene Dedication' on the Acropolis of Athens). From top left: *Dying Celt*. H. 59 cm. MAN (inv.6015); *Dead Giant*. L. 134 cm. MAN (inv.6013); *Dead Amazon*. L.125 cm. MAN (inv.6012); *Dead Persian*. MAN (inv.6014). Restorations include: Persian's arms, Celt's l. arm, plus details of all the figures. Photo Alinari, Florence.

113. The Forum of Augustus, Rome. Drawing after A. Degrassi, from P. Zanker, *Il Foro di Augusto* (Rome: Fratelli Palombi Editori, 1984).

114. Coloured marbles from the *Forum Augustum*: (a) Phrygian purple (*pavonazzetto*) from central Turkey; (b) Lucullan red/black (*africano*) from western Turkey; (c) Numidian yellow (*giallo antico*) from Tunisia; (d) Carystian green (*cipollino*) from Euboea, Greece. From *Kaiser Augustus und die Verlorene Republik*, catalogue (Berlin: Staatliche Museen Preussischer Kulturbesitz, 1988), Farbtafel 3.

115. Detail of the Forum of Augustus, Rome (118). Photo G. Fittschen-Badura, from P. Zanker, *Il Foro di Augusto* (Rome: Fratelli Palombi Editori, 1984), pl.5.

116. Reconstruction of the caryatids flanking a shield with the head of Jupiter Ammon on the upper storey of the porticoes of the Forum of Augustus. Marble fragments and plaster. H.105 cm. Palazzo dei Cavalieri di Rodi, Rome/photo DAIR 61.1059.

117. *Mars and Venus*. Wall painting from the *tablinum* of the House of the Wedding of Hercules, Pompeii (region VII.9.47). Third quarter of first century CE. 90 x 90 cm. MAN (inv.9248)/photo Luciano Pedicini, Naples.

118. Scale model of the Forum of Augustus. Di Carlo, scale model (1:50), 1937. Wood and plaster. 67 x 286 x 191 cm. Antiquarium of the Cavalieri di Rodi, Rome/Fototeca Unione, American Academy in Rome.

119. B. Mussolini inaugurating the *Via dell' Impero*, Rome, 1932. Photograph from C. Ricci, *Via dell'Impero (Itinéraires des Musées et Monuments d'Italie, 24)* (Rome: La Libreria dello Stato, 1933), p. 4.

120. Relief sculpture on a Roman altar (the *Algiers Relief*), from Carthage. Marble. First

century CE. 98 x 113 cm. Archaeological Museum (inv.217), Algiers/photo Alinari, Florence.

121. Relief sculpture on the 'Altar of Piety', Rome. *c*.50 CE (?) (plaster recomposition). Original in marble. W. (total) 122 cm. Left, Musei Capitolini; right, Villa Medici, Rome. From P. Zanker, *Il Foro di Augusto* (Rome: Fratelli Palombi Editori, 1984), pl. 45.

122. (a) and (b) Aeneas and Romulus, from the doorposts of the Fullery of Ululutremulus, Pompeii (region IX.13.5). From V. Spinazzola, *Pompei alla luce degli scavi nuovi di Via dell' Abbondanza 1910-23* (Rome: La Libreria dello Stato, 1953), figs. 183–4.

123. The Pantheon (S. Maria ad Martyres), Rome, early second century CE. Marble brick and concrete. Internal diameter of rotunda 44.4 m. H. from floor to oculus [also] 44.4 m. Diameter of *oculus* 8.8 m. (a) Façade. From *Art and History of Rome* (Florence: Casa Editrici Bonechi, 1997), p. 146; (b) Vault and 'eye' (*oculus*). Photo (c) G. Dagli Orti, Paris.

124. *Trajan's Column*, Rome, *c*.113 CE. Italian marble. H. 29.78 m. Column: diameter 3.83 m. (bottom), 3.66 m. (top). Relief: 0.89 m. (base), 1.25 m. (top). (a) As it is today, beside the modern monument to Vittorio Emanuele II. From *Art and History of Rome* (Florence: Casa Editrice Bonechi, 1997), pp. 78–9. (b) An axonometric reconstruction of the Forum complex, after R. Meneghini, 'L'architettura del Foro di Traiano attraversi I ritrovamenti archéologici più recenti', *Mitteilungen des Deutschen Archäologischen Instituts* (Römische Abteilung), vol. 105 (1998), p. 139, fig. 9. (c) Gold coin of Trajan, 112/14 CE. British Museum (BMC.449), London. Relief on Trajan's Column, Rome (detail of lowest register). See 124. Photo © G. Dagli Orti, Paris.

126. Reading *Trajan's Column* vertically, after 'Column of Trajan, Southeast Side, Middle Section', in R. Brilliant, *Visual Narratives. Storytelling in Etruscan and Roman Art* (Ithaca/London: Cornell University Press, 1984), p. 99, fig.3.4.

127. The Fall of the Vendôme Column, Paris, 1871. Bibliothèque Nationale, Paris.

128. A. Speer, design for a triumphal arch in Berlin, 1939. Landesarchiv, Berlin.

129. Napoleon steals the chariot group from the top of the Brandenburg Gate, Berlin 1806. Coloured engraving, 1813. Kunstbibliothek (sign.1005.58), Berlin/Bildarchiv Preussischer Kulturbesitz.

130. Roman *denarius* of 19 BCE, showing the (lost) Arch of Augustus, Rome. Diameter 19

mm. British Museum (BMC.428), London.

131. The Arch of Titus, *Forum Romanum*, Rome, *c*.81 CE, as restored. Originally Greek (Pentelic) marble; restored with travertine. Arch: 15.4 x 13.5 x 4.75 m.; archway: 8.30 x 5.36 m. Photo DAIR 79.2000.

132. *View of the Arch of Titus*, etching (detail) from *Vedute di Roma*, 1760. 39 x 62 cm. Ashmolean Museum, Oxford.

133. Marble reliefs from the passage of the Arch of Titus, Rome. Greek marble, *c*.81 CE. H. 2.02 x 3.92 m. (a) Triumphal procession. (b) Spoils from the sack of Jerusalem (70–1 CE). Photos Scala, Florence.

134. Relief panel in the vault of the Arch of Titus, showing the emperor's ascension. Marble relief, as seen from the ground, *c*.81 CE. Photo DAIR 79.2393.

135. Italy (or Earth), relief sculpture on a Roman altar from Carthage. Marble (detail). First century CE. 90 x 113 cm. Musée du Louvre (inv.1838)/photo Réunion des Musées Nationaux/R. G. Ojeda.

136. The 'eastern' face of the *Ara Pacis*, Rome, showing Italy (or Earth) on left of entrance. Restoration includes much of baby and cow. Fototeca Unione, American Academy in Rome.

137. The outside wall of the Temple of Rome and Augustus, Ankara, *c*.15 CE. Inscription 1.38 x 21 m. Photo Deutsches Archäologisches Institut (R.23.490), Istanbul.

138. Reconstruction of the porticoes of the 'Sebasteion' at Aphrodisias, looking west from temple to propylon. Sketch from *The Journal of Roman Studies*, vol.LXVII (1987), p. 94, fig. 3.

139. (a) Relief panel from the centre of the triptych in the upper storey above the ninth or tenth room along the south portico of the 'Sebasteion' at Aphrodisias. Greek (Aphrodisian) marble. 160 x 156–66 x 44 cm. Recomposed from four large and four smaller fragments. Photo Professor R. R. R. Smith, Ashmolean Museum, University of Oxford. (b) Relief panel from the right side of the triptych in the upper storey above the third room along the south portico of the 'Sebasteion' at Aphrodisias. Greek (Aphrodisian) marble. 165 x 132–35 x 43 cm. Recomposed from twelve main fragments. Inscribed base with 'Bretannia' and Claudius' title. Also found on same spot. New York University Excavations at Aphrodisias, Institute of Fine Arts, New York/photo M. Alì Dögenci.

140. One of the 'Skeleton Cups' from Boscoreale. Silver. H. 10.4 cm. Musée du Louvre (inv.BJ.1923), Paris, from A. Héron de

Villefosse, 'Le trésor de Boscoreale', *Monuments et Mémoires, Fondation Eugène Piot* 5 (1899), pl. VIII.1. Faculty of Classics Library, University of Cambridge.

141. The 'Boscoreale Cups'. Late first century BCE (?). Silver. H. 10 cm.; D. 13 cm. (with handles 21 cm.). Musée du Louvre, Paris. (a) the emperor Augustus receives submission and soaks up adoration. From A. Héron de Villefosse, 'le trésor de Boscoreale', *Monuments et Mémoires, Fondation Eugène Piot* 5 (1899), pl. XXXVI.2. Faculty of Classics Library, University of Cambridge. (b) A public sacrifice before a temple. Musée du Louvre (inv.BJ.2367), Paris/photo Réunion des Musées Nationaux.

142. *Great Cameo of France*. Sardonyx. *c*.50 CE (?). 30 x 25 cm. Cabinet des Monnaies, Médailles (inv.264), Bibliothèque Nationale, Paris.

143. Statue of *Hercules Epitrapezios*. Greek (Pentelic) marble, from the Baths at Alba Fucens, central Italy. Date disputed (perhaps first century BCE). H. *c*.240 cm. (head 46 cm.) Museo Archaeologico (inv.4742), Chieti/Soprintendenza Archeologica dell'Abruzzo.

144. The *Farnese (Weary) Hercules*. Greek (Parian) marble, from the Baths of Caracalla, Rome. H. (without base) 292 cm. Inscribed 'Made by Glycon of Athens'. *c*.200–20 CE. copy of a Lysippan original of late fourth century BCE. Restorations include: tip of nose, l. lower arm and hand, toes, fingers of r. hand. MAN (inv.6001)/photo Scala, Florence. Detail: sixteenth-century legs by G. della Porta. Marble. H. 83–91cm. Derestored in 1787. MAN (inv.138151-2)/photo Paul Larsen, Lechlade.

145. Wedgwood and Bentley, eighteenth-century oval plaque of the *Farnese Hercules*. Blue and white jasper. *c*.1778. H. 18.5 cm. By courtesy of the Trustees of the Wedgwood Museum, Barlaston, Staffs.

146. Anthoni of Augsburg, *Herkules the Landmark of Kassel*, the Park Wilhelmshöhe, Kassel, Westphalia, 1713-17. Photo Verwaltung der Staatlichen Schlösser und Gärten Hessen, Bad Homburg v.d.H.

147. Head of Augustus from Suasa, north Italy. Marble. Early first century CE. Now restored. From D. Boschung, *Die Bildnisse des Augustus* (Berlin: Gebr. Mann Verlag, 1993), Kat.27a, Taf.239.6.

148. Detail of 179.

149. Plaster casts of volcano victims at Pompeii: a male and a female. Photograph from G. Picard, *Rome* (Geneva/Paris/Munich: Nagel Publishers, 1969), fig. 10.

150. The 'Azara Alexander' herm. Inscribed in Greek 'Alexander of Macedon, son of Philip'. Greek (Pentelic) marble, from a villa in Tivoli. Second century CE. H. 68 cm. Restorations include: nose, back of herm, mouth and eyelids re-cut; head re-attached. Musée du Louvre (inv.MA.436), Paris/photo Réunion des Musées Nationaux.

151. J. Nollekens, Bust of Charles James Fox, 1805. Marble. Victoria and Albert Museum, London.

152. Mosaic portrait of a woman from *tablinum* of a thermopolium, Pompeii (region VI.15.14). Late first century BCE, reused third quarter of first century CE as centrepiece of *opus sectile* pavement. 26 x 21 cm. MAN (inv.124666)/photo Luciano Pedicini, Naples.

153. (a) Silver platter from the Boscoreale Treasure. Beaten silver. *c.*40-60 CE (?). Diameter (plate) 24 cm. (emblema 2 cm.). Weight 0.834 kg. Inscribed 'Maxima's' underneath. Musée du Louvre, Paris/photo Réunion des Musées Nationaux. (b) silver head torn from a lost platter (the pair of the first). Figure on the same scale and in the same style as the first. Silver. Found elsewhere in the villa at Boscoreale. *c.*40–60 CE (?). Drawing after M. Vincenzo de Prisco from A. Héron de Villefosse, 'Le trésor de Boscoreale', *Monuments et Mémoires, Fondation Eugène Piot* 5 (1899), p. 46, fig.8. Faculty of Classics Library, University of Cambridge.

154. Herm of Lucius (Caecilius Iucundus?). Bronze from the House of Caecilius Iucundus, Pompeii (region V.1.26). H. 35 cm. MAN (inv.110663)/photo Luciano Pedicini, Naples.

155. The *Ny Carlsberg Head* of Gnaeus Pompeius Magnus, from Rome. Pentelic marble. Traces of brown in hair. First century CE (?). H. (from break of the neck up) 25 cm. Ny Carlsberg Glyptotek, Copenhagen.

156. (a) Red jasper intaglio, with oval ringstone: portrait of Pompey the Great. Inscribed 'P. P'. Date disputed (first century BCE–first century CE). H. 14 mm. Antikensammlung (inv.FG.6536) Staatliche Museen zu Berlin Preussischer Kulturbesitz. (b) Bronze coin with portrait of Pompey the Great, minted in Spain, 46–5 BCE, by Cn. Pompeius. British Museum (BMC.RR.Spain 80), London. (c) Bronze coin with portrait of Pompey the Great as one of the god Janus' two heads, minted in Spain, 45–4 BCE, by Sex. Pompeius. British Museum (BMC.RR. Spain 95), London.

157. The *Palazzo Spada Pompey*. Pentelic marble. *c.*100 CE (?). H.345 cm. found on the Campus Martius, Rome, *c.*1550. Restorations include: (body) l. arm, plus a slice of arm up to the shoulder; sword hilt, fingers of the l. hand, penis, r. big toe. Head plus half the neck white marble. Perhaps modern (16th century). H. 45 cm. Smoothed and pegged to fit the body. Salone del Trono, Palazzo Spada, Rome/ photo Alinari, Florence.

158. The *Louvre Augustus* (=the *Velletri Augustus*). Portrait statue of Augustus wearing the toga. Marble. H. 207 cm. Head found at Velletri (?), and added by Albacini to statue acquired from the Palazzo Giustiniani in Venice. Bought by the Pope in 1780, it was taken to Paris in 1798, and ceded by the next Pope in 1816, to the new King of France. H. (of head) 27 cm. Restored: nose tip. Salle d'Auguste, Musée du Louvre, (MA.1212), Paris/photo Réunion des Musées Nationaux.

159. The *Genius of Augustus*. Greek (Pentelic) marble. Found in Campania, once in the Palazzo Caraffa in Naples. Bought by the Pope in the late 18th century. H. 247 cm. Restored: nose, lower lip, r. forearm and bowl, l. forearm and the end of the cornucopia, parts of the drapery. Sala Rotunda (555) Musei Vaticani (inv.259), Vatican City, Rome/photo Alinari, Florence.

160. (a) Statue of the emperor Augustus as *imperator*. Marble, from the 'Villa of Livia', at Prima Porta. Yellowish marble. Many traces of paint. H. 204 cm. Restored: lance (or sceptre), pointing finger, index of l. hand, part of l. ear and l. shoulder, some of the cloak. Braccio Nuovo, Musei Vaticani (inv.2290), Vatican City, Rome/photo Scala, Florence. (b). Lawrence Alma-Tadema, *An Audience at Agrippa's*, 1875. Oil on panel. 90 x 63 cm. Dick Institute (inv.FA/A3), Kilmarnock/photo Museums & Arts Section, East Ayrshire Council.

161. The *Via Labicana Augustus*: portrait statue of Augustus, dressed for ritual, found in Rome. Greek marble: head and forearm; Italian marble: body. The back was left rough. Traces of violet paint on the toga and red on the hair. Found in 1910 beneath a house in the Via Labicana (at the intersection with Via Mecenate), Rome. H. 217 cm. MNR, Palazzo Massimo alle Terme (inv.56230)/photo Alinari, Florence.

162. Fragment of a portrait statue of Augustus, found off Euboea in the north Aegean sea, 1979. Bronze. H. 123 cm. National Museum, Athens/photo Scala, Florence.

163. Detail of the Stela of Augustus, from the Bucheum at Hermonthis, Egypt. The Egyptian Museum, Cairo. From A. K. Bowman, *Egypt After the Pharaohs 332 BC–AD*

642 from Alexander to the Arab Conquest (London: British Museum Publications, 1986), p. 36, fig. 24.

164. (a) Portrait statue of Claudius as Jupiter. Greek marble. Found at Lanuvium in 1865. H. 254 cm. Restored: r. ear, both arms, top of eagle, most of crown, side of nose, drapery, lance. The Sala Rotunda, Musei Vaticani, Vatican City, Rome/photo Alinari, Florence. (b) Portrait statue of Trajan as *imperator*. Marble, from Ostia. Museo Ostiense, Ostia Antica/photo Scala, Florence. (c) portrait statue of Hadrian, ready for ritual, from Rome. Musei Capitolini, Rome/photo Maria Teresa Natale.

165. Silver portrait bust of the emperor Galba. Beaten silver (*c.*95% pure). Found at Herculaneum, outside the 'House of Galba'. 69 CE (?). H. 41 cm. In sixteen fragments: restored by V. Bramante. MAN (inv.110127)/photo Luciano Pedicini, Naples.

166. Coins from Seleucid Syria: (a) head of Seleucus I of Syria, with bull's horn (reigned 311–281 BCE); (b) head of Seleucus II Kallinkikos of Syria, with bull's horn (reigned 264–25 BCE); (c) head of Seleucus III Soter of Syria (reigned 225–3 BCE); head of Seleucus IV Philopator of Syria (reigned 182–75 BCE); (e) head of Seleucus VI Epiphanes Nikator of Syria (reigned (?) 96–5 BCE). (NB: Seleucus V 'reigned' in 125.) Courtesy The American Numismatic Society, New York/photos Sharon Suchma.

167. Nero and his mother Agrippina share a gold coin, 54 CE. Obverse: 'Agripp(ina), Aug(usta) (Widow) of Divinized Claud(ius), Mother of Nero Aug(ustus) Germ(anicus) emp(eror), with Tr(ibunician) Pow(er)'. Diameter 19 mm. British Museum (BMC I Nero), London.

168. Page 222 (textbox): Drawings after K. Vierneisel and P. Zanker, *Die Bildnisse des Augustus: Herrscherbild und Politik im kaiserlichen Rom* (Munich, 1979), figs. 5.1–3.

169. The *Alcudia Head* of Augustus. Marble. From Pollentia, found at Alcudia on Majorca in 1757 (or 1658?). H. 37 cm. Private Collection. From D. Boschung, *Die Bildnisse des Augustus* (Berlin: Gebr. Mann Verlag, 1993), Kat.6, Taf.7.

170. Head of Augustus, found at Meroe, south Sudan, in 1910. Bronze. Eyes inset: the whites are alabaster, the irises a yellow–black stone, the pupils glass in a bronze ring. *c.*27–5 BCE. H. 44 cm. British Museum (GR.1911), London/photo Werner Forman Archive.

171. The *Forbes Head* of Augustus. Marble. First century CE. H. 31 cm. x L. 20 cm.

Courtesy Museum of Fine Arts (Gift of Edward Waldo Forbes, 1906; inv.06.1873), Boston.

172. Detail of the south frieze of the Altar of Peace in Rome, showing Augustus and Agrippa. Marble, from Rome. Dedicated 9 BCE. H. 55 cm. Photo Scala, Florence.

173. (a) A coin from Pergamum, with head of Alexander the Great. *c.*297 BCE. Diameter 32 mm. British Museum (1919-8-20), London; (b) a round gem, with the head of Alexander the Great. With Brahmi inscription. 2.5 x 2.5 cm. Third century BCE (?). Ashmolean Museum (E. J. Chester Bequest; inv.1892-1499), Oxford.

174. The *Terme* (or *Hellenistic*) *Ruler*. Bronze. H. 222 cm. MNR Palazzo Massimo delle Term (inv.1049), Rome/photo DAIR 66.1686.

175. Harmodius and Aristogiton (the Tyrannicides). Marble copies from Hadrian's Villa at Tivoli. H. 195–203 cm. The head of Aristogiton (l.) is restored from another copy. MAN (inv.6009-6010)/photo Luciano Pedicini, Naples

176. The face of Rome (mid-first century BCE) Portrait head of a Roman, facing, and l. profile. Marble, acquired 1954. *c.*50 BCE. H. 26 cm. Nose shattered, damage to ear lobes, r. eyebrow, chin; lacks back and (on separate stone) top of head. Ny Carlsberg Glyptotek (inv.3158), Copenhagen/© Jo Selsing.

177. Portrait of a Flavian Roman matron (thought by Poulsen to be Marcia Furnilla) as sex goddess. Marble, from a villa near Lake Albano in central Italy. A cupid lost above the feet. *c.*90 CE. H. 191 cm. Ny Carlsberg Glyptotek, Copenhagen/© Jo Selsing.

178. The Barberini Portrait (*Togatus Barberini*). Marble. Late first century BCE. H. 165 cm. Restorations include: head and parts o toga, nose of the images, l. ear of image in l. hand, plus half the bust and the l. hand. Muse del Palazzo dei Conservatori, Rome/photo © G. Dagli Orti, Paris.

179. Mummy of Artemidorus, from Hawara, Egypt. Painted stucco, with portrait in encaustic on limewood, with gold leaf added. Early second century CE. 171 x 45 x 37 cm. Presented by H. Martyn Kennard, 1888. British Museum (EA 21810), London.

180. Miniature portrait on glass, from Pompei (regio v between insula 1 and 20. First half of first century CE. 2 x 2 cm. Found in 1907. MAN (inv.132424)/photo Luciano Pedicini, Naples.

181. 'The European', mummy portrait from Antinoöpolis, Egypt. Encaustic on wood, with bib of gold leaf. 42 x 24 cm. Early second century CE (?). Acquired in 1952. Musée du

Louvre (Antiquités Grecques et Romaines P.217), Paris/photo Réunion des Musées Nationaux.

182. Herm of Panyassis. Marble, from the 'Villa of the Papyri', Herculaneum, 1757. The faint inscription on the front was detected (by Sgobbo) in 1971. H. 49 (head 23) cm. MAN (inv.6152)/photo Luciano Pedicini, Naples.

183. Portraits of Socrates: (a) 'Type A' head, marble, from Italy (once in the Farnese Collection). H .37 cm. Restored: tip of nose, edge of l. ear. MAN (inv.6129)/photo Luciano Pedicini, Naples; (b) 'Type B' head, marble, from Italy (once in the Farnese Collection). Marble. H. 77 (head 36) cm. Inscribed with (a slightly independent version of) Plato, Crito 47b. MAN (inv.6415)/photo Luciano Pedicini, Naples; (c) statuette, alabaster, found in Alexandria in 1925. Late second century BCE. H. 28 cm. British Museum (1925.11-18.1), London; (d) fragmentary statuette. Marble. Found in Athens in 1976. Photo © Agora Excavations, American School of Classical Studies in Athens.

184. Graffito from Rome, found in the 'Paedagogium' of the imperial palace on the Palatine, 1856. Third century CE (?). 38 x 33 cm. Museo Palatino (inv.381403), Rome. Photo DAIR 59.376.

Maps and Plans

1. The Mediterranean World from Greece to Rome, showing (a) the empire of Alexander the Great, King of Macedon (336–23 BCE); (b) the Roman Empire under the Emperor Hadrian (117–38 CE).

2. The area around Vesuvius. After J. Ward-Perkins and A. Claridge, *Pompeii AD 79*, exhibition catalogue (London: Royal Academy, 1976), p. 36.
The city and houses of Pompeii. City plan after R. Etienne, *Pompeii. The Day a City Died* (London: Thames & Hudson, 1992), 46–7. House plans after H. Eschebach, *Stadtplan von Pompeji* (Heidelberg: Deutsches Archäologisches Institut, 1969).

4. The Villa of the Mysteries, outside Pompeii, showing *oecus* ('Room') 5, with megalographic wall painting of 'The Mysteries'. Drawing after Claus Henning in M. Grant, *Cities of Vesuvius: Pompeii and Herculaneum* (London: Michael Grant, 1971; edition published by the Hamlyn Publishing Group, 1974), p. 135, fig. 13.

5. The 'Villa of the Papyri', Herculaneum. After C. C. Parslow, *Rediscovering Antiquity* (Cambridge University Press, 1998), p. 78, fig. 20.

6. The Villa della Pisanella, Boscoreale, showing the wine-tank where the silver hoard was found. From Héron de Villefosse, 'Le trésor de Boscoreale', *Monuments et Mémoires, Fondation Eugène Piot*, vol.5 (1899), fig. 1.

7. The Villa of P. Fannius Synistor, Boscoreale; axonometric plan showing *cubiculum* M, after E. Wahle, in M. L. Anderson, *Pompeian Frescoes in the Metropolitan Museum of Art* (New York: Metropolitan Museum of Art, 1987), p. 16, fig. 21.

8. The Imperial Villa at Boscotrecase, axonometric plan after E. Wahle, in M. L. Anderson, *Pompeian Frescoes in the Metropolitan Museum of Art* (New York: Metropolitan Museum of Art, 1987), p. 36, fig. 44.

9. The Villa della Farnesina. After D. Marchetti, in M. R. S. Di Mino (ed), *La Villa della Farnesina: in Palazzo Massimo alle Terme* (Rome: Electa/Ministero per I Beni Culturali e Ambientali Soprintendenza Archeologica di Roma, 1998), p. 11, fig. 5.

10. The *Ara Pacis*. After A. Claridge, *Rome. An Oxford Archaeological Guide* (Oxford University Press, 1998), p. 185.

11. (a) The city of Rome; (b) the Imperial Fora, with the Via dell' Impero (today Via dei Fori Imperiali). City: after N. H. Ramage and A. Ramage, *The Cambridge Illustrated History of Roman Art* (Cambridge University Press, 1991). Imperial Fora: after A. Claridge, *Rome. An Oxford Archaeological Guide* (Oxford University Press, 1998), p. 146.

12. The Golden House of Nero (with the superstructure of the Baths of Trajan). After E. Segala and I. Sciortino, *Domus Aurea* (Rome: Electa/Ministero per I Beni e le Attività Culturali, Soprintendenza Archeologica di Roma, 1999), English edition, pp. 17–18.

13. The Pantheon, showing (a) porch; (b) rotunda. After R. Brilliant, *Roman Art: from the Republic to Constantine* (London: Phaidon Press, 1974), p. 26, fig. 1.7a.

14. The Cave of Tiberius, Sperlonga. After B. Andreae and B. Conticello, *Die Skulpturen von Sperlonga* (Berlin: Gebr. Mann Verlag, 1974), p. 11, fig .1.

15. 'Livia's Villa' at Prima Porta. After G. Messineo, *La Via Flaminia da Porta del Populo a Malborghetto* (Rome: Quasar, 1991), p. 228.

16. Hadrian's Villa at Tivoli. After W. L. MacDonald and J. A. Pinto, *Hadrian's Villa and its Legacy* (New Haven and London: Yale University Press, 1995), fold-out after p. 382.

16. The citadel of Pergamum, after drawing by W. Hoepfner in R. Dreyfus and E.

Schraudolph (eds), *Pergamon: the Telephos Frieze from the Great Altar*, exhibition catalogue, vol.2 (Fine Arts Museum of San Francisco and Staatliche Museen zu Berlin Preussischer Kulturbesitz, 1997), p. 36, fig. 12.

17. The imperial sanctuary at Antioch in Pisidia, with the Achievements of Augustus (*c*.15 CE) displayed in the passage of a gateway leading to the Temple of (?) Augustus and Rome (*c*.2 BCE.). After S. Mitchel and M. Waelkens, *Pisidian Antioch. The Site and its Monuments* (London: Gerald Duckworth & Co., 1998), p. 153, fig. 31.

The publisher and authors apologize for any errors or omissions in the above list. If contacted they will be pleased to rectify these at the earliest opportunity.

Index